Invention of Hysteria

Invention of Hygiene

Invention of Hysteria

Charcot and the Photographic Iconography of the Salpêtrière

Georges Didi-Huberman

Translated by Alisa Hartz

The MIT Press
Cambridge, Massachusetts
London, England

Originally published in 1982 by Éditions Macula, Paris. ©1982 Éditions Macula, Paris.
This translation ©2003 Massachusetts Institute of Technology

This book was set in Bembo by Graphic Composition, Inc.

Cet ouvrage, publié dans le cadre d'un programme d'aide à la publication, bénéficie du soutien du Ministère des Affaires étrangères et du Service Culturel de l'Ambassade de France aux Etats-Unis.

This work, published as part of a program of aid for publication, received support from the French Ministry of Foreign Affairs and the Cultural Services of the French Embassy in the United States.

Library of Congress Cataloging-in-Publication Data

Didi-Huberman, Georges.
[Invention de l'hysterie, English]
Invention of hysteria : Charcot and the photographic iconography of the Salpêtrière / Georges Didi-Huberman ; translated by Alisa Hartz.
p. cm.
Includes bibliographical references and index.
ISBN 978-0-262-04215-4 (hc. : alk. paper) — 978-0-262-54180-0 (pb. : alk. paper)
1. Salpêtrière (Hospital). 2. Hysteria—History. 3. Mental illness—Pictorial works. 4. Facial expression—History. I. Charcot, J. M. (Jean Martin), 1825–1893. II. Title.

RC532 .D5313 2003
616.85'24'009—dc21
 2002029382

Contents

Contents

Acknowledgments

Pierre Bérenger, Jérôme Cantérot, Jacqueline Carroy-Thirard, Paul Castaigne, Jean Clay, Hubert Damisch, Monique David-Ménard, Pianine Desroche, Michel Foucault, Marie-Georges Gervasoni, Claude Imbert, Brigitte Montet, Véronique Leroux-Hugon, Louis Marin, Jaqueline Ozanne, Sylvia Pollock, Daniel Ponsard, Jacqueline Sonolet, Harrie Teunissen, and the *Trésor de la langue française* all had a part in this text, and I am grateful to each of them, quite specifically.

G. D.-H.

The translator gratefully acknowledges the generous assistance of Tania Roy, Enrico J. Cullen, Laura Chiesa, Dr. Arthur J. Hartz, Joshua Cody, and, in particular, Juliette Leary Adams.

A. H.

Editions Macula would like to thank the Bibliothèque Charcot of the Salpêtrière (Service of Professor Castaigne), as well as the Archivio storico delle arti contemporanee of Venice for their courteous cooperation.

Principal Works Cited

IPS 1875 *Iconographie photographique de la Salpêtrière.* Bibliothèque Charcot, Salpêtrière Hospital.

IPS I *Iconographie photographique de la Salpêtrière.* By Bourneville and Régnard. Paris: Bureaux du Progrès médical/Delahaye and Lecrosnier, 1876–1877. 167 pp. Figures: 40 plates.

IPS II *Iconographie photographique de la Salpêtrière.* By Bourneville and Régnard. Paris: Bureaux du Progrès médical/Delahaye and Lecrosnier, 1878. 232 pp. Figures: 39 plates.

IPS III *Iconographie photographique de la Salpêtrière.* By Bourneville and Régnard. Paris: Bureaux du Progrès médical/Delahaye and Lecrosnier, 1879–1880. 261 pp. Figures: 40 plates.

NIS *Nouvelle Iconographie de la Salpêtrière.* 1888–1918. Cited by article.

All references to the work of Sigmund Freud are to the *Standard Edition of the Complete Psychological Works of Sigmund Freud.* Trans. and ed. James Strachey. London: Hogarth Press, 1953–1974.

Argument

In the last few decades of the nineteenth century, the Salpêtrière was what it had always been: a kind of feminine inferno, a *citta dolorosa* confining four thousand incurable or mad women. It was a nightmare in the midst of Paris's *Belle Epoque.*

This is where Charcot rediscovered hysteria. I attempt to retrace how he did so, amidst all the various clinical and experimental procedures, through hypnosis and the spectacular presentations of patients having hysterical attacks in the amphitheater where he held his famous Tuesday Lectures. With Charcot we discover the capacity of the hysterical body, which is, in fact, prodigious. It is prodigious; it surpasses the imagination, surpasses "all hopes," as they say.

Whose imagination? Whose hopes? There's the rub. What the hysterics of the Salpêtrière could exhibit with their bodies betokens an extraordinary complicity between patients and doctors, a relationship of desires, gazes, and knowledge. This relationship is interrogated here.

What still remains with us is the series of images of the *Iconographie photographique de la Salpêtrière.* It contains everything: poses, attacks, cries, "*attitudes passionnelles,*" "crucifixions," "ecstasy," and all the postures of delirium. If everything seems to be in these images, it is because photography was in the ideal position to crystallize the link between the fantasy of hysteria and the fantasy of knowledge. A reciprocity of charm was instituted between physicians, with their insatiable desire for images of Hysteria, and hysterics, who willingly participated and actually raised the stakes through their increasingly theatricalized bodies. In this way, hysteria in the clinic became the spectacle, the *invention of hysteria.* Indeed, hysteria was covertly identified with something like an art, close to theater or painting.

But the constant escalation of these charms produced a paradoxical situation: the more the hysteric delighted in reinventing and imaging herself to a greater extent, the more a kind of ill was exacerbated. At a

certain moment the charm was broken, and consent turned to hatred. This turning point is interrogated here.

Freud was the disoriented witness of the immensity of hysteria *in camera* and the manufacturing of images. His disorientation was not without bearing on the beginnings of psychoanalysis.

I

Spectacular Evidence

1

Outbreaks

Spectacle

I am attempting, fundamentally, to reopen the question of what the word "spectacle" might have meant in the expression "the spectacle of pain." It is an infernal question, I think, profoundly shrill and strident.

How might a relationship to pain already be projected, as it were, in our approach to works and images? How does pain get to work, what might be its form, what is the temporality of its emergence, or its return? How does this occur before—and within—us and our gaze? This also raises the question of which oblique paths true pain employs to give us mute access, but access nonetheless, to the question of forms and signifiers.

In the end pain was the only name I could find for the event of hysteria, even in the very passage of its terrible attraction (and this is how the question was first opened up).

I will interrogate this paradox of atrocity; at every moment of its history, hysteria was a pain that was compelled to be invented, as spectacle and image. It went so far as to invent itself (for this compulsion was its essence) when the talents of hysteria's established fabricators fell into decline. An invention is the *event* of signifiers. But what I want to speak of is the meaning of the *extreme visibility* of this event of pain, the all too evident pain of hysteria.

Invention

Inventing can be understood in three different senses:
Imagining; imagining to the point of "creating," as they say.—Then, *contriving* [*controuver*], that is, exploiting in the imagination, overcreating; in short, lying with ingenuity, if not genius. The Littré dictionary says that *controuver* is incorrectly but nonetheless commonly used to mean *contradicting*.—Finally, inventing is finding or falling right on the shock of the thing, the "thing itself"; *invenire,* coming to it, and perhaps unveiling it.

3

Inventing is a kind of miracle (the miracle by which Christ's Cross was disinterred from the Temple of Venus surmounting the Holy Sepulcher, and then "recognized" by Saint Helena among two other crosses. This miracle is celebrated as the liturgy of the so-called Invention and Exaltation of the True Cross. What will be attempted here, between the venereal body and crucifixions of pain, is precisely the opening of the writings concerning the belated reinvention of a "Christian body.") This miracle is always *infected,* smoothly concealing the creation, imagination, and abuse of images, the lies and contradictions—and, finally, the shock.

Infected, but from what? Nietzsche wrote: "Even in the midst of the strangest experiences we still do the same: we make up the major part of the experience and can scarcely be forced *not* to contemplate some event as its 'inventors.' All this means: basically and from time immemorial we are—*accustomed to lying.* Or to put it more virtuously and hypocritically, in short, more pleasantly: one is much more of an artist than one knows."[1] It is question four pages later of "counsels for behavior in relation to the degree of *dangerousness* in which the individual lives with himself."[2]

I would like to interrogate this compromise and this threat, when, in the context of hysteria, a physician finds it next to impossible not to observe, as an artist, the luxurious pain of a body in the throes of its symptoms. Nor can I myself escape this paradox of atrocity, for I am nearly compelled to consider hysteria, insofar as it was fabricated at the Salpêtrière in the last third of the nineteenth century, as a chapter in the history of art.

The Outbreak of Madwomen

But there was indeed an extraordinary proliferation of images. Charcot worked under the aegis of Fleury's painting,[3] which exhibits, in the foreground, the fetters and tools that tell the tale of the enchaining of the madwomen and their "liberation" by Pinel (fig. 1); what is depicted is the turning point, or rather the decisive *chiasmus,* which Pinel is said to have effected in the mythology of madness.[4] This chiasmus was, in the first place, the concept of madness that Hegel formulated, declaring himself wholly indebted to Pinel; madness was not supposed to be an abstract loss of reason, but a simple disorder, "a simple contradiction within reason." This means that, in principle, a madwoman should be supposed, or presupposed, writes Hegel, to be quite simply a reasonable being.[5] This was

Figure 1
Fleury, *Pinel Liberating the Madwomen of the Salpêtrière* (detail),
Bibliothèque Charcot, Salpêtrière.

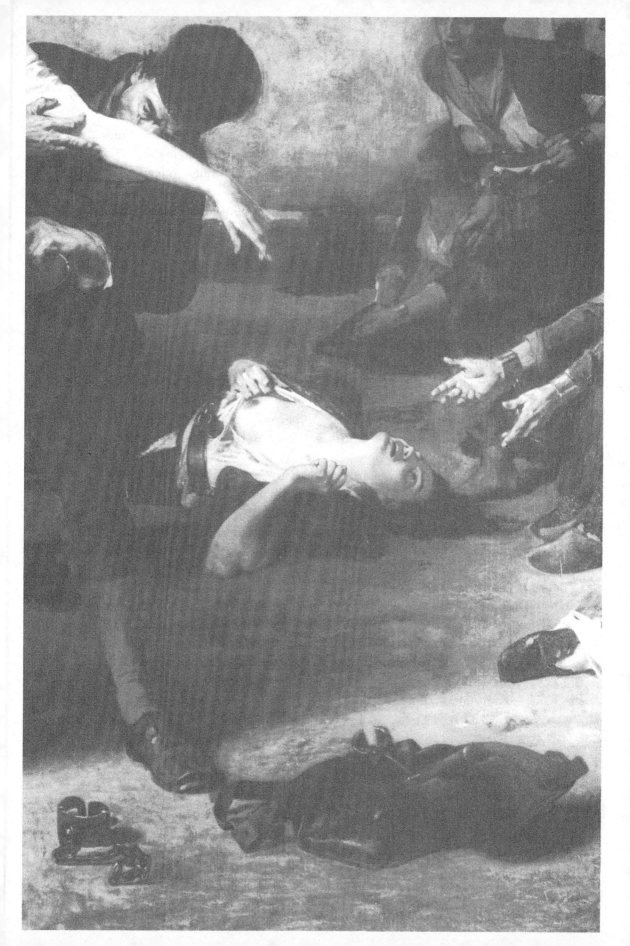

also the chiasmus of a new, philanthropic relation to madness, a *democratic* indignation in the face of the misery of this unfortunate class of humanity, madwomen and madmen; Fleury's canvas was painted to recount this, too. And finally, Pinel's Salpêtrière was opened as an asylum in the modern sense, whose first principle was the *treatment* of madness. A figure was even put to the curability of insanity; a science was emerging, a therapeutic science: ". . . there is a kind of probability, 0.93, that the treatment adopted at the Salpêtrière will be attended with success if the alienation is recent and has not been treated elsewhere."[6]

But it was only a chiasmus: criss-crossed, but symmetrical.

Beautiful Souls

Pinel did indeed deliver the madwomen of the Salpêtrière; he released them from total confinement, allowing them to coexist, notably through work. This opening up, however, was also an insertion: Pinel invented the asylum as a "little Government," he said, with its own "interior Police chief" and with "lodges," "cells," "dungeons," and "padded cells." And when Esquirol arrived at the Salpêtrière in 1811, it was not as a doctor, but still as a guard.

In short, the philanthropic "chiasmus" had the effect of tightening other bonds, those of the asylum's guilt, and thus isolating madness in another way. *Treatment* became bound up with internment, for the felicitous reason that one does not "submit" to an asylum's organization, one simply enters into it. One enters into it as one enters into the routine of daily life, an infinitesimal and at the same time unlimited routine: the banal tenderness of the State. And the particularity of this chiasmus thus appears to us as the permanence of a division made symmetrical: didn't "psychiatric consciousness" exist in an unhappy rift between the assurance of its immediate knowledge and the failure of this knowledge in acts?

The failure consisted in the fact that madness can change form and does do so, if you will, ninety-three percent of the time (see hysteria); but madness was never scoured away, neither at the Salpêtrière nor anywhere else.

Now, a science that fails in its acts would have every reason to produce *anxious* scholars, as it were, especially if the object of the science is madness, which, no matter what concept is sought for it, never ceases to *manifest* itself as effects of speech, that is, something irrepressible. On the other hand, it is said that the madman resembles us a little. Can a physician of madness refuse to see him as the dereliction of his own semblance? Of course, this refusal takes place; it is existentially and epistemologically

vital. "Psychiatric consciousness" could only refuse to be a shattered consciousness, an unhappy consciousness at the very least. It held firm so as to preserve its certainty as universality; it even preferred to refuse the act, or to invent acts adequate to its certainty. With this risk of anxiety, it refused to tarnish the splendor of its certainty and genius.

Then this consciousness could truly show itself to be an *Artist,* but an artist in the sense of an aesthetic religion, in the sense of Hegel's *beautiful soul.*

Hypocrisy

This could also be called *hypocrisy:* hypocrisy offers a simple judgment as an act or decree of reality, and is fully—if obscurely—aware that it is doing so.[7] Hypocrisy is the equivocal displacement, *Verstellung,* of an intimate consciousness of feigned truth, to the assumption of a feint of truth before everyone—and the disdain for this very displacement. Hypocrisy does of course characterize an ethical problem, but it must also be interrogated along the following lines: how could a science, doubtless seeking to ground its efficacy, find the constitutive principle of its methodological demands in hypocrisy? I maintain that everything that happened at the Salpêtrière, the great epic story of the clinic, is vested in hypocrisy, if the complexity of the practices this word designates are admitted, and if this complexity is not dismantled.

Hypocrisy is an act of choice, decision, and selection, of distinguishing, separating, and resolving. It is an explanation. But it is only a little of all these things, or perhaps it lies beneath them (*hypo*), secretly. The true hypocrite (in Greek tradition, the *hypokriter*) is above all the one who knows how to discriminate, but discreetly (in law, it is he who directs an investigation). He is the one who knows how to give an *interpreting response,* a soothsayer and a therapist; he can explain your dreams, humbly lending his person to the voice of truth, and he can recite this truth, for he is its rhapsodist. Which is also to say that he is the *actor* of truth. Hypocrisy is a Greek art, the classical art of theater, a recitation of truth through theatrical means, and thus fact [*fait*], counterfeit [*contrefait*], and feint [*feint*] of the interpreting response.

"He was a hypocrite, an eye-twister, he twisted my eyes, he had twisted [my] eyes . . . now [I see] the world with different eyes," a woman said of her beloved, a woman on the verge of madness.[8]

For, as theater and an interpreting response, hypocrisy carries with it the extraordinary epistemological gain of love. Pinel allowed the free and public "license" of the madwomen,[9] and they in turn assumed an immense

debt of love to him. Indeed, it was the conjugate effect of permission and debt that allowed Pinel to glimpse the possibility of circumventing madness as a whole. This hypocrisy *as stage direction* is what I will interrogate in Charcot: a strategic letting–be, a response that feigns to allow the word of the other to spin out at its own rhythm, but a response that is always already interpretive, and thus oracular. It is hypocrisy as *method,* a ruse of theatrical reason as it presumes to invent truth.

The Outbreak of Images

This failure should be rigorously judged. But the phenomenon is no less dazzling nor even less effective—a dreadfully effective outbreak of images.

I must insist on the fact that Charcot was as if constrained to this method, condemned to imagination and above all to what Kant called the *imaginatio plastica* that represents [*figure*] an intuition in space for the purposes of transmission.[10] And this was Charcot's great clinical and pedagogical promise, continually renewed: "In a moment I will give you a first-hand experience, so to speak, of this pain; I will help you to recognize all its characteristics"—how?—"by presenting you five patients"— and he would have them enter the stage of his amphitheater.[11] (Perhaps he was recalling Claude Bernard's "scopic postulate": "To understand how men and animals live, *it is indispensable to see a great number of them die*". . .).[12]

Figuring and directing, but always at the limits of counterfeiting: this is experimental fabrication (method) itself, a solid means of the modern "conquest of the world as picture"—"*die Zeit des Weltbildes.*"[13] But this method could not escape the *figurative problem* that obsessed every medical clinic, the problem of the link—the phantasmatic link—between seeing and knowing, seeing and suffering. How could all this passion be produced from figures of pain? This is the crucial phenomenological problem of approaching the body of the Other and of the intimacy of its pain. It is the political problem of the *spectacular interest* paid by the observed in return for the "hospitality" (the hospital's capitalization) that he enjoys as a patient. It is the problem of the *violence of seeing* in its scientific pretensions to experimentation on the body. That this experimentation on bodies is performed so as to make some part of them—their essence—visible is beyond doubt. Why then presuppose that Charcot was *constrained to the image,* or to the imaginary?

Because the visible is a twisted modality.

And, first and foremost, the visible has its own particular manner of interweaving that which is indelible in anxieties with their mastery. What's

more, Charcot was not alone in his practical debate with the visible; the madwomen, too, had their own practices, no less sophisticated, of the ineluctable modality of the visible.

Crystal of Madness

The question is thus extraordinarily complex. It can never be reduced to a smooth relation, free of angles, between seeing and being seen. How should it be broached?

By dashing a crystal on the ground?

By way of an inquiry into psychic agency, Freud pictured the—how shall I put it—crystalline, split, shattered relationship between madness and the gaze:

> Where [pathology] points to a breach or a rent, there may normally be articulation present. If we throw a crystal to the floor, it breaks; but not into haphazard pieces. It comes apart along its lines of cleavage into fragments whose boundaries, though they were invisible, were predetermined by the crystal's structure. Mental patients are split and broken structures of this same kind. Even we cannot withhold from them reverential awe which peoples of the past felt for the insane. They have turned away from external reality, but for that very reason they know more about internal, psychical reality and can reveal a number of things to us that would otherwise be inaccessible to us. We describe one group of these patients as suffering from delusions of being observed. They complain to us that perpetually, and down to their most intimate actions, they are being molested by the observation of unknown powers—presumably persons—and that in hallucinations they hear these persons reporting the outcome of their observation: "now he's going to say this, now he's dressing to go out" and so on. Observation of this sort is not yet the same thing as persecution, but it is not far from it; it presupposes that people distrust them, and they would be punished. How would it be if these insane people were right. . . . ?[14]

I will leave his strange question suspended there: patience.

Morality of the Toy

To return to our subject, something was constructed at the Salpêtrière, something resembling a great optical machine to decipher the invisible lineaments of a crystal: the great, territorial, experimental, magical machine of hysteria. And in order to decipher the crystal, one had to break

it, be fascinated by its fall, then break it again and invent machines permitting an even more visible, regimented fall, and then break it once again—just to see.

Thus nineteenth-century psychiatric knowledge must be interrogated well beyond its affirmations, designations, and discoveries. For this knowledge is also like the prodigious diffraction of its own discourse into often contradictory itineraries. It organizes itself around splits, incompatibilities, and transgressions unknown to the beautiful soul. If the efficacy of psychology is so poorly *grounded,* in all aspects of its method,[15] it is also perhaps because it was often incapable of preventing itself from inflicting on another the lethal gesture of a horrid, overcurious babe; psychology can be pardoned for this, of course, for it *wanted to know,* just to know. This passage, then, as an epigraph:

> Most of the children want more than anything to *see the soul,* some of them after a certain period of exertion, others *right away.* The more or less rapid invasion of this desire determines the greater or lesser longevity of the toy. I haven't the heart to rebuke this childhood mania: it's a first metaphysical tendency. When this desire has penetrated the child's brain marrow, it fills his fingers and nails with a singular strength and agility. The child turns his toy over and over; he scratches it, shakes it, knocks it against the wall, dashes it on the ground. From time to time he puts it through the mechanical movements yet again, sometimes in the opposite order. Marvelous life comes to a halt. The child, like the people laying siege to the Tuileries, makes a supreme effort: finally he pries it partly open, for he is the stronger. But *where is the soul?* Here begin stupor and sadness. There are others who break the toy, barely examined, barely placed in their hands. As for them, I admit that I am ignorant of the mysterious feeling that impels them to act. Are they seized by a superstitious rage against these diminutive objects that imitate humanity, or rather are they submitting them to a kind of Masonic rite before introducing them into childhood life?—Puzzling question!*[16]

Might this be an introduction to the experimental method in psychology?

Disasters of Efficacy

One must retrace the experimental protocol of the great optical machine of the Salpêtrière, while also summoning up a concern for its flaw, as infinitesimal as it may be—the sovereignty of the accidental: calling on disaster itself as the horizon of its efficacy.

*[The final exclamation is in English in the original.—Trans.]

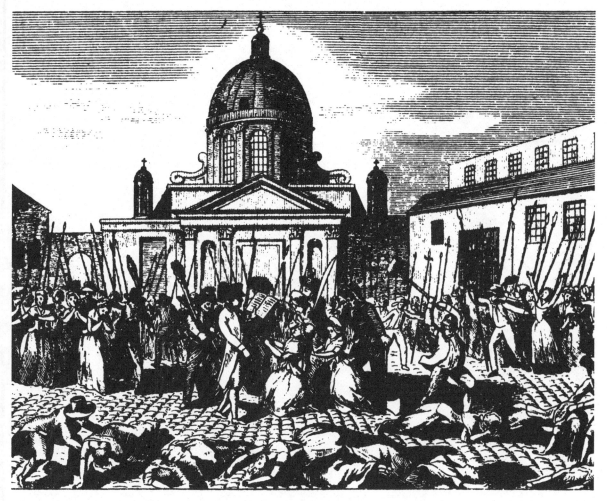

Figure 2
The Terrible Massacre of Women at the Salpêtrière in 1792 (detail),
Musée Carnavalet.

And what was the "drop of cruelty," diffused throughout this will to knowledge?[17] This blood of images?

Listen closely to these significant traumas: *Salpêtrière,* the great asylum for women—a former gunpowder factory—the historic mistake of 1792 (a "conspiracy of women" supposed to be associated with a "conspiracy of prisons")—and the "terrible massacre of women, of which History has provided no other example"[18] (fig. 2).

2

Clinical Knowledge

The Scene of the Crimes

The Salpêtrière was the mecca of the great confinement, known locally as the "little Arsenal," and was the largest hospice in France. It was another Bastille,[1] . . . with its "courtyard of massacres," "debauched women," convulsionaries of Saint-Médard, and "women of abnormal constitution" confined all together. It was the general hospital for women, or rather for the feminine dregs of society; "physicians of the Hôtel-Dieu were even forbidden to receive and treat them," for women with venereal diseases, among others, were "gathered up" only at the Salpêtrière. They were whipped on arrival, the "punishment certificate" was completed, and they were interned.[2] The largest hospice in France was the hospice for women. One must imagine, or try to imagine the Salpêtrière, in Paris itself, as such an improbable place of femininity—I mean, it was a city of women, *the city of incurable women.*

In 1690 there were already three thousand women there: three thousand female paupers, vagabonds, beggars, "decrepit women," "old maids," epileptics, "women in second childhood," "misshapen and malformed innocents," incorrigible women—madwomen. In 1873 there were 4,383 people, including 580 employees, 87 *"reposantes,"* 2,780 "administered women," 853 "demented women," and 103 children.[3] It was the mecca of female death, extending over 275,448 square meters (fig. 3) with a splendid cruciform church in the center.[4]

In 1863, the Director of the General Administration of Public Assistance, Monsieur Husson, presented the Senator and Prefect of the Seine, Monsieur Dupon, with his voluminous *Report on the Service of the Insane of the Department of the Seine in the Year 1862,*[5] the very same year that Charcot entered the Salpêtrière. He presents some interesting statistics; there were approximately one physician per five hundred patients and three different diets: two daily portions, one portion, and starvation diets. One hundred and fifty-three epileptic attacks occurred that year.

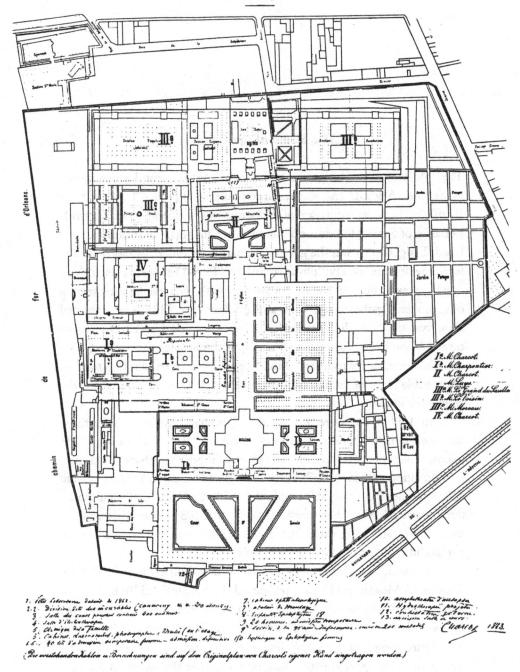

Figure 3
Map of the Salpêtrière, with Charcot's annotations.

The rate of cure was estimated at 9.72 percent. Two hundred fifty-four women died in 1862 of "causes presumed to be due to insanity." What exactly were these causes? Monsieur Husson compiled a total of sixty: thirty-eight physical causes (including masturbation, scrofula, blows and wounds, debauchery and licentiousness, cholera, erotomania, alcoholism, rape), twenty-one moral causes (including love, joy, "bad reading habits," nostalgia, and misery), and one category that regrouped all the "unknown causes."[6]

Hysteria did not yet appear in the vocabulary.

The administrative improvements effected by Monsieur Husson at the Salpêtrière included the transformation of part of the courtyard into a garden, and the purchase of a piano.[7]

Descent into Hell

It nonetheless resembled a hell.

The images do not err in this regard (fig. 4). Charcot's admirers, who came to "visit" the Salpêtrière and "attend" the celebrated Tuesday lectures, expressed their belletristic pity, as in this text by Jules Claretie (no less than a member of the Académie française): "Behind those walls, a particular population lives, swarms, and drags itself around: old people, poor women, *reposantes* awaiting death on a bench, lunatics howling their fury or weeping their sorrow in the insanity ward or the solitude of the cells. The thick gray walls of this *citta dolorosa* seem to retain, in their solemn dilapidation, the majestic qualities of Paris under the reign of Louis the Fourteenth, forgotten by the age of electric tramways. It is the Versailles of pain."[8]

This text (entitled *Charcot, the Consoler*) had a single purport; in this city of pain, Charcot was not only Sun King and Caesar, but also an apostle, who "reigned over his age and consoled it."[9] Charcot was also likened to Napoleon.

But above all, with his "lovely pensive brow," "somber visage," "severe eyebrows," "searching eyes, set deep in the shadow of their sockets," "lips accustomed to silence," "head carved after antiquity,"—above all, he was likened to Dante, the same Dante of the Descent into Hell.[10] "*Lasciate ogni speranza voi ch'intrare. . . .*" "The heavy sleep within my head was smashed by an enormous thunderclap, so that I started up as one whom force awakens; I stood erect and turned my rested eyes from side to side, and I stared steadily to learn what place it was surrounding me. In truth I found myself upon the brink of an abyss, the melancholy valley containing thundering, unending wailings": the first circle, Limbo.[11]

Figure 4
The Courtyard for Women at the Salpêtrière, drawing by Vierge,
published in *Paris illustré,* September 24, 1887.

The hagiographies of Charcot did not fail to point out that over the
course of long years he was confronted with these *women from hell,* ex-
hibiting their drooping breasts and their open gowns, writhing, and who,
like a great herd of victims to the slaughter, were trailed by a long bel-
lowing.[12] But they insisted that *it was not his fault:* Charcot "found himself
plunged into the midst of hysteria" despite himself, through an adminis-
trative happenstance (with epistemological consequences that ultimately
proved to be definitive):

> As chance would have it, the Sainte-Laure building at the Salpêtrière
> was in such a dilapidated state that the hospital administration was
> obliged to evacuate it. This building, belonging to the Psychiatric
> service of Doctor Delasiauve, was where epileptics and hysterics were
> indiscriminately hospitalized with madwomen. The administration
> took the opportunity provided by the evacuation to *finally separate*

the non-psychotic epileptics and hysterics from the insane women, and since both of these categories presented convulsive attacks, it was logical to put them together and to create a *special division* called the "Division of Simple Epileptics." The most senior of the two doctors of the Salpêtrière, Charcot was automatically charged with the new service. This is how, through force of circumstance, Charcot found himself plunged into the midst of hysteria.[13]

Veni Vedi

Charcot thus descended into hell; but he didn't feel so badly there.

Because the four or five thousand women of hell furnished him with *material*. Immersed in the inferno as early as 1862, Charcot, in fact, had the pleasant—and scientific, as one says calori-, sopori- or honorific, the "fic" (from the Latin *fictus* or "make") indicating a very strong factitve derivation[14]—the pleasant sensation of, quite simply, entering a museum. He himself put it quite well: it was *a living museum of pathology,* with its old "collection" and new "collection"(see appendix 1).

After calling it the "great emporium of human misery,"[15] he immediately added that, thanks to him, a catalog had been drawn up, and the emporium, the warehouse, had in his hands become "the center of truly useful theoretical and clinical teaching."[16]

For what was at stake was knowledge. In 1872, Charcot was named Professor of Pathological Anatomy, but it wasn't yet sufficient to open up a new field of knowledge. This had to wait until 1881, when his friend Gambetta had Parliament vote in favor of a two hundred thousand franc credit for the creation of a "Clinical Chair of Diseases of the Nervous System" devised by Charcot at the Salpêtrière. An addition on a rather different scale than the purchase of a piano and a gardening allowance.

Emporium—Imperium

The "Caesarism of the medical profession"[17] is how Léon Daudet described Charcot's position, although Daudet was of course on familiar terms with Charcot through his father Alphonse. Charcot elevated the figure of the doctor into the Chief, a figure that has stubbornly persisted ever since. Perhaps this figure is only the spectacular dimension of the immanence of medical power (reinforced by the 1892 law proscribing the monopoly of medical practice, among other things); still, its very magnificence leaves us dumbfounded.

This great age of a kind of medicine, with its own particular style, is what must be interrogated: the medicine of the *Belle Epoque.*

The domains Charcot explored were vast and magnificent: chronic rheumatism, gout, geriatric diseases, sporadic limping, the painful paraplegia of cancer patients, cerebral hemorrhages, gluteal bedsores, exophthalmic goiters, amyotrophic lateral sclerosis (known as Charcot's disease), Charcot-Marie atrophy, multiple sclerosis, tabes and tabetic arthropathy, medullary localization, aphasia, a theory of cerebral localization; he made considerable advances in pathological anatomy. He quickly became a writer of reference. By 1877, students at Oxford had to translate Charcot, just as they translated Hippocrates and Celsus, for the "Degree of Bachelor of Medicine."

His works were translated into every language: English, Russian, German (Freud, notably, was on the job in 1886 and from 1892 to 1894), Portuguese, and so on.

He was talented in diagnosis, and had a famous, international private clientele, including great dukes of Russia, sons of the Bey of Tunis, an emperor of Brazil, a minister of finances (the banker Fould was his first important client, as early as 1853–1855), and so on.

Charcot was the founder of a school and a whole movement of thought—"the School of the Salpêtrière," with its innumerable disciples. He was an enlightened master and censor: "none of his students would ever publish a work of any importance whatsoever without him re-reading and correcting it with his own hand. And how very much was gained in those corrections!"[18]

He held courses on Fridays, lectures on Tuesdays. His evening receptions on Tuesdays in his private mansion, 217 boulevard Saint-Germain, were of course attended by high society: the elite of medicine, politicians (Waldeck-Rousseau), the most famous painters and sculptors (Gérôme, Rochegrosse, Dalou, Falguière), architects (Charles Garnier), men of letters (the Daudets, Mistral, Théodore de Banville, Burty, Claretie), art collectors (Cernuschi), police chiefs (Lépine), and even Cardinals (Lavigerie).

But above all Charcot is known as the founder of neurology. Four hundred and sixty-one pages of tributes were written for the centenary of his birth.[19] In 1955, he was also honored for having paved the way for today's psychiatry, our psychiatry: "From a therapeutic point of view, he was quite right in advocating, before the present day, the isolation of patients, persuasion, physical agents, electrification."[20]

And along the way, he rediscovered hysteria.

Naming Hysteria

In the obituary he wrote for Charcot in 1893, Freud, strangely enough, compares him to the statue of Cuvier in Paris's Jardin des Plantes (perhaps because Cuvier is petrified amidst the species to which he himself gave position and stature?). Freud then continues, in the logic of the strange, with another comparison: Charcot is like Adam, an Adam before whom God paraded nosological entities for him to name.[21]

Charcot did indeed rediscover hysteria (and in this respect his work is pioneering—but what, exactly, did it pioneer? This is the question). He named hysteria. He distinguished it from epilepsy in particular and from all other mental disorders. In short, *he isolated hysteria as a pure nosological object*. This does not exactly mean that he grasped its motivating forces and then determined what therapeutic steps should be taken. Then what *more* did he do or want to do with hysteria, what did he make of hysteria? Or rather: what took place between the exemplary moment when Charcot affirmed that, after all, the word "hysteria" did not mean anything,[22] and the moment of the "dismemberment" of hysteria, that is, the attempt of his own disciples to lay the word to rest on the death of the master?[23]

The Art of Putting Facts to Work

Am I being unfair? I should also say that Charcot's work is a great *effort to understand* what hysteria is. Of course. And this effort was methodical, based on a genuine method.

But since this method ran aground (because it worked *too much,* too well or too poorly), the attempt became frenetic and then abject, in a certain way. First, consider the method: what Charcot wanted or expected in principle from this method was for it to *bear an idea,* an accurate concept of "pathological life," the life of the nervous system in this case. Pierre Janet rightly insists on the fact that Charcot "was at least as attached to *theory* and the *interpretation of facts* as to describing them."[24] And he hoped to make this idea emerge by *provoking its observation,* its regulated visibility.

This is a strict formulation of the experimental method, as proposed by Claude Bernard, to whom I now return. The experimental method is not observation, he writes, but "provoked" observation; this means, in the first place, that it is *the art of obtaining facts,* and, second, that it is *the art of putting them to work.*[25] Observation, insofar as it is "puts to work," is *experimentation*. And according to Claude Bernard, one must learn to believe only in experiments, because they are beyond doctrine.[26]

Here I have reached something like the edge of a doctrine, and thus a denial, in the account of this method: it bears only on facts, never on words;[27] it is free of all ideas and knows how to "avoid *idées fixes*";[28] finally, it functions as a safeguard against the aporia of "contradictory facts."[29] If I call this a denial, it is because everything in Charcot's clinic relating to hysteria indeed bears the mark of an *idée fixe,* which may be implicated in an almost desperate debate: the debate between knowledge and bodies, acts and "observations" that, although "put to work," remain permeated and knotted with contradictions.

The fact remains that the experimental method is devised to defy such contradictions, and, as an "art of putting facts to work," this method is as vested in an aesthetics as an ethics of the fact.

Pathological Life, *Nature morte**

Gaining knowledge of "pathological life" as anything other than the refuse of corpses also posed a problem for the experimental method. Claude Bernard's decisive answer is well known:

> If we wish to attain the exact conditions of vital manifestations in men and animals, we must seek them not in the exterior cosmic environment, but rather in the organic internal environment. . . . But how can the interior environment of complex organisms such as men and the higher animals be known, if not by descending to them, in a sense, and penetrating them through experimentation applied to living bodies? This means that in order to analyze the phenomena of life, it is necessary to penetrate living organisms with the help of vivisectional procedures.[30]

To know life, it must be vivisected. As for Charcot, he was faced with an even more daunting problem, for one cannot, one truly cannot get under the skin of a nervous patient to see how the illness works. Still less can one penetrate the "pathological life" of the cerebral convolutions of a deranged mind, without putting this life to death. Must one restrain oneself to *observing without touching,* and to *merely observing the surface*?

Of course not, for pathology must do everything in its power to get beyond the mere recognition of symptoms, exceeding even the pure perspective of pathological anatomy: the study of the diseases of the nervous system must first and foremost be conducted as "pathology of functional

[*Nature morte,* meaning "still life" in the context of painting, has the literal meaning of "dead nature."—Trans.]

regulations."[31] This does not mean that all pathology should be subordinated to physiological inquiry; nonetheless, "clinical observation must be allied with general science and progressively approach physiology in order to give rise to truly rational medicine."[32] The extension of the functional perspective, with its neuro-motor diagrams and physiological regulations, opens the psychopathological region onto the possibility of a *representation:* "My explanation may seem difficult and far-fetched. I understand that comprehending it requires more or less profound studies that are not within everyone's grasp. One must become accustomed to this, perhaps, for, where nervous disorders are concerned, psychology indeed has a presence, and what I call psychology is the rational physiology of the cerebral cortex."[33]

Twenty years earlier, he had put it like this:

> Gentlemen, we have yet to determine the relationship that ought now to exist between pathology and physiology. . . . While recognizing that living beings present *phenomena that cannot be found in dead nature* [*nature morte*], and which therefore belong to them alone, the new physiology *absolutely refuses* to see life as a mysterious and supernatural influence, which acts as fancy takes it, free from all laws. Physiology goes so far as to believe that vital properties will one day be reduced to properties of a physical order.[34]

Autopsy Anticipated in the Symptom

Charcot was obliged, in fact, to *idealize* his method, that is, to de-actualize it in a certain sense: idealization is said to be close to but still distinguishable from sublimation,[35] for its role is wholly defensive: it is a compromise. And the "anatomo-clinical method," as Charcot advanced it, was indeed something like this: A compromise on the physiological and essentialist *aim* of the study of nervous diseases. One cannot watch the brain as it functions, but one *can* locate the effects on the symptomatic body provoked by alterations, and thus prejudge its operation.[36]

A compromise on the *time* of the implemented observation. Charcot was obliged to study ("methodically," and "precisely") the symptoms presented by a patient; then—meaning, after the death of said patient—to study the "seat" of the lesions noted; then, to repeat such studies on a large number of cases, and finally to correlate them so as to establish with certainty the "real seat" of the lesions that had produced certain determinate symptoms. This is the doctrine of "cerebral localization," Charcot's claim to fame.

It thus implicates a *temporalization, as if paradoxical, of the clinical gaze:* it anticipates the results of an autopsy on the living; and it is proud of this,

dubbing itself "anatomy" (*anatemnein:* to tear, to open a body, to dissect) "on the living."[37]

Exercise of the Clinic

It was through such a "non-variable of the clinic" that medicine "meant to bind truth and time together":[38] the clinic held itself up as the "absolute age" of medicine, the age of absolute knowledge. At the same time, Charcot also recognized its limitation, as a pure practice and a pure exercise. But it was essential, for in itself it was the exercise of an "*art*" and the exercise of (medical and therapeutic) "*power*": "But I maintain that in this collaboration, the preponderant role and supreme jurisdiction should always belong to clinical observation. With this declaration, I place myself under the patronage of the chiefs of the French school, our immediate masters, whose teaching has bestowed such brilliance upon this great Faculty of Medicine of Paris to which I have the honor of belonging."[39]

("But I maintain . . ."—isn't that a formula for what I've called a compromise?)

The fact remains that the methodological difficulty evoked earlier is exchanged for or transformed into a tremendous escalation of clinical protocol; in addition to the traditional lectures of Tuesday and Friday (see appendix 2), a "poliolinic" and a service for the "external" consultation of patients were also instituted: "This [service] takes on a greater extension every day, and according to the numbers recorded by Georges Guinon, the number of consultations per year has reached 5,000. One can imagine, with such a figure, the great number of interesting cases that are encountered."[40]

And the protocol included: sort, display, sort, compare, glance, diagnose, give instructions for therapy:

> He sits down near a bare table, and immediately has the patient to be studied brought in. The patient is then completely stripped. The intern reads the "observation," while the Master listens attentively. Then there is a long silence during which he gazes; he gazes at the patient and drums his fingers on the table. The assistants are standing, crowded together, anxiously awaiting a word that will shed some light. Charcot remains silent. Then he instructs the patient to move in a certain way, makes her speak, asks for her reflexes to be measured, for her sensitivity to be examined. And again he falls silent, Charcot's mysterious silence. Finally he brings in a second patient, examines her like the first, calls for a third, and, still without a word, compares them.

This minute observation, primarily visual, is the source of all of Charcot's discoveries. The artist who, in his case, goes hand in hand with the doctor, is not extraneous to his discoveries.

The clock strikes noon and he rises. Leaving his interns with a few instructions, he returns to his car with small steps, followed by his personnel. He gives a friendly slap to the horses of his hired landau and a brief bow to his entourage. And he departs.[41] (See also appendix 3)

Dramaturgy of the Summons

A gaze that observes and forbears, or rather feigns to forbear, from intervening. A mute gaze, without gesture. It feigns to be pure, to be the ideal of the "clinical gaze," endowed only with a capacity to understand the language of the spectacle "offered" by pathological life.[42] But can there be a spectacle without staging [*mise en scène*]?

And if there is a border between the clinical and the experimental, well then, Charcot often transgressed it, by clouding it over. One might say that it wasn't his fault, but the fault of the illnesses and neuroses that he was dealing with; illnesses that, precisely, "experiment" on the body in the service of an "*idée fixe*," as they said. Was the "clinical gaze" as practiced by Charcot therefore constrained by its own object *not* to be pure of experimental intervention? Did not Charcot put something of himself into it?

The accounts given by Souques and Meige suggest that Charcot could nearly forgo traditional questions like "What is the matter?" or "Where does it hurt?" For he seemed to *have always already seen*.

He was sparing with words, but so efficient; in retrospect, he seems to have been the great director of symptoms that, in return, spoke to him of their own accord. And in this silent dramaturgy, *the symptom became sign*: it seems that it was enough for Charcot to "order the patient to move" or to call for a certain second or third patient to come to his side—this was enough to transfigure the visibility of the *summoning* of the patients into the visibility of explanation: a sign. A sign, that is, the temporal circumscription of the changeable, lacunal cryptography of the symptom. "The sign announces: the prognostic sign, what will happen; the anamenestic sign, what has happened; the diagnostic, what is now taking place."[43]

Case

How indeed can the actuality, or the present, of the symptom be defined? How can its catastrophic and thus singular appearance be staged? First, by instituting it as a *case*.

The "case" serves as the clinic's original "genre," already outlining its whole "stylistics." It implicates, in the first place, a concern for integrity: the letting-be of the individuality of the sick body as such, without neglecting its always possible value as counter-proof. But this is merely a ruse of reason. For the clinic, wants—I mean, Charcot wants to be able to expect anything, including its own nosological amazement. It wants to anticipate "not being able to get over" an extraordinary case, and, for this purpose, even calls on it, summons it. This is scientific, because science calls up and challenges the challenges of science.

> Among these cases, one in particular is worthy of attention, and will be the object of our first interview: it is—if I am not mistaken—a legitimate example of a rare, a very rare, ailment, the very existence of which is contested by most physicians. One must not disdain, gentlemen, the examination of exceptional cases. They are not always simply a lure for vain curiosity. Many a time indeed have they provided the solution to difficult problems. In this sense, they are comparable to the lost or paradoxical species for which the naturalist carefully searches, for they establish the transition between zoological groups or allow an obscure point of philosophical anatomy or physiology to be disentangled.[44]

(Exceptional and paradoxical, but nonetheless legitimate. It was a question, of course, of a case of hysteria.)

The clinic thus summons the exceptional as much out of a concern for integration as for "integrity." For once multiplicity has been entirely explored (the ideal goal), it will efface itself of its own accord as both multiplicity and contingency, integrating itself into the path of the exploration. And the Baroque deployment of the case is but a ruse of classificatory reason, leaving the question of style open.

Tableaux*

Classification *configures* the disorder and multiplicity of the case, making it into tables [*tableaux*]. And what is a *tableau*? (A *tableau* has no being, but only a quasi-being; but then a *tableau* does not even "have" . . .—This is not an answer.) It holds a place and proliferates. And yet it responds to something like a concern for the *organization of the simultaneous*. For a long time, medicine was circling around a fantasy of a *language*-tableau—its

[The French *tableau* signifies painting and scene (as in *tableau vivant*), but also table (as in a table used to organize data).—Trans.]

own language: integrating the successive nature and, in particular, the temporal dissemination of the "case" into a two-dimensional space of simultaneity and tabulation, into an outline against a ground of Cartesian coordinates. This tabulation would then be an exact "portrait" of "the" illness, to the extent that it could lay out, in a very visible way, just what the history of an illness (with its remissions, its concurrent or percurrent causes) tended to conceal.

Dreaming of being such a language-*tableau,* medicine devotes itself to the design or desire of resolving a double aporia: the aporia of the *form of forms,* in the first place. According to Charcot, the "type" is the form of the "whole" of the symptoms, from which an illness comes into existence as a nosological concept. It is "an *ensemble*" of symptoms that *depend* on each other, arranged into a *hierarchy,* which can be *classified* in clearly delimited groups, and which, especially through their character and combinations, can be *distinguished* from the characters of other similar illnesses.[45] This is crucial where hysteria is concerned, for all Charcot's efforts aimed to refute categorically Briquet's famous definition of hysteria (drawing on the definitions of Galien and Sydenham): "A Proteus who presents himself in a thousand guises and cannot be grasped in any of them."[46]

Then there is the aporia of the *form of temporal motions.* If the grammar of the visible was imagined in this way, it was in order to fully dissolve the symptom into a sign, a probabilistic sign, more precisely: spatially organizing scattered temporalities. For the unstable time of the "case" could then become a minute element in a grand narrative-tabular procedure, in which history, diagnosis, and prognosis would be simultaneously configured: a dream worthy of Condillac.[47]

This would seem to place a surprising amount of confidence in form.

Observations, Descriptions

I cannot help wondering, said Freud, how the authorities on hysteria can produce such consequential, precise observations of hysterics.

> As a matter of fact the patients are incapable of giving such reports about themselves. They can, indeed, give the physician plenty of coherent information about this or that period of their lives; but it is sure to be followed by another period as to which their communications run dry, leaving gaps unfilled and riddles unanswered; and then again will come yet another period which will remain totally obscure and unilluminated by even a single piece of serviceable information. The connections—even the ostensible ones—are for the most part incoherent, and the sequence of different events is uncertain.[48]

For time is stubborn in the cryptography of the symptom: it always bends a little, raveling and unraveling, but, in a certain sense, it remains stubborn—very stubborn, in hysteria.

A language-*tableau* is meant to disavow both the obstacle and meaning of these slight shifts. Case and table culminate in *observation,* the act of surveillance—the great psychiatric genre. For Charcot at least, observation aimed less toward an intimate narrative of pathological history (and how could he not have intuited the obstacle of time in hysteria?) as toward a well-made *description* of *states of the body.* Of course he provided them with a succession, but he implicitly admitted its hypothetical nature: he reinvented it.

What he had to save at any cost was form. Starting from the case, and with the design of inscribing the case as a whole, what is written is like a visible alphabet of the body. Seeing everything, knowing everything. Circumscribing (and not writing). Making the eye expound (and not speak, nor even really listen): the ideal of the *exhaustive description.*

"You know that a well-made description has a remarkable power of propagation. At any given moment, the light shed is such that it will strike even the most poorly prepared mind; what had until then been confined to nothingness begins to live, and the description of a previously unknown morbid species is a great thing, a very great thing in pathology."[49]

Curiosities

This text makes a surreptitious leap: the experience of the clinic comes to be identified with something like a *"fine sensibility."* It was a "concrete" sensibility, or, if you prefer, "sensory" knowledge[50]—but an aesthetic, in any case, a scholarly aesthetic (the beautiful soul mentioned above).

Not a single biographer of Charcot fails to insist on his artistic "competence" and "taste," nor on his vocation as a painter.[51]

In his 1893 article, Freud also insists on this figurative vocation:

> He was not a reflective man, not a thinker: he had the nature of an artist—he was, as he himself said, a "visuel," a man who sees. Here is what he himself told us about his method of working. He used to look again and again at the things he did not understand, to deepen his impression of them day by day, till suddenly an understanding of them dawned on him. In his mind's eye the apparent chaos presented by the continual repetition of the same symptoms then gave way to order: the new nosological pictures emerged, characterized by the constant combination of certain groups of symptoms. . . . He might

be heard to say that the greatest satisfaction a man could have was to see something new—that is, to recognize it as new; and he remarked again and again on the difficulty and value of this kind of "seeing." He would ask why it was that in medicine people only see what they have already learned to see. He would say that it was wonderful how one was suddenly able to see new things—new states of illness—which are likely as old as the human race.[52]

Never tiring—always seeing something new, indefatigable *curiosity.* Curiosity (let it be said in passing) is the first step on the road to the sublime, according to Burke.[53]

Cure and curiosity, with their identical root and profusion of meanings, seem to encompass Charcot's debate with hysteria. One must not forget that "cure" is nearly a founding word in psychiatry:[54] cure is a care, concern, or treatment, but it is also a burden, direction, and thus a power; and it is precisely the effect of this power when conjugated with a medical concern, cleaning out from top to bottom (in the erotic language of the Romans, *cura* also designates an object of concern, curiosity, and cleaning: namely, the sex). There is perhaps no more essential *indiscretion* than such curiosity made into power.

I would like to interrogate what, in the cure, and in curiosity, might be entailed by its more fundamental meaning as concern: *cura, an anxiety.* My question is: what anxiety bore within itself the compulsion, shared by Charcot and the Salpêtrière in general, to always "see something new"? What might have been its temporal stasis? And what was it—in the visible, in Charcot's daily comings and goings—that might have profoundly demanded this stasis?

Glances and Clicks

"Seeing something new" is a temporal protension of seeing. It is as implicated, I think, in an ideal (scientific goals, clinical prognosis for which seeing is foreseeing) as in an *ulterior anxiety,* where seeing would be premonition. Such is the fundamental instability of the pleasure of seeing, of *Schaulust,* between memory and threat.

Its ideal is certainty, which, in the always intersubjective moment of sight, emerges only as a theft, and as anticipated;[55] this is to say that it also denies the time that engenders it, denies memory and threat, inventing itself as a victory over time (the beautiful soul mentioned above).

It invents itself an instantaneity and efficiency of seeing, although seeing has a terrible duration, a single moment of hesitation in efficiency.

And the fruit of its invention is an ethics of seeing. This is called, in the first place, the glance [*coup d'oeil*], which also implicates the "fine sensibility" with which the clinical gaze identifies. It is an "exercise of the senses"—an exercise, the acting-out of seeing: glance, diagnosis, cure, prognosis. The clinical glance is already *contact*, simultaneously ideal and percussive. It is a stroke [*trait*] that goes directly to the body of the patient, almost palpating it.*

Charcot went "further" in percussion in a straight line, in ideal contact and the instantaneity of the stroke [*trait*]; he armed his gaze for a more subtle, less tactile percussion, for he was disputing with neurosis, an intimate, specific intertwining of ground and surface.

And he armed himself with photography.

[*Coup d'oeil,* signifying "glance," literally means the "blow of an eye." Here as elsewhere, Didi-Huberman draws on the notion of the glance as a blow. He also works with the various meanings of *trait,* including trait, line, draught, and shaft of an arrow.—Trans.]

3

Legends of Photography

"Behold the Truth"

Behold the truth. I've never said anything else; I'm not in the habit of advancing things that aren't experimentally demonstrable. You know that my principle is to give no weight to theory, and leave aside all prejudice: if you want to see clearly, you must take things as they are. It would seem that hystero-epilepsy exists only in France and only, I might say, as has sometimes been said, at the Salpêtrière, as if I had forged it through the power of my will. It would be truly fantastic if I could create ailments as my whim or fancy dictate. But, truth to tell, in this I am nothing more than a photographer; I inscribe what I see. . . .[1]

—And this seems to say everything.

To the detractors and quibblers who reproached him for "cultivating" if not inventing hysteria at the Salpêtrière, Charcot thus retorts that, in the first place, it would be too fantastic and must therefore be false, a fiction (but we will see that what is fantastic exceeds fiction by realizing it, despite the fiction). Moreover, and above all, Charcot responds with a remarkable *denial of theory*, doubled with an *allegation of "script"*: an inscription-description (a fantasy of writing) understood as recording, the immediacy of recording: I inscribe what I see.

Charcot puts this argument forward to defend his project from the refutations of any potential heckler: I am not inventing—(since) I take things as they are—(for) I photograph them. And this was no metaphor.

The Museum, Sublation of the Real

Or rather, yes—it was a metaphor, but *sublated* in reality. It was the collusion of a practice and its metaphorical value (its epochal value, that of the first half-century of the history of photography). It was, in fact, like the original declaration that the ideal of an absolute clinical eye and an

absolute memory of forms was on the verge of being realized. Indeed, photography was born at a moment when not only the end of history[2] but the advent of absolute knowledge were awaited. When Hegel died, Niepce and Daguerre were nearing their second year of collaboration.

As for Charcot, inaugurating his famous "Clinical Chair of Diseases of the Nervous System" (which still exists), he himself did not fail to underline the epistemological and practical coherence of an *image factory* with its triple project of science, therapy, and pedagogy:

> All this forms a whole whose parts follow logically from one another, and which is completed by other affiliated departments. We have an *anatomo-pathological museum* with a *casting* annex and a *photographic studio;* a well-equipped *laboratory of anatomy* and of *pathological physiology*. . . ; an *ophthalmology service,* an essential complement to any Institute of neuropathology; the teaching *amphitheater* where I have the honor of receiving you and which is equipped, as you can see, with all the modern tools of demonstration.[3]

The metaphor is grafted onto reality and meddles with it. As I said, when Charcot first entered the Salpêtrière, he felt like a visitor or a new guard of a museum; and now twenty years later, as the head conservator of a real museum, he was toasting the museum's opening.

(The nineteenth century was the great era of the medical museum. Charcot had a large collection of catalogs: the Pathological Museum of St. George's Hospital, the Museum of the Royal College of Surgeons, the Orifila and Dupuytren Museums, etc. There was also the traveling museum of the [quack] Doctor Spitzner, who would go from fair to fair, with his exhibit number one hundred: a life-size group representing a "Lecture of Professor Charcot"!)[4]

In this way, photography, for Charcot, was simultaneously an experimental procedure (a laboratory tool), a museological procedure (scientific archive), and a teaching procedure (a tool of transmission). In reality it was far more than this, but note that photography was in the first place a museological authority of the sick body, the museological agency of its "observation": the figurative possibility of generalizing the *case* into a *tableau.* And its modality of signification was initially envisaged only as a "middle" state of the trace, between the always incomplete *outline* [*trait*] (a diagram, a clinical note) and the commonly practiced, but very time-consuming *live casting* (figs. 5, 6).

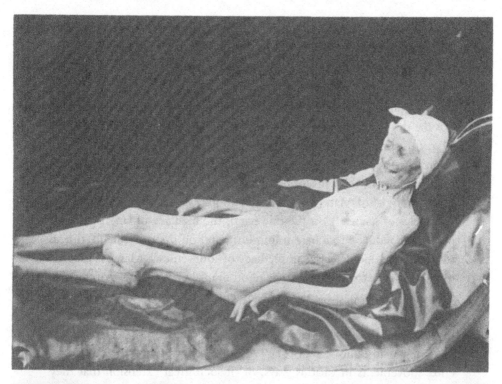

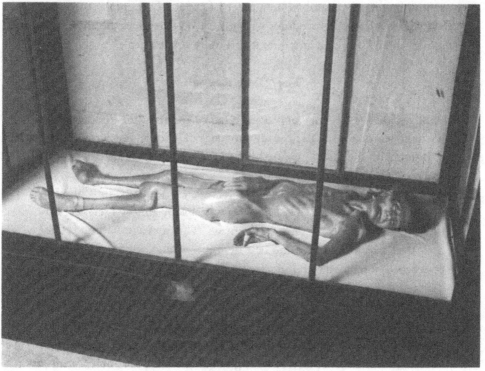

Figures 5 and 6
Two museological procedures of diseases.
Fig. 5: photograph excerpted from one of Charcot's clinical dossiers;
fig. 6: cast of the same "case."

Graphics

Photography procedes, first and foremost, from the *graphic*. More precisely, it is the development and supplement of the graphic, if one is to believe Marey, the proponent of the famous "graphic method": a profusion of extraordinary apparatuses (pantographs, odographs, myographs, pneumographs, and so forth), a profusion of script-tools (instantaneous recorders).

The goal of Marey's "graphic method" was to push aside the two "obstacles of science": on the one hand, the mediacy of language (here practically reduced to a bare minimum), and on the other hand, the all too distracted and defective immediacy of "our senses."[5] Marey's "graphic method" began to appropriate the photograph as an extension of the spatial point of view of the scale of movements to be recorded—this was just before he fully embraced his famous *chronographic* project. I'll return to this, but first this, from Marey: "When the moving body is inaccessible, like a star whose movements one wishes to follow; when the body executes movements in various ways, or of such great extension that they cannot be directly inscribed on a piece of paper, photography compensates for mechanical procedures with great ease: it reduces the amplitude of movement, or else it amplifies it to a more suitable scale."[6]

The "True Retina"

Photography: "The Pencil of Nature" (Talbot 1833)—"the Photographer needs in many cases no aid from any language of his own, but prefers rather to listen, with the picture before him, to the silent but telling language of Nature" (H. W. Diamond, the first photographer of madness, 1856).[7] In photography, everything is already objective, even cruelty; in it one can see, so they say, "the very least flaw." It was already almost a science, humility made into the absence of language. This message without code[8] thus always says more than the best description; and, where medicine is concerned, it seemed to fulfill *the very ideal of the "Observation,"* reuniting case and *tableau*. This is why, in the nineteenth century, photography became the paradigm of the scientist's "true retina."

In the words of Albert Londe, director of the photographic department of the Salpêtrière in the 1880s, "*the photographic plate is the scientist's true retina.*" In the first place, it is designed to complete the "observation," the document established under the scrutiny of the physician, containing all the information about the history and current state of the patient. "If the photograph is not always necessary, it is, to the contrary, indisputably useful when the manifestations of the illness are translated by exterior de-

formations affecting the whole or a certain part of the individual. One might even say that, in many cases, a simple print before the eyes tells far more than a complete description."[9]

The photograph thus produced a historic change in sight, such that "you cannot claim to have really seen something until you have photographed it."[10] But why not?

Iconographics and Foresight

Perhaps because sight thus armed not only *certifies* what is seen and what in normal *time* would be invisible or merely glimpsed, but also becomes capable of *foresight*.

The photographic image has *indexical* value, in the sense of evidence;[11] it designates the one who is guilty of evil [*le mal*], it prejudges his arrest. It is as if photography makes us susceptible to evil's secret origins, nearly implicating a microbial theory of visibility (we know that in medicine "the germ theory of contagious disease has certainly owed much of its success to the fact that it embodies an ontological representation of sickness [*le mal*]. After all, a germ can be seen, even if this requires the complicated mediation of a microscope, stains and cultures, while we would never be able to see a miasma or an influence. To see an entity is already to foresee an action").[12]

Photography's capacity of foresight is also a function of its own special "sensitivity": "We know that the photographic plate is not sensitive to the same rays as our retina: thus, in certain cases, it can give us more than the eye, showing what the eye could never perceive. This particular sensitivity has its own special value that is not, in our opinion, the least important of photography's properties."[13]

It is indeed on the basis of photography's capacity for (diagnostic, pedagogical) certification and (prognostic, scientific) "foresight" that Charcot's *iconographic impulse,* as it has been called, must be understood:

> Knowing that images speak more vividly to the mind than words, he gave images a place of the highest order. With Paul Richer, he published *The Deformed and the Ill in Art* [*Les Difformes et les Malades dans l'Art*]; he created the *Nouvelle Iconographie de la Salpêtrière*. . . . Since then, this iconographic impulse has extended to all branches of medicine. To appreciate this fact, one need only open a treatise published in 1880 and compare it with one of our current treatises.[14]

Sight and foresight, *anticipating* knowledge in sight: of course. But something lingers, like a doubt. For example, this anticipation may also have been effective in obscuring or conjuring up another efficacy, the efficacy

of sight as presence. And in reversing its affective motions, in any case—
like what Freud called *Verkehrung ins Gegenteil,* the *reversal into the opposite.*

The Least Flaw

Until now, this is all hypothesis, but it grips me. Before all these photographs,
I always think, stupidly, about the anxiety the physician-photographer
must have felt. (I recall—is it relevant?—the story of Jumelin, a famous
anatomical modeler of the time. One day, he made a cast of a liver freshly
extracted from a man suffering from "pox," and, not in the least anxious
and even a bit distracted, he happened to blow his nose on the cloth that
had wrapped the organ to be "reproduced." He, too, died of pox, a vic-
tim of his art and of some jovial refusal to be anxious about dissecting
other people's bodies, sick bodies.)

In the 1860s, photography made its triumphal, triumphalist entry
into the museum of pathology. Photography, showing the least flaw. And
what an impression it made: photographic endoscopy, finally able to un-
veil the most secret anatomy—as it is. The seat of nervous illnesses could
finally be seen, and in person.

Swollen Style

In 1869 the *Revue photographique des Hôpitaux de Paris* became the great *re-
view,* I stress, of pathology, surgery, ophthalmology, dermatology, and so
on. It had its own stars, its anonymous teratological stars.

In Montméja and Rengade's presentation of the review (see appen-
dix 4), the word "horror" naturally does not figure (instead, there is *"the
honor to offer the medical public"* (my emphasis) a veritable spectacle—the
veritable spectacle of *"the most interesting"* and *"rarest cases"* of pathology.
In this preface there are also words such as *"truth," "advantages," "magnifi-
cent," "total success,"* and so on). But for us, sensitive creatures (who are not
"in the trade"), it is a true catalog of horrors; this is to state the obvious,
but it should not for all that be neglected. For it is truly glaring.

When we hold these works in our hands, we are also struck by the
now cracked accents of paint and colored ink that "clarify" and "embel-
lish" certain photographic images. And it is no less striking to find an oc-
casional signature, the great return of pictorial tradition—for example:
"A. de Montméja—*Ad naturam phot. et pinx.*"[15]

This review also defined a page layout that was to become canoni-
cal—leaving a large space for the legend, notably. Its use of the close-up
tends to isolate the monstrous organ: the space of the image collapses on

the organ, as the depth of field is reduced—the prodigy and the abomination, in their aggressive incongruity, are doubly framed. It is the same incongruity in which Bataille sought the element of a "dialectic of forms":

> Any "freak" [*phénomène*] at a fair provokes the positive impression of aggressive incongruity, somewhat comical but far more generative of a malaise. This malaise is obscurely linked to a profound seduction. And, if there is a question of a *dialectic of forms,* it is evident that one must, first and foremost, take into account this sort of gap which, although most often defined as against nature, is unquestionably nature's responsibility. Practically this impression of incongruity is elementary and constant: it is possible to assert that it manifests itself to some degree in the presence of any human individual whatsoever. But it is hard to sense. Thus it is preferable to define it in reference to monsters. . . . Without addressing, here, the question of the metaphysical foundation of a dialectic as such, it is permissible to assert that defining a dialectical development of facts as *concrete* as visible forms would be a literal upheaval.[16]

A "style" sometimes swells in the approach to or the *parergon* of the photographed (for the teratological subject, even alive, is *already* a work, a museum piece); it swells and comes to produce chancy resonances—but are they always by chance?—with the very thing the abomination of which it elsewhere attempts to contain. Bourneville, as can be seen in his battle with a leg's improbable contortions, comes close to losing himself in a far too twisted description of the phenomenon: "the femurs are considerably curved, concavity directed inwards, and convexity looking outward. The leg bones present curvatures in the opposite direction, that is, with external concavity, and internal convexity."[17] Then, as if the leg itself were not enough for its own exhibition, he confirms the wonder with the adventitious support of a chair whose legs are no less twisted (fig. 7).

Traits of Madness

I am now coming to the madwomen. The problem of their representation was no less labyrinthine. It is, in the first place, a physiognomic problem, as if the portraitists of the madwomen had not ceased seeking an *adequate line* [*trait*] for the expression of their passions (figs. 8–10).

The "expression of the passions" is a classic problem of painting: in 1668 Le Brun consecrated a conference and a whole series of figures to it. For the problem was posed in terms of *graphic notation* (in reference to a weave, a system of coordinates almost like a musical staff)—the graphic notation of movements, I mean, the *movements of the soul in the body:* he

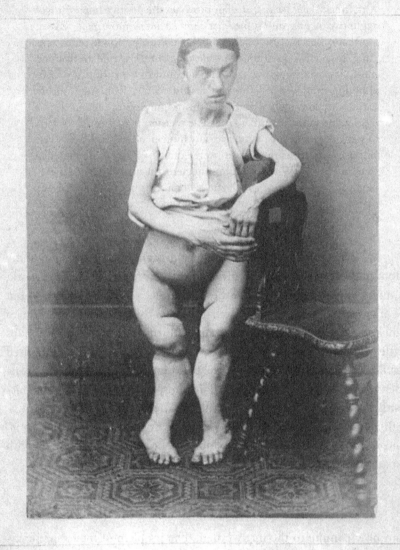

Figure 7
Layout of the *Revue photographique des Hôpitaux de Paris* (1871).

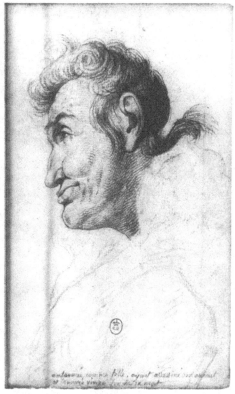

Figure 8
Lavater, *Physiognomy of a madwoman,*
L'art de connaître
(1835 edition).

Figure 9
Gabriel, *Head of an insane woman,*
drawn for Esquirol
around 1823.

defines expression, in fact, as the "part that marks the movements of the soul, that makes visible the effects of passion"; and further on, he writes that "*Passion* is a movement of the soul that resides in the sensitive area, which is formed to follow what the soul thinks is good for it, or to flee what it thinks is bad, and, ordinarily, everything that provokes passion in the soul causes some *action* in the body."[18] Le Brun right saw this action as something like a *symptom,* the visible figure of the passions. But he counted them only up to twenty-four, perhaps terrified of this in fact transfinite mathematics, the mathematics of symptoms that he had lighted upon; so he stopped with an alphabet.[19]

Of course, this alphabet was expanded by Lavater, among others.[20] As early as 1820 (when Moreau came out with the new edition of Lavater's work, in ten volumes), Esquirol asked Gabriel, draftsman and disciple of the great physiognomist, to sketch him some madmen and madwomen: "The study of physiognomy of the insane is not an object of

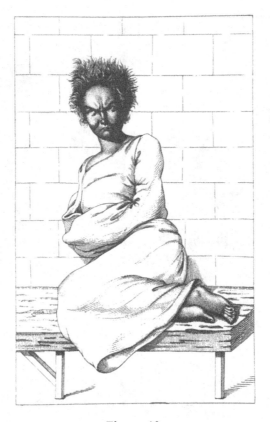

Figure 10
Tardieu, *Physiognomy of an insane woman,* engraved for Esquirol,
in *Les maladies mentales* (1838).

futile curiosity," he wrote. "This thing helps untangle the nature of the
ideas and affections that sustain the delirium of these patients. . . . I've had
over 200 insane people drawn for this purpose. Perhaps one day I will
publish my observations on this interesting subject"[21] (see fig. 9). The fail-
ure of this project was perhaps due to the fact that the alphabet was still
not fully the "silent but telling language of nature."

First Run

The first photographs of lunacy were portraits of the madwomen of the
Surrey County Asylum in Springfield, calotypes executed beginning in
1851 by Doctor Hugh W. Diamond, militant and herald of the "silent but
telling language of Nature," founder and president of the Royal Photo-
graphic Society of London (1853), director of the *Photographic Journal,* and
so on, and so on.

In regard to these extraordinary images, I will mention only that a *passage into line* [*passage au trait*], the drawing of an engraving based on a photograph, was still a necessary operation for the pictures to be used and transmitted. This may seem surprising, in that the technique of the calotype (negative on paper) was meant to resolve the problem of the picture's reproducibility (for one can print an unlimited number of proofs from a negative, which is impossible with a daguerreotype).

In this passage something was always forgotten, something yielded despite Diamond's alleged passion for exactitude—something about the situation, for instance. Take this woman positioned outside, doubtless in a courtyard where there would be more light, with a curtain placed behind her (already an attempt to make the situation abstract) (fig. 11); in the engraving this woman is nowhere—how could her gaze not appear insane, drawn without space or destination? A pure question (fig. 12). And something was also forgotten in the split between the essential or the significant, and the merely accessory. In the images of the same woman, her printed dress, for example, becomes "uniform" in the engraving. (Although this multicolored pattern itself may have been a signifier in her own madness, which was, they say, melancholia on the verge of mania—pure hypothesis.) The posture, too, is graphically bent, or rather, straightened so as to provide more convincing meanings: for example, the clasped hands, rendered symmetrical, of a woman who in fact suffers from "religious madness" (figs.13, 14). And let me note, finally, that the legends of these engravings serve to designate not an attribute of the referent ("melancholic") but a concept ("Melancholia"), the referent of which—this particular madwoman here—is only an attribute.

Gorged with Images

But all this—I'm thinking of photography—was not just the whim of one man; it was in the air, as they say. Could a budding art have made psychiatrists recognize their nosological shortage of the *visible signs* of this or that madness? The fact remains that almost everywhere in Europe, madwomen and madmen found themselves *obliged to pose;* their portraits were being taken, one outdoing the other.

A few prodigious collections remain to us today, at the Bethlem Royal Hospital of Beckenham (where the painter Richerd Dadd, committed for patricide, was photographed), and the San Clemente hospital in Venice (an immense clinical and administrative record of madwomen—thousands of images)[22] (figs.15, 16).

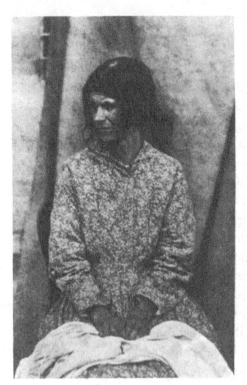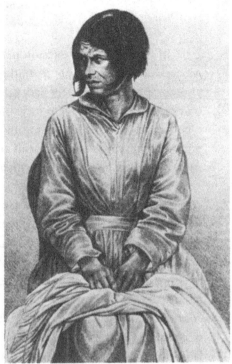

Figures 11 and 12
Engraved version (fig. 12) of a photograph (fig. 11)
by H. W. Diamond. Engraving published under the title
‘ *Melancholy passing into Mania* in *The Medical Times* (1858).

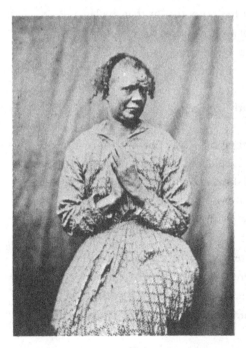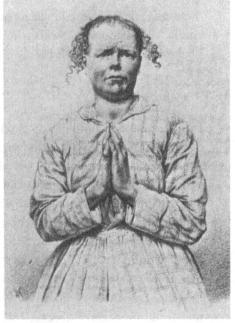

Figures 13 and14
Choice of poses: photograph by H. W. Diamond and
engraving in the *Medical Times* (“Religious Mania,” 1858).

Figure 15
Clinical certificate from the San Clemente Hospital in Venice (1873).

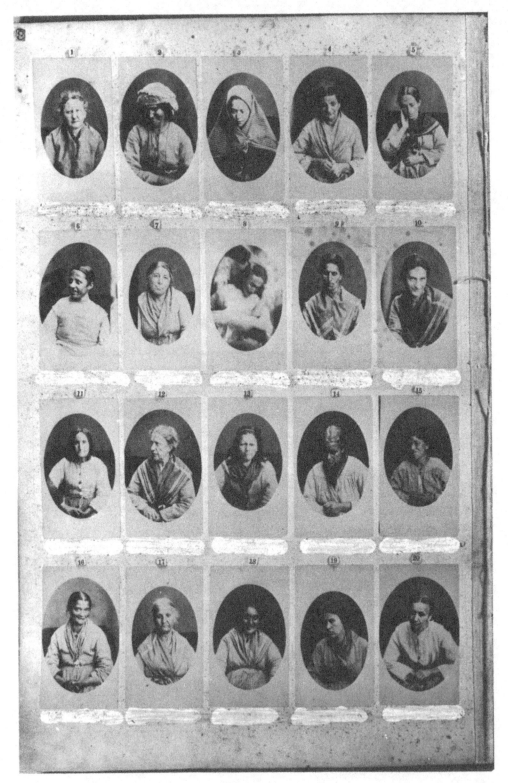

Figure 16
Registry from the San Clemente Hospital in Venice (1873).

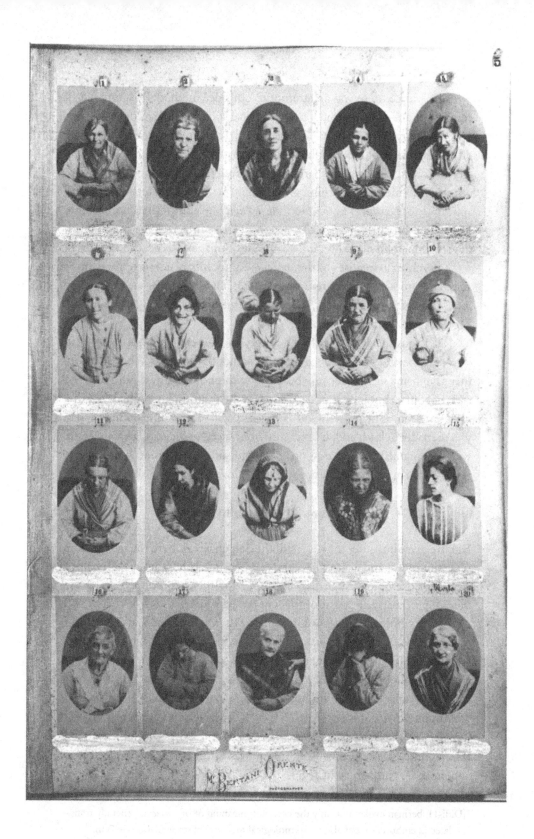

In France there was an attempt to consider method. For instance, a certain session of the medico-psychological society in Paris, on April 27, 1867, was organized around the theme of "the application of photography to the study of mental illness." Participating in this session were, notably, Moreau de Tours, Baillarger, and Morel. Considering a method did not so much mean questioning photography's epistemic interest—for this appeared to everyone as evident, *all too evident*—but rather establishing the basic protocol for the transmission of these images. The problem of the reproducibility and literary treatment of images was on the agenda.

Psychiatric treatises of the day were thus enhanced with plates, images, and proof of nosologies in progress: Baillarger and Bourneville's idiots, Dagonet's lypemaniacs, Voisin's sthenic madwomen, Magnan and Morel's degenerates, and others.[23]

If I thus speak of a veritable gorge [*engouement*]* of photographs, it is to draw on the profoundly equivocal nature of the phrase, for the claim that psychiatry simply became besotted with photography would be correct, of course, but it does not account for the profound complexity of the phenomenon. Gorging oneself [*s'engouer*] with something signifies that you're madly in love, and so you "stuff your face," as they say, gobbling and swallowing until you can't go on. And you suffocate from it: *l'engouement* is obstruction, strangling, from too much love.

Salpêtrière, Photographic Service

But the great image factory was still the Salpêtrière, where the fabrication was methodical and nearly theoretical; it became truly canonical (Tebaldi's work, for example,[24] published in Verona in 1884, reproduced the exact typographical arrangement of the Salpêtrière's plates).

The whole thing was put into place when a "devoted and able" photographer, Paul Régnard, was able to settle in for good at the Salpêtrière and indulge his predation at any opportune moment. It seems that the album completed in 1875[25] convinced Charcot to sponsor a clinical publication, organized around this body of images, and written by Bourneville. This publication appeared in 1876 and 1877: the first volume of the *Iconographie photographique de la Salpêtrière* (see appendix 5), followed by a second volume, whose printing technique was a little less do-it-yourself (see appendix 6), and a third in 1880.

*[Didi-Huberman evokes not only the common meaning of *engouement*, generally translated as enthusiasm, but also its etymological meaning of strangulation.—Trans.]

And then there was nothing: a silence of almost ten years, during which Bourneville and Régnard disappeared, in a way, from this circulation of images. In fact, they were relieved of their functions by Albert Londe, much fussier about the organization, who made the most of the means conferred on him by the official inauguration of Charcot's chair.

Londe maintained a strange silence about his predecessors;[26] were their photographs that much more beautiful than his own?—Mere hypothesis. Then, in 1888, the first volume of the *Nouvelle Iconographie de la Salpêtrière* appeared, still under Charcot's auspices, by Gilles de la Tourette, Paul Richer, and the selfsame Londe.

In this way the practice of photography attained the full dignity of a hospital service.[27] That is, it had its own domain: a glass-walled studio, dark and light laboratories[28] (fig.17). It had its official equipment: platforms, beds, screens and backdrops in black, dark gray, and light gray, headrests, gallows (fig. 18 and appendix 7). Its photographic technology grew more and more sophisticated, as the phrase so aptly goes: the proliferation of all kinds of lenses and cameras (figs. 19, 20), the use of artificial lighting,[29] "photochronography,"[30] and all the latest developments in development,[31] and finally, it had its clinical and administrative procedures of archiving: a whole itinerary of the image, from the "observation" all the way to the filing cabinet (see appendixes 8 and 9).

Service is nonetheless a horrible little word; it already contains servitude and abuse [*sévice*]. My question is not only what purpose photography served, but also who, or what, at the Salpêtrière, was subjugated to the photographic images?

The Legend of Memory

These images were, in fact, supposed to serve a memory. Or rather, the fantasy of a memory—a memory that would be absolute, quite simply: in the moment of the shot, the photograph is absolutely immediate, "exact and sincere."[32] And it endures: it is, "like all graphic representations, a faithful memory that conserves, unaltered, the impressions it has received."[33] I call it a fantasy, in the first place, because the technical problem of the *permanence of images* was never, in fact, self-evident. And the first fifty years of photography still bear the mark of a major anxiety, more or less expressed, over the *toning* and *effacement* of prints. All efforts aimed either at perfecting the calotype or at allying photographic reproduction with the lithographic technique, in ink and carbon, supposed to be indelible. The earliest period of the *Iconographie Photographique de la Salpêtrière*

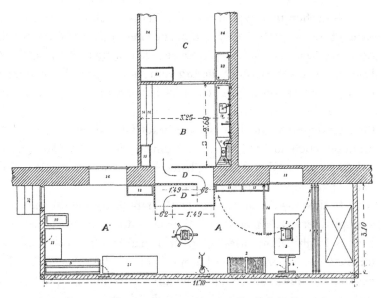

Plan du Service photographique de la Salpêtrière (¹).

> A. Atelier vitré.
> B. Laboratoire noir.
> C. Laboratoire clair.
> D. Entrée en chicane du laboratoire noir.

Figure 17
Map of the photographic service of the Salpêtrière.

Figure 18
Poyet, *Photography at the Salpêtrière*
(Bibliothèque nationale, East Wing).

Figures 19 and 20
Albert Londe's stereoscopic camera (fig. 19) and camera with
multiple lenses (fig. 20), *La photographie médicale* (1893).

was marked by this effort and anxiety. Only a few years later, Albert Londe's discourse flaunted the triumphalism of an absolute photographic memory. For he had behind him the birth of photomechanical procedures, photocollography, photoglyphy, heliogravure, similigravure,[34] and so on.

The same goes for Photography, with a capital "P"—I mean the ideal of photography, an incontestable Trace, incontestably faithful, durable, transmissible. Photography, far more than a mere scientist's cheat-sheet,[35] had the duty of being knowledge's memory, or rather its access to memory, its mastery of memory. "It is a question, in fact, of preserving the durable trace of all pathological manifestations whatsoever, which may modify the exterior form of the patient and imprint a particular character, attitude, or special facies upon him. These impartial and rapidly collected documents add a considerable value to medical observations insofar as they place a faithful image of the subject under study before everyone's eyes."[36]

And Photography, in the end, was supposed to allow for a single image, or a series of images, that would crystallize and memorize for everyone *the whole time of an inquiry* and, beyond that, the time of a history ("obtain anterior photographs: one will thus have the proof that the existing anomalies are indeed the consequence of the illness and did not exist before"[37]).

Photography had to crystallize the case into a *Tableau:* not an extensive tableau, but a tableau in which the Type was condensed in a unique image, or in a univocal series of images—the *facies.*

> Determining the facies appropriate to each illness and each affection, placing it before everyone's eyes is precisely what photography is able to do. In certain doubtful or little known cases, a comparison of prints taken in various places or at distant times provides the assurance that the illness in different subjects who were not on hand at the same time is indeed one and the same. This work has been accomplished to great success by M. Charcot, and the facies belonging to this or that affliction of nervous centers is now well-known. With the prints thus obtained, it would be easy to repeat Galton's experiment and obtain, through superposition, a composite print providing a type in which individual variations disappear, bringing to light their shared modifications.[38]

A facies is that which is bound and determined to summarize and generalize the case, determined to make *foresight* possible: and this, in the aspect of a *face.*

The Legend of the Surface, the Facies

Facies simultaneously signifies the singular *air* of a face, the particularity of its aspect, as well as the *genre* or *species* under which this aspect should be subsumed. The facies would thus be a face fixed to a synthetic combination of the universal and the singular: the visage fixed to the regime of *representation,* in a Hegelian sense.[39]

Why the face?—Because in the face the corporeal *surface* makes visible something of the movements of the soul, ideally. This also holds for the Cartesian science of the expression of the passions, and perhaps also explains why, from the outset, psychiatric photography took the form of an *art of the portrait.*

In any case, this portraiture was a very particular art, in which "face" was understood as "facies." It was an art of *surface territories,* yet always seeking a more intimate localization, the concomitant convolution in the brain. Doubtless, this was a legacy of that strange territorial or configurative science, if I may put it like that, of Gall's phrenology. Gall was passionately interested, for instance, in a certain woman's face; he even took her delicate head in his hands—but his caressing fingers were only seeking the region, bump, or cephalic fold corresponding to the lady's monomania. And in his other hand, opposite her, he held a death's head—I mean a skull—for comparison (fig. 21). I speak of a legacy because phrenology lost no time in positing itself as the theoretical basis of all psychology under the ensign of positivism;[40] Charcot's cerebral localizations are affiliated, as it were.

It was also an art of the detailed, the tenuous, the fragmented—an art of the *commissure* of territories, but always in search of a law prescribing their minuscule differences. Bourneville photographed idiots and, on the basis of his portrait gallery, sought a concept of Idiocy in the minute anatomical pinpointing of buccal openings, the commissure of the lips, the form of cheeks, the roof of the mouth, gums and teeth, uvulas, soft palates.[41] Duchenne de Boulogne also sought the differential muscular commissures of every emotion, pathos, and pathology[42] (fig. 22). And Darwin, extending the same research to the whole animal kingdom, used it as the basis for his great phylogenetic history of the expression of emotions.[43]

The face subsumed under a facies thus allowed for a logic and etiology of its own accidents. It did so through a subtle and constant art of the *recovering of surfaces,* always seeking depth—conceptual depth—in the filmy fabric or stratum he constructed: the depth of the Type. Galton was a virtuoso of this art of recovering: he *produced* the Type through the regulated superposition of portraits he had collected. If the *facies* obtained

Figure 21
Phrenology, print (Musée d'Histoire de la Médecine, Paris).

was a bit blurred, what did it matter; it still constituted a figurative probability, rigorous in itself, and thus a "scientific" portrait[44] (fig. 23).

Albert Londe, at the Salpêtrière, was searching for exactly that: the rigorous figurative probability that would find its law in time and the differences of a face:

> The study of the facies in nervous pathology was carried out in a remarkable manner by the School of the Salpêtrière, and, without exaggerating, it can be asserted that Photography was of no small assistance in the circumstance. Certain modifications of the face that themselves cannot in isolation constitute the sign of any malady whatsoever, take on great importance when found in similar patients. Unless, perchance, one has patients presenting these characteristic facies at the same time, they can often pass unnoticed. To the contrary, when photographs are brought together, numerous specimens can be compared and the typical modifications that constitute this or that facies can be deduced. . . , creating, through superposition, composite types in which all individual particularities are effaced and only common characteristics persist, and so determine the *facies* appropriate to this or that malady.[45]
>
> . . . This result is important, for once the type is defined it remains engraved on the memory and, in certain cases, can be precious for diagnosis.[46]

In this way the aspect of the face, subsumed under a facies, became amenable to a codifiable, recordable state of signification; through a vigilant inquiry into forms, it opened the way for something like *signalment.*

The Legend of Identity and its Protocol

The physicians of the Salpêtrière thus resembled "scientific constables," in search of a criterion of difference understood as *principium individuationis:* a criterion that could ground "signalment," that is, the recognition or assignment of identity. And indeed, the "scientific police" is not a mere fable.

For there was a remarkable complicity, tacit and impeccable, between the Salpêtrière and the Préfecture de police. Their photographic techniques were identical and sustained the same hopes (the techniques were equally implicated in an art: the first identity photographs were oval, just like family portraits; and above all, it seems to me that *at a certain moment,* any passion for forms and configurations implicates an art. The way in which the École des Beaux-Arts aided the Salpêtrière and the Préfecture de police in their efforts must also be interrogated).

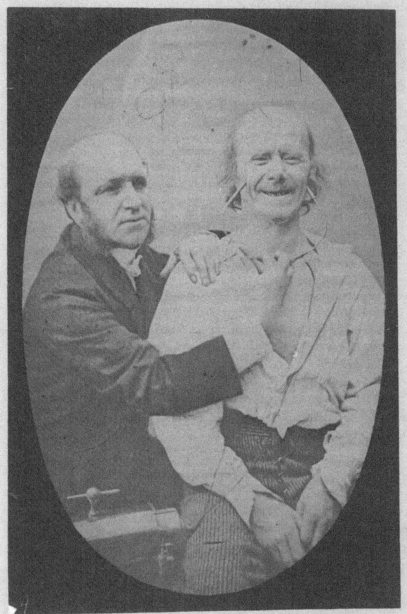

Figure 22
Duchenne de Boulogne, "Specimen of an
Electro-physiological Experiment," *Mechanism of
human physiognomy* (1862) (frontispiece plate).

SPECIMENS OF COMPOSITE PORTRAITURE

PERSONAL AND FAMILY.

Alexander the Great
From 6 Different
Medals.

Two Sisters.

From 6 Members
of same Family
Male & Female.

HEALTH, | DISEASE. | CRIMINALITY,

23 Cases,
Royal Engineers,
12 Officers,
11 Privates

6
Cases

9
Cases

Tubercular Disease

8
Cases

4
Cases

2 Of the many
Criminal Types

CONSUMPTION AND OTHER MALADIES

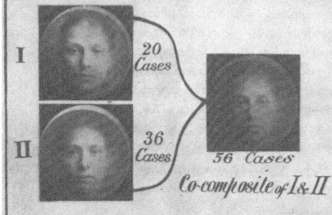

I
20
Cases

II
36
Cases

56 Cases
Co-composite of I & II

Consumptive Cases.

100
Cases

50
Cases

Not Consumptive.

In any case, the development of psychiatric photography in the nineteenth century emerged from the same general movement as forensic photography.[47] Moreover, the pivotal discipline of criminal anthropology occupied an eminent strategic position in this movement; it took as much interest in the photographic portraits of criminals and the insane as it did in their skulls (fig. 24, 25).

A certain Lacan, taking stock of photography's miraculous progress, did not hesitate to equate "the accusatory image" of criminals with "Dr. Diamond's erudite work":

> What convicted criminal could escape police vigilance? For even if he escapes the walls where punishment restrains him; even if, once liberated, he breaks the order that prescribes him a residence; even then his portrait is in the hands of the authorities. He has no escape. He cannot but recognize himself in his accusatory image. And, from a physiognomic point of view, what studies are these collections in which the nature of the crime is inscribed along side the culprit's face! One could read the history of human passions in this book with each face as a page, and each feature an eloquent line! What a philosophical treatise! What a poem, which light alone can write! If we pass from illnesses of the soul to those of the body, we again find the photographer ready to play an important role. Before my eyes I have a collection of fourteen portraits of women of different ages. Some are smiling, others seem to be dreaming, and all of them have something strange in their physiognomy: one understands this at first glance. If one considers them longer, one is saddened despite oneself: all these faces have an extraordinary expression that gives pain. A single word suffices to explain everything: they are madwomen. These portraits are part of a scholarly work by Dr. Diamond.[48]

Simply note, for the moment, that in this subtle complicity between physicians and police, a concept of identity was necessarily elaborated on the basis of a combination of scientific or forensic petitions and their technical and photographic responses. What's more, photography was the new machinery of a legend: *the having-to-read of identity in the image.*

This having-to-read found its "theoretical basis," its "philosophy," under the pen of its own practitioners: I am thinking of Alphonse Bertillon, creator of Signaletic Anthropometrics, who died in 1914, and whose "system" was adopted by police forces across the Western world starting in 1888. He was the director of the photographic service of

Figure 23 (previous page)
Galton, *Inquiries into Human Faculties . . .* (1883) (frontispiece plate).

the Préfecture de Paris (the first in the world, created as early as 1872 by Bazard).[49]

Alphonse Bertillon's "theoretical considerations of signalment"[50] sprang from a reflection on the nature of and means for a "descriptive analysis of the human figure," on the "mathematical rules" of the "mysterious distribution of forms" and the "distribution of dimensions in nature."[51] These considerations then opened the way to establishing the technical means for the identification and anthropometric classification of individuals.

> Whether one is concerned with a dangerous repeat offender concealing himself under an assumed name, or an unknown cadaver deposited in the Morgue, or a child of a young age who has been lost intentionally, or an insane person stopped on the public highway who persists, out of imaginary fears, in concealing his identity, or a poor man struck with sudden paralysis in the street, and incapable of pronouncing his name and address; the end in view is always identification and the means of action is Photography.[52]

Thus this having-to-read was above all the commandeering of the efficacy of sight, defined in photographic procedures. These procedures included, in the first place, a standardization of the pose and shooting of portraits (the uniformity of procedures would ensure that differences are identified and fully measurable):[53] "And it is furthermore desirable that photography coupled with signalment come as close as possible to the well-defined uniform type, adopted, according to my indications, by the central Archives of the Identification Service."[54] Bertillon had a number of gadgets perfected, including a "posing chair mechanically assuring the uniformity of reduction between full-face photographs and those in profile:"[55] the subjects had to be bent into the type of image required, this face and that profile, to bring out, with regulated specificity, their physiognomic-criminal clues (appendix 10; fig. 26). An art of warders. And the only thing left to do was to *archive*, a weighty problem when there is such a multiplicity of images and clues: making it possible to locate a certain suspect of a certain crime from among some 90,000 photographs taken by the Identification Service of the Préfecture between 1882 and 1889,[56] in accordance with the well-named process of "Bertillonage."

Let us return to my subject, Albert Londe who, in his own orbit (the Salpêtrière, a quasi-city, complete with its own seedy areas and surveil-

Figures 24 and 25 (see overleaf)
Portraits and skulls of criminal women, collected by Lombroso
and reproduced in his *Atlas de l'homme criminel* (1878).

PORTRAITS DE CRIMINELLES ALLEMANDES.

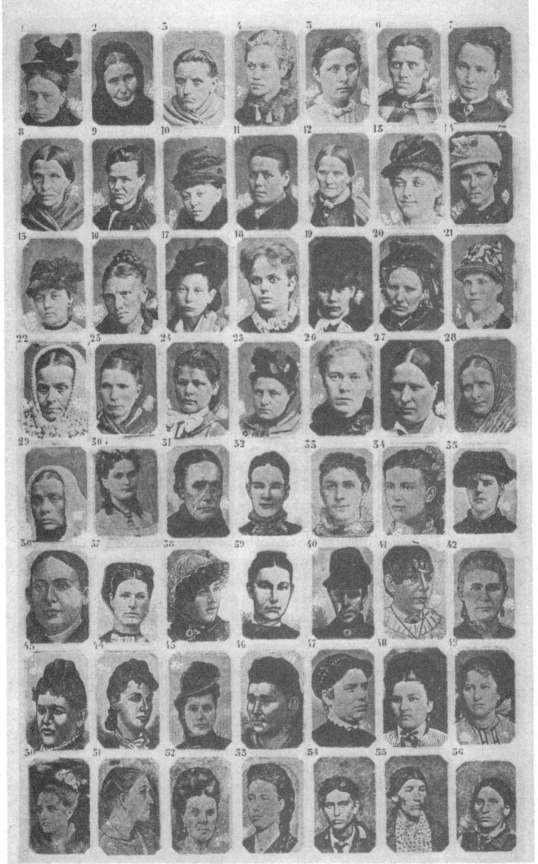

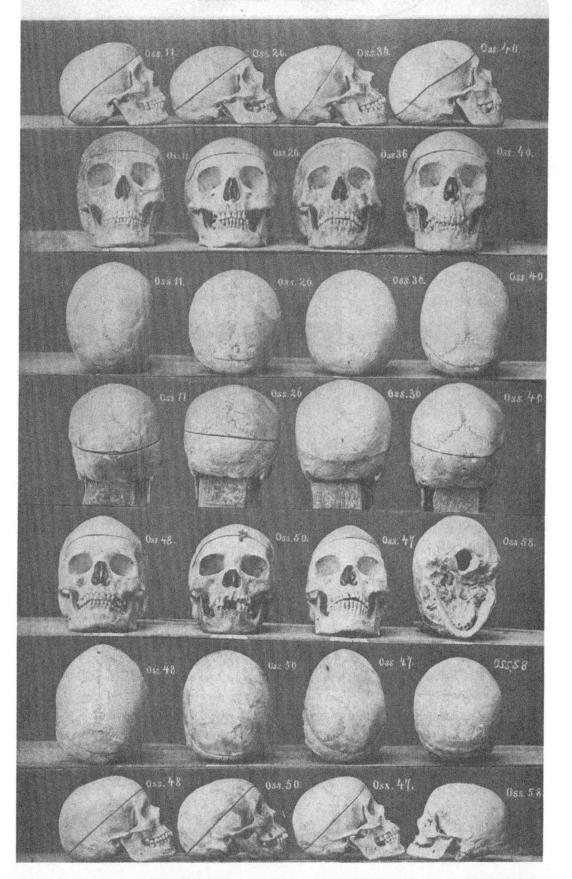

Figure 26
"Bertillonage" at Police Headquarters in Paris (1893).

lance services), was posing analogous questions and inventing analogous procedures so as to regulate the conditions of visibility of symptomatic bodies, so they would produce signs and signalments. He regulated the conditions of their exhibition and even the advent of differences, so as to derive a unique concept and adopt a programmable "curative" conduct with no risk of surprise. For example: "For a photograph of the feet, the subject must be elevated on a table or some support such that he is placed at the level of the camera. In every case, and principally where modifications bearing on the dimensions of the limbs are concerned, it is advisable to photograph a metric scale at the same time, or else the hands and feet of a normal person. In this way the comparison will be all the more telling."[57] As for the feet, so for the face, which had to be raised to the level and disposition of the camera. This is how the "face of madness" became the "pathological facies of nervous illness," meaning that the face lost its aura.

But let us return to my subjects, Bourneville and Régnard, who, a few years before Londe, were—still hesitating. They confined themselves to procedures that were more aleatory; their predation of images, in regards to hysterics, was still marked by something adventurous, and the portraits they took still left room for the *aura,* I mean, the temporal tenor of images that were so much more complex, equivocal, and troubling. And, doubtless, this happened despite their intentions.

Bourneville, for one, later compensated for such hesitations regarding both Bertillonage and wardership, by photo-measuring the children in his service at the Bicêtre hospital (figs. 27–30).

But while at the Salpêtrière, Régnard and Bourneville were still exposed to the *risk* of a more intimate paradox of photographic practice. They were searching for the facies in faces and they attempted to deny all paradoxical effect, of course; but they were only partially successful. This is why their images, more than others, are still enigmatic and disconcerting. The *facies* is not yet the policing of the image, not quite a subject detained for observation. It still offers itself, I would say, as a *spectacle* (also signified by "facies" in Latin), never wholly cloistered in fixed stage-scenes. The facies still offers itself as an act, a *factitive* (that which "gives"—*facit*—something)—an event of the portrait.

Paradox of Evidence

The paradox of photography is what I would call a *paradox of spectacular evidence.*

It is, in the first place, a paradox of a sort of *knowledge* that slips away from itself, despite itself; the endless flight of knowledge, even as the object of knowledge is photographically detained for observation, fixed to objectivity. It is also, precisely, the paradox of photographic *resemblance,* which is not the essence of photography though it wanted to be, and which, in the end, was always only stasis, effect, and temporal drama of its repeated failure. But perhaps this is why the paradox is the paradox of Resembling.

Every image summoned to appear in the *Iconographie photographique de la Salpêtrière* confronts us with this paradox. But I will be somewhat more specific, in reviewing its principles.

Exactitude?

Baudelaire was aware of a paradox when he railed against photographic exactitude, treating it not as a material effect, a "pure effect" of the photographic act, but as the credo of a "multitude" for whom Daguerre was

Figures 27–30
Bourneville, "Diagnostic Biography" of a child (extracts),
taken at the Hôpital Bicêtre.

the "messiah."[58] What everyone in photography called evidence, Baudelaire was already calling belief. He went further yet, characterizing this belief as adulterous, imbecile, narcissistic, obscene, as modern Posturing and Fatuity, even as blind—and especially as a revenge, industry's imbecilic revenge on art.[59] The great, tireless quarrel between art and science.

But art or science, art or meaning[60]—the quarrel deserved only to be sublated and exceeded. Perhaps photography never stopped striving for the sublation, *Aufhebung,* of art,[61] a sublation of science, and thus sublation of their mode of coexistence. This sublation first manifested itself as the invention of the twisted and novel means to the figurativity of knowledge. Now, photography is not just any representative system; when it denies that it is self-representational or autoreferential, we always come close to believing it. It can connote, doctor, pose, aestheticize, disconnect its referents, oversyntax the visible, invent new qualities, such as *photogénie* and so on; but it is nonetheless always credited with truth. Not the truth of meaning (precisely because of its capacity for connotative flippancy), but the truth of existence: a photograph is always supposed to

Lard Marcelle Charlotte
Née à Paris, le 3 Octobre 1898

Lard Marcelle Charlotte
Mars 1902

authenticate the existence of its referent, and in this way it always grants us *some* knowledge, and is always justified in pointing to something in itself like a "that has been."[62] Of course. Is that its exactitude?

Facticity

But what of this "exact" knowledge? Photography might be right about something (but what?), even as it falls short of what it leads one to believe by virtue of its tricks, points of view, and fabrications of beauty. Inversely, what exactly does it lead one to believe or imagine about that thing whose existence it nonetheless certifies?

Another way to describe this paradox of evidence is to say that photography is a practice of facticity. Facticity is the double quality of that which is *in fact* (irrefutable, even if contingent) and that which is *factitious*. It is a paradox of mendacious irrefutability, as it were.

And what of the photographic *portrait*? This is my concern here. Consider this historical sketch by Lacan:

> The portrait was the earliest application of photography. As soon as Daguerre's procedures were made public, fragile glass constructions

resembling hothouses began to appear on the top floor of buildings, where the public would come to pose with commendable patience under the burning rays of the sun. At the time, one had to pose for up to five minutes, and even then one had, in principle, to cover one's face with whiting to obtain a satisfactory image.[63]

The fact that the photographic portrait required not only studios and make-up (as if to help the light come into its own) but also headrests, knee-braces, curtains, and scenery is a good indication of the terms of the paradox: an existence was authenticated, but through theatrical means. Let us reconsider the history: photography never stopped certifying presences, and at the same time, never stopped ritualizing this certification. One might think that photography would necessarily defy every notion of genre (the portrait, in this case), since it sticks so humbly to the configuration and "existence" of its referent. One is thus obliged to suspect that there is some retortion of its procedure, when one realizes that photography nonetheless a genre. And that it accedes to a standstill in a genre. As if in a very intimate movement, perhaps in the negation of its miraculous technical potential (to graph *hic et nunc* the *hic et nunc* of the visible), photography never stopped desiring to be a formalism. Photography wanted to make the simple exhibition of the body in an image, which it first made possible, into a display of Formality, Ideal, even Morality; at the same time that photography showed bodies, it solemnized them, assigning them to a familial and social rite—and thus *refuted* them through a certain kind of theatricality.

A kind of cutting-up of bodies, cutting-up on stage, a staging aimed at knowledge, knowledge aiming at the *what* (rather than the who) of bodies. In this sense, photography entered the domain of anthropological certitude,[64] although it was perhaps a means of undermining it.

Through this cutting up and its staging, photography also incorporated Text, the *Legend:* stage directions for theatrical arrangements, not simply writing in the corner of an image, but indeed a legend, a having-to-read, an explanation: its dramaturgy, in short.

By its dramaturgy I mean its prospect, its own perspective and project, to which it attempts theatrically to subjugate an aspect, and denies this very temptation. Its dramaturgy is the *making* of representational objects from the point of departure—yes, departure—of the singular differences of a photographed "model." This *making* supposes and imposes a conceived identity, a judged or prejudged analogy, of previously conceived oppositions or similarities. And this is how photography invents itself as scientificity, target, generality—although initially it was merely an exemplary act of contingence.

And photography came to imagine that it had the power of a symbol. But this, in fact, is but a still more solemn, and perhaps more crazed, entry into the imaginary. I mean, the imaginary as act: facticity.

Subject?

This might be called the anchoring of photography in fiction, but in truth, it is far worse.

The worst is that, fundamentally, the camera is merely a subjective apparatus, *an apparatus of subjectivity.* This would of course make Albert Londe turn in his grave. But Londe, incidentally, could not have been unaware that optics itself, with its perennial laws, functions according to a relation, regulated of course, between real space and something that must indeed be called imaginary space—that is, psychic space.

I would go so far as to say that the camera is a wholly philosophical product; it is an instrument of *cogito.*

The camera produces showers of metaphors, and the stakes are universals. Valéry compared the darkroom to Plato's cave.[65] And photography would seem to have finally achieved the "indiscreet resemblance" that leaves no "gap" between the portrait and the portrayed, and that occupies such a decisive position in Descartes's problem of certainty. Note nonetheless that Cartesian certainty itself, between *"ego sum"* and *"larvatus prodeo,"* follows factitious detours, stage directions, feints of exposition, *trompe-l'oeil,* figuration, masks, and portraiture: always *impossible resemblances.*[66] The photographic apparatus would thus be the apparatus of a cogito already unhappy in its certainty, turned chaotic, *torn.*

Finally, in a chapter entitled "Regression" in the *Traumdeutung,* the photographic apparatus appears as the figure for a notion of *psychical locality* in the dream;[67] but the analogy did not prove wholly satisfactory. It was too simple or too complex as a metaphoric machine, and also doubtless unadapted to the vertigo to which the camera condemns us, as subjects. This vertigo implicates, notably, the Freudian dialectic of the subject, perhaps less in terms of topographies or psychical localities than in economic or dynamic terms. It is in any case, or at least, the vertigo of the subject's self-betrayal, an experimental self-betrayal.

Treachery!

Tradire—to *transmit,* to *deliver* in all senses—and then, to *betray.*

An anecdote, in passing: in the spring of 1921, two of those so-called instantaneous photo machines, recently invented abroad, were installed

in Prague. On a single piece of paper they could affix sixteen different expressions of the subject, if not more. And Janouch said to Kafka, in a lighthearted and philosophical tone: "The apparatus is a mechanical *Know-Thyself!*" And Kafka replied, "You mean to say, the *Mistake-Thyself.*" (With a faint smile, of course.) Janouch mildly protested: "What do you mean? The camera cannot lie!" and what an answer Kafka gave: "Who told you that the camera cannot lie?" Then, writes Janouch, Kafka tilted his head toward his shoulder.[68] All those inclined heads in photographic portraits—heads submitted to the image.

Photography *delivers* us, in all senses, as I said. It delivers our image, delivers us to the image, multiplying and repeating the transmission and, in the exactitude of this passage—our modern tradition, in the exactitude of its figurative facilitations, it traffics in our history and betrays it. Its superb "materialist" myth, the filmy production of the double,[69] in fact constitutes *the passing to the limits of evidence.* Exacerbated, multiplied, magnified: evidence passes into simulacrum.

Albert Londe himself was led to demonstrate the essentially fantastic tenor of the photographic portrait, as in this treble figure, thrice present in the same image. Portraitist, portrayed, and portrait, one might say,

Figure 31
Londe, The "multiple portrait," *La photographie moderne* (1888).

and perhaps a triple self-portrait, a muddling in any case of self- and allo-portrait (fig. 31).

Resemblance?

Thus photography is ultimately an *uncertain* technique,[70] changeable and ill-famed, too. Photography stages bodies: changeability. And at one moment or another, subtly, it belies them (invents them), submitting them instead to figurative extortion. As figuration, photography always poses the enigma of the "recumbence of the intelligible body,"[71] even as it lends itself to some understanding of this enigma, and even as this understanding is suffocated.

A photographic portrait ("Resemblance Guaranteed," read the bills advertising Daguerrotypes) never presented the "model" "as such." It already represented and *complicated*[72] the model, already chiseled it into something else, perhaps an ideal, perhaps an enigma, perhaps both; the identity of the model was essentially dissociated, twisted, and therefore terribly troubling. This trouble was due to the *evidence of Resembling:* too evident (at risk of being evacuated) not to be theatricalized, "ex-act" resemblance acts out—the act of facticity, the act of *miming* (miming its own obviousness). This is to say that it passes into the invention of an other, alternative temporality of the pose; "here preceding, there recollecting, in the future, in the past, in the false appearance of the present"[73] (why does this mime's sentence demand so imperiously to be thought and rethought?).

And when one comes to pose oneself, before a photograph, paradoxical questions: whom does this photographed face resemble? Exactly whose face is photographed? In the end, doesn't a photograph resemble just anyone?[74] Well, one cannot, for all that, simply push resemblance aside like a poorly posed problem. Rather, one points a finger at Resembling as an unstable, vain, and phantasmatic temporal motion. One interrogates the drama of imaginary evidence.

For "to resemble," or Resembling, is the name for a major concern about time in the visible. This is precisely what exposes all photographic evidence to anxiety, and beyond it, to staging, compromises, twisted meanings, and *simulacra*. And this is how photography circumvents itself—in its own sacrilege. It blasphemes its own evidence because evidence is diabolical. It ruins evidence, from a theater.

Vide!

"*Me vide!*"—An interjection in old comic performances, "Look at me!" This formula was used to signify something like "Have confidence!"—

But we all know, don't we, that confidence is always meant to be betrayed, especially on the stage of a theater.

So with photography. The treasure of photographic evidence is the confidence accorded to the existence of the referent, a confidence photography pillages at leisure, often devastating something entirely. In place of this devastation, as faint as it might be (a prick, hole, spot, or small cut: *punctum*), a sort of implosion takes place, the always irreparable effect of the shock of the void, something exorbitant.[75] I, too, am chasing after the time of this besmirching of the image in a few portraits of madwomen. It is something in the gaze, or rather something crucified between gaze and representation; it is something about time, the excessive immobilization of a desire, or a countermemory, or a hallucinatory flight, or a hallucinatory retention of a fleeting present, or who knows what else.

And with these somethings of gaze and time, so photography invents itself a very real proximity to madness.

4

A Thousand Forms, in None

"Behold the Madwoman"

Behold the madwoman who dances by, as she vaguely recalls something. Children chase her with stones, as if she were a blackbird. Men chase her with their gaze. She brandishes a stick, pretending to chase them, and then continues on her way. She loses a shoe on the road and doesn't notice. Long spider legs circulate around the nape of her neck—it's only her hair. Her face no longer looks human, so it seems for an instant, and she bursts out laughing like a hyena. She lets shreds of sentences slip out, which, if stitched back together, would make sense to very few; but who would restitch them? Her dress, torn in more than one place, jerks about her bony legs covered in mud. She walks straight ahead, carried along like a poplar leaf, with her youth, illusions, and past felicity, which she sees again through the whirlwind of her unconscious faculties. Her step is ignoble and her breath smells of brandy. Why does one still find oneself thinking she is beautiful?

The madwoman makes no reproaches; she is too proud to complain and will die without having revealed her secret to those who take interest in her, but whom she has forbidden to address her, ever. Still she calls to them with her extravagant poses. Children chase her with stones, as if she were a blackbird.[1] Men chase her with their gaze.

La Bête Noire

What men were chasing in hysteria was, above all, a *bête noire;* this is quite exactly how Freud described it, in French, in 1888.[2]

Twenty-nine years earlier—and that's not long—Briquet had begun his great "clinical and therapeutic" treatise on hysteria by insisting on the veritable repulsion that "this sort of patient" inspired in him. He wrote: "In order to acquit my conscience, I was obliged to bestow all my attention on this sort of patient, although my taste for positive science did not in the

least draw me to them. Treating illnesses that all authors see as the classic example of the unstable, irregular, fantastic, unforeseeable, ungoverned by any law or rule, not linked together by any serious theory: the task disgusted me more than any other. I resigned myself to it and set to work."[3]

Because hysteria represented a *great fear* for everyone, it was the *bête noire* of physicians for a very, very long time: for it was aporia made into a symptom.

It was the symptom, to put it crudely, *of being a woman*. And everyone still knows it. *Ustéra:* that which is all the way back, at the limit: the womb. The word "hysteria" appears for the first time in Hippocrates' thirty-fifth aphorism, where it is said: "When a woman suffers from hysteria or difficult labor an attack of sneezing is beneficial."[4] This means that sneezing puts the uterus in place, in its true place. This means that the uterus is endowed with the capacity of movement. This means that the woman's sort of "member" is an *animal*.

And its least shaking [*ébranlements*]—*branler* means moving and agitating*—is just as dreadful as lechery, suffocation, swoons, and "real semblance of death":

> When I say woman, I mean a sex so fragile, so variable, so mutable, so inconstant and imperfect, that Nature (Speaking in all honor and reverence) seems to me to have strayed from that good sense by which she had created and formed all things, when she built woman. And, having thought about it one hundred and five hundred times, I don't know what to conclude, unless that in creating woman she had regard more to man's social delectation and the perpetuation of the human species than to the perfection of individual femininity. Certainly Plato does not know in what category he should place them, that of reasonable animals or that of brute beasts. For Nature has placed in their body, in a secret place inside, an animal, a member, which is not in men, in which are sometimes engendered certain salty humors, nitrous, boracic, acrid, biting, tearing, bitterly tickly, by whose pricking and painful titillation (for this member is all nerves and acutely sensitive), their entire body is shaken, all their senses transported, all desires internalized, all thoughts confused, so that if Nature had not sprinkled their foreheads with a little shame, you would see them, as if beside themselves, chasing the codpiece, more frightfully than ever did the Proetids, the Mimallonids, or the Bacchic Thyades on the day of their Bachanals, because this terrible animal has connections with all the main parts of the body, as is evident in anatomy.
>
> I call it animal, following the doctrine of both the Academics and the Peripatetitcs. For if automotion is a certain indicator of an

*[*Branler* is also slang for masturbation.—Trans.]

animate being, as Aristotle writes, and if all that by itself moves itself is called animal, then Palot rightly calls it animal, recognizing in it independent motions of suffocation, precipitation, corrugation, and indignation, indeed so violent that by them very often is ravished from woman every other sense and movement, as if it were a lipothymy, a swoon, epilepsy, apoplexy, and a real semblance of death.[5]

Shameful Part

Hysteria was named, designated, and renamed a thousand times (Janet, who no longer believed in uterine hysteria, still found it "difficult to give up" this most Aristotelian word.)[6] A brief extract from the catalog of names:

> In France: hysteria, hysterisis, hystericism, hysteralgia, hysterical spasm, hysterical passion, spasms, nerve aches, nerve attacks, vapors, ammarry, women's asthma, melancholia of virgins and widows, uterine suffocation, womb suffocation [*suffocation de matrice*]*—Jordan called it: "suffocation of the mother" [*suffocation de la mère*]—uterine epilepsy, uterine strangulation, uterine vapors, uterine neurosis, metro-nervy, metric neurosis, metralgia, ovaralgia, utero-cephalitis, spasmodic encephalitis, etc.[7]

But what Hysteria *means,* what this word was meant to say, this so oft-used word—its meaning was often *silenced,* even during a century in which positively everything was decreed to be speakable. Perhaps the illustrious figure of Rougon, contemporary of Charcot, will serve as an example:

> Rougon, in turn, inveighed against books. In particular, he was outraged by a novel that had recently appeared, a work of the most depraved imagination, affecting a concern for exact truth, dragging the reader through the excesses of a hysterical woman. The word "hysteria" seemed to please him, for he repeated it three times. When Clorinde asked him its meaning, he refused to provide it, overcome by a great modesty.
>
> "Everything can be said," he continued. "Only, there is a way of saying everything."[8]

The *bête noire* was a secret and at the same time an excess. The *bête noire* was a dirty trick of feminine desire, its most shameful part. Paraclesus called hysteria *chorea lasciva*—the dance or choreography of lechery. Hysteria almost never stopped calling the feminine *guilty.*

*[*Matrice*, meaning womb (and matrix), is derived from a Latin root signifying mother.— Trans.]

The Untreatable

Treating a hysteric?—Putting the animal-womb back in its proper place, meaning the lowest point. Ambroise Paré, to take but one example, informs us that "the womb, out of a natural instinct and a peculiar faculty, recoils from things that stink and enjoys the fragrant."[9] The therapy deduced from this was to have the women inhale the most horrid smells through their nose: bitumen, sulfur and petroleum oils, woodcock feathers, hairs of men and billy goats, nails, animal horns, gunpowder, old sheets—all burned! This forces the womb to "descend" (repulsion, toward the bottom). Inversely, it was advised to "maintain the neck of the womb open with a spring" and then, with the help of an instrument made specially for the purpose, fumigate the vagina with sweet smells (attraction, toward the bottom). Incidentally, they would cry loudly in the patient's ears during the operation (so she didn't play the trick of fainting on them), and would "pull the hair on her temples and the back of her neck, or rather the hair on her shameful parts, so that she not only remains awake, but so that the pain experienced on the bottom forces the vapor that is rising up and inducing the suffocation to be withdrawn and pulled back down by revulsion."[10] Subtle mechanics—and this is only one example.

In the nineteenth century, Briquet, along with everyone else, was groping: stimulants, antiphlogistics, narcotics, revulsives, and so on.[11] He even thought it necessary to experiment with arsenic as the ideal medication of hysteria.[12] But Dubois's treatise opened its "therapeutic" chapter with this observation, disguised as an adage: "*In therapeiâ maximē claudicamus.*"[13] Was hysteria incurable, in fact?

Yet the theory is quite simple: hysteria could perhaps be eradicated by eradicating or scouring away [*récurer*] its cause. Briquet also cites an adage, a real one, this time: "*Sublata causa, tollitur effectus.*"[14] The *cure* would be the ideal means to excise the morbid causes. It would be the true intermediary of the *panacea*, the aim of which is not only to eliminate the illness entirely, but to eliminate illness entirely.

One might ask why the treatments of hysteria, because of pharmaceutical and surgical failures, came to be a therapy of *putting under observation*.

Malum sine materia

The problem was that no one could truly discover where the cause of hysteria was embedded. No one even ever truly discovered where hysteria itself was embedded.

There were the convulsions, of course; overheated minds, reciprocally pushing each other along, and the "nervous woman" would explode, jerked in all directions, in spasms, movements modestly called "irregular." There were the vapors, of course; hysteria was distinguished by its "bilious-melancholic temperament," plus something not quite right in the womb— but what? There were classifications, situating hysteria in the ranks of hysterias: the "venomous" woman, the "chlorotic," the "menorrhagic," the "feverish," the "visceral," the "libidinosa."[15]

All the efforts of pathological anatomy in the nineteenth century were not only directed toward configuring the illness through a distribution of symptoms, but also and above all to subsuming this configuration: to *localizing the essence of the ill*. The sign of the illness became less the symptom than the lesion.

This is how an illness came to require definition by its *seat*. But "unfortunately, from this point of view, hysteria is still part of the domain of neuroses, that is, the domain of these maladies *sine materia* or at least the 'matter' of which is yet to be uncovered. Autopsies of hysterics who succumbed directly to attacks of spasms or anorexia, or to intercurrent affections, revealed nothing palpable or, in a word, nothing organic apart from the lesions attributable to additional illnesses."[16] Charcot himself admitted that hysteria and its related illnesses, epilepsy and chorea, "offer themselves to us like so many sphinxes who defy the most penetrating anatomy."[17] Not only does hysteria seem able to escape the legislation of the anatomico-clinical method and of the said "doctrine of localizations" but also, explains Charcot, hysteria intervenes in them "dangerously," as a source of errors.[18]

A source of errors, yes. Because hysteria, essentially, is a great paradoxical blow dealt to medical intelligibility. It is not a problem of "seat" but of trajectory and multiple location; not a problem of "cause" but of dispersed quasi-causes, whose effectiveness was the effectiveness of the paradox itself: the genesis in the act, always in the act, of contradiction.

But medical intelligibility renounced neither "cause" nor "seat." Thus it did not fear to confront paradoxes. I can only give a sketch of the historical movement of this crazed quest and denial.

Paradoxes of Cause

If you grant for an instant that the uterus is not an animal, something that moves on its own, then you must go elsewhere to find something to *incriminate*. But where? Isn't hysteria madness? If so, is it a disorder of *sensation* or a disorder of the *soul*? Or of the *humors*? Or a malady of *passion*?—Ah

yes, perhaps. Passion (one of the six "unnatural" things, according to the Galenist tradition) provided something like a providential "contact surface" between body and soul;[19] perhaps, but it wasn't quite enough. The concept of *irritation* also had to mediate: "the faculty of tissue to move upon contact with a foreign body."[20] Thus, "hysterical women are initially tormented by a feeling of heat and acridity in their sexual organs. They often have the whites (drips, flows), their menses are often irregular, the neck of the uterus burns, and if the uterus is lifted with the finger, the feeling of breathlessness is reborn, like a lump rising in the throat."[21] Acridity of the organs!

Then they got tangled up in all too subtle distinctions between causes that are far or nigh, specific or con-, per-, intercurrent, predisposing or determining, physical or psychic or moral, or imaginary or . . .

Then Briquet admitted that this ragbag of causes was a little confusing.[22] After that he didn't have much more to say, but still alleged that if the hysteric "disposition" is not strictly "genital," it is no less the effect of a "special mode of sensibility"—feminine sensibility, quite simply.[23] Femininity: a causal ragbag, *circulus vitiosus.*

Then came Charcot. The causes were reorganized into *"agents provocateurs"* and "predisposing factors," with primacy granted, of course, to heredity. But even then, it was a great etiological ragbag: "moral impressions," "fears," "the marvelous," "exaggerated religious practices," "epidemics," "imitation," "untimely experience of hypnotization," "traumatism" or "nervous shocks," "earthquakes" and "lightning," "typhoid fever," "pneumonia," "scarlet fever," "the flu," "articular rheumatism," "diabetes," "impaludism," "syphilis"—of course syphilis—"chlorosis," "overwork," "hemorrhages," "masturbation," "venereal excesses"; but also "continence," "intoxication," "tobacco," "camphor," certain "professions," certain "races," "Israelites,"[24] and so on.

A chaotic and fantastic ragbag of causes, again. A dissemination of causality: *circulus vitiosus.* But is this not the very same causality, specific and strategic, as it were, of hysterical temporality?

Paradoxes of the Seat

If only something could have been found, somewhere. But nothing was; because hysterics are everything at once—a clinical paradox—suffering from the most serious symptoms, and yet intact, unharmed by concomitant lesions. Hysteralgia, ovarialgia—look in the uterus, look in the ovaries, there's nothing to be found; vapors, delirium—look in the skull: nothing.

The paradox of the seat of hysteria tells hysteria's whole history. It is the history of a great debate, as vain as it was ferocious: the *uterine explorers* against *encephalic inquisitors,* to put it briefly (the most refined were the theoreticians of the commerce between a woman's head and her sex: the brain played the role of a relay, a visceral "distributor"). The "uterine theories," as old as the hills, had a hard life—I mean, they endured. In 1846, Landouzy again defined hysteria as a "neurosis of the woman's generative apparatus." "We remain convinced," he enjoins, "that the genital apparatus is often the cause and always the seat of hysteria."[25]

("Neurosis of the woman's generative apparatus"?—or the neurosis of an immense discursive apparatus, which generated "woman" as a specific image, compatible with hysteria?)

No, answers Briquet a few years later, "in my opinion, hysteria is a neurosis of the encephalon, the apparent phenomena of which consist primarily in perturbations of the vital acts contributing to the manifestation of affective sensations and passions."[26] A herald of the second tradition (dating back to Sydenham and Baglivi, among others), Briquet maintains that hysteria is an *illness of impression,* of impressionability: "In the encephalo-rachidian axis there is a division of the nervous system devoted to receiving affective impressions, that is, the action of causes coming from the outside or from the inner nature of organs, which produce pleasure or pain that is as physical as it is psychic. . . . One might consider hysteria to be a product of the suffering of the portion of the encephalon destined to receive affective impressions and sensations."[27]

Moreover, Voisin had "verified" and "opened up," as he said, some hysterics; he saw nothing in the pelvic cavities but thought he saw the seat of hysterical madness in some gray matter[28] (which did not stop him from elsewhere asserting the pure spirituality of the soul, and its immortality).[29]

Nota bene, for it bears repeating: "The woman, in order to fulfill her providential mission, must present this susceptibility to a much greater degree than the man."[30] Even as its relation to the uterus is called into question, hysteria remains a feminine prerogative, and Briquet accomplished the feat of making it simultaneously a woman's illness and a desexualized illness: a sentimental illness.[31]

Yet hysteria is not only a sentimental event. In it, affects become bodily disasters, enigmatic and violent spatiality. If the uterus and encephalon are invoked, it is because they were also the crucible of fantasies on which medical ignorance and disarray drew. When the cause cannot be grasped, it is because of the uterus, or else some central obscurity in the back of the head. Yes, hysteria was a feat and drama of depth; its ins and outs were thus sought respectively in the head (gray matter, in infinite

circumvolution, behind the traits of the face) and deep in the sex, which is the other of the face and therefore connivent.

But hysteria persistently defied any concept of a seat, any notion of monomania (local madness). Its extreme visibility retained a secret in its possession, an invisibility and a changeability, the freedom of absolutely untreatable manifestations: an irreducible unpredictability. Hysteria obliged paradoxical thinking, here the integral porosity of the body, there a dynamic of vapors and sympathies, elsewhere the obscure course of "nervousness." And the course appropriate to medical thought became more and more obscure.

Paradox of Spectacular Evidence

Thus, "it is impossible to give a precise nosological definition of hysteria, as this neurosis has neither known lesions nor constant and pathogno-monic symptoms."[32] The only practicable definition would be a "clinical definition of hysteria based on the characteristics common to the accidents of the neurosis."[33] Evidence returns to the obscure trajectory whose evidence is a symptom. Symptoms return to the obscurity of lesions. Hysteria compelled medicine, as it were, to *dwell* [*s'arrêter*] *on its own evidence.* And dwelling means not location but stasis, suspense, dialectic of desire, seemingly fomented by hysteria itself. This dwelling [*arrêt*] is the physician's ever-suspended craving to penetrate more deeply.

And if this suspense describes a logical time, its nature is a repeated *without.** Hysterical ataxia, as they said in the nineteenth century (*ataxia:* disorder, confusion, deserting one's post or ranks); it is a spectacular conflagration of all paradoxes in a single gesture, cry, symptom, laugh, gaze. The return of evidence [*retour d'évidence*], like a backfire [*retour de flammes*]. It is a fire of paradoxes, paradoxes of all kinds: hysterics are in fact (and always to an extreme) hot and cold, moist and dry, inert and convulsive, faint and full of life, wearied and merry, fluid and heavy, stagnant and vibratory, fermented and acidic, and so on. The hysterical body is an affront to Cuvier—an affront to any submission of an organ to a function: "The hysteric always seems to exist outside the rule: sometimes her organs function in an exaggerated fashion, sometimes to the contrary their functions slow to the point that they occasionally appear to have ceased altogether."[34] The body of the hysteric, finally, exists in an always stupefying temporality, composed of intermissions, "propagations," influences, acute

*[In English in the original text.—Trans.]

crises; it resists all attempted treatment for years, and then one day, without anyone knowing why, the hysteric recovers all by herself.[35]

The body of the hysteric is even able to offer a total spectacle of all illnesses at once. And, contradictorily, it matters little to her. And there is still no lesion. This is the paradox of spectacular evidence: hysteria offers all symptoms, an extraordinary bounty of symptoms—but these symptoms issue from *nothing* (they have no organic basis).

Suspicions: The Symptom as Lie

Hysteria thus bespeaks a truly unfathomable and secret force, still inviolate after centuries of opinionated inquiry. Unless it bespeaks a farce, or a pure surface phenomenon—What's that? The hysterical symptom is nothing but a lie [*mensonge*]? (*mensonge:* a word that, until the seventeenth century, was feminine in French, perhaps eventually changing, according to etymologists, under the influence of the masculine word for dream, *le songe*).

A lie! That a madman has lost his sense of truth, and can't grasp the laws of the world or even of his own essence, this is conceivable—*but for a woman to make her own body lie.* How can medicine continue to be practiced honestly if bodies themselves start to lie? Everyone lies, but normally the body betrays and "admits" the truth, on the tip of a nose, in the flush of a cheek. So how is this possible, a betrayal given body and symptom beyond any intentionality conceived by a subject? How can a fever be a lie?

And here again is the paradox of spectacular evidence, at its most crucial point: symptomatic visibility (its "presentation") can merely be a representation, mask or *fictum,* the masquerade of a "true" organic symptom. A symptom can occur but be false: pseudo-hemiplegia, pseudo-hypertrophy, and so on. A hysteric can spontaneously suffer from "stigmata," cutaneous gangrene for example, and nothing will prevent her from dying from it. But Charcot says: be wary, it was pseudo-gangrene, the "double" of the organic complaint "which we must learn how to unmask."[36] Perhaps her death also a ringer, a double for her "true" death.

"That doesn't stop it from existing"

There is a famous anecdote about a young soul who, one day, made a fastidious objection to the concomitance of hemianesthesia and hemianopsia in hysteria. The Master retorted: "The theory is good, *but that doesn't stop it from existing.*" Later Freud, for it was he, translated Charcot's *Leçons*

du Mardi, and in telling the anecdote he added this note: "If one only knew *what* exists!"[37]

Freud never stopped asking himself this question (the existence of this [*ça*] or that*): a crucial question where hysteria is concerned, for it formulates the paradox of evidence. Freud said that the most striking characteristic of hysteria is that it is governed by "active yet unconscious" ideas,[38] and that it is, in fact, the efficiency of a "dramatic reproduction": facticity, the paradox of desire in representation, in which the hysteric *puts on view,* and even acts out, exactly that which *she cannot accomplish.*

Charcot did not pose the problem in these terms. He demanded description, at the risk of clouding the entity of the illness, or even making it disappear entirely; he did not separate what is accomplished from what is put on view. He was a perfect clinician. And, after all, his celebrated remark tells me next to nothing, except that he strongly desired that hysteria exist, for his eyes.

Extirpating a Form, Nevertheless

For this purpose, it was essential that Charcot, faced with a hysteric, not pose the existential question "Who is the being—there?" or any such question. All paradoxes and *ficta* had to be denied (meaning that they were still preserved in the back of his mind, like something malicious, a vigilant spell). The crucial thing was to postulate, "pose in fact," as they say in the so-called exact sciences.

"It's not something out of a novel: *hysteria has its laws.*" And hysteria submits to them! I can assure you that it has "the regularity of a mechanism."[39]

The remarkable thing is that Charcot almost kept his word: he provided a form and a *tableau* of hysteria. He began with a decisive step, the diagnostic formulation of the difference between hysteria and epilepsy, which Landouzy had previously attempted.[40] He said that epileptics had "fits" and hysterics had "attacks." He compared the respective gravity of the symptoms. He declared that epilepsy was more "true" (because more "severe") than hysteria. And he even had a figurative model: *hysteria imitates epilepsy,* as he could see every day in his service at the Salpêtrière.

Then, like all the great physicians, he forged his own nosological concept, *hystero-epilepsy,* or *hysteria major,* obliging him to set up an assemblage of "mixed crises" and "separated crises"[41]—what really belongs

*[The French term *ça* commonly signifies "this," but is also used to translate the Freudian *Es,* rendered in English as the "id."—Trans.]

to which complaint in which complex symptom, and so on. He wanted to forge a concept of a hysteria that could not lie, a major hysteria.

This assemblage was required by a diagnosis that was always complicated (for example: "To summarize, it is question of a sciatic neuritis provoked by the use of the sewing machine . . . then generalized to the whole member . . . with hysteria as a complication"),[42] and it required a sort of theoretical compromise in regard to the dialectic of nosological forms. Charcot maintained, on the one hand, the "doctrine of the fixity of morbid species,"[43] and on the other hand, he recognized "nosological complexus" that "do not, in reality, represent hybrid forms, variable and unstable products of a mix or an intimate fusion, but result from an association or juxtaposition in which each component conserves its autonomy."[44] It was absolutely necessary to isolate hysteria, because it had a tendency to contaminate (and not simply imitate) all nosological landmarks. In this way, hysteria "complicates" epilepsy, but, says Charcot, it is imperative that the two do not "fuse."[45]

Isolating hysteria also signified isolating it in theory, from the point of view of pathological anatomy and physiology. Thus, despite the fact that hysteria was "*sine materia,*" Charcot fomented a concept of the hysterical lesion: a lesion of the cortex and not the center, a "dynamic lesion" he said, physiological and not anatomical, "elusive, changeable, always prone to disappear."[46]

Was it a pure effect of the trace, then?—I should say not. The hint of what I would call the crazed nature of this theoretical explanation of hysteria is clearly marked by the persistence of the *anatomo-clinical ideal* throughout it all. As if it were only the compromise and expectation of what is *nevertheless* the "matter" of hysteria: "It is crucial to recognize that hysteria has its own laws, its own determinism, precisely like a nervous complaint with a material lesion. Its anatomical lesion *still* escapes our means of investigation, but it is undeniably translated for the attentive observer. . . ."[47] With this, Charcot opened the way for a space of neurological intelligibility, laying the groundwork for modern psycho-physiology.[48] I claim that he *clarified hysteria* in the sense that he anticipated a concept through the calculation and strategy of preexisting views, just the opposite of a "virgin comprehension." An invention.

The Passage of a Silhouette

How could I omit, in this whole business, the discreet passage of a young, sad student? He was single, foreign, chaste, and very poor. He stayed in Paris for nineteen weeks, from October 13, 1885 until February 28, 1886, splitting his time between the Louvre (the *Venus de Milo,* the *Mona Lisa*),

the theater (Sarah Bernhardt), and the Salpêtrière (hysterical madwomen). For a long time he had dreamed of Paris.

The whole time, he could not stop thinking that he was a fool. He was constantly devoured by absurd remorse: he saw himself as lazy, resigned, and incapable. He had resigned himself to perpetual migraines. He made "slips."[49] One day, he realized he had become depressed in Paris[50] (at the time, depression was thought of as veritable degeneration, said to be incurable).

But what had attracted him to Paris was the "great name of Charcot."[51] In Vienna he had done a nice job on some pretty, colored brain sections, and he wanted to show them to the "boss," as he said. He also hoped to borrow a few children's skulls and examine them up close. But at the Salpêtrière, it was the madwomen who were center stage.

They decided, instead, to give him the body of Joséphine Delet, who had died of "cerebral atrophy" and "partial epilepsy," photographed not long before by Régnard for the *Iconographie photographique* (fig. 32).[52]

Figure 32
Régnard, photograph of "Joséphine Delet" in 1878 (autopsied by Freud at the Salpêtrière in 1886), *Iconographie,* vol. II.

So he did his necropsies. He attended the Tuesday lectures, a witness to obscenities, contortions, hysterical wails, and worse yet.

He wrote: "Charcot, who is one of the greatest of physicians and a man whose common sense borders on genius, is simply wrecking all my aims and opinions."[53] He imagined Charcot kissing him on the forehead.[54] But he managed only to obtain an inscribed photograph (fig. 33). He was invited to Charcot's home three times—"a little cocaine to unleash my tongue"[55] he said—and he would haunt, happy and unhappy,

Figure 33
Photographic portrait of Charcot, inscribed to Freud
and presented to him in 1886.

the socialite receptions on the Boulevard Saint-Germain. He asked his fiancée to embroider two or three "votive panels" in Charcot's honor.[56] Later, he named his son Jean-Martin, after Charcot. He claimed to be filled with joy at Charcot's side.

However, it didn't go as well as all that. He kept hesitating: should he stay in or leave Paris? He was suspicious of everything including his bedspread, which he took in for chemical analysis one day to be sure that it didn't contain arsenic—it was yellow.[57] He returned to Vienna addicted to cocaine and depressed.

Then he translated Charcot, already betraying him (modifying titles and adding notes).[58] He even began critiquing Charcot's conceptions,[59] and then he wrote him a nice obituary.[60]

And then he reopened the space that Charcot had spent so many years filling in. Charcot had forced hysteria to subjugate itself to the domain of neuropathology. Because Freud listened, hysteria returned to rattle the epistemic bases of neuropathology.[61] But Freud had had to pass through the great theater of hysteria at the Salpêtrière before beginning to listen, and before inventing psychoanalysis. The spectacle and its pain were necessary; first he had to *get an eyeful*.

Women's Traits

An eyeful of what?—That's precisely my question. Of women's bodies, in all their states.

Of course, "hysteria in the male is not as rare as is thought,"[62] and Charcot's "polyclinics" were filled with hysterical men, like the famous case of a man by the name of Pin. This was Charcot's great act of "courage," his "discovery"[63] of masculine hysteria.

It just so happens that the *Iconographie photographique de la Salpêtrière*, between 1875 and 1880, does not offer a single portrait of a man. Men did not enter the Salpêtrière as patients until June 21, 1881, when the "outpatient clinic was opened."[64] But it was not until 1888 that one could contemplate the photographed traits of a hysterical man.[65]

Even so, a tactic of sexual difference is implicated. Raising it to the level of a "temperament" changed nothing—quite to the contrary: hysteria as "feminine temperament turned into neurosis," as the dictionaries of 1889 still put it,[66] allowed the nomadic sexuality of "effeminates" of all kinds to be circumscribed all the better. Moreover, the instituted if not institutionalized hysteria of the woman's body persisted and even refabricated itself in the nineteenth century; the asylum, for example, redefined itself as the medicalized inversion of the brothel (for a simple step sepa-

rates the hysteric from the prostitute, that of scaling the walls of the Salpêtrière, and ending up on the street). In short, all the procedures of the generalized invention of the sexuality of an époque[67] still understood hysteria as a *holding of femininity.*

One must thus register the fact that these photographs of the *Iconographie photographique de la Salpêtrière* are, first and foremost, drawing traits, drawing traits of women.

Moreover the word "star," in French *vedette,* is used only in the feminine. Diderot wrote that "when one writes women, one must dip one's pen in a rainbow and throw the dust from a butterfly's wings on one's line."[68] But where did Bourneville dip his pen, and Régnard his little birdie?

And, first and foremost, how did the pin come to be between the butterfly's wings?

II

Charming Augustine

Augustine said:

What do you know about medicine? . . . I don't want to feel you near me! . . . I won't uncross my legs! . . . Oh! You really did hurt me. . . . no, you won't manage! . . . Help! . . . Camel! Lout! Good-for-nothing! . . . Pardon me! Pardon me, Monsieur! Leave me alone. . . . It's impossible! . . . You don't want to any more? Again! . . . Get rid of that snake you have in your pants! . . . You wanted me to sin before you, but you had already sinned. . . .

(She opens her mouth, and introduces her hand as if to pull something out.) I confide secrets in you. . . . Words fade, writing remains. . . . Listen, all that is turnstiles, that aren't worth even one of them. . . . That means nothing at all. . . . The thing is fixed, in a word . . . I think you're trying to worm it out of me. . . . Insist as you will, but I say no. . . . I won't uncross my legs. . . . It's impossible. . . . I don't have the time. . . . I don't have the time. . . .

(IPS, II:146–164)

5

Auras

Quasi-Face

A word, in the corner, in the corner of the image: let me warn you. Or a question, rather. The lady you see here—did her half-smile heal the ill cast by her gaze?[1] What ill? But let us leave that question for the moment, and have a look (fig. 34). Here, gentlemen, is Augustine, your favorite case.[2] Are you prepared for your curiosity, sacrilegious and tattling, as Baudelaire wrote, to be satisfied? For here, by grace of Photography, is Augustine, as if in person. And here is the portrait of what is called her "normal" and "actual state."

But, mind you, the perfect photographic gesture would surely be to surprise "its subject" Augustine, and even to carry itself out unbeknownst to her, wouldn't it? Here, this isn't the case. Here, "our subject" is posing, with a motionless bust, a side-long glance, a stiff arm. *A body taking on a pose.*

On the other hand, you see that Augustine isn't quite facing forward—a mere detail of course. But doesn't the slight tilt of her "making-face," as they called *presentation* in old French, suggest that the "matter of the portrait" consists solely of a "quasi-face"?[3] And what curiosity could possibly be satisfied by a face that is so very neutral? What subjective drama could be borne by such neutrality? Indeed, such neutrality *deprives* first and foremost. It deprives the image of something that would be its meaning, a history, a drama that the image itself is nonetheless supposed to figure. In this image, plate 14 of the *Iconographie photographique de la Salpêtrière,* Augustine looks more or less like anyone, which is why, at first, her quasi-face is all that reaches us.

This neutrality is also why the *Iconographie* is arrayed as a *series* of images, itself riveted to another sequence that grounds it in a complete narration, the case's *script.* This script supplements and explicates the images, providing a commentary or legend for that which, in the end, is supposed to be its essential enigmatic tenor; the images were, after all, meant merely to illustrate, clarify, and prove the truth of the clinical discourse. A little

Figure 34
Régnard, photograph of Augustine (detail; cf. fig. 44),
Iconographie, vol. II.

vicious circle of knowledge, in which each authority—legend and image—is there to salvage the other, which is always at risk. At risk of what? Of fiction?

The fact remains that the commentary here, on this particular photograph, develops something quite different than an explanation of the surface of an image. Perhaps to supplement the face's neutrality, it instead tells the story of a character. Augustine "is a blond, tall and broad for her age, and in all respects gives the impression of a pubescent girl. She is active, intelligent, affectionate and impressionable, but also capricious, and quite enjoys attracting attention. She is a coquette, taking great care in her toilette and in arranging her thick hair now one way, now another. Ribbons, especially brightly colored, are her bliss" (PL. XIV).[4]

Don't be surprised if they go right to probing under her skirts, beyond the portrait, for this too concerns hysteria. Augustine "is tall, well-developed (neck a bit thick, ample breasts, underarms and pubis covered with hair), with a determined tone and bearing, temperamental, noisy. No longer behaving in the least like a child, she looks almost like a full-grown woman, and yet she has never menstruated. She was admitted for paralysis of sensation in the right arm and attacks of severe hysteria, preceded by pains in the lower right abdomen."[5]

She was fifteen and a half.

Such is the "presentation" of Augustine. In the course of the pages and plates, in the course of the observations, scripts, measurements and records, we are guaranteed enlightenment on the most intimate aspect of her story and her ill. The *Iconographie* exists for this reason alone. I nonetheless maintain that, for us, Augustine will always remain only *quasi:* quasi-face, quasi-body, quasi-story. And I would say that *even her name remains quasi.* Scientists as seasoned as Bourneville and Régnard, so anxious to comply with clinical protocol, did not succeed in giving her one name, continually hesitating between "Augustine," "Louise," "X," "L. . . ," "G. . . ."[6]

And I, too, will have written only about a quasi-Augustine.

Shadows and Slowness

Her face, moreover, is always just emerging from obscurity. One can hardly see, as Bourneville assures us, that she was blond.

To my mind, the dominant problem and quality of all these images is their slowness. This is owing first of all to the problem of photographic *sensitization,* as it is called. Régnard was working with wet collodion plates:

slow to prepare, slow to exploit, slow to expose, slow to develop. And the images always seemed darkened (as soon as it became possible, around the time of *Nouvelle Iconographie,* the wet collodion was replaced with silver gelatino-bromide coating). Régnard's photographs, providing both account and image of hysteria, were therefore not exactly instantaneous predations of the visible. They were almost like ill-starred durations, desire for the instantaneous nearly run aground.

I cannot regard the inumbration of these portraits as a simple failure of light. I see it rather as the procrastination of photographic revelation, thus the temporal retreat of light, suspending the manifested in something that remains nonetheless a manifestation par excellence. And this retreat, the suspense of darkness, suggests something like a *being-there,* like what Heidegger says about the dawn of an "ecstatic realm of the revealing and concealing of Being."[7]

But how can the kind of efficacy these images secrete be described, everything about them that "impresses" us as the underside of their figurative organization? I repeat: "The shadow is not an effect of light, nor is it a disquieting double. It is, as in the theater, the veritable interior *support* of every scene."[8] I repeat: these images come from a time when one still had to *wait for light.*

Expose,* Specter, Laterality

The quality of the photograph's "graph" was all the more magical on these slow plates. But who was waiting? Who, in truth, was waiting? Régnard? He was mostly bustling about, enjoying the time of seeing, framing, focusing, preparing, and positioning the body. During the long seconds or even minutes of the exposure he was waiting, of course, for "it to take," for the light to write.

Augustine was waiting too, but as an adolescent, a hysteric to boot, and the image's subject, she was not qualified to know what she was waiting for. To my mind, she was truly in the expectative. Something like visibility was being woven around her body. If she cast a glance (as in plate 14 [see fig. 34]), it was surely not truly returned—not by Régnard who was camouflaged, buried under the photographer's black tent. I suppose that, if only because of its enigmatic purpose, the exposure meant anxiety for her.

*[The French *pose* signifies both the "pose" of the model and photographic "exposure."—Trans.]

Note that Nadar did not hesitate to characterize the photographic pose as a "brain disease" and that he boldly described the "waves of fear" of all his models. With a wink at Balzac, he called bodies, insofar as they are photographed, "specters."[9]

Posing is like waiting for a moment, the shot, of which one knows nothing except that it must be the "right" moment. It's like a simple yet obscure emergency, the emergency of having to resemble oneself at a specific moment that will occur, which always occurs almost-now, always quite soon, always at risk of coming too early or too late. Having to resemble oneself soon becomes the requisitioning of a body ready, and thus readied, for the image. Posing consists of inventing a spare body for oneself, even against the will, inventing a proper site for the future remains of resemblance. Posing is, in this sense, a "microversion of death." While I am posing, indeed, "I am truly becoming a specter;"[10] as the photographed subject, I myself am making a ghostly return.

Nadar, moreover, ultimately elaborated a kind of spectral theory of photographed bodies. Each one of them, he writes, "was made up of a series of ghostly images superimposed in layers to infinity, wrapped in infinitesimal films."[11]

Let me mention in passing that, from the outset, Bourneville took the precaution of presenting Augustine's portrait as the afterlife of seven ghosts, seven dead people—a father, six brothers and sisters.[12] I would characterize the temporal haunting of the pose rather as a kind of laterality in the image. One sign of this is the fact that Augustine's body could never be resolved to present itself straight on, except under hypnosis. Another sign is her hand at her temple—the pensive or, here, strained temporality of the portrait.

But it remains difficult to fathom this temporal haunting. This image in my hands testifies to the moment of exposure, and, more crucially, to the being-there of the pose. As photography, it constrains me to an affect, to another affect, that is, no longer relative to the mere fiction of a body, nor to the thirty centimeters that separate my eye from the surface of the proof, of this proof here in my hands. Rather, it is relative to someone else's body, a body authenticated and thus *perhaps* authentic. A wholly other brilliance thus passes through the word *proof* [*épreuve*]. The bodies of others haunt, and not by an orthogonal encounter of surfaces. They constitute a sort of multifarious imaginary activity, as if they were lateralizing vision itself. I mean, simply, that they infect vision as they affect it, perhaps by flesh, perhaps by death. And the "flesh" in the image would then be like a lateral investment, putting us at great risk of imaginary obnubliation.

Aura: Risk of Distance

The risk of *fascination*. Quasi-face, neutrality, semblance, the dissolution of what is definite in the image: all this is precisely what is fascinating because there is, simultaneously, an abiding contact, the inevitable authenticity of Resembling. It fascinates us by demonstrating that the face is, above all, intimate and that this intimacy is always in the act of retrenchment. The contact is precisely the experience of moving toward contact, that is to say, the experience of a distance. The photographed face is relentlessly suspended between these alternatives. The distance is always exorbitant, the encounter always *imminent*. We are always summoned there at intervals of a time that is itself woven from manifestation and erasure, from the near and the far, because distance is at its very heart. This is why resemblance has nothing to resemble, even if, in all photography, Resembling always transmits itself and raises questions.

I speak of a danger that photography had the means of implementing as a manipulation of time, in an exemplary fashion. And as a technique of the reproducibility of such manipulation, photography could also annihilate this danger. Walter Benjamin's name for it was *aura*, something that weaves itself into the image. The aura, he writes, is "a strange weave of space and time: the unique semblance or appearance of distance, however close it may be."[13] The aura is how we wait before visible things "until the moment or the hour becomes part of their appearance."[14]

Benjamin adds: "In photography, exhibition value begins to displace cult value all along the line. But cult value does not give way without resistance. It retires into an ultimate retrenchment: the human countenance. It is no accident that the portrait was the focal point of early photography. The cult of remembrance of loved ones, absent or dead, offers a last refuge for the cult value of the picture. For the last time the aura emanates from the early photographs in the fleeting expression of a human face. This is what constitutes their melancholy, incomparable beauty."[15] And Benjamin speaks of images enveloped in silence, bearers of "ominous distance,"[16] but also, before a portrait of a woman, in fact, he is arrested by "something that cannot be silenced, that fills you with an unruly desire to know what her name was, the woman who was alive there, who even now is still real and will never consent to be wholly absorbed in 'art.'"[17] And this is at the very heart of my own question.

The aura would thus name the way time burns, sounds, and dumbfounds the image. To our risk and peril, it summons us to what Benjamin calls an "optical unconscious":[18] the punctum, *punctum caecum,* the blind spot of contact and distance in the visible.

Contacts of Distance

But in the nineteenth century, *aura* also designated one of photography's technical problems, and not the least of them: a problem that fundamentally, or rather, obliquely, concerns precisely what Benjamin wanted to address. This was the problem of aureoles and "veils": all these luminous or paraluminous phenomena that would accidentally form halos around certain photographed subjects, for some unknown reason.[19] Was this a problem of the overarrival of distance in the image? Sometimes they thought so, and sought reasons for this excess—"why does the distant emerge too much in photography?"[20] they would ask themselves.

This was also the problem of photographic spectrality, a problem of the "weave" and of revelation beyond the veil; that is, the magical character, already diabolical and blasphemous,[21] of photography. Finally, it is the problem of *contact at a distance*, the givens of which photography overturned, since in photography touches or marks of light are no longer vain words. Let me illustrate this by dwelling for a moment on the work of Dr. Hippolyte Baraduc. For his oeuvre, quite singular and quite restricted in a sense, strikes me as exemplary—but madly exemplary—of the movement I am questioning in regard to the *Iconographie photographique de la Salpêtrière:* the discreet but astonishing passage to the limit, in which medical practices relating to hysteria become figurative invention, thanks to that diabolical instrument of knowledge, the camera.

With Baraduc, there was something more than invention: delirium. He was, nonetheless, a very serious "specialist," as they say, on "nervous illness." He was interested above all in what Charcot called suggestion, imitation, or even a psychic epidemic, in the context of hysteria. But Baraduc called it *contact*—and that says everything.

This passion for contact can be illustrated instrumentally by the perfection of an intravaginal method of ovarian compression (introducing the index and middle finger into the hysterical woman's vagina during the attack, to "grasp the ovary," he said, and put it back in place, like Ambroise Paré, thus stopping the "painful state").[22] Still with his sights on a therapy for hysteria, he began recommending more and more subtle "contacts" such as electricity and magnetism, energy from storms, hypnosis, and auto-suggestion, as well as what he baptized "electro-suasion," a mix of electrotherapy and hypnotism.[23]

On this basis he cooked up some "cerebral" or "luminous static showers," little mechanized panaceas for brain illnesses.[24] Was he a mad scientist, making bachelor machines?—No, he was working in a direction nearly parallel to the one Charcot had taken but a few years earlier.

Moreover, he established quite cordial if not professional relations with the most eminent members of the so-called School of the Salpêtrière, such as Charles Féré.

Why was Baraduc interested in hysteria?—Because, and in this sense he adopts Briquet's definition, hysteria is an *illness of contact, an illness of impression.*[25]

Veil, Revelation

Children, no less than nervous women, are "impressionable" beings. One day Baraduc took a photograph of his own son. The child was at that very moment holding a dead pheasant in his hands, a pheasant recently killed. Papa does not say a word about who might have put this corpse in his hands; the fact remains that the image *revealed itself as veiled,* if I may say so (fig. 35).

In this image, the psychiatrist Baraduc saw the veil and wind of a state of mind, graphed on the plate by some other light—this is how the aura was revealed to his eyes for the first time. From that day on, Baraduc could not rest so long as the aura was not fully unveiled.

He experimentally distinguished the aura from "electric winds" and other magnetisms prone to leave an impression on the plate.[26] He attempted to describe it according to the form of its trace. He called it a "curved force." He recognized it as the explanation of everything unexplainable—occult influences, mystical visions, nimbuses, "unconscious impressions," and so on.[27] He identified it with Hippocrates' "Enormon," the Glorious Body of the Church, and Newtonian ether. He indiscriminately invoked Aristotle, Descartes, Leibniz, Kant, Mesmer, Maxwell, and Eliphas Lévy. He subsumed it under the category of "movements" and "lights of the soul": movements of the soul, because the soul permits movement without trajectory, thus distance without separation, thus contact at a distance;[28] light of the soul because it is *intrinsic, shadowed, and invisible—but graphable!*[29] (provided that a very sensitive plate is presented to it).

Let us return to the veiled print. It was by no means the effect of the simple "warping" [*voilement*] of visible light. It was *aura,* "veil [*voile*] of life," in which the "spirit involutes its form"[30] (and perhaps it was a strange return, an involution enabled by the specificity of photography's technical mode of existence, thus by the specificity of its possible metaphorical machinations; perhaps it was like an involution of the paradigm of the *vera icona.* Something like the passage to the limit of that which was figuratively invented in Veronique's kerchief, or rather that which was reinvented—by virtue, indeed, of the photographic medium—in the case of

Psychon : OD, force vitale attirée par l'état d'âme
attendrie d'un enfant.

(Sans électricité, avec appareil photographique, sans la main.)

Figure 35
Apparition of the "vital force" (aura) on the photograph of a child,
taken by Dr. Baraduc, *L'Ame humaine* (1896).

the Holy Shroud of Turin: the *revelation of a form imprinted invisibly, and at a distance?* For the trace on the Shroud, far from being the impression of a body, is the contour of its "emanation at a distance," so they say. It could thus "explain" the form of the imprints, and was "proven" by the negative of a photo that Pia obtained with an exposure time of no less than twenty minutes).

Iconography of the Aura

It is far from immaterial that Baraduc settled on the name *Iconography* and, elsewhere, *Radiography,*[31] for the aura's ability to show itself in prints, and for the experimental technique, the synthesis of this ability. Iconography, in fact, was a kind of scientific instrumentalization, according to Baraduc, as were Marey's "graphic methods," for instance. He was aiming to *record* always subtler movements and contacts, which thus constituted not the reverse side of the epistemic myth of total inscribability-describability but rather its realization, its most extreme realization. Moreover, Baraduc presented his work to the most "scholarly" societies, of which he was always a venerable member. He would "submit his discoveries," stating that "today, the photographic plate allows each of us to glimpse concealed forces, thus subjecting the marvelous to an indisputable control by situating it within the natural domain of experimental physics."[32]

His method was indeed based on the purest experimental orthodoxy: the iconographic capturing of the aura, meaning an invisible light, was a regulated and progressive flirtation with the intrinsic nature of light—which is to say, with *darkness.*

What is remarkable, moreover, in this approach, is that its very procedure implicates a strategic modification of *time that reveals,* meaning, first of all, exposure time.

For a start, Baraduc reproduced his "originary" experience, a photographic portrait "affected" by critical time; in order to "obtain once again the vital effluvia" of children, he placed two children in front of the camera and waited. When his little models were fed up, becoming impatient and making a rumpus, click: he "stopped them short in their antics with a sharp word." They instantly froze, and snap, he took a photo. But all of a sudden "a veil was produced that hid them and covered the photo," a veil whose "luminous fabric, like a piece of knitting with stitches and knots" he studied at his leisure[33] (fig. 36; see appendix 11). Aura: a luminous weave of time, the intrinsic light of the affect of a photographed subject.

Visible, extrinsic light quickly became superfluous for Baraduc. After his hysterics and children, he found an abbot, also doubtless impres-

Figure 36
Baraduc, experiment on the "vibration of vital force"
in the portrait of two children, *L'Ame humaine* (1896).

sionable, and leaned his camera over the head of his bed as he slept, in the dark. The "black cloud" he obtained on the print—what a surprise— made him realize that he was confronted with the "aura of a nightmare"[34] (fig. 37). In this way he developed a whole photographic and *auracular* iconography, if I may be allowed the term: an iconography of contempla- tion (white and horizontal), of the will ("sparkling beads" or vertical "lines of force"), and so on.

In the end, Baraduc dispensed with the camera itself. All he had to do was introduce a simple sensitive plate to his model's forehead, in the dark and—oh, Saint Veronica!—the writing of his soul would spontaneously appear: for example, a certain "storm" of the forms of a certain aura, is equivalent to "suppressed anger"[35] (suppressed, of course, because it was *invisible* anger). The "Iconography" could also be mediatized, or rather mediumized, by contact with the hand—"the most noble organ after the brain" and a "mirror of the soul"[36]—touching the plate, grazing it, or simply facing it in the developing bath [*bain révélateur*],* revealing the op- erator's "elevation of the spirit," for example, or any other of his qualities,

*[*Révéler* signifies both "to reveal" and "to develop" in a photographic sense.—Trans.]

Figure 37
Baraduc, photograph (in the dark) of the "aura of a nightmare,"
L'Ame humaine (1896).

even his obsession (fig. 38). His obsession? Baraduc methodically lost himself, indeed, in his obsession with contact at a distance. He was always going further in his search for the trace of always more subtle auras.

Recall Balzac's and Nadar's specters. Baraduc would go to Nadar's to find them. The fifth plate in Baraduc's work, entitled *The Human Soul, its movements, lights and the Iconography of the fluidic invisible*—this fifth plate is signed "Nadar." It presents the "luminous ghost," or "sensitive soul," or "half-ghost" of a certain lady, plunged into hypnotic catalepsy, who managed to exteriorize "her double," her aura or her intrinsic, luminous vapor, and have it pose for a photo at her side in the dark. The few accidents, spots, and "luminous dots" on the print were recognized by our psychiatrist as "hypnogenic points" on the lady's face, while the profile of the "double" was recognizable, as anyone may or may not be able to see for themselves (fig. 39).

Baraduc crossed other boundaries, in his indefinite obsession. He worked on the "Day of the Dead," gratified to see the "signature" of a real ghost developed [*se révéler*].[37]

Figure 38
Baraduc, photograph "without a camera" of the "psychicons" of an
obsession taken "in the dark," *L'Ame humaine* (1896).

Photographic Oracles

Baraduc's body itself finally became hysterical, through contact with the
practice, the mad practice of photography—strangely poetic justice.

The body of the photographer was transfigured, involuted in his own
desire for the image (or the aura, rather: the image made into a "signa-
ture" of time). He requested a photograph of his own features, (by Nadar),
which he flanked with his own "psychicon," the image of his thought
thinking itself, the "thought of my myself" made graphic, an *auracular au-
tograph* (fig. 40; see appendix 12). His hystericized, impressionable cogito
was seeking itself in a specter; a self-portrait of the artist as a ghost.

What obsessed Baraduc, of course, was time. He who had gone so
far in the literality of exposure time as *prae-sens,* that is, as imminence[38]—
imminence developed [*révélée*] on a sensitized plate at the very moment that
the captured visible veils itself—he who called his photographs "provi-
dential signs" or "appeals to something";[39] he was trying to see something
of time, quite simply, trying to recognize time's graphic signature in the

Figure 39

Baraduc, photograph of "hypnogenic points" emitted by the body
of a woman under hypnosis (taken in Nadar's studio),
L'Ame humaine (1896).

defects of visible light. *The Human Soul* [*L'Âme humaine*], his technical
treatise on the photography of auras, culminates with a chapter devoted
to prophesy. There Baraduc defends a "synthesis" of experimental science
with something that would be the ecstasy of time as it approaches the vis-
ible; he defines Photography as a modality of the "Verb," as Prophesy.[40]

And he himself described his quasi-hysterical return to hysteria—
the sort of curve of the lens made him into a spectrum—as a sort of deliri-
ous inversion of his engagement in neuropathological scholarship: as a
psychiatrist, but one infected with such a passion for photography, he in-
sisted on verifying, and thus *seeing and confirming what is seen in delirium:*
hysterical hyperesthesia became his epistemic goal: "The results obtained
are most convincing, and consequently neuropathology must revise its
theory of hallucination, for the hyperesthetized retina can perceive forms
that the Iconography proves to be real."[41]

All this was, of course, repudiated by photographers and psychia-
trists as a dubious (if unwitting) darkroom concoction.[42] But it was far
from marginal to the knowledge or practice of photography, or to the

ÉPREUVE XXVIII

PSYCHICONE.

PORTRAIT PHOTOGRAPHIQUE.

ÂME SPIRITUELLE.
(Dessin.)

FORME OBLIQUE.

Figure 40
Baraduc, Baraduc's photographic portrait
(taken by Nadar the younger) and his own "psychicon."

neuropathology of the time. Scientific teratology is effective in science's own domain.

Aura Hysterica

Of what might Augustine's portrait be an oracle? The relation between the visible and the object for which it is the signature, the "intrinsic light," cannot be compared, here, with the premise of Baraduc's *Iconography*. Here invisibility is not an object to be grasped and convoked, but denied—which is another way of naming its efficiency.

Are you looking for the image's secret? Then take another look at plate 14 (see fig. 44). *Its secret is written beneath it,* in capital letters, its secret is its legend; *HYSTÉRO-ÉPILEPSIE.* This means that Augustine, only fifteen and a half, found herself sequestered in the inferno of the

"Incurables" at the Salpêtrière; it means that she would wake up "in attacks"—spasms, convulsions, losses of consciousness—no less than one thousand two hundred ninety-three times a year, plus three special, so-called epileptiform attacks.[43] This means that her right arm—take another look at it—was only trying to adopt the appropriate pose, since at the time, Augustine was for the most part wholly unable to use or control this arm: "She was admitted," we are informed, "for paralysis of sensation in the right arm" and for contractures or anesthesias affecting all the organs on the right side of her body.[44]

In this sense, the legend and scriptural commentary let a gust of aura slip through, despite themselves (for they were meant to clarify). A hint of aura. They admit it in denying it, that is, preserving the meaning of the word, the word *aura*.

For the word itself was too perfect: I mention a gust because *aura* means wind, breeze, and breath. An aura is air, air blowing across a face or through a body, the air of pathos, the event it imposes. It is the proof and its breath, that is, its imminence, a slight breeze before the storm. *Aura*, a Greek word, was an attested medical formula since Galen, a breath that "traverses the body" the very moment the body finds itself plunged into pain and crisis. Charcot called the prodrome of the hysterical attack the *aura hysterica*.

Always displayed, this phenomenon is perhaps the distinctive character of hysteria itself, because an "epileptic aura," for example, even if it exists, is never displayed: it is too short, says Charcot, and is always overwhelmed by the attack itself. To the contrary, the displayed, patient aura indicates hysteria, and indicates that hysteria knows how to await the time of the crisis.[45] And it knows how to perform this wait even in extreme pain.

The Three Knots

Aura hysterica: the sensation of an acidic burning in all the limbs, twisted and almost raw muscles; the feeling of being glasslike and breakable; a fear; a retreat from movement; an unconscious confusion of gait, gestures, and movements; a will perpetually straining to perform even the simplest gestures; the renunciation of the simple gesture; an astonishing, central fatigue, a kind of dead tiredness;[46] the sensation of a wave—Augustine said that it felt like a breath was rising from her feet to her belly, and then from her belly to her neck.[47]

Speech interrupts itself, the gaze wanders, temples beat, ears whistle with inconceivable, intimate blares. Bourneville adds that in these moments, Augustine is "impolite, irritable."[48]

The aura is also described as the rising of three "knots," three pains and an intense twitching that surge through the whole body: the first throbbing in the ovary; the second, called "epigastric," that rises like a "lump," agitating the heart and breathing; then the third, called "laryngism," contracting the whole neck like some invisible strangler[49] (see appendix 13). In these moments Augustine herself clamors out for the straitjacket.[50]

For she "feels her tongue freezing and twisting, the tip raised, pressing on her palate. She can no longer speak, but she can hear; a fog descends over her eyes, her mind becomes blurred, and she feels her head turning to the right and her hands painfully contracting. At the same time, the pain in her belly, epigastric cavity, and head attains its height. The suffocation is extreme, and she soon loses consciousness."[51] Her thoughts are then dispersed and involute into harrowing pain and organ cramps. She can no longer bear the slightest touch, and the contracture of her whole body exhibits an "almost invincible resistance."[52]

Charcot recognized that the aura suggests the definition of a complex pain specific to hysteria, composed of "ascending irradiations" and painful nodal constrictions: "This pain proves to have specific characteristics, so to speak. It is no ordinary pain, for it is a complex sensation."[53]

Dissimulation and Dissimilation

What might be a reason for, or at least an aspect of this complexity? Remember the suspicion of the lie, remember the *proton pseudos hystericon,*[54] the "first hysterical lie" that Freud had begun to pursue.

After observing hysterics and their spectacle of throbbing pains and cries, strangulations, or spontaneous convulsions, the physicians would be surprised and have to adjust their spectacles when confronted with what Freud, citing Charcot, called "*la belle indifférence* of a hysteric."[55] Their suspicions would return when they considered the following paradox, which did not fail to evoke a certain paradox of the actress: hysterics speak and act their pain, abandoning themselves to the *coup de théâtre* of auras and symptoms, though just a moment ago there they were, living, beautiful, free of all affect and anxiety, and a moment after the vile attack they return to you merry, free of all anxiety. In 1926 Freud admitted that he still knew very little about this paradox, a paradox of intermittence.[56]

These suspicions only heighten the enigma of Augustine's portrait, her "*belle indifférence,*" her neutrality, her quasi-smile. Moreover, the *Iconographie photographique de la Salpêtrière* provided many other images of these hysterics, images that might have caused Breuer to revise his reference to the picture-book without pictures.[57] Such are the portraits

Figure 41
Régnard, "The Approaching Attack"
(*aura hysterica*), *Iconographie,* vol. I.

Figure 42
Régnard, "Onset of the Attack,"
Iconographie, vol. I.

of "Th. . ." in the very first plates of the *Iconographie,* whose facies during the attack enjoys [*jouit de*], as it were, the same "reserve" as her "normal physiognomy," save the straitjacket. Eyes open or closed, she remains, as even expert photographers and observers admit, "dissimulated."[58] Or, in the series of images of "Geneviève," the legend *qua* aura that reads "approach of the attack," or "onset of the attack" (figs. 41, 42), is visibly manifested only by a simple inflection of the gaze, which I would perhaps call patience.

In any case, these young women seem to show that they are not at all what they seem. The images taken of them compel us from the outset to be skeptical of images. This is an effect of their quasi-faceness. It names the aura, the rustling of a feather, the flight of their *actio in distans,* and everything about them that attracts us for this reason. It is a gap, a dissimulation that veils, the suspension of any decidable opposition between truth and untruth in the image; it is the veiled enigma of a proximation.

No one knew how this effect of *dissimulation* might resolve itself. The suspicion of simulation had weight, still has weight, precisely because of the neutrality of the faces. The *aura* means that Augustine's temporal attack as she posed for the photograph and waited—for what? a crisis? the

crisis already indicated by the legend?—it means that this attack, thus this torment of time commands Augustine to the retreat and action of dis-semblance: to dissimilation.[59]

That Augustine dissimulated and "dissimilated" herself still indicates that she was approaching disaster. The quasi-face of her portrait, nearly what would be manifested as an *aura hysterica,* but not manifesting itself to the image, not yet—this quasi-body remains, for us as for Bourneville and Régnard, more than an appearance and less than a phenomenon. Something like an *indicating-phenomenon,* perhaps:

> This is what one is talking about when one speaks of the "symptoms of a disease" [*Krankheitserscheinungen*].* Here one has in mind certain occurrences in the body which show themselves and which, in show-ing themselves as thus showing themselves, "indicate" something which does *not* show itself. The emergence of such occurrences, their showing-themselves, goes together with the Being-present-at-hand of disturbances which do not show themselves. Thus appearance, as the appearance "of something," does *not* mean showing-itself; it means rather the announcing-itself by something which does not show itself, but which announces itself through something which does show itself. Appearing is a *not-showing-itself.* But the "not" we find here is by no means to be confused with the privative "not" which we used in defining the structure of semblance.[60]

Expectation as a Method ("Temporizing")

What does medicine do when faced with an indicating-phenomenon? It waits; it observes. This is called *expectation,* a concept employed by Pinel, notably. In 1857, Charcot in fact devoted his thesis for the professorship exam [*agrégation*] to this concept. And he continued to draw on it now and then, when confronted with difficult questions about hysteria, such as, "She'll be cured one day or another, but when?"[61]

Expectation is the "therapeutic methodology" employed when one does not know how to cure an illness because it is extremely benign (un-interesting) or else incurable. It is a methodology of what is called "tem-porization,"[62] a splendid word. And this method has the immense scientific advantage of providing a way of studying the "natural evolution of ill-nesses."[63] It is thus half the way to experimentation, or perhaps merely static experimentation elevated into a response to therapeutic deficiencies,

*[The German *Erscheinung* can be translated "symptom," "phenomenon," or "indication," and is rendered in French as *phénomène-indice.*—Trans.]

no?—Yes and no, said Charcot, in substance, for "there is but one art, and its basis is observation, experiment and reasoning."[64] This is to say that, when confronted with an indicating-phenomenon, because something inevitably escapes, the physician waits, watches, hopes, scrutinizes, augurs, lies in ambush: he "observes," or "puts under observation." His hope is something like what Baudelaire wrote of the "promises of a face": black tresses, soon downy fleece, soon opening a cleft, soon a "night without stars."[65] Temporizing means this, too.

Expectation is a question of time made into a question of the visible: what is hidden, what hides itself, what threatens to hide in the most infinitesimal creases of this face? Expectation is the suspicion of a history, or even a destiny, made into an art of description, an art of the detail: "If we enter into the minute details of the childhood of patients under observation, of the circumstances that produced convulsive hysteria, it is certainly not with the aim of over-developing facts that are interesting enough to be pruned of anything superfluous. Rather, it is because we want to bring out the characteristics that distinguish hysterics, such that they can be *recognized before the appearance* of convulsive crises; it is also in order to show in an obvious fashion the causes that exerted an influence."[66] Thus no detail in Augustine's history should escape the reader of the *Iconographie* (but—you'll see that the future of seeing is always on the verge of taking a wrong turn).

A Secret Soon Visible

Expectation as method and even, here, as iconography, as publication, is only content when it can bring secrets to light. It is the instrumentalized hope of the making-visible of a secret.

Expectation is in fact the implementation, cultivation, and figurative fabrication of what deontology called the "medical secret." It is an exercise of the gaze such that the secret becomes the thing, the physician's work itself: "For us, the secret is not only what is confided in us, but what we have seen, heard, and understood in the course of our medical duties. Our client's secret belongs to us, we physicians, to such an extent that the client himself is often ignorant of its existence or scope. He cannot release it to us because he himself is ignorant of what he is releasing."[67] And note that the fundamental elements or domains of the medical secret, as Brouardel codified them in 1887, concern in the first place the *shameful* part of illnesses ("venereal affections, called shameful or secret in popular language, all reputedly hereditary illnesses," including hysteria, according

to Charcot), as well as the *temporal* element of all serious illness, more precisely "the future, the prognosis"[68] that must by no means be revealed to anyone but the immediate family.

In this sense, the *Iconographie photographique de la Salpêtrière* is a scandal sheet (except for the fact that it is reserved for a so-called informed public—but informed of what?), an iconography of medical secrets, the effort to make something about these shameful parts visible, something that hysteria seems to magnify—and perhaps precisely because it magnifies them. The *Iconographie,* as a series of photographic images, is also arranged according to a legend, a manipulation of time, where time provides the "positive determination of things insofar as they are not,"[69] insofar as they remain fallen and mute on the underside, in invisibility, in the past, a yet-to-come [*à-venir*].

In the portrait that opens the series, Augustine's aura is a halo of untimely visibility, a visibility that is not so much the imaginary—presence to or of the absent—as it is the presence of the *imminent visibility* of something latent, of a secret.

Time-Symptom (The Impossible Tale)

To constrain photographic visibility to imminence is to constrain the visibility of the hysterical body to the *intermittence of the symptom.*

For this reason, it is all but impossible to situate the symptom as an *iconic tale,* that is, "the representation of a narrative moment-instant presented in the form of an a-chronic model of intelligibility."[70] Take, for example, the plates Restout engraved for Carré de Montgeron's extraordinary work on the Convulsionaries of Saint-Médard[71] (it is entitled *The Truth of the Miracles. . .* , and fascinated Charcot, who collected the various editions): the figurative system requires a double page, a "before" and an "after," to obtain a *minimum of intelligibility* of the miraculous appearance-disappearance of "convulsionary" symptoms. And it was indeed a minimum, for the temporality of the symptom becomes hieratic, transfixing and emblematizing itself; it is never quite the temporality of appearing. Recall also Lessing's remarks about painting as an iconic tale: "if painting, in virtue of her signs or the methods of her imitation, which she can combine only in space, must wholly renounce time, then continuous actions as such cannot be reckoned amongst her subjects; but she must content herself with actions set side by side, or with mere bodies which by their attitudes can be supposed an action."[72] (I will let this text lie dormant for the moment, as it calls for a discussion of the Renouncing and Satisfying of painting.)

Figure 43
Régnard, "Contracture of the Face," *Iconographie,* vol. I.

As for photography, in its act—the shot—it is dealing with the *this, das Diese:* the here and now.[73] And photography neither restores nor recollects a tale of any *this* whatsoever. Rather, it gives only a kind of attestation of the *this,* one might even say a punctual "resurrection." There lies photography's terribly troubling capacity, its intensity: a constative force of time, ravaging and sharp as a scalpel. The past of a photograph is, unfortunately, as sharp and "sure" as the present of my own gaze, as intensive as a painful point, pointed time, and not extensive like a story that can be told. This is what is confusing. A photograph is far more constative of time than of its own model or "subject" or "object"; and it goes so far as to widen the gap between its model and time.

Why? Because time itself already seems undermined: it *has to do with an instant, but is furrowed with duration*—the measureless duration of the exposure.

Exposure Time

Note, for example, the wind of fear that seems to pass over the face of another hysteric in the *Iconographie,* called "Ler . . . Rosalie" (fig. 43). Her fear is not in the least passing, but rather a kind of transfixion, an intensive duration, a true "contracture of the face," "more or less persistent,"[74] and it allows for the relative clarity of the image, for an exposure time that was fatally long.

Régnard's great concern, with his wet collodion plates, must always have been to determine how, given a certain light (the use of artificial light coming into practice only several years later), a certain lens, a certain diaphragm, a certain "agitation" of the subject, a certain distance, not to mention the developer—given all this, how to obtain a "good proof."

At this stage the photographic act was still a risk against time, a gamble on exposure time. And even later, Albert Londe had a hard time shaking the question of exposure time, "one of the most delicate questions of photography."[75] Recall that the first model to pose for a photographer had to remain motionless in front of the lens for eight whole hours; thankfully for her, she was an already still life [*nature déjà morte*]. Indeed the history of photography wanted to be analyzed as a progressive "wrenching from time." The instant became the essence of the photographic, an attempt to forget that the instant bears absence and retreat within it (they said "instant," but thought *temporal synthesis*). It was therefore necessary to cut through the duration, always excessive, of the exposure (an excess that allows me to propose something like the counteranalysis of this history). This process was bolstered by guillotines, rapid circular shutters, the calculation of the "effective time" of exposure (thus reducing the "total time"), blinking blades of the iris, refined oversensibilities of more and more impressionable film, expendable flashes—anything to reduce this time, this veritable time of discomfort [*gêne*].

(Note that *gêne* signifies humiliation, torture, and avowal. Bossuet used the word to mean *Hell*.)

In any case, "when it is a question of reproducing illnesses," wrote Albert Londe, "one indeed has an obvious interest in reducing exposure time as far as possible, either because one is dealing with subjects who can remain still only with great difficulty, or because one is working in hospital rooms that are, in general, poorly lit. The increase in the speed of photographic preparations has therefore been decisive from the perspective of its application to the medical sciences."[76]

What photography, soon called "instantaneous" photography, wanted to deny and reduce here was something like its own temporal matrix.* I mean its mother-temporality, something in the quick of its birth: the exposure [*la pose*], a word that we must hearken.

From *ponere,* meaning to stand a person up, put him on his feet, "arrange" him, put him in place. Look at Augustine, again, if only at her verticality, her provisional verticality that is "iconographed" as signifying a kind of ideal or clinical concept, her so-called normal state.

From *pausa* (the Greek *pausis*), the halt, cessation, pause. I mean the arresting, yes, the *arresting* that constitutes the photographic exposure, like retention in a rhythm, retention of a rhythm.

Pausa is also the name for the "station" in a procession, a Penance on the Way of the Cross, and photographed bodies are already glorious and martyred bodies, precisely because they have already been delivered over to the image and held (by the camera) in "so ambiguous a place between execution and representation, between torture chamber and throne room."[77]

Listen again to *ponere,* posing, deposing: extending on a funerary bed, calming for eternity, even destroying, burying, disposing relics. Never, wrote Barthes, were corpses as alive as in photography,[78] because photography employs the most paradoxical relics of all: moments of life.

Lend an ear, one last time, to the word: it means to place, that is *to invest.* And retention (arrest and cessation) is reflated as a *protention* that is at the same time an act of *diversion* [*détournement*] (Greek *pauein*): investment and detour, embezzlement, or a gamble on a future, a speculation. I mean, above all, that exposing is an intimate movement of the *expectative.* Regarding old photographic portraits, Benjamin writes: "During the considerable period of the exposure, the subject (as it were) grew into the picture";[79] and this installation was investment, protention, expectative. For "'what was inevitably felt to be inhuman, one might even say deadly in the daguerreotype, was the (prolonged) looking into the camera, since the camera records our likeness without returning our gaze.'" For *there is no gaze that does not wait,* this is the essential point: 'there is no gaze that does not await a response of the being it concerns.'"[80]

The Expectative

Expectative is a word of the gaze and a word of time. It is something in visibility that nearly deprives itself, committing itself to a time of waiting.

*[Didi-Huberman is playing on the double meaning of *matrice,* both "womb" and "matrix." Cf. chapter 4, note 2.—Trans.]

Something like a tenuous but radical gap exists between the expectative and the wait, a distancing perhaps comparable to the way anxiety turns its back on the closest fear.

I cannot say that images *have* a temporality. That formulation would be—how shall I put it?—timorous, even superstitious, and quite weak given the way images *attack* something in us. Images do not "have" a temporality, neither as having, nor as predication. They *are durations,* sublogical durations and times of gazing on modulations: rhythms of retentions (past retentions, which have not really or not yet passed) and protentions (a time to come [*avenir*] that is already no longer to come [*à venir*]), the flutter of an opening-closing, like lashes and lids; durations of the *Augenblick,* of winks and glances. Durations of "eyegonblack," as Joyce wrote,[81] of "fadographs," and who knows what else.

Photography seems to have no future, because it "flows back from presentation to retention,"[82] of course; because the present of the image reaches us only as an unfailing delay. Even if the image itself were endowed with a capacity for movement, it could not catch up with this delay.

For in a photograph, a gesture has come to an end. It is a pause, of course. Indeed, the expectative calls this pause presence, that is, I repeat, imminence and urgency, the urgency of what is there before me, *prae-sens,* looking over at me, and suddenly coming upon me as an absolute event—but now I am speaking of the photographic manufacture of the event; now I am speaking of facticity.

Nonetheless, each photographic detail functions as a threat. And each morsel of this threat plummets our imaginary into a perspective of flesh or—already—death, which is always very, very real. In photographic portraits, perhaps despite themselves, there is always a "dark precursor"[83] that keeps watch, in a way. It is always waiting, awaiting some flash, commotion, or disaster. And this wait is made an image, and the image is made in the wait, the image is made to wait: insomniac.

At this point I ought to raise the question of what is known as an originary fantasy. For despite its turns and diversions, despite its protention, a delay made into anticipation remains a delay. It merely becomes an anterior delay. Something in the protention itself lingers behind—no, I would say rather that what was behind becomes *the lateral* of the gaze, a fantasy. To which I am indebted—as if originally.

And the expectative also names this summons to the future perfect [*futur antérieur*]. It is the delineated posture, always abandoned to paradox, of the contortions of the very anterior future. Look again at Augustine's portrait: you may think you are contemplating a destiny, precisely because this portrait presents a *quick* delay in Augustine's death—for us

Augustine is dead and buried, and has been for so long. For her portrait, her face is past, even passed away, although for us her death is very latent, imminent.

Such is the trial [*épreuve*] of the photographic print, a constraint of the expectative. It draws a "living line" [*trait vif*] of its "subject" and with this extraction or treatment (the *pour-traire* itself, as they used to say), with this slow traction, it assigns its subject to the paradoxical existence of *still life*[*] in but the time of an exposure. A silenced life, a soon to be dead nature [*nature morte*]. It is thus like the suspension of mourning, the *imaginary anticipation of mourning.*

"The time of a trial [*épreuve*], whose profit or remainder will be your image, the image of your 'living traits' [*traits vifs*]—your death adorns itself [*se pare*], my beauty: *si vis vitam, para mortem,*[84] prepare your death; let us make you an ornament, a photograph; let us keep everything in images, to preserve you from all loss through these filmy doubles of yourself that are your portraits, our portraits." This is what a photographer might have said to "his" subjected Augustine.

For there are the photographer and the photographed: the former prepares [*prépare*] and parries [*pare*], the latter is constrained to a patience of suffering and drama—the drama of the exposure, the subject's combat with the image that is drawn from him by subjecting him to the resemblance of a quasi-face, as if through a *quasi-murder*. This drama is represented here by the troubling incidence of a symptom that Augustine "presented" at the very time that all these photographs were being taken: she could no longer see colors; she saw everything in black and white.[85]

"I don't have the time" (The *Entr'acte*)

And she would also say (perhaps even repeating herself until her head spun), "I don't have the time. . . . I don't have the time. . . ." And then: "I'm telling you that tonight I can't. . . . he swore he'd kill me. . . ."[86]

I believe that the photographic proof (its imposition of the expectative) took advantage of a coincidence, a veritable godsend for the factory of images: *the hysteric's time is already guilty.* It is already guilty, and in its simple relation to visibility, it is silhouetted like a theater of shadows.

The Greek *hystérikē* can be translated by "she who is always late, she who is intermittent." Yes, she who is intermittent is the hysteric, she is the *intermittent of her body.* She lives with the risk and misfortune of always mis-

*[In English in the original text.—Trans.]

taking the possession of her body. She feels that perhaps it is not hers; she even attempts, frequently, to take the body of others for her own body. This risk is an endless hesitation, a repeated attempt to cut hesitation short, an unrelenting questioning of misfortune. Where should this body be put?

By temporalizing meaning according to this hesitation, risk, and intermittence, a hysteric perhaps experiences something like a *beside-oneself* in her relation to time, a beside-oneself that leaves a wake, traces, and symptoms in the visible. Deviation and decoration [*atours et détours*] of the hysteric in being, the relationship of time to being-there: this perhaps, right here, is the "questionable" par excellence. The wake may be the *aura,* a breath caressing her hair and wafting strange noises to her mind.[87] A desire, something in the future that affects representation and in which a subject, a madwoman, self-defines her power.[88] The misfortune, of, quite simply, an "uncertain and changing course of events," the very meaning of the Greek word *aura.*

This kind of misfortune affects the portrait of Augustine (plate 14; see fig. 44) in these terms: this image is itself merely an intermittence. It is quite precisely an *entr'acte,* a time of repose in the "state of hysterical illness," for, says Charcot, "contracture is always imminent with hysterics";[89] "in the state of hystero-epileptic illness, there are from time to time moments of respite, like *entr'actes,* during which the convulsions and delirium are momentarily interrupted."[90] This portrait corresponds to a wait and a haste. They waited for a respite in Augustine's suffering so as to take her quickly to the platform, perhaps—coifed, dressed, between a dark curtain and the photographer's black veil—and then, in all haste, to photograph her "normal physiognomy." It is therefore likely that it was an *entr'acte* between violent scenes and *coups de théâtre.*

Losing Consciousness (The *Coup de Théâtre*)

In short, in this portrait, Augustine may be on the verge of losing consciousness. How shall I put it?—verging on a state of the body that is a state, and a state that is no longer a state, and across from the body, but on the other side, parallel to it but on the other side, consciousness is still being jolted like the limb of a forgotten being, and consciousness is a theater where one day something happened, one felt, I believe one felt, like the extended limb of a being in the paroxysm of the maximum, but the head has gone, there is no more head or being, no more paroxysm or maximum, and across from it but on the other side, parallel to it, as if the

Planche XIV.

HYSTÉRO-ÉPILEPSIE

ÉTAT NORMAL

Figure 44
Régnard, photograph of Augustine ("Normal State"),
Iconographie, vol. II.

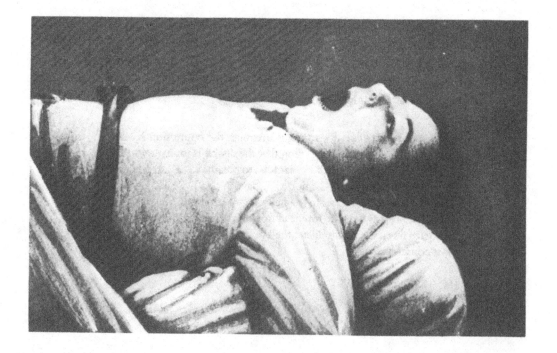

Planche XV.

DÉBUT DE L'ATTAQUE

CRI

Figure 45
Régnard, photograph of Augustine ("Onset of the Attack:
The Cry"), *Iconographie*, vol. II.

head were parallel to it, only the body is found despoiled of its con-
sciousness, all the more alive because it is dead,[91] and the body no longer
belongs, no longer belongs to Augustine.

Augustine's body does not exactly remain to us even as an image.
Rather, for us it is more the intermittence of two images: quite simply the
crossing from one page to another—plate 14 to plate 15 (figs. 44–45).

Plate 15: a cry, a straitjacket, retouches in *gouache* required by a ru-
ined proof, the proof of Augustine's convulsions, on a bed that she would
have turned upside down if she had not been fettered; an event that would
have made the image itself tremble, and perhaps even put the camera's in-
tegrity at risk, if she had not been fettered.

And between these two images there is the intermittence, with no respite for us, of someone who no longer looks anything like herself. This staggering loss, from one page and one image to the next and this true *coup de théâtre,* are merely the wind of the symptom in the image: the crisis, the attack as they say, is only just beginning.

> *Beginning of the attack.* Breathing is irregular, the oppression is obvious, words are broken off; feeling that the attack is immanent. L. . . tries to restrain herself: "It's . . . hard . . . to breathe . . . I . . . won't . . . be . . . sick . . . so . . . I . . . don't . . . have . . . to . . . take . . . amyl nitrate." There are heaves in the belly; an intermittent chewing motion; the nostrils flex, the forehead frowns, the eyelids flutter rapidly, the gaze fixes, the pupils dilate, the eyes roll upwards: the patient has lost consciousness.[92]

6

Attacks and Exposures

A Classical Tableau

If the patient loses consciousness, what remains for knowledge to grasp as the being of the illness—The *spectacle* of the illness remains.

Spasms, convulsions, blackouts, semblances of epilepsy, catalepsies, ecstasies, comas, lethargies, deliria: a thousand forms within a few moments. Charcot's "genius" was, I repeat, not simply to arrive at a description of all this, but to calibrate it into a general type that can be called "the great hysterical attack," examples of which can be further qualified as "complete and regular."[1] This attack proceeds in four phases or periods: the *epileptoid* phase, mimicking or "reproducing" a standard epileptic fit; *clownism,* the phase of contortions or so-called illogical movements;"*plastic poses*" or "*attitudes passionnelles*"; finally *delirium,* so-called terminal delirium, the painful phase during which hysterics "start talking," during which one tries to stop the attack, by every possible means.

This categorization is like the iconic tale's great revenge on the intermittences and paradoxes of evidence of the hysterical body: an eye for an eye. Charcot domesticated the most Baroque theatricality; he achieved the *coup de force,* and I mean force, of making theatricality into not only a *clinical* but a *classical tableau.* It was the academy's revenge on the profusion of heterodox forms: their classification, finally.

To be more precise: Charcot was a kind of entrepreneur and sponsor of the narrative and iconic type required by the principles of his concept of hysteria and his epistemological objectives. The overseer—tough, and meticulous, and a practiced hand—was Paul Richer, the pet intern of the service, and (because?) a very gifted graphic artist, which is no surprise: he was a professor of artistic anatomy at École national supérieure des Beaux-Arts in Paris.

With his black pencil, Richer surveyed the "complete and regular form of the great hysterical attack" in eighty-six figures. That he needed

merely nine figures to encompass the "principal varieties" or variants speaks to the perfection of the model. The finishing touch was to subsume the whole figurative series in a single synoptic chart that provided, horizontally, "the schematic reproduction of the great attack in its perfect development," and, vertically, a sample of the most, let's say, classic "varieties"[2] for each phase (fig. 46; cf. appendix 14). Synoptically: in a single, all-embracing glance [*coup d'oeil*].

Indeed, this chart was just as good as the most rigorous, concise, but fatally long descriptions. Or, rather, it ensured the description's existence and the methodological validity of its pertinent traits; it made description possible, and even concise.[3] A figurative standard thus made it possible to distinguish hysteria's "complete" forms, "medium" forms, and "rudimentary" or "crude" forms.[4]

The tableau was classic in another sense as well: it was accepted as authoritative. It was everyone's point of departure.[5] Everyone, in his own way, paid homage to it, or defined himself in relation to it. Thus the Germans Andree and Knoblauch did for male hysterics, traumatized by war, what Richer had done in representing exclusively—did anyone notice?—the feminine type in his tableau.[6] Professor Rummo, saw fit to publish an *Omaggio al prof. J.-M. Charcot* from his clinic in Pisa, a series of seventy photographs, seventy postures and positions: living catalog of "the" hysterical crisis (a recurring striped garment gives an almost cinematic impression), a catalog in which the real, photographically authenticated, itself pays homage to the rationality of the Salpêtrière's nosological concepts and figurative types[7] (figs. 47, 48).

Even in the *Iconographie,* there was something like a confession, an implicit confession of this homage, which is also a form of vassalage. At one point in the text, Bourneville suggests that the photographs it presents resemble the types defined by Charcot, because, he said, Charcot was their entrepreneur [*maître d'ouvrage*] (or the mentor [*maître à penser*]?—do these images think?): "In the succession of their periods, the attacks of A. . . . resemble the attacks of the patients we have spoken of before now. Suffice it to remark that here we find all the characteristics that M. Charcot has described in the lectures that he has recently given at the Salpêtrière. This is quite natural, seeing as the task of publishing the *Iconographie* was undertaken according to his advice and indications."[8] It is indeed quite natural. It is in the nature of classic images, and it is what makes them efficient: constraining the real to resemble the rational.

Augustine as a Masterpiece

And Augustine? In this figurative and taxonomic manufacture, Augustine was like a pearl, a masterpiece, perfection itself—that is, she was the perfect alibi.

Charcot spoke of her as a "very regular, very classical example,"[9] and Richer went one better, as always, writing that she "is the patient of ours whose plastic poses and *attitudes passionnelles* have the most regularity."[10] Notice also that it is Augustine's face, above all, that illustrates and "synopsizes" the hysterical type in Richer's grand chart.

And Augustine—but we are speaking more of the magnificent and regular series of her poses (and I am speaking of what still remains of them, the magnificent series of plates of the *Iconographie*)—Augustine was thus the star model for a whole concept of hysteria, to the point that Moebius, for example, the most misogynist of all psychiatrists of the time, could not abstain from "figuring" her in his treatise on nervous illnesses.[11]

Besides, Augustine did not seem all that cunning. She was fifteen and a half when she entered the Salpêtrière; at that age one does not set one's heart on fraudulently imitating the "rhythmic chorea," for example, from which she in fact suffered. She was thus considered, in a sense, to be an honest hystero-epileptic, neither "joker" nor "stylist";[12] and thus she was "regular." She was fifteen and a half when she entered the Salpêtrière, and it was under the very eyes and tender concern of her physicians that she "became a woman," as they don't fail to tell us,[13] meaning she had her periods: she became regular [*reglée*].*

But, I repeat, what made Augustine one of the great stars of the *Iconographie photographique de la Salpêtrière* was above all the temporal progression of her attacks, always showing well-delineated periods of "repose" and "*entr'acte*"; the sort of dramaturgical cutting of her symptoms into acts, scenes, and tableaux: the so-called plastically regular intermittence. Her body thus made a rigorous gift of itself, small a, small b, small c.[14] This seemed to make it possible to forget that representation, as a form of time, forgets a certain misfortune of time.

The Sculptural Moment (The Contracture)

There is a moment, writes Hegel, when the statue, which is "perfectly free repose," demands to become a living Self: this is how "man thus puts himself in the place of the statue": he makes himself a "living work of art."

*[*Reglée* signifies 'regulated,' but also designates a girl who has begun menstruating. —Trans.]

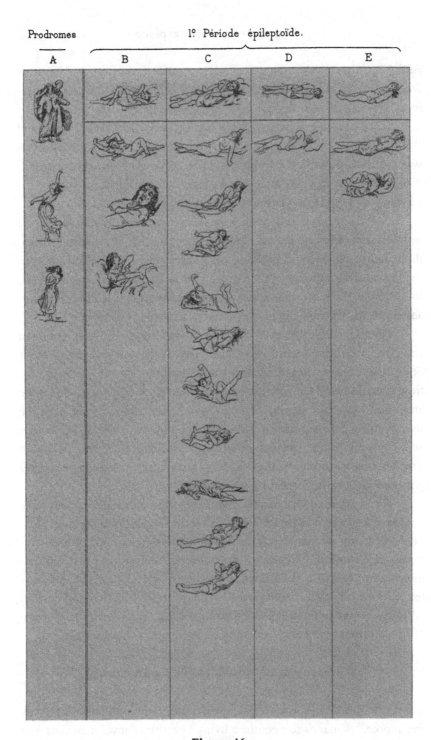

Figure 46
Richer, synoptic table of the "complete and regular great
hysterical attack," with typical positions and their "variants,"
Etudes cliniques (1881).

Attacks and Exposures

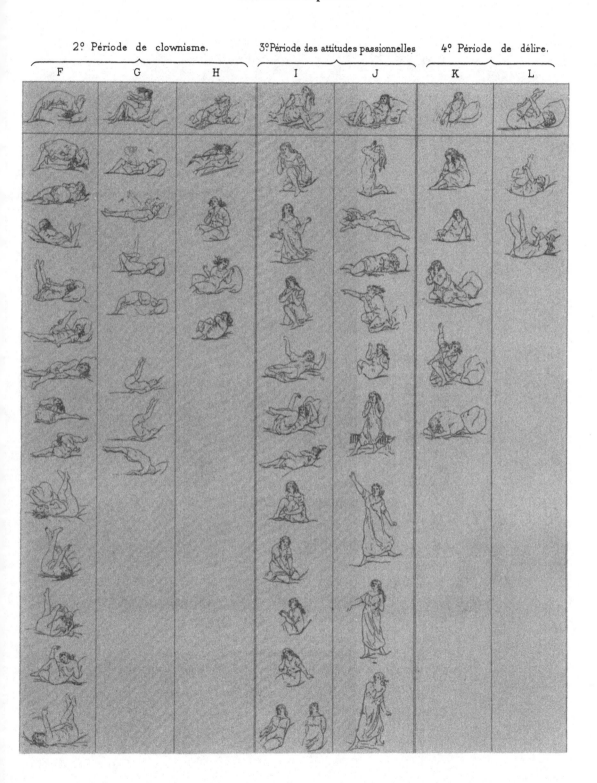

2º Période de clownisme. 3ºPériode des attitudes passionnelles 4º Période de délire.

F G H I J K L

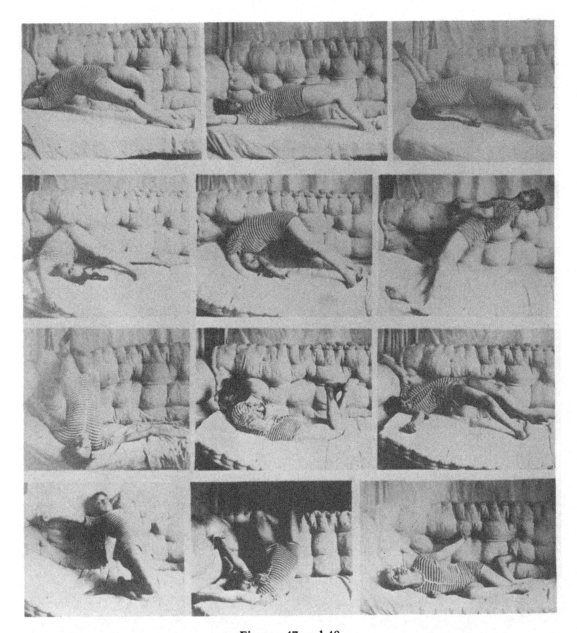

Figures 47 and 48
Rummo, two plates from the *Iconografia fotografica del grande Isterismo*
(1890), dedicated to Charcot.

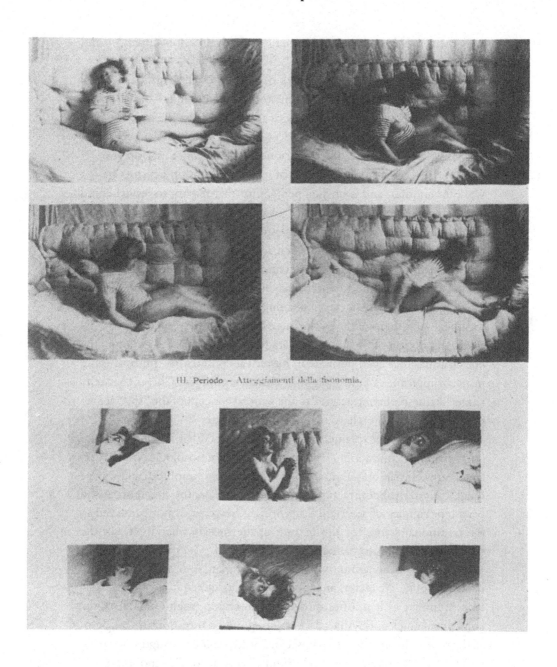

III. Periodo – Atteggiamenti della fisonomia.

And then, says Hegel, man becomes "perfectly free movement,"[15] and then comes the festival [*c'est la fête*].*

A hysteric can be a living work of art, and I will continue to speak of Augustine as a masterpiece, the masterpiece and "thing" of her physicians. But, in a sense, a hysteric remains a statue, because she lacks the perfect freedom of movement evoked by Hegel. When she moves, even violently, she seems more like a marionette—but whose marionette?

Perhaps she remains in a state of self-gorgonization because she is a work for another, and is unable, perhaps for that reason, to leave behind something like the "immobile now" of a fantasy. Indeed, this is a godsend for the photographer, when the exposure time is long. It is called a hysterical contracture. And it is not such a simple concept. Some claim that it is a *paradoxical* muscular phenomenon, that could be described as follows: a muscle is prone to enter into an (even permanent) state of contraction by the mere fact of its points of attachment coming closer together—in other words, by the mere fact of its relaxation. Charcot critiques this notion of the muscular paradox, due to Westphal, among others, claiming that even permanent hysterical contracture "finds its cause in an abrupt *tension* of the antagonist muscular group."[16] Charcot gave the name "diathesis of contracture" to the general concept of the "special predisposition of the muscle to enter into contracture."[17]

But a few unexplained paradoxes subsist. What Briquet called a "perversion of contractility"[18] remained a kind of nosological no-man's-land, between paralysis and contortion, between immobility and movement.[19] Hysterical contracture is motor impotence, the involuntary and persistent rigidity of a certain limb, which, however, is not paralyzed in the traditional sense, for the texture of the muscle fiber itself and the structures of the motor centers remain unaltered. The paradox resides in its exclusively local nature (without a concomitant lesion), in its extraordinarily mobile character, and, above all, in its intermittence. It is paradoxical insofar as it is a (local) detail or interlude (itself a phase) of the convulsive attacks of hysteria, constituting only a thread in the tangle of all the motor disturbances that upset and nearly dislocate Augustine's poor body: "jolts," "quakes," "cramps," "jumps," and "throes"—and so on.[20]

Her contractures were unpredictable: her neck would suddenly twist so violently that her chin would pass her shoulder and touch her shoulder blade; her leg would suddenly stiffen, like a club foot, flexing until "the heel pressed against the perineum"; her two arms would suddenly

*[The colloquial expression *c'est la fête* would be more idiomatically rendered by something like "anything goes"; but in this context, D.-H. is also making reference to the Hegelian *Feste* of absolute spirit in art, which is translated in English as "festival."—Trans.]

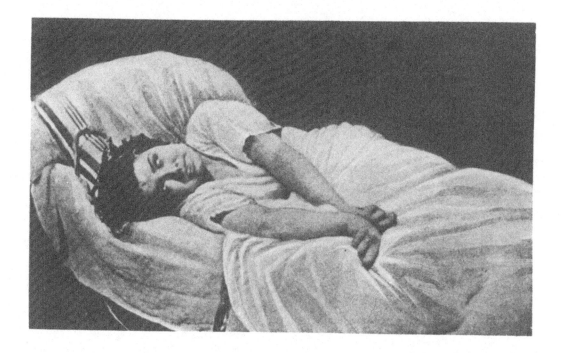

Planche XVI.

TÉTANISME

Figure 49
Régnard, photograph of Augustine ("Tetanism"), *Iconographie*, vol. II.

bend backwards several times in a row, then become completely rigid: "The whole *body* became rigid; the *arms* stiffened, sometimes executing a more or less perfect circumduction; then they would often approach each other on the median line, the wrists touching each other on the dorsal side (pl. XVI)"[21] (fig. 49). This describes the paradox and throes of *tetanism*: a body abandoned to contractures that are fantastic and recurrent, unpredictable and intermittent. Richer called this "tonic immobility" (fig. 50).[22]

The Dead Hand (Mortmain)

Tetanism was a godsend for Régnard, because it was simultaneously a respite from movement, an exposure made possible, and thus also the possibility of a clear image—and at the same time it was the deepest sign of the completely maladjusted gesticulation of the hysterical body in an at-

Figure 50
Richer, the "phase of tonic immobility or tetanism," plate engraved
after the preceding photograph (fig. 49), *Etudes cliniques* (1881).

tack. It was a fixed moment of contortion or convulsion, the sculptural
moment of a kind of motivity that is nonetheless completely unbridled: a
statue of living pain.

And this phase should not be understood as a metaphor, because
hysterical contractures, notably of the hands and feet, generously pro-
vided the material for a museum of casts that Charcot founded at the
Salpêtrière: another eminent "laboratory" of the predation of pathologi-
cal forms (almost completely destroyed today). It was so easy, indeed, to
throw some plaster on this "club-hand" or that "equino-varus foot," so
easy to mix up some plaster and coat limbs knotted with pain, so easy to
let the plaster dry and end up with a lovely cast of the least pores and folds,
the folds of the hysterical attack itself! It was easy because it simply con-
firmed a state of fact, the contracture. Doubtless the contracture was
slightly prolonged, occasionally, but what did it matter: the stuccoed hys-
terical body was all the more worthy of attention, science, tenderness, and
so on (fig. 51).

I am thinking here of a word, mortmain, from the French for dead
hand, that designates a practice you may think of as out-of-date: the right
of a master to dispose of the goods of his vassal upon the latter's death. The
casting studio and the photography studio were, in this way, like instru-
ments of a kind of right of figurative *mortmain* on the bodies of hysterics.
Their bodies were their only good, and their contractures were, remark-
ably, like a donation to the great Parisian museum of pathology. I speak of

Figure 51
"Live" plaster cast for the "Cast Museum" of the Salpêtrière,
called the "Charcot Museum."

rights rather than knowledge, because the cast did not always explain very much about the actual mechanism of the hysterical contracture.[23] But it already took the place, and worked like a charm, of the best description or the best schema.[24]

Or did it? Nothing is simple, and we must be aware of the fact, for instance, that neither casts nor photographs could truly supplant the use of the schema in the procedures of figuration and transmission. In fact, the photograph of the tetanized Augustine (see fig. 49) served Paul Richer as the basis for an engraving of the "epileptoid" stage from the so-called first period of the hysterical attack[25] (see fig. 50). This is a fundamental operation, because it *recomposes* the photographic image and, in so doing, ascribes it to a clinical story: these were the stakes.

Thus the engraving invokes its right of mortmain over the photograph. It endows the photograph with a significant coherence *after the fact,* from the visible "good" left by the print. Compare the two images: the legs are denuded, in an additional contracture, like the revealed underside of a photograph that does not show enough; the tensing of the shoulders "expressively" exaggerated; distinct foam emerges from the mouth; the restraints on the bed have disappeared; Richer even makes the hair more "expressive," like a wild torrent of passion.

The Overhang of the Affect

Richer did not, of course, draw any schema from the subsequent plate of the *Iconographie* (fig. 52), although it bears the same legend, "tetanism," with the specification (is it really a specification?) "facial expression." He could not, because this print tells no story, nothing really describable—it is all face and gaze, surrounded by shadow. They only seem to be battling with an *overhang.*

In this photograph, the ever-present enigma of hysterical contracture falls to our lot yet again, something that schematization, descriptions, or casts fail to alleviate. It is the enigma, I repeat, of its temporality and intermittence, raising the question: will this contracture that has "suddenly reached its height" be permanent? Will it "suddenly" and "spontaneously" disappear? Shouldn't it "quite naturally lead us to suspect that it is the imminence of a hysterical *storm*"?[26] And so on

With this photograph a question, in fact, falls to our lot, the question of the relationship between the hysterical contracture and what it hides, which is also perhaps its foundation. The overhang that obsesses this image is perhaps an *affect.* Kant speaks of emotions that "share the characteristic that they *paralyze* themselves with regard to their purpose.

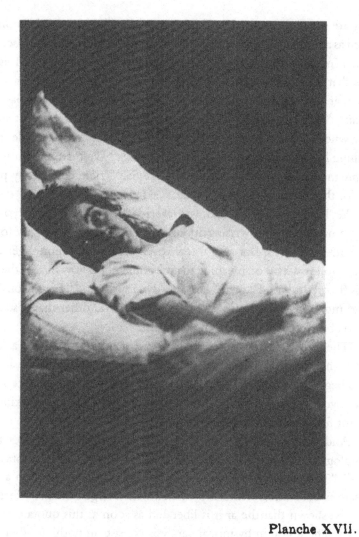

Planche XVII.

TÉTANISME

ATTITUDE DE LA FACE

Figure 52
Régnard, photograph of Augustine ("Tetanism: Facial Expression"),
Iconographie, vol. II.

They are suddenly aroused feelings against an evil which has been interpreted as an insult. However, these feelings are also incapacitating because of their intensity, so that the evil cannot be effectively averted."[27] It is curious that Kant immediately refers this definition to an enigma, a suspicion that in fact concerns something like *the overhang of imminence in visibility:* "Who is more to be feared, he who *grows pale* in violent anger, or he who *flushes* in the same situation?"[28] We are of course unable to see anything like that in Augustine's face, but I still have the premonition of the pregnance of an affect. No text of the Salpêtrière could truly prove this, for the scripts treat only "physical" symptoms.

Yet Freud, as early as 1888, was interrogating hysterical paralysis and contractures, and even writing about it in French; did he strictly follow Charcot?—He tried. But after a few pages Freud could no longer continue to follow Charcot, meaning that he could not follow him all the way to his theoretical model of the famous "dynamic lesion." Freud considers things more "naively," noting that "in paralysis and other manifestations hysteria behaves as if anatomy did not exist."[29]

Then, to escape this aporia (why is the organ in contracture a "dead mass," why does it play dead when it is intact and even highly sensitive?), Freud begs for a pardon: "For that purpose I only ask permission to move on to psychological ground,"[30] he writes, almost like a prisoner asking the director for permission to go abroad.

And before definitely deciding to flee, he offers examples from mythology and anthropology. He speaks of "association," the "quota of an affect": "The paralyzed organ or the lost function is involved in a subconscious association which is provided with a large quota of affect and it can be shown that the arm is liberated as soon as this quota is wiped out. . . . The lesion in hysterical paralysis consists in nothing other than the inaccessibility of the organ or function concerned to the associations of the conscious ego."[31]

The value of association that strikes Freud as suspect is crucial: might it not guide us through the extraordinary trajectory of Augustine's contractures? "*Contracture of the jaw and the tongue.* The jaw cannot be moved." Nonetheless, her mouth is finally opened.

> The *tongue* can be seen in the back of the mouth, fully curved into a half-circle, with the tip invisible. One might say that the patient is going to swallow her tongue. . . . Sometimes L . . . , in a straight-jacket, attempts to rub her *right eye,* on the pretext that it is cramped, "that it wants to join the left eye." Quite probably it is a matter of a *contracture of the right internal muscle.* L . . . has been deaf for three quarters of an hour now. She claims that she has "a spider in her right ear," doubtless to translate the sensations she is experiencing.[32]

The Twisted Gaze of the Hysteric

What Bourneville refused to imagine in regard to Augustine was that an affect could overhang and constrain the gaze. If he noticed, correctly, a link between visual disturbance and hysterical contracture, it was in order to record the fact that it was solely, or almost solely, a question of muscles.

There was already a hatred of the gaze. But there was also a passion for examining, *scrutinizing within* hysterics' pupils, irises, and retinas. It was a way of rigging a face-off with hysteria, to the advantage of science. Charcot boasts out loud, "I've examined the visual field of hysterics perhaps a thousand times,"[33] and this is how he would tackle the subject.

There was also a passion for exhaustivity, or rather exhaustion: drawing up tables of all the "ocular symptoms" of hysteria, using them up (and exhaustion drains not by facing something, but by encircling it. To name but a few: paralyses of the motor apparatus of the eye, lid spasms, micropsia, macropsia, concentric shrinking of the visual field, and dys-chromatopsia (attacks on the sense of color) of the most diverse nature, al-though "rather often the *notion of red* remains," notes Charcot.[34] Hysterics see the world, for example, as "in a gray monochrome painting or a sepia watercolor,"[35] and so on.

For a long time the crucial word was "functional": all these distur-bances were functional, no more, no less, because, once again, they were not accompanied by any visible alteration[36] within the eye.

Another thing that was quite improbable but persisted nonetheless, was the fact that the so-called law of fascicule of opticus fibers[37] was shamelessly mocked by "hysterical vision." "Hysterical vision" thumbed its nose at anatomy, or the physiology of the eye: it was crooked, or even twisted. In any case, it was by and large dissymmetrical: thus Augustine suffered from a significant decrease in visual acuity on the right side, but also enjoyed "above normal" vision on the left.[38] On the right, in partic-ular, she was dyschromatopsic: she would confuse red and blue, green and orange, or else she would become fully achromatopsic and see everything as in a photograph.[39]

The psychiatrists of the Salpêtrière paid close attention to the phe-nomena of the nonsymmetry of the gaze. Mydriasis, or the abnormal di-lation of the pupil (often accompanied by a persistent immobility of the iris) was considered to be a hysterical stigma,[40] or a neurotic stigma in gen-eral. Charles Féré, the great specialist of criminality and "degeneracy," also wrote a little article on the "chromatic asymmetry of the iris considered as a neurotic stigma."[41]

(I will divulge a little gossip. Professor Charcot himself suffered from this stamp of shame—a certain silence surrounds the question, but notice that more often than not his photographic portraits leave its trace, in his refusal to pose full-face.)

When hysterics suffering from ocular disturbances were photographed, it was necessary to place them perpendicular to the camera in order precisely to locate the least dissymmetry. Albert Londe required a gaze that was "natural and normal in the general direction of the figure." He required a gaze that "looked but did not fix," for a fixed stare, so he said, was too "hard."[42] Thus he provides us, in the *Nouvelle Iconographie de la Salpêtrière,* with a few classic portraits of the genre, such as one young woman suffering from a spasmodic contracture of the eyelid (to the point that when one "attempts to lift it, one feels a resistance that, while not considerable, is nonetheless appreciable"),[43] who was still aphonic when Gilles de la Tourette, her physician, attempted to eliminate her permanent, insulting wink (fig. 53). Or else, the portrait of "Jeanne Ag., age 26," whose eyes were "the seat of an exquisite hyperesthesia,"[44] and note that in medicine the word "exquisite" bears no connotations of pleasure; any light at all was a torment to this young woman (but Londe required significant amounts of light to take his snapshot, and we can still see in her retreating face and lowered lids the pain of the ordeal [*épreuve*] of the exposure). A well-meaning physician had severed this photophobe's suborbital nerves on both sides—a rather heavy-handed technique—before she entered the Salpêtrière, just before Gilles de la Tourette, perhaps a bit nosologically disappointed, came to recognize the "psychiatric origin" of this symptom[45] (fig. 54).

Sizing Up, at Pleasure

Psychic, at the Salpêtrière, meant psychophysiologic, or rather, neuropathologic. It was as a "necessary complement to a neuropathological Institute"[46] that, in 1881, Charcot decided to have a whole laboratory of ophthalmology built next to the photographic studio and the museum of casts. There was a veritable industry of standardization and measurement of every act of perception, imaginable or unimaginable. There they would size up [*toiser*] the twisted gaze of hysterics at their leisure. They would draw up maps of visual fields, notably, on standardized questionnaires to be "filled in" and "colored."

Yes, size up [*toiser*] also means to look, but with what a look!—And with which look?—This is my question. I want to point out that the

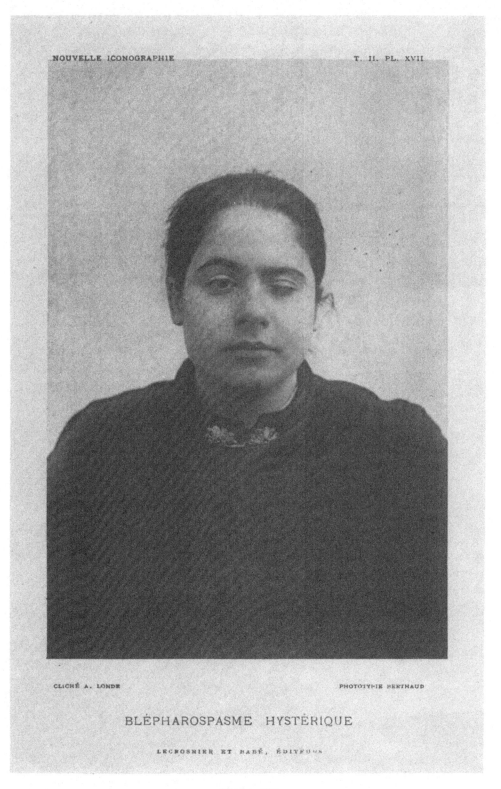

Figure 53
Londe, photograph of the "hysterical wink,"
Nouvelle Iconographie (1889).

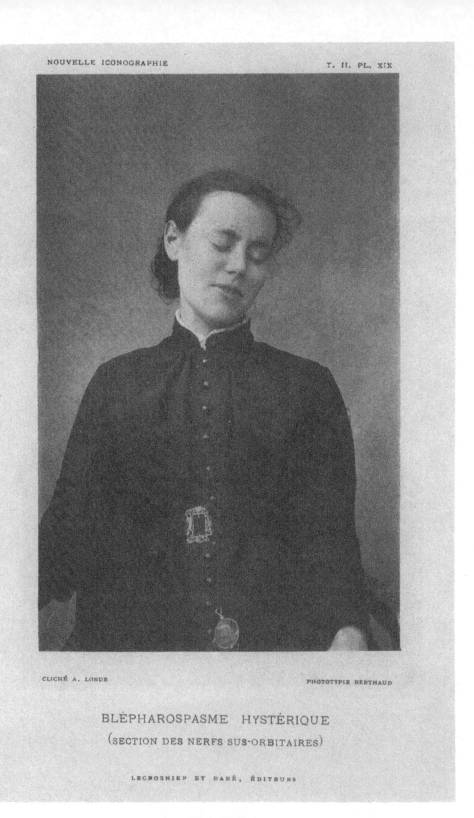

Figure 54
Londe, photograph of a "photophobic" hysteric,
Nouvelle Iconographie (1889).

protocol of the eye exam implicates something like a drive, the object of which was vision of another (sick vision, more precisely); it was a *scopic drive*, the scopic drive insofar as it is devoted to enjoying all other drives: the totalitarian scopic drive. Hysteria was conducive to or even instrumental in all this. Its intermittences, its fleeting auras in which a certain sense of color was entirely converted,[47] and each of its symptomatic transfigurations in general were an opportunity for Charcot and the clinic to "see the new."

As for Freud, he indicated that visual disturbances in hysteria concerned, in fact, a dissociation in the perceptual process between what he called sexual drives and ego drives. The result of this dissociative effect is that when hysterics see into the unconscious, they go blind unexpectedly. For sight is subject to repression, a "group of representations" subjected to something like an *Urteilverwerfung*, as they say, a "condemnatory judgment."[48] The symptom, however, has as its "precondition" the failure of repression.[49] What does this mean?—That the eye is condemned to an impossible situation, that of "serving two masters at once," writes Freud,[50] and an attraction, for example, or a charm—*Reize*—will inevitably give rise to a certain "irritation"—*Reize*, an infection, a dissociation of visibility.

This situation exists because there is guilt[51] at the very heart of sight. I suspect that within the walls of the Salpêtrière, one of the two "masters" in question may very well have been called "Charcot"—"Charcot" as the authority at the heart of the hysterical syndrome itself. I also imagine that Charcot and his colleagues (his accomplices?) would see more and more of the "new" to the extent that "their" hysterics were more deeply guilty, a guilt that I imagine to be administered by the Salpêtrière itself.

Charcot thus had the chance to push his *Schaulust* even further, and he drifted in this direction, to the point of trying to see within the most elusive and unconscious vision of these young girls, assigned to reside in his service, with their incomprehensibly irritated eyes. Yes, charm and irritation did indeed go hand in hand.

For example, Charcot set his sights on the *scintillating scotoma*, the evanescent "luminous figure" that clouds vision during "ophthalmic migraines" or other symptoms characteristic of hysteria. He grew fond of describing them, recounting them as scenes or stories, convoking them as a figurative schema, and producing sketches[52] (fig. 55). He frequently attempted to extort descriptions from his colleagues in conformity with his own, and with his figurative schema (he himself was "occasionally," he said, subject to scotomata, perhaps making him all the more anxious to analyze them). But his only results were a few paradoxes, such as

Figure 55
Representation of the "scintillating scotoma" (with letters
indicating colors), Charcot, *OC,* vol. III.

"dazzling" shadows, a formulation he could not tolerate. Charcot saw the
scotoma as a "fortification," he said, "à la Vauban*"[53] (see appendix 15).

Take another example of this passion for using the gaze to penetrate
the intimacy of another's vision, and even the intimacy of his nonvision:
the case of an "abrupt and isolated suppression of the mental vision of
signs and objects, forms and colors."[54] Someone who nearly resembled
Charcot, I mean, a man endowed with a taste for forms and an extraor-
dinary visual memory, came to him because he was experiencing a com-
plete loss of any ideation of form and color. He could no longer "picture
himself," and had forgotten the faces of those closest to him, and even his

*[French military engineer who revolutionized the art of defensive fortifications.—Trans.]

own, which he was unable to recognize in a mirror. He dreamed without images,[55] poor man. We do not know whether this strange, anonymous case was ever cured, but he did serve as material for Charcot as he elaborated concepts dominated by the function of the image: a concept of the *word* as a "complexus" of images ("commemorative image," "auditory image," "visual image," "motor image of articulation," "graphic motor image"); a theory of amnesia and of memory in general as a pregnance of images; and even a science of dreams as a science of intimate images.[56]

In any case, the misfortunes of sight were his chance to see something new.

Dreams (Theaters, Fire, and Blood)

But remember the dreams of fire, image, and jewel-case, the dreams of paintings and the Sistine Madonna. Freud scanned Dora's words, the tangle of the two dreams she poured out to him, and what did he discover? That there was already a schism between the hysterical body and the hysterical dream (the dream of an erotic, a totally erotic, body, but fundamentally unsymbolized, frozen in an image).[57] Freud understood this as the *indirection of representation,* obliging him to follow signifiers not simply by their traces but by the modulations of their detours—this is what it means to interpret.[58]

As for Charcot, he was seeking dramatic unity, not a schism. Rather than interpreting, he was creating a scenography in accordance with the unity of place and time of the most "classical" representation. For him, *everything had to be in the same scene,* a kind of enclosure of visibility, unified for his gaze. He was deaf to noises from the wings or the street behind him. He could not imagine the existence of another theatricality, another style—that of a "private theater" [*théâtre privé*], for example, perhaps deprived [*privé*] of any spectators. For Charcot demanded to watch everything. He refuted the idea, before the fact, of an "other scene" (i.e., a scene that is absolutely inaccessible to the gaze).

Let me note in passing that he was a reader of Hervey de Saint-Denys, author of a kind of staging manual, a guide to directing one's own dreams.[59] A whole chapter is dedicated to the analogy between the dream and the photograph ("memory-snapshots");[60] a frontispiece provides us a "typical" sketch of a dream (a nude woman, ogling men, a painter, etc.) and figures of a few little scotomata in color (fig. 56).

As for Bourneville, one might say that he was honestly attempting to recount everything that Augustine dreamed—the clinic (from *klinē,* the bed) of, if not the key to, her dreams. There were dreams of fire,

LES RÈVES.

Imp. Lemercier & Cⁱᵉ de Seine 57, Paris

Pour l'explication du frontispice voir pages 381, 421 et 422.

Figure 56
Hervey de Saint-Denys, frontispiece plate, *Dreams and the Means
of Directing Them* (1867).

too[61]—dreams of no longer being sequestered at the Salpêtrière, dreams of leaving and attending a "theater where a revolution was being performed,"[62] dreams of blood, often "horrid dreams, the details of which the patient refuses to provide."[63]

Augustine also poured out other words, but to whose ear? "*One thinks one has dreamed* something," she said, "when one has simply heard of it."[64] And we can never know much more about this, because Bourneville, indeed, did not insist.

Visions

Yet Augustine had visions and heard voices, irrepressibly, and something like a secret was not only released but was at play, in an excessive foreground.

With moist lips, she knew that science had lost its ancient conscience beneath a bed,[65] and demonstrated this through a hundred gestures! It became clear that she was falling under the influence of "imaginary visions caused by the body alone," thus pure illusions,[66] and official medicine was most careful to denounce the "false allegations of hallucinating hysterics."[67]

Most often she had visions of rape, blood, more fires, terrors, and hatred of men. They were terrors, of course. But still, what a stroke of luck for psychiatric knowledge spurred on, as it was, by its dramaturgical passion.

I repeat that with these "hysterical visions," a representation* was foregrounded,[68] the same representation I described as being subject to repression. But in this case the repression was condemned to such radical failure that the Augustine-identity fully expelled itself from reality. And the repressed returned with such a fury, like a backfire, in Augustine's worldliness—something like a projection in the strong sense of the word, a projection focalized on an image, a specular image. These "visions," then, were an attack on Augustine's whole being-there through an image "in act," a gesticulated image.

The most intimate and immediate "vision" was played and actualized, like publicly raising the stakes of a spectacle of oneself, of the self—this is what made it possible for their snapshots to be taken (figs. 57, 58). All the more so, as Augustine would often tetanize herself in the very act of the image that her "vision" constituted (see fig. 52).

"Cries of fear and pain, stifled tears; X. . . becomes excited, raises herself, crouches on her heels, her attitude and physiognomy express a

*["*Représentation*" translates the German "*Vorstellung*," rendered into English as "idea" in psychoanalytic contexts. Representation is used here to accentuate its visuality.—Trans.]

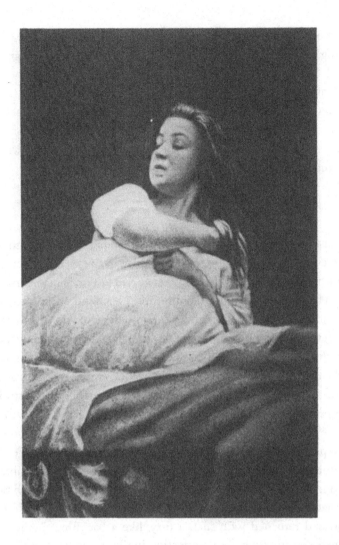

Planche XVIII.

ATTITUDES PASSIONNELLES

MENACE

Figure 57
Régnard, photograph of Augustine ("Threat"), *Iconographie,* vol. II.

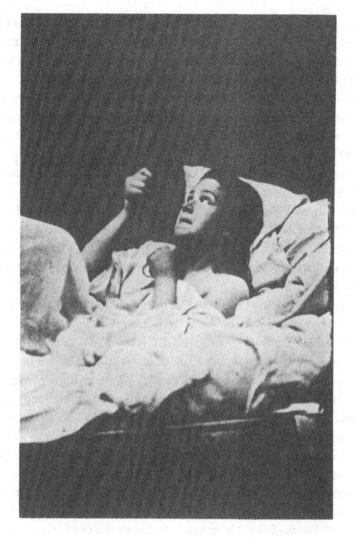

Planche XXVII

ATTITUDES PASSIONNELLES

MENACE

Figure 58
Régnard, photograph of Augustine ("Threat"), *Iconographie,* vol. II.

threat. Plates XVIII [fig. 57] and XVII [fig. 58] represent this phase in two different attacks."[69] What Bourneville passes over in silence is the meaning of this threat—its subject; for in these plates Augustine seems as much to suffer from this threat (fig. 58) as to inflict it (fig. 57).

There are thus things passed over in silence in the commentary, even as Augustine, liberating her "vision" in the appearance of a gesticulation, nearly condemns herself to a narration, a very slightly mediatized statement, of her delirious experience. As if to justify the "forthcoming" image of her in the *Iconographie,* she herself provided a legend of her gestures, with a certain amount of pleasure.

(In this way she did not reach the place where Rimbaud left his tracks: "The hallucinations are innumerable. This is just what I've always had: no more faith in history, oblivious to principles. *I won't speak of it:* poets and visionaries would be jealous. I'm a thousand times richer; let us be as avaricious as the sea.")[70]

Her physiognomy "expressed" a threat, therefore, or because, her mouth was proffering at the same time, almost simultaneously, under Bourneville's pen: "'Dirty beast! Lout! . . . Is that allowed? . . .' She hides her face in her hands, crosses her arms, making threats with her head: 'He gets me in a state! . . . I'll go soon as I can . . . You're giving me frogs.' She opens her mouth and introduces her hand as if to pull something out."[71]

But from there, apparently, there was no retreat. To the contrary, something would race out of control, a hallucinatory infection of all space and all time, so it seemed. Crazed words, crazed organs. She saw black beasts everywhere, "like big rats," or else "flat, black, and with shells."[72] Sometimes the whole world was colored with strange glints. Ghosts populated Augustine's life. She found herself plunged into the heart of dramas she had lived or read about in novels.[73] Suddenly the dead "were roused," and, as Bourneville reports (without implicating himself in any way): "When the men around her speak, flames emerge from their mouths."[74]

Even when Augustine had simple aural hallucinations, she never failed to join a gesture to the word (or music) from faraway places. And the snapshot was all the more convincing[75] (fig. 59).

Her sexual fears were innumerable,[76] but not "iconographed"— why not? While hysterical delirium plays with the fire of the *Unheimliche,* sexual fear so often became an inevitable fate.

But Charcot, full of his clinical descriptions and the taxonomical problems they raised, was not in the least concerned with problematizing anxiety or desire. His attentions were directed toward effects such as the fact that hysterics hallucinate in direct proportion to the territorial structure of their perverse, I mean perverted, aesthesias (to wit, Augustine could

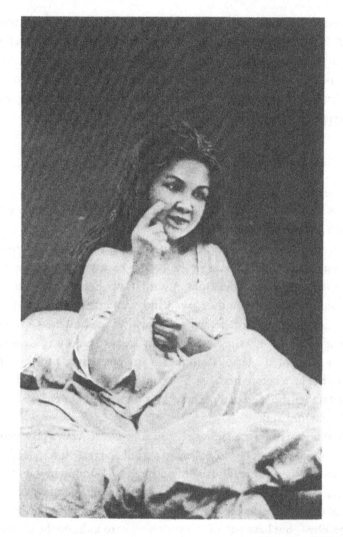

Planche XXIV.

ATTITUDES PASSIONNELLES

HALLUCINATIONS DE L'OUIE

Figure 59
Régnard, photograph of Augustine ("Aural Hallucinations,"
Iconographie, vol. II.

hallucinate kisses only on the right side of her hemianaesthetized body).[77] As for Richer, he believed that his famous chart provided the secret structure of all these so-called *attitudes passionnelles,* by ordering them according to the so very sophisticated and subtle distinction between a "sad phase" and a "happy phase."[78] But he does not tell us what Augustine's "call" refers to, intimately (fig. 60).

Ecstasies

A call, perhaps a prayer, the text of which was fundamentally dismembered. A vision that was too—too mad, perhaps, strangling speech, alarming Augustine's eye.

An ecstasy. *Exstasis, raptus, excessus mentis, dilatatio mentis, mentis alienatio:* attested, traditional forms of the border between madness and mysticism. Of course, Augustine looks upward, clasps her hands together, and so on. Bourneville incessantly evoked and even invoked the great Christian mystics to account for, describe, and justify the combined scandal and beauty of hysterical ecstasies in history. In order to recount "Geneviève's story," he recounted Marie Alacoque's: "She incessantly had the *invisible* object of her love before her eyes. She contemplated him, listened to him; she lived under the spell of a perpetual vision that let her enjoy* [*jouir de*] her celestial husband."[79]

In this way Augustine herself became an *attested form,* a classic or typical form of hysteria in her so-called attacks of ecstasy.[80] It is indeed a crucial moment when a "great form" of nosology (also found in Ribot, Janet, and so many others) comes to be born through a transfiguration of a "great form" of the most "classical" or perhaps I should say "Baroque" religious iconography—but have patience. I simply want to indicate the fundamental complicity between clinical practice and figurative, plastic, and literary paradigms. The Salpêtrière revealed as the enclave of experimentation and the fabrication of "living models" for an imaginary museum that one might have thought was out of fashion—. No indeed—look for yourself (fig. 61–64).

Calls and prayers, perhaps: hands raised toward someone she cannot clasp, but who *is,* and who is separated from her by a space.[81] Perhaps she is praying, begging, or mourning?—No indeed. What we are seeing is obviously "amorous supplication." The call was to a man! "X. . . says: psst,

*[The French *jouir* means to take pleasure or enjoy, but also to reach sexual orgasm. I have indicated where D.-H. exploits both meanings of the term, and retained the nominal form, *jouissance,* in French.—Trans.]

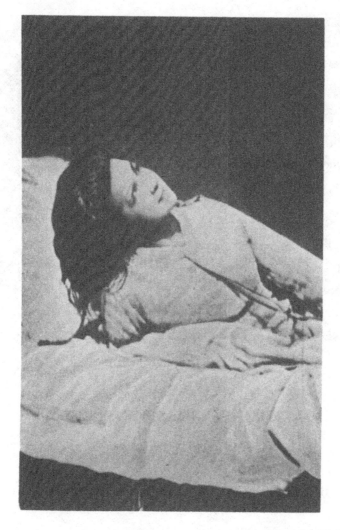

Planche XIX.

ATTITUDES PASSIONNELLES

APPEL

Figure 60
Régnard, photograph of Augustine ("*Attitudes passionnelles: The Call*"), *Iconographie,* vol. II.

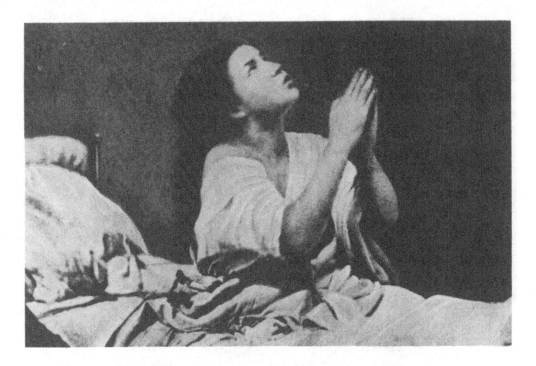

Planche XX.

ATTITUDES PASSIONNELLES

SUPPLICATION AMOUREUSE

Figure 61
Régnard, photograph of Augustine ("*Attitudes passionnelles:*
Amorous Supplication"), *Iconographie,* vol. II.

psst; she is half sitting, she sees an imaginary lover whom she calls."[82]—
And then what?

> He yields. X. . . lies down, staying to the left side of the bed, show-
> ing the place she has made for him beside her. She closes her eyes,
> her physiognomy denoting possession and satisfied desire; her arms
> are crossed, as if she were clasping the lover of her dreams to her
> breast; at other times, she clasps the pillow. Then come little cries,
> smiles, movements of the pelvis, words of desire or encouragement.
> After less than a minute—everything goes quickly in a dream—
> X. . . raises herself up, sits down, looks upwards, joins her hands to-
> gether like a supplicant (pl. XX) [fig. 61] and says in a plaintive tone:
> "You don't want to anymore? Again [*encore*]. . . !"[83]

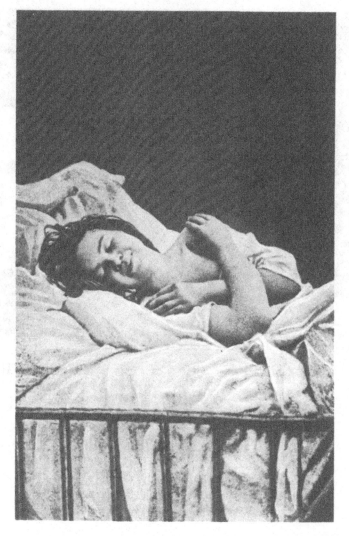

Planche XXI.

ATTITUDES PASSIONNELLES

EROTISME

Figure 62
Régnard, photograph of Augustine ("*Attitudes passionnelles:*
Erotism"), *Iconographie,* vol. II.

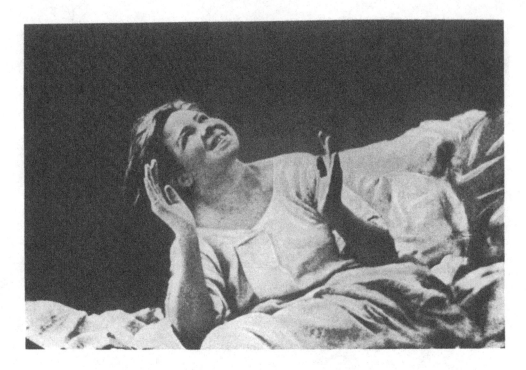

Planche XXII.

ATTITUDES PASSIONNELLES

EXTASE (1876).

Figure 63
Régnard, photograph of Augustine (*"Attitudes passionnelles:*
Ecstasy"), Iconographie, vol. II.

The Infernal Husband

Encore means: from there (*hinc*) to (*ha*) this hour (*hora*). It is perhaps the
word for a very, very old pursuit, temporal and unfathomable, and which
extravasates in *jouissance*.[84]

Artaud writes that in ecstasy a penetration exceeds itself,[85] not in a
retreat [*retrait*], but an attraction [*attrait*], an attraction beyond the self. The
inmost depths, if not stupidity, are uprooted and become sublime. And a
nonrelation is utterly shaken.[86] Listen, too, to *pâmoison* [swoon], with the
echo of *spasmos,* the act of pulling out, attracting to, the act of ripping, de-
vouring, almost rousing the dead in spasms.[87]

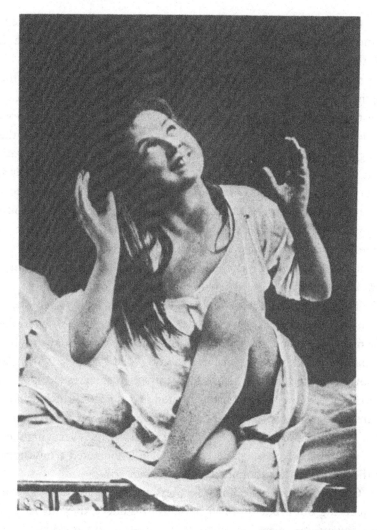

Planche XXIII.

ATTITUDES PASSIONNELLES

EXTASE (1878).

Figure 64
Régnard, photograph of Augustine (*"Attitudes passionnelles:
Ecstasy"*), *Iconographie,* vol. II.

But those of us who share the common lot have only an extreme fascination, always a little suspect, for this movement. For example, the surrealists saw fit to commemorate the "50th anniversary of Hysteria" in 1928 with reproductions of these photographed ecstasies of Augustine, these snapshots of ecstasy, and beginning with the slogan: "We, the surrealists want to celebrate the fiftieth anniversary of hysteria, the greatest poetic discovery of the nineteenth century. . . . We love nothing better than these young hysterics, of whom the perfect type is provided by the observation of the delicious X. L. (Augustine). . . ,"[88] and so on. Once again, they annexed hysteria to a "means of expression," to "art"; they continued to get an eyeful of Augustine's painful gesticulations, the poor starlet. Of course, ecstasy can only fascinate, transfiguring its witness or partner gorgonized by the *encore* into a spectator. Because an excessive call is always addressed beyond those who are present. The call provokes those present, of course, but it is addressed to an Absent—in the very anterior future.

The Absent, the object of the *encore,* is always nearby, invisible, imminent, and lost forever. For example, one of "Geneviève's" lovers died. One night she escaped through a window and tried to exhume his body. She had an "attack" in the cemetery; she was "like a corpse."[89] Years later the lover returned, and, as Bourneville notes (in the present indicative, forgetful of the *fictum*), "they have repeated sexual relations during which she insists that she feels as she felt before: she sweats and her genitals are moist" (present indicative, in the act of verification: he is verifying the efficacy of the *fictum*).[90] Geneviève eventually hallucinated a miscarriage, but the blood actually abounded.[91] Fascinating, no?

Charcot, Bourneville, and the others put this fascination "to work" by squeezing out profits from all sides. To this effect, they invoked religious ecstasy to explain hysterical ecstasy, and in return explained religious ecstasy, its stigmata of all kinds and its whole history, as the hysterical manifestations of pure erotic deliria. This allowed them, among other things, to reduce the existence of this Absent to unadulterated absence, and reduce the lovemaking in "*solitude partenaire*"[92] to the "abolition of the genesial sense,"[93] for hysterics make love with nothing: how could they feel anything? I call this a reduction, especially because the hysterical call, in its relationship with the nothing, remains a provocation.[94]

And because the Absent that is called to is so very efficient: *diabolical.* Rimbaud described exactly this in 1873, lending voice, for a moment, to a delirious woman:

I'm the slave of the infernal Husband, he who ruined the mad virgins. He's that very demon, indeed. He's not a specter, not a ghost.

But I, who have lost my wisdom, who am damned and dead to the world,—I won't be killed!—How can I describe him for you! I don't even know how to speak anymore. I'm in mourning, I'm crying, I'm afraid. . . . His mysterious delicacies seduced me. I forgot all my human duties to follow him. What a life! The true life is absent. We are not in the world. I go where he goes, for I must. And he often loses his temper with me, *me, poor soul.* The Demon!—He's a demon, you know, *he's not a man.*[95]

The Altered Woman* [*La femme altérée*]

And so she lived in the inextinguishable intoxication (that social blight!) of a ghost-encounter, *alfin son tua, alfin sei mio,* finally I'm yours, finally you're mine (from the slow waltz, the ghostly duet in *Lucia di Lamermoor*). But it was grounded in nothing. All she was doing there, poor woman, was deteriorating her pleasure as she found it: this is indeed the definition Kant gives of the hysterical "vapors" that "consume" women, as he says.[96]

For it is the destiny of women, as it is also said, for "their wait to be deceived one hundred times."[97]

In any case, the hysterical attack was "sparked" as if by the literally catastrophic effect (a sudden, evident, visible discontinuity) of a state of crisis, that is, a state of threat generated by the transfinite *expectative* of a *jouissance.* For this *jouissance* was brought on by an Absent; it then became ecstatic in a beyond, that is, in an empty, unpredicated absolute, a radical alterity: a loss, a poignant, tetanized loss.

An amorous state persists in this loss, and perhaps makes it livable. An amorous state animates this expectative even as the expectative condemns the poor soul to immobility. Perhaps this double constraint of waiting and love was necessarily invented as pose, as scenography. As "*attitudes passionnelles*"? In any case, this love remains impotent and narcissistic—though in fact mutual.[98]

For this loss, exclusion, and dilaceration reciprocally indicate something like a *supplementary jouissance,* something that seems to exist, over there, in front, violent, and excessive, but very intimate, signaling the witnesses of the scene: something that seems to supplement the real impossibility of a relation—the "sexual relation"—in ecstasy.[99] If our Augustine is suffering from the "abolition of the genesial sense," and notably from total anesthesia of the right side of the vulva, and if nonetheless we all can see her in her *attitudes passionnelles* enjoying an orgasm [*jouir*], discharging

*[*Altérée* signifies "altered," but also "thirsty," a double meaning D.-H. exploits in this section.—Trans.]

and secreting,[100] must this not mean, dear colleague, that her *jouissance* has some other object?—But of course, dear colleague—Oh, that, dear colleague, that's how women are.

But, gentlemen, of what does this supplement consist? That is the mystery of a signifier, of which hysteria shows itself imperatively and theatrically to be the succubus.

Between the spectacle of this loss and this alteration, and the suspicion of a supplement or an enigmatic *jouissance,* a knowledge of hysteria, fascinating itself, could only lose its head—despite the fact that the neurophysiological model of *jouissance* as a discharge of pressure was developed to deny this tension and alteration, which is indeed of an entirely different kind.[101]

Knowledge, faced with the evidence of a spectacle of orgasm, *knowledge alters* [*s'altère*] too. And, notably, knowledge thirsts for itself, excites itself, tantalizes itself. *What does a woman want:* the question was still unresolved, even if, as a hysteric, this woman seemed able to have fits, accessions, possessions, or invasions of desire, at will. She herself experienced the split between the ordeal [*épreuve*] and knowledge.[102] How might she have expressed it?

"I don't know how jubilation *fabricates itself*!!!—but as for me, I filter it through an abyssal plate."[103] Augustine would never have been given these lines, of course. But I repeat that Augustine, as was central to the "classic" plasticity of her poses, kept her cheek against the plate, that is her face suspended from an abyss of ulterior guilt that ineluctably instilled discord into all her euphoria and feasts of images, into all her exultations and all her smiles.

And perhaps there was something, deep within her, like this:

"I don't care about you at all. I'm afraid I myself may well stop loving someone. . . . I must be guilty before *him* in some very big way . . . only I don't know what I'm guilty of, that is my whole grief forever. . . . And so it's turned out to be true."
"But what is it?"
"I'm only afraid there may be something on *his* part."[104]

Poses of Pleasure (A Double Body [*un double corps*])

I cannot imagine that this guilt, which is already a scission, and this other scission between loss and supplement in *jouissance*—do not affect the spectacle.

How? First by splitting the body into two. Temporally, a pose is extirpated from a movement or tension; a pose is an intermittence, the internal split in the image of bodies.

The reproduction of these scenes, as various as they are unforeseen, is performed by Photography with some difficulty, it must be said, for they follow one upon the other in rapid succession. One must always be ready to proceed and seize the interesting attitude at the desired moment. According to this hypothesis, as in the previous hypotheses moreover, the use of a camera with a two-section bellows [*chambre à corps double*] is recommended, for the patient is constantly moving about and it is impossible to establish focus through ordinary procedures.[105]

In this sense, even the camera obscura, the predatory organ of hysterical passions, seemed to be constrained to a *double body [corps double]*.) This describes, above all, a fundamental scission between *being* and *identification,* with all the heat of the word. But identification in hysteria is so changeable.

A kind of general instability of images is the only possible result—an effect of sheer cruelty. At the moment of the shot, all scissions were linked, tied together, pinned down. They were made hieratic, in a few exposures. Pleasure was condemned to representations, according to the law of the genre.

But, where hysteria is concerned, the representations are particularly excessive, *excessively intense,* said Freud. Every pose obeys them in return, alienated in this intensity. The psychic consequences are incalculable, perhaps unintelligible.[106]

Representation, in the Freudian economy notably, does not "reproduce" an object (an object of desire): *it produces its absence,* and animates its loss. In producing this loss, representation endows it with a value of "supplement" and I would even say with the force not of illumination but of a flash. Representation, in hysteria, would be *jouissance* itself made into loss insofar as the loss becomes event, a visible event, and an eventful event, too.

And that is the nature of a double body: an event of hysterical *jouissance* that is simultaneously open, offered, and indecipherable; and then the intervention, in this aporia, of a spectacle, a semblance.

Affected Gestures

Perhaps hysteria is unintelligible. In hysteria, manifestation cannot extirpate itself from appearance. It sets something of *mimesis* into motion, but something that cannot extirpate art from nature, or, vice versa, *agere* from *facere.* In hysteria, affects are gestures, and gestures are appearances.

Gesture comes from the Latin verb *gerere,* meaning "to produce" but also "to make appear"; to play a character (*gerere aliquem*) but also to

accomplish something, in a real sense. Perhaps this verb does indeed speak to us of facticity. Finally, it means "to pass time."

The hysterical gesture is indeed affected, in all senses. Somehow it is crucified between affectation and affect—and affliction, in the sense of an attack, on the distress of time.

There is thus an *affect*—but what is it? The School of the Salpêtrière recognized a hysterical "mental state"—emotive sensibility was often associated with something called "mental degeneration."[107] At the same time, Breuer and Freud were going further. They were, of course, attempting to establish a link between the visibility of an emotion and the most intimate "intracerebral tonic excitation." They were hoping to formulate, or perhaps formalize the affect in terms of quota. They spoke of the motor expression of affects as a "reflex."[108] But their concept of *abreaction* also tended quite clearly to account for affective motivity through concepts like "wishful states" and "subconscious association."[109] *Language* and *representation* were utterly implicated in the affair, already: "Language serves as a substitute for action; with its help, an affect can be 'abreacted' almost as effectively. . . . In this way a normal person is able to bring about the disappearance of the accompanying affect through the process of association."[110] This, in fact, is exactly what the hysteric is unable to do. The affliction sticks in her throat, spreading itself to all her organs; it remains "fresh," that is, always renewing its cruelty, and it infects all representations, which become pathogenic. "It may therefore be said that the representations which have become pathological have persisted with such freshness and affective strength because they have been denied the normal wearing-away processes by means of abreaction and reproduction in states of uninhibited association."[111]

And then there is *time*. The persistence of the affect clinging to representations is retention, the work of memory. The "contact-barriers" are too fragile.[112] Breuer and Freud proposed this pioneering formula: "*Hysterics suffer mainly from reminiscences.*"[113] And the very concept of the facilitation of pain was seeking its own psychic notion.[114]

Finally there is movement—a certain facilitation of pain, for example—in the "*attitudes passionnelles*" of the hysterical attack. Breuer and Freud ventured the hypothesis that these movements express memory although (or because?), as they said, "they cannot be explained in this way."[115]

Finding oneself in a state of extreme tremors, an interval of unreality, in a sudden decline in the sense of one's movements, even as they follow upon each other—this touches the hysteric like an affect or the effectiveness of a virtual drama (which, in this sense, is far from opposed

to a real one), a drama that memory returns to her, like a backlash or a counterblow.

The First Scene: "Like a Slap in the Face"

A virtual drama: quite distant, past, forgotten in a certain way; very, near, imminent, going on repeating itself.

Charcot used the expression *traumatic hysteria* very early on. He studied, for example, the psychopathological effects of train collisions, the disasters of his day, and ventured a theory of the causal relation between what he called the "nervous shock" and its subsequent symptoms, neurasthenia in men and hysteria in more "impressionable" women.[116]

(In 1898, based on this science of the shock, a law pertaining to industrial accidents was established in order to compensate certain "traumatized" workers; being-traumatized was finally and fully annexed to being-sick.)

The Salpêtrière's brand of trauma dealt in quite simple scenes: "One day, the amphitheater boy brought a head to the laboratory to be photographed. It was the head of a patient who had succumbed as a result of the growth of an enormous tumor, which had occasioned a considerable deformity. W. . . surreptitiously entered the laboratory, and there was no time to cover the head. This caused a violent impression which her imagination then reproduced in her attacks."[117] (And how could she not have lost her head at the thought of having her own portrait taken for the *Iconographie* in the exact same place?)

"A. . . was working in a silk factory, rue d'Enfer, and in the evening she would go to school. Her employer was pleased with her.—One day in April (?) 1875, one of the machines in the factory exploded at her side. Although no one was injured, A. . . , who had her period, was quite frightened. She was struck with a fit of laughter and, after a few minutes, with *hystero-epileptic attacks.*"[118]

And the passion for the *picturesque* went even further: Charcot had some of his patients draw their own personal traumatic scene, such as the lightning that made one man become nervous, made him a hysterical madman. Charcot had this scene re-engraved for publication in his Tuesday Lectures.[119]

The mute attack of family dramas was less dear to his "clairvoyant" mind. But it was there, and ineluctable. So he would take it into consideration, but with a kind of detachment (we will see later that he theorized and instrumentalized this detachment), and sometimes even with, how shall I put it, perhaps with a sense of humor:

(A person is accompanying the young woman of sixteen.)

M. Charcot: What's your relation to her?

Answer: I'm her friend.

M. Charcot: Well now, what about her mother?

Answer: Her mother is dead. She has a step-mother, but she can't live with her.

M. Charcot: You see that step-mothers must be included as one of the causes of chorea. In this case, the step-mother might be one of the occasional causes.[120]

But he often remained perplexed. A certain woman gives her child the most benign, ordinary slap [*coup*], and she becomes totally paralyzed: why?[121] Can trauma be occasioned by something insignificant, or something that only almost happened, or even something merely in the imagination of hysterics?[122]

In fact, the frequent discrepancy between the effects and the presumed traumatizing cause (here a shock, there a symptom) was one reason among others that Charcot was led to consider the event, the "blow" [*coup*], as a mere "*agent provacateur*" of hysteria.[123] Heredity continued to be the decisive factor.

This same discrepancy or "disproportion" was precisely what drew Freud to hysteria.[124] He annotated Charcot's descriptions of the hysterical attack, describing the "*attitude passionnelle*" as an effect not of a trauma but of the *memory of a trauma*. In a certain sense he began quite simply by transposing Charcot's "physical" determinism into the "psychic domain."[125]

Moreover, he took the hysteric at her word. He understood that a simple sentence could be "like a slap in the face,"[126] that it is still a blow [*coup*], a real blow, and that the face may indeed bear its trace in some way or another. Freud saw that certain hysterical contractures—as in the case Elizabeth von R. . . who found herself "rooted to the ground"—could be the *image-act*, if I may be allowed the term, of old terrors.[127] He did not refute the inverted temporality of the trauma's power. Rather, he interrogated this inversion as the strange operation of memory.[128] He also attempted to understand the no less strange proclivity of these traumas to be summoned up in the actuality of hysterical symptoms.[129]

In short, even when he recognized the trauma as a fragment with reference in the real, Freud questioned it through its effects of meaning, through its displacements in memory.

The trauma as an incident[130] thus lent itself in its concept to the play of its literal meaning. For within it is *incidere*, with a short "i": *in-cado*, to fall by chance, descend on, arise, or suddenly become the prey of some-

thing (*incedere in furorem et insaniam:* to go mad). And *incidere* also, but with a long "i," is *in-cædo,* the verb of gashing and incising, cutting and engraving at the same time, the violence of a wound—the permanence of a stigma, of writing, of a sentence. Freud interrogated trauma as a *signifying event.*

Repressions and Reflux of the First Scene

There is a subject for time, but not the converse. What delivers the subject to effectivity is memory; memory itself liberates the untimely—the untimeliness of a symptom, for example.[131]

That hysteria is primarily an illness of reminiscence means, in the first place, that memory is at fault in hysteria. Article forty-two of Bergson's *Passions de l'Ame,* "How to find the things in one's memory that one wishes to remember,"[132] is thwarted, and the "photographic focusing" that fixes in the memory, à la Bergson, is no more successful.[133] Charcot, of course, often examined cases of "retrograde amnesia" following nervous shocks. He considered "anterograde amnesia" (the impossibility of "registering" actual facts in the memory) to be a hysterical-type symptom, because, as he said, "this amnesia is, in reality, only apparent."[134] Apparent, but effective. Charcot, faced with the extreme lability of hysterical amnesia, drew on a "territorial" concept of memory, derived from Gall and Ribot, a concept consistent with the anatomo-clinical concept of "*partial memories*" that are relatively independent, linked to concomitant "centers" in the brain that they hoped to localize down to the least convolution.[135]

But there are also hypermnesiacs, for whom repetition is like an erotics. In hysteria, there are also *excesses of memory:* subjects delivered to memory, effectivity, untimely effectivity; *attitudes passionnelles*—the violent reflux of the "first scene," a restaging.

It is remarkable that Freud did not understand excess and fault in terms of what they constitute, in clinical terms: a contradiction. He related them both to the single (nonclinical) concept of *repression.* As early as the *Project for a Scientific Psychology* Freud understood obsession and hysterical amnesia as two effects, always *displaced,* of the same repression, and "we might think, then," he writes, "that the riddle resides only in the mechanism of this displacement."[136] This, in any case, is why *representations* remain so "fresh" in hysteria, so "excessively intense," so "effective," although they are in fact inaccessible to the ego.[137] In hysteria, representations are fatal; they are the destiny and punishment of a subject,[138] at the same time that they deprive and satisfy a memory.

Conversions of the First Scene

The "first scene," the so-called traumatic scene, is already a signifying event because it *displaces itself.* A signifier attacks the subject in its entirety—body, word, past, the advent of its destiny. Something that displaces itself, and escapes.

The hysteric says: *non memini,* meaning: "I remember not knowing it in the past,"[139] but once remembered, this poignant ignorance arises yet again, as a decline in the hysteric's feeling of her gestures, even as they are carried out, exhausting her, in the form of *attitudes passionnelles.*

The "scene" is also, in a sense, like an "idea,"—I mean, in the sense that ideas do not go without limbs [*membres*], and then they are no longer ideas but limbs, limbs waging war between themselves, for the mental world was always only what remained of an infernal plodding of organs.[140]

There was an immense aporia between the "organic" and the "psychic." Every hysterical symptom exhibited, flaunted, and displayed this aporia, for an often mute physician: an almost-farce, infernal snickering, nonknowledge's nasty challenge of knowledge.

In this aporia, Charcot attempted to make a drawing or outline of a border, a rememberment of territories. He had to bend (or carve up) bodies into the spatiality of his concept. Freud took an entirely different theoretical risk. He flung out the word "conversion" and then chased after it for a very long time. Freud ran "after" conversion, as they say, and his *oeuvre* contains no less than three conceptualizations.[141]

This is because any attempt to define a causal chain of hysteria is embarrassing, and betrays itself. Admittedly, the "work" of the formation of hysterical symptoms can be ascribed to a few analyzable mechanisms and operations, including "regression," "condensation," "subtraction" (from consciousness), "detachment," and "innervation" (of "mnemic symbols").[142] But something remains ineffable—the thousand and one itineraries of "conversion" and its intermittences, a hodgepodge of visibilities that result from the raw, essential, but enigmatic fact that a drive comes to present itself in *attitudes passionnelles.* A whole hodgepodge of spatialities, which are neither quite real nor quite imaginary.

"Conversion" in fact describes a causal paradox. How does hysterical visibility "cause" itself [*se causer*], how does it speak to itself? Note, in this regard, the prudence and fragility of the Freudian metaphor of the *festoon:* "I suspect that we are here concerned with unconscious processes of thought which are twined around a pre-existing structure of organic relations, much as festoons of flowers are twined around a wire; so that on

another occasion one might find other lines of thought inserted between the same points of departure and termination."[143]

Screens of the First Scene

So where might one find the center, the heart, the kernel, the *Es* of a festoon?

Many hysterics spout out their "first scene" in simple, honest words, with what is known as a wealth of details. The narration itself derives a certain shock effect from this wealth. The delirium is too precise, it would seem, to be merely delirium.

Bourneville camouflaged his indecision, in Augustine's case, by placing the story of the "first scene" under the rubric of "further information" (and he does not cite all his sources). It is question of the rape of Augustine, then thirteen and a half, by "C. . . ," her employer, in whose home she lived, and who was, moreover, her mother's lover.

> C. . . , after making her all sorts of dazzling promises and giving her pretty dresses, etc., seeing that she would not give in, threatened her with a razor. Taking advantage of her fright, he forced her to drink some liqueur, undressed her, threw her on the bed and consummated relations. The next day L. . . was unwell; she had lost some blood and had pain in her genital area and could not walk. The following day she came downstairs and, since she refused to kiss C. . . as was customary, and turned pale at the sight of him, Madame C. became suspicious. During the meal, C. . . continually threw her threatening looks to keep her silent. Since her malaise continued, it was attributed to the first appearance of her menses. L. . . returned to her parents' house. She was vomiting and had stomach pains. A physician was called and he too, without examining her, thought she had begun menstruating. A few days later, L. . . was lying in her room and became frightened when she saw the green eyes of a cat looking at her; when she cried out, her mother arrived to find her utterly terrified and bleeding from her nose. Then the *attacks* broke out. . . .[144]

One must try to understand how Bourneville managed to form an idea of the scene's veracity, given the classic concept of hysterical fabulation.

Confronted with all of Augustine's allegations (most often proffered during the delirious period of the attack), he must at some point have asked himself the simple question: are they true or not? Although the hysterical symptom was finally recognized by Charcot in its specificity, the problem of the simulating subject remained, and all hysterical speech

demanded, methodologically, to be put through the test [*épreuve*] of regulated suspicion.[145] Physicians were always wary of fabulation, considered, as I said, to be typical in hysteria, and they would therefore become inquisitors for the occasion, interrogating family and witnesses for verification. Verifying a rape, already long passed, is difficult. If true, it still cannot explain the nature of the symptoms (and can only barely explain the content of certain deliria). If not true the problem becomes more pointed, given the ineluctable persistence of traumatic effects.

Verifying an absolute past is difficult. Augustine nonetheless reassured her physicians as to the exactitude of her "scene" because the image she advanced, as one advances an argument for one's defense at a trial, was coherent: the "quality of the image" was the proof. It gained credence.

But, let us turn once more to the devil's advocate. Freud, on this point, complicates the task of any truth seeker. He tells us about the most precise and coherent memories, memories that are perfectly "focused," with a wealth of detail—he speaks of them as *screens* (a word that in 1864, doubtless through the extension of photography, took on the entirely new meaning of a surface on which a projected image can be reproduced).

The "screen-memory" is the hypothesis of a strangely strategic image in memory. It emerges as distinct, formed, and precise, although its only aim, says Freud, is to evade, deform, and displace. For it doesn't actually "emerge"; it forms itself, meaning that it also modifies forms. Its aim is to allow the "essential" (the real, in a "first scene") to be forgotten.[146] The question of whether this image is "true" or "false" is no longer relevant; it is a problem of truth and not veracity.

This image is a compromise turned into figuration, a displacement of affects and intensities onto an "inessential" image. It thus deploys a temporal manipulation, becoming, alternately, retrograde and anticipatory. It is in clever symmetry, as it were, with hysterical amnesia. It is a trick of memory, but still a memory. It is, writes Freud, "the key to understanding [the symptom's] formation."[147]

It is the image turned legend,[148] the (overly) precise legend of the symptom, and thus corresponded to the style of the *Iconographie*. But it is wholly alienated from the symptom: it is the fantasy of the symptom's unfolding or even its explication, a festoon that is only imaginary.

Après-coups

After this detour, I find myself faced with a paradox, the same paradox: the most evident visibility, in which to bear a legend is almost to "go without saying," this evident visibility of *attitudes passionnelles* (figs. 57–65) is

the very same visibility that now seems to thwart all knowledge of or will to veracity.

For these images are, admittedly, coherent; they convey a meaning—and what a meaning. But their very stability hushes up the displacement that was in fact their ground. This was their strategy, and their coherence thus entails something abusive, duplicitous, and fallacious.

How so? Perhaps in the manner of a rebus? If the symptom in hysteria makes use of images and attitudes, it is because hysteria itself behaves, says Freud, like an image, an image of memory.[149] The symptom, he writes elsewhere, but only a hundred pages away, the symptom is like a symbol.[150]

Here again is a causal paradox of the formation of the hysterical symptom as Freud envisaged it, around the time of Charcot's death. The "first scene" (the "trauma" in fact) is effective only when it first unfolds in an inextricable chain of memory, in multiple associations, in symbolization.[151] And the image, and here I mean the symptomatic ostentation of *attitudes passionnelles,* the image shows itself to be an agency of overdetermination, that is, the "very complex work," says Freud, of signifiers in the logic of a time.[152] It is borne by and bound to multiplicity, and sets the time of its manifestation trembling.

The "first scene" is wholly diffracted, thus wholly fractured. Farewell to the unity of time and place. A certain mystery thus abides regarding the meaning of Augustine's *attitudes passionnelles.* The mystery might be, in the end, the mystery of the event: "action merged with a wishful idea," "*a representation of desire.*"[153]

Desire, representation, activity: this "fusion" rattled everything in its passage, in its "facilitation." Desire: Freud was obliged, as it were, to dialectize desire beyond Hegel, and always to further diffract the representative unity of "first scenes," of which the *attitudes passionnelles* are replays. Freud gave the name of fantasy to the logic of this diffraction and the "fusion" of act, desire, and representation, wreaking havoc with the notion of the symptom: "hysterical symptoms are nothing other than unconscious phantasies brought into view through 'conversion.'"[154]

If the "scene" is primal, this is above all because its *drama* (act, desire, representation) is already an *economy* of drives. If the *attitude passionnelle* frustrates, overwhelms, and corrupts its legend, this is because its *dramaturgy* is *crystallized* (concretized, petrified, shattered, diffracted) in the return or interruption of an unconscious fantasy that, through the symbolic event of the return, marks the agonizing real of a hysterical attack.

Irruption: one might recall that as early as 1892, Freud announced in precise terms the central nature of the *attitudes passionnelles* in the hysterical

attack. He said that they bear the whole meaning of the symptom; he said that the meaning of *attitudes passionnelles* creates a scene through the "return of memory."[155]

Crystal: "The attack becomes unintelligible," he wrote seventeen years later, "through the fact that it represents several phantasies in the same material simultaneously—that is to say through *condensation.*"[156]

Straying:

> A particularly extensive distortion is effected by an *antagonistic inversion of the innervations.* This is analogous to the transformation of an element into its opposite, which commonly happens in the dream-work. For instance, an embrace may be represented in the attack by drawing back the arms convulsively till the hands meet over the spinal column. . . . Scarcely less confusing and misleading is a *reversal of the chronological order* within the phantasy that is portrayed, which once more has its complete counterpart in a number of dreams which begin with the end of the action and end with its beginning.[157]

If a scene is called "primal," it means that the event is in no way confused with effectuation in reality: the "origin" of hysteria is already a proton, a *pseudos,* which is not a falsehood but an invention: simply a deferred action [*après-coup*]: "A memory is repressed," recounts Freud, "which has only become a trauma by *deferred action.*"[158]

And the present of the image in the *attitude passionnelle* is perhaps itself only the *après-coup* of an *après-coup;* its "plastic regularity," in any case, to whatever extent it induces meaning, is but a very fallacious crystal.

Assaults

And yet, evidently, the present of the attack is very violent: arms and legs in twists and turns, piercing pains—Bourneville called them exacerbations.[159] As for Augustine, she was prey to incessant deliria of rape: "Pig! Pig! I'll tell Papa . . . Pig! How heavy you are! . . . You're hurting me. . . . C. . . told me he'd kill me. . . . That thing he showed me, I didn't know what it meant. . . . He spread my legs. . . . I didn't know it was a beast that would bite me"[160]—and yet, it bears repeating, these moments were not once deemed worthy of being photographed, or at least not worthy of being printed.

Nonetheless, Augustine would replay her rape, replay it *après-coup.* But what does *replay* mean? And what is the efficiency peculiar to an *après-coup?*

To replay is to punctuate, underline in some way, put back, add, force the spectators of the scene to "call a spade a spade," which in the end

is not so easy, for it makes one think that "*pour faire une omelette, il faut casser des oeufs. . . .*"[161] In short, it means that to make a "plastically regular" Augustine, there has to be at least one first scene; so that, in front of everyone, on the stage, facing the lens, there could be a replay of the "shameful action," the "affair," the "abuse," the "adventure"; so that, in front of everyone, it remains what it was or what it should have been—"battle," "brusqueness," "low dance," and so forth[162]—that is, here, *a rape.*

(And it is hard not to imagine that Augustine, through her memory of such assaults, must have found it terrifying to see the faces of a public all around her, undressing each of her *attitudes passionnelles* over and over?)

Freud came to believe that the specificity of hysteria's cause lay in a precocious and cruel experience of sexual assault,[163] which symbolizes itself,[164] and replays itself in a "converted" form in the attack.[165]

And Charcot?—He was supposed to believe this as well, though he never mentioned it; this is suggested by the famous anecdote of an aside between Charcot and Brouardel during a reception, surprised by the young Freud's sharp ears. Charcot murmured: "But in such cases, it's always a question of the genitals—always, always, always." Freud recounts that "he crossed his arms over his stomach, hugging himself and jumping up and down on his toes several times in his own characteristically lively way. I know that for a moment I was almost paralysed with amazement and said to myself: 'Well, but if he knows that, why does he never say so?'"[166]—He never said it, because his will to know, to have a few "plastic regularities" before his eyes, this will to knowledge was also perhaps a will to evasion.

How did he manage to evade the meaning that Augustine incessantly shouted through the halls of the asylum: "Get rid of the snake you have in your pants . . . It's a sin. . . ."[167]?

For the hysteric incessantly repeats her misfortune, not only by replaying it, but also by always reconvening its emergence. Then the hysteric invents a generalized assault, an assault on all modesty: "Addressing one of the assistants, she abruptly leaned toward him, saying: 'Kiss me! . . . Give me . . . Here, here's my. . .' And her gestures accentuated the meaning of her words."[168] Bourneville, taking the scene down in shorthand, hesitated in his note-taking and affixed suspension points, out of propriety or "etiquette" one might say. He was shocked—no?—by the obscene kowtows (sometimes he would refer to them as "salutations")[169] of which he was certainly, one day or another, the martyr or lucky recipient.

In any case, there proves to be a kind of feat figured in a hysterical attack, around which a whole kind of psychiatric knowledge was fluttering and panicking, sometimes worrying, often reassuring itself; for in this

repetition of the sexual misfortune, the rape, Augustine did not only play her "own" role, which would have been pain or mere "passivity." She merged her own suffering with the aggressive act, she would also play the assaulting body,[170] and her fear was overtaken by a kind of intense satisfaction—an autoerotic satisfaction.[171] And a fascinating satisfaction.

This merging is a true feat of plasticity, a veritable feat of theatricality: two bodies in one, a body in which "the woman is not only inwardly united to man, but hideously visible, agitated as they are in a hysterical spasm, by a piercing laugh that convulses their knees and their hands," as Proust wrote.[172]

The hysteric thus has no role of her own. She assumes everything, an omni-actress of her memory; she is very far from being the picture of innocence.

Obstinate Shreds of Images (Paradoxes of Visibility)

And yet her whole destiny, as I have already suggested, is a punishment through images. An act she is forced to perform, all the movements of all her limbs executed beyond her will, with a view to a representation of which she is utterly unaware (it is an unconscious representation),[173] but which stubbornly makes use of images, of *attitudes passionnelles*—this is the sort of punishment she carries with her.

She tries in vain to attend at every moment to the appearing of her body, to twisted and violent putting-into-act of the fantasy, which short-circuits all speculation and all speech; and this putting-into-act, the "motor language" of the attack, stubbornly persists at the heart of visibility, but at the limits of the analyzable.

The anxiety of the hysterical body, the incessant motor anxiety, functions as *plastic obstinacy*, though always fragmentary, always guilty and painful. Thus this anxiety can nonetheless call to the gaze.

It calls to the gaze by its very paradox of visibility. The paradox: the *attitude passionnelle* contrived a *jouissance* in the replay of a torment. Quite precisely, it replayed exactly what the hysteric feared to suffer and resuffer, by madly displacing organs, limbs, and space itself. A sexual relation was always attempted, but only with the Absent, and all that remained were a few sparse fragments of pleasure. All *jouissance* was suspended, although or because it was figured in this way, and the symptom itself finally yielded a cruel gain, like the shady return of the suspension.

Another paradox: every *attitude passionnelle* is profoundly "illogical."[174] A coherent body was only dreamed of, always diverted from rhythms to disasters—and then reembarking from metonymies, desires, and dreams

of an other, coherent, and inhabitable body. This body, delivered to its exacerbations, inhabited an imaginary space; but imaginary does not mean unrealized here, for gestures indeed take place. Imaginary means that the drive as such cannot be realized, and the fantasy cannot be figured. This is the rift and misfortune of hysterical visibility.

The hysteric, writes Freud, attempts to escape, "constantly switching his associations . . . into the field of the contrary meaning."[175] And the paradox that is being constructed plastically acts [*agit*] and shakes [*agite*] an entire body: "In one case which I observed, for instance, the patient pressed her dress up against her body with one hand (as the woman), while she tried to tear it off with the other (as the man). The *simultaneity of contradictory actions* serves to a large extent to obscure the *situation, which is otherwise so plastically portrayed* in the attack, and it is thus well suited to *conceal* the unconscious phantasy that is at work."[176]

Paradox of evidence, paradox of temporality: for here it is memory that twists time, leaving it trembling between the indicative and desiderative, forcing absolutely heterogeneous series to coincide;[177] it is a fallacious strategy of memory, nonetheless taking a spectacle to its height: perfecting it, twisting and exceeding it.

Finery and Diversions

A spectacle at its height: this also means that the hysterical body demands (rather than uses) a kind of theater, which the art of theater itself would have trembled to encounter, so rawly does it stigmatize a painful kind of theatrical essence. This essence is taken to its height. Thus an art hurries along, madly impatient, passing through the experience of the absence of an end, idling in the very extremity of its act.[178]

Remember also: "The scene illustrates only the idea, not an effective action, in a vicious but sacred hymen (from which the Dream proceeds) between the desire and its accomplishment, the perpetration and its memory: here preceding, there recollecting, in the future, in the past, *in the false appearance of the present.*"[179]

Facticity. Even in idleness, facticity. It is a kind of temporal antinomy of an imitation to the extreme. The Freudian *Darstellbarkeit,* or "capacity for staging," here thoroughly dramatizes each real pain as a fiction of the primal scene, propelling the body of pain into the cruel, transfinite pleasure of a body-actor. (Diderot was suspicious of this "contradictory simultaneity" of temporalities in hysterical delirium: "The woman," he writes, "bears within her an organ prone to terrible spasms, which uses her and arouses ghosts of all kinds in her imagination. It is in hysterical

delirium that she returns to the past, hurls herself into the future, and that *all times are present to her.*")[180]

Gilles de la Tourette, at the Salpêtrière, proposed this historic axiom in his great treatise: "Nothing that is the symptom of hysteria itself can imitate hysteria."[181] *Mimesis* is the hysterical symptom par excellence. Hysteria is considered to be "a whole art," the art and manner of "theatricalism," as is always said in psychiatry, and which no theatricality is strong enough to equal in its swaggers.

Hysteria reveals itself in histrionics and a tragic mask turned flesh; and at the same time there is a veil, dissimulation; and at the same time a naive, sincere gift of multiple identifications.

A hysteric will repeat anything she hears around her;[182] a hysteric wants to be everyone, or rather she wants to have the being of anyone and everyone. But she only seems to want this, in a perpetual distraction, smashing all roles into pieces. Freud tried to understand this obstinate, unfortunate deviation of identifications: in hysteria they are terribly partial, the regression and "place-taking" of an initial "erotic penchant," as he says, but this is only an incoherent "tie," disseminating itself, always antagonistic (one would expect instead a certain coherence of roles in identification, because this is how the "personality" is supposed to organize itself).[183]

An actress could never go as "far" or as "deep" as a hysteric, in whatever role she inhabits. Blood always comes of its own accord (a wound opens inside the body!) in the hands of a hysteric "playing" a saint affected with stigmata. But a hysteric, for whom a single role is by no means sufficient, wants to play everything, wants to play too much—and thus can never again be credible.

Finally, a *misfortune of identity* forever hollows out this play of surfaces laced with exhausting, multiple identifications. This is precisely why, writes Freud, "the attack becomes obscured."[184]

Yet the *attitude passionnelle* is an absolute gift, an open gift—a gift of images, of course, but so generous that something more is abandoned. Bourneville expressed the ostentation of Augustine's pain by writing that she "offered" one symptom, then another symptom, and so on.[185]

Augustine was feigning "for real"; this paradox of the actress nearly dismembered her. Her body seemed to repent this very feint, and yet her body was as if already painted, that is, departed though apparent. That is, photographed. All her portraits were generously and efficiently constituted out of this feint and this fault.

Perhaps I can clarify the word *feint* through the word *makeup* [*fard*]. "Everything that adorns a woman," writes Baudelaire—by way of a eu-

logy?—"everything that serves to illustrate her beauty, is part of her," and a few lines later, there is a eulogy of makeup:"The *nothing* embellishes that which is."[186]

It is as if makeup were not only visibility, but also time, duration, destiny, and I do mean destiny—a woman's destiny (recall *The Demons*: "It was obvious that Mlle. Lebyadkin used white makeup and rouge on her face, and wore lipstick. . . . She just sits like that, alone as can be, literally for days on end, without moving; she reads the cards and looks at herself in the mirror").[187] Would *putting on makeup [maquillage]* be a making (the etymology of *maquillage* indeed designates a "making," and only a "making"), a woman-making? A hysteric-making?—The confusion itself speaks volumes.

And as for Augustine:

> Everything about her, moreover, announces the hysteric. The care she puts into her toilet, the arrangement of her hair, the ribbons which she is so happy to don. This need for ornaments is so keen that if in the course of an attack there is a remission, she takes advantage of it to attach a ribbon to her garment; this distracts her and gives her pleasure: "When I'm bored," she says, "all I have to do is make a red knot and look at it." It goes without saying that the sight of men is agreeable to her, that she likes to be seen and wants to be coddled.[188]

What does that "moreover" mean? Read the preceding paragraph: "The history of X. . . shows us to what extent she was neglected in childhood. Her mother's behavior and the relations that the brother established between his sister and his friends explain in large part the loose conduct of the patient."[189] Is this a moral retreat on the past of the physician when confronted with a thing that is also his iconographic mine, the hysteric's vocation for adornment?

A moral retreat, or perhaps mere "scientific" perplexity, the perplexity of knowledge when faced with hysterical desire. What in fact is her aim in adorning herself? Of what *jouissance* is the image she offers *(attitudes passionnelles)* the remainder, the orthopedics, or the diversion?

And why does the hysteric's *extreme narcissism* oscillate between giggle fits and pain, spasms, and sometimes death? Might adornment be the diversion of death?

La solitude partenaire

And me—whatever happened to me? The *attitudes passionnelles* left me there, procrastinating before these photographs, before a frozen temporal

complexity, before the complexity of the relationship of (contradictory) gestures to (multiple) fantasies and to (paradoxical) figuration.

What is the hysterical fantasy calling, in its gesture-making turned into debauchery, always turned into spectacle? Perhaps it is in fact calling *the very situation of the spectacle,* its lewd intersubjectivity that always verges on scandal, as on debauchery, provocation, and proximation—but always, or almost always, maintained within the limits of a photographically frameable visibility, the limits of a distance or separation that can be regulated.

My hypothesis is that for a time, the photographic situation was as providential for the hysterical fantasy as the *attitudes passionnelles* were for the iconographic fantasies of Bourneville and Régnard. A certain proximation, a certain separation; a frame, an embellishment (finish, iridescence, ornament, demarcation).

Augustine was nearly dancing in front of Bourneville and Régnard. She winked at her own contortions, but veiled the emergence of her delirium, which she perhaps witnessed. But she was also playing this dissimulation—no?—though she endeavored to be the model of truth (the truth of one of Charcot's concepts, "hystero-epilepsy"); though she was condemned to miming a too partial, too changeable identification; though she was condemned to the very simple pain of a true symptom.

In this perpetual chain of semblances, supplementing, *recalling* her real misfortune, any sexual relation is impossible except with an Absent, that is, with Nothing. The chains and adornment of semblance were the only bearable part of her misfortune: *existing, for others, at least as a spectacle.*

Augustine was looking to *mimesis* for a remedy for *mimesis,* for its incredibility: the paradox of an actress who does not know of what spectacle what she is the model, mannequin, or star [*vedette*] (in *vedetta,* moreover, you will find sight—*vedere*—as well as the veil, *veletta, vela*).

She constrained and bent her whole body into a kind of triviality of appearance: appearance as spark and shine; appearance as appearing, the "*ad-parence*"; appearance as illusion.[190] All the same, it still made an apparition, meaning that on each occasion *something* took place, shaking and stunning all space. It was an event of the image that could not be pacified, the meaning of which could not be developed because it always escaped, right in front of you, photographer, right under your nose, a duplicitous event, the unpacifiable duplicity of veiling and of a cruel nudity that always put one at a loss.

For example, "Geneviève" invented a rival for herself (in regard to her absent lover), and even wrote her letters: "Salpêtrière, December 28, 1878. Madame, ah Madame! Can you ever forgive me, for I have indeed wronged you; for I can see you know everything; I'll be frank with you,

I'll confess everything. Do you remember, on the evening of August 15, *the veiled woman* you saw leaving your room, whom you let pass? Well, *that was me. . . .*"[191] Then "Geneviève" took off all her clothes, and made love with some ghost, "subsequently maintaining that it was Monsieur X. . . who had taken off her shirt."[192] And then, in front of Régnard's camera, she again donned the long black veil of, as they said, her "sorrows."[193]

What was this stubborn, immutable movement if not a movement of desire? Bourneville spoke of the hysterics' "brilliant gaze" of a "kind of particular excitation"[194] that held them without respite, until they were overcome by crises, fainting fits, or deliria.

The spectacle of the *attitude passionnelle* was thus like the formalism of desire, the signifying event of a relation to the Other.

In the first place, it is separation: nonreciprocity (the hysteric veils herself in shreds of roles, and the psychiatrist, in the shadows, says to himself: "She's showing me that, but what does she want?"); adornment and partition (enigmatic partiality of identifications); and finally, "torsion in the return,"[195] the alienation that Augustine made into a spectacle and paraded in front of her physicians. This alienation offered itself as a living dialectic of gazes. She fatally interrogated the viewer's gaze, crudely interrogating the fantasmatic—yes, fantasmatic—meaning of his "scientific" position.

This, perhaps, is the hysteric's whole strategy concerning the spectacle of symptoms that she, long suffering, offers: *she defies the spectator's desire, she consecrates and defies his mastery.* As if she were aiming a spotlight (projector) on this spectator who, until then, thought he was safe in the velvety darkness of his seat in the orchestra; yet she is only explaining to him, through unwonted gestures, that the quality of her own pain will bend to the pleasure of his own figurative desire. But the effect of this *expli* is fundamentally very cruel.

She entirely loses herself in the spectacle, demanding that every spectator be a true director. With clamors, cries, and convulsions, she demands to *sustain the desire of others.* But the cry of this demand resonates, of course, as challenge, farce, malice, mockery.[196]

And this is how the terrible solitude of the *attitudes passionnelles* becomes a *solitude partenaire,* which is no less terrible in a sense: a partner of the gaze, present here and now, of an other.

The hysteric was calling an Absent, of course, but with her ostentatious smiles at no one, she was also seeking an "incentive bonus," *Verlockungsprämie,*[197] that nonetheless turned her unhappy smile into a smile for someone. Even her mockery remained in this interstice. Who then was she addressing (fig. 65)?

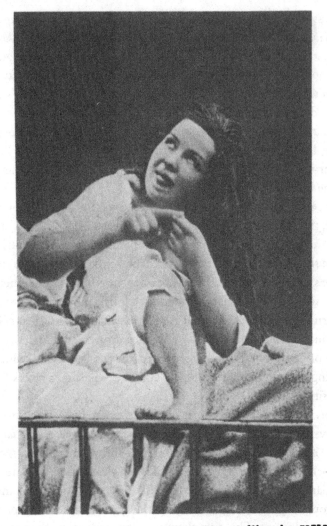

Planche XXVI.

ATTITUDES PASSIONNELLES

MOQUERIE

Figure 65
Régnard, photograph of Augustine ("*Attitudes passionnelles:*
Mockery"), *Iconographie,* vol. II.

Here is the supplementary pleasure: *a gaze.* It is nothing at all, of course, but it is a treasure added to the Nothing of the relation attempted through crises and misfortunes. Thus, "the hysteric poses herself as a sign of something in which the Other might believe; but to constitute this sign she is quite real and the sign must impose itself at any price and mark the Other."[198] For example, Augustine treated herself to *jouissance,* imposed it on herself, and thus climaxed, and her "a-void-ed" [*à-vide*] *jouissance* was diffracted into the *jouissances* of others (including us, beyond her death) at seeing hers, or at seeing her lose herself in a (masquerade of) masochistic passion.

In any case there is an imaginary pairing of the hysteric and her image-taking physician.

The *attitude passionnelle* is thus a theatrical drama that doubly aims for an impossible relation: either a relation takes place, but with Nothing (with the Absent); or the one present, the witness—Régnard, for example—is there as a spectator lost in the suspense of whether he will or will not become a leading man to his *prima donna,* still alone on stage.

The Desire to Captivate

In a certain sense, the hysteric foments the desire of the Other.[199] But she hallucinates it, knotting the recognition of this desire to her own desire for recognition, and she naturally deludes herself (neurotic captation) as to the meaning of the other's desire. She is thus bound to networks of infatuation, the law of the heart, and narcissism, because her whole strategy speculates in imaginary hypotheses.[200]

And she remains the captive of a situation, the spectacle (of her body), thinking that through a choreography of convulsions and "*attitudes passionnelles,*" she can *incorporate all gazes,* all the possible and imaginable "*libido spectandi;*" thinking she can become "a kind of idol, perhaps stupid but dazzling and enchanting, who holds destinies and wills suspended in her gazes,"[201] her gaze dreaming of creating a master-gaze in its own image. In short, she dreams of being the feminine idol about which all men dream.

Although captured, alienated, and illusory, this strategy can quite often function efficiently. Sometimes the hysteric is fatal, a *femme fatale,* to her physician; sometimes she captivates him.

For her intrigues are refined and terribly intelligent. She has an almost scientific experience with the *given-to-be-seen;* she seems to know the art of weaving the evidence of her body's spectacle into the suspicion of what she actually wants to sketch, namely her call to be a whole—yes,

the whole object of another's desire. She knows the science of objectifying herself for another.

But as she objectifies herself, her ego dilacerates her presence, and her gesture becomes *acting-out* in the strong sense: an act beside one's self. This, then, is the point to which her call for love impels her: a misfortune of identity.

The Constraint of Charm

Sexual love is undoubtedly one of the chief things in life, and the union of mental and bodily satisfaction in the enjoyment of love is one of its culminating peaks. Apart from a few queer fanatics, all the world knows this and conducts its life accordingly; science alone is too delicate to admit it. Again, when a woman sues for love, to reject and refuse is a distressing part for a man to play; and in spite of neurosis and resistance, there is an *incomparable charm* in a woman of high principles who confesses her passion. It is not a patient's crudely sensual desires which constitute the temptation. These are more likely to repel, and it will call for all the doctor's tolerance if he is to regard them as a natural phenomenon. It is rather, perhaps, a woman's subtler and aim-inhibited wishes which *bring with them the danger of making a man forget* his technique and his medical task for the sake of a fine experience.[202]

Is the treatment of hysteria at risk—at the risk of a *charm*?

A charm, yes. In the hell of the Salpêtrière, hysterics incessantly made eyes at their physicians. It was a kind of law of the genre, not only a law of hysterical fantasy (its desire to captivate), but the law of the institution of the asylum itself. And I would say that this institution was structured as a bribe: in fact, every hysteric had to make a regular show of her orthodox "hysterical nature" (love of colors, "looseness," erotic ecstasies, and so forth) to avoid being transferred to the severe "division" of the quite simple and so-called incurable "alienated women."[203]

Seduction was thus a forced tactic, Hell-Salpêtrière weighing and distributing its poor souls to more or less appalling circles, of which the Service of Hysterics, with its "experimental" component, was like an annex of Purgatory.

The bribe went something like this: either you seduce me (showing yourself in this way to be hysterical), or else I will consider you to be an incurable, and then you will no longer be exhibited but hidden away, forever, in the dark.

For the hysterics, seducing consisted in always further reassuring their physicians by confirming their concept of Hysteria. Seducing was thus also,

reciprocally, a technique of scientific mastery, everyone making an effort (an enormous energy) for his or her own dispossession, in word and body. For the hysteric, seducing was perhaps having the Master at her beck and call—but she could only lead him to be the Master to a still greater extent. In a strange reversal, the hysteric's seduction did an even crueler violence to herself where her own identity, already so unhappy, was concerned.

Thus hysteria at the Salpêtrière was always being aggravated, always becoming more demonstrative, in high colors, always even more subjected to scenarios (this was the case until the time of Charcot's death). A kind of masochistic fantasy was in full swing, functioning according to its demonstrative trait (making oneself be seen suffering), and according to its distinguished character of a pact, and of connivance, too.

("Connivance: connivere: means at one and the same time: I wink, I blink, I close my eyes.")[204]

And this connivance, although a constraint, was an almost amorous relation, because charm was at work, and was even the effective, efficient (if illusory) motor of the whole operation.

"Désirer: ma gloire" [To Desire: My Glory]: Or, How the Hysteric Enamored her Physician

Freud admitted early on that when a physician studies hysteria, it "is time-consuming . . . [and] presupposes great interest in psychological happenings, but personal concern for the patients as well. I cannot imagine bringing myself to delve into the psychical mechanism of a hysteria in anyone who struck me as low-minded and repellent, and who, on closer acquaintance, would not be capable of arousing human sympathy. . . ."[205] It takes time, it takes charm: time for the transference to take.

But at the Salpêtrière, "charm" and "sympathy" were not procedures confined to bourgeois offices, couches, velvet, and objets d'art. "Charm" and "sympathy" were voiced as the sin of a whorehouse, all the women pell-mell interjecting the intern or the external physician, shouting themselves horse with unsavory calls, performing stripteases—all these—how shall I put it?—insignia of "crude carnal solicitation."[206] Was it still charm?

It could in any case be called transference, in the Freudian sense. But here transference was repetition in the sense of a theatrical rehearsal,* and it was theater, in the hard-core sense of smut.

*[The French répétition signifies both "repetition" and "rehearsal," an ambiguity D.-H. consistently exploits.—Trans.]

"What are transferences? They are new editions or facsimiles of the impulses and phantasies which are aroused and made conscious during the progress of analysis; but they have this peculiarity, which is characteristic for the species, that they replace some earlier person by the person of the physician."[207] This movement of the fantasy toward its reproduction may come to lose itself, writes Freud, in a veritable *sexual dependence.*[208] And what characterizes hysteria, from this point of view, is its unrelenting *creativity of transference,* incessantly renewed,[209] relieved by the unrelenting creativity (yes, creativity) of *symptoms.*

What is to be done? What is to be done, Freud wondered, when confronted with the "exposure of a patient's body"?[210] Abstain? Should "need and longing [be] allowed to persist in her?"[211] Cold sweats. In any case, he thought, regarding "women of elemental pasionnateness," an "intractable need for love" propels the cure toward an "inevitable failure" (from the therapeutic point of view; but is this the only point of view in an experience of madness?) and then "one has to withdraw, unsuccessful."[212] What is to be done?

Freud tried to find a suitable solution—another pact—among these ethical or erotic alternatives. It is necessary, he writes, "to keep firm hold of the transference-love, but treat it as something unreal," never forgetting that the love of a hysteric is "impaired," that she "finds herself in the impossibility of freely disposing of her ability to love."[213]

But this proposal sounds a bit like wishful thinking. Loving, in the first place, is less a (controllable) faculty than something like the haste of existence, perhaps; and the love of the hysteric, though kindled by a decoy, is so violent, so veracious (at least for a time; must the physician speculate on time, on the faithfulness of his "transferant"?). How can one face this voracious and vociferous implacable love, speculating about it and derrealizing it, when, in all kinds of *coups de théâtre* and acting out,[214] this love never stops showing itself, outrageously?

Transference has a mad consistency. It is like the gap (which was glaring, at the Salpêtrière) necessary for bodies to finally touch each other.[215] And it is only so consistent, so persistent, because it is a *gain on both sides.*

For the hysteric in fact, it is the sole "gain" through an illness:[216] a bonus of seduction that the symptom offers to the physician's gaze. A desire represents itself, stages itself, lets itself be visible (if not audible) and, though unhappy, it exists before everyone's eyes, as a kind of affirmation.

For the physician: in transference, the hysteric makes herself over *in the image of his desire to know,* in the image of the concept "Hysteria" that a certain physician attempted to advance when confronted with the in-

coherence of "a thousand forms in none." And it worked—or seemed to work, at least for a time, but there were high hopes, on the part of the physician, for its continuance. The charm was a double: not only did Augustine offer her body to Bourneville and perhaps called him—psst psst!—by his providential moniker *"Désiré Magloire"* [Desired my glory], but she also rendered his desire into *attitudes passionnelles:* how could Bourneville not have adored Augustine as the idol of his whole science?

And this is how he came to fall for his hysteric, if only because the permanence of the transference should realize the perpetuity of his own scientific fantasy, and *the permanence of the transference should guarantee the perpetuity of his concept of Hysteria.* "Should," I say, in all its senses. The hysteric should "remain to him," remain (his) hysteric, thanks to transference. And so one might come to imagine that Bourneville, Charcot, or others, ideally or not, secretly or not, were adonising themselves[217] (Adonis, the almost sadistic hunter of desires, or Adonis dying in Venus's arms), perhaps actually intoxicated by the hysterics' lies.

(Ah! "Let my heart be drunk on a lie, / Plunge into your fine eyes as in a fine dream, / And drowse a long while in the shadow of your lashes!"—"But isn't it enough that you are appearance, / To rejoice a heart that flees truth?")[218]

This, perhaps, is the dark continent of the "beautiful sensibility" and of the medical touch: an *adoration.* Adoration is indeed an idolatrous demand, and it passes through a figurative operation. I propose the hypothesis that Bourneville (or even Régnard, perhaps) was struck by a *coup de foudre* for Augustine, insofar as a *coup de foudre* is the extemporaneous consecration of a body into a *tableau,* whose temporal modality is a pure "past tense," as Roland Barthes writes.[219] Do you see why a physician would have such a weakness for this so very feminine object of science, and do you see why this physician reciprocated the transference through theatrical and photographic procedures?

Note the following consequence of my hypothesis; that the Hippocratic oath—"I will abstain from any voluptuous act," and so on—had forgotten itself at the Salpêtrière. Unless—another hypothesis—it was the repetition of its own founding myth in transference (for Hippocrates' first patient was the charming Avlavia, whose illness resisted the care of her father, himself a physician; Hippocrates gently enjoined the young woman to consult the Delphic oracle which said: love, love this young and handsome physician, and you will be cured; and so they were married. . .).

Every interpretation is implicated in a story of transference, a love story that is, in fact, always on the verge of going wrong. Perhaps transference is that which cannot be theorized in the relation between

knowledge and madness[220]—I do not know. In any case, at the Salpêtrière, under Charcot, this question was so far from being posed (although and because it was utilized and instrumentalized) that transference relieved the hysteric of any intention of giving up her illness.[221]

And this is how hysteria, at the Salpêtrière, always went on *repeating itself.*

7

Repetitions, Rehearsals, Staging

Gazes and Tact

A terrible charm, then, went on repeating itself.

How? Charm is a ruse of visibility: a certain hysteric pretended to constitute the *whole object* of psychiatric knowledge and scoptophilia, in poses and in photographs. And she believed it. The charm was reciprocal: the physician made the *attitudes passionnelles* of "his" hysteric into a masterpiece, the *living image* of a nosological concept, and he practically glorified it, as an image. Charm was the photographer's birdie. Augustine bewitched her physicians as an ideal apparition and they, in return, were like guiding spirits—or not.

In any case, it is through the photographic medium that the hysterical woman offered herself, in an exemplary fashion, *to be touched* in the most subtle and most exquisite of contacts.

Yet the *Iconographie photographique de la Salpêtrière* was, in a sense, a *negation of tact,* of contact. The utmost was done to fabricate the semblance of the "life," and thus the independence, of the image; from plate to plate [*planche*]*, the hysterics seem to frolic freely in their fantasies or phantasmagorias, and I do mean "seem." "*Planche*" suggests to me, moreover, that there were still procedures for posing: platforms, discreet yokes, boxes for framing the image. The *Iconographie photographique de la Salpêtrière* does not show the way the hysterics were touched. It only showed, that is, it tried to prove that they were not touched, that this prodigious body of the hysteric was not touched, and that "it" happened all by itself (just as Marey tied up his birds to "chronophotograph" their flight in a veritable *trompe-l'oeil* of departure).

There was an illusion of a neutral distance, of a gaze that does not touch (but this shortened, almost tactile distance between camera and subject is no less material than the exposure time).

*[*Planche* designates both the photographic plate and the boards of a stage.—Trans.]

One must not forget that the clinical gaze and its "beautiful sensibility" were wholly dominated by an incurable metaphor of tact,[1]—nor that *touching the hysteric* was, from time immemorial, the only way of eliciting a *response* from her.

And I am not only referring to Galen or Ambroise Paré. In 1859, Briquet was still arguing against certain methods for terminating hysterical attacks, meaning that they were still in use. Briquet goes so far as to provide examples of their efficacy (but he was making a slightly different point: he was arguing against a concept of hysteria that was in fact grounded in the efficacy of such methods). Uterine compressions, all kinds of "confrications of the genital areas," masturbating them—let's face it—until they could take no more (an extenuated, exuding hysteric is pacified), and even prescriptions for coitus:[2] Briquet had tried all of these, of course, but he said they did not work. Perhaps his heart was not really in it. In any case, Briquet admits his disgust for practices that he judges, and rightly so, far from "innocent."[3]

Charcot revived tradition, to a certain extent. He had no qualms about plunging his fist into a hysteric's groin, nor about instrumentalizing the so-called ovarian compression or prescribing the cauterization of the uterine neck, in certain cases.[4] He condemned hysterectomy as a treatment specific to hysteria, but was in this sense in the avant-garde, for hysterectomies continued to be practiced, despite Charcot, throughout the nineteenth century.[5]

Tact became torture. *Speculum*—scalpel, cauterization. How dare I relate it to a dialectic of charm?

That is precisely the question: the paradox of atrocity. And the movement I am interrogating is the following: how the relation between a physician and his patient, in a hospice of four thousand incurable bodies, how this relation, which, in principle, was nearly the only one besides marriage to authorize and even institute the *fondling of bodies*[6]— how this relation could become servitude, property, torment. How did the patient's body come to *belong* to the body of medicine, and how could this dispossession take place within what hysteria itself obliges us to call a *charm*?

My hypothesis bears on the mediating function of the image and the fabrication of images, in the paradoxical movement from tact to torment via charm. But the paradox remains insistent: how could a body become an *experimental,* experimentable object for another, simply because it was suited to the making of an image, and *why would this body have consented,* to this extent? The word "consent" is quite strong. Consenting is loving, in a sense, loving madly, and the hysterics at the Salpê-

trière truly consented to extraordinary stagings, with a major semblance of desire.

(Note that this was not my principal line of inquiry, but a suspicion that emerged in the fascinating, dumbfounding trajectory of the strange waltz of the images in the *Iconographie photographique de la Salpêtrière.* It is a particular kind of *punctum,* only tangential to the visible, because it exists only in relation to the entire series of images.)

But this movement is, of course, denied by the *Iconographie.* Bourneville and Régnard dissimulated their activity, and can thus never be seen within the frame or in the picture. Many details indicate an attempt to erase touches, conniving caresses, or brutality. A nurse's arm firmly grasping a runaway hysteric posing for her "remorse," was "corrected" for publication—the engraving of the picture omits the warder's "touch."[7] Another slight but significant example: in 1887, Régnard, who had stopped working at the Salpêtrière many years before, published a series of engravings after plates of the *Iconographie photographique,* including some previously unpublished images. Perhaps they were unfit to serve as proof; perhaps that was photographic specificity.[8] And what they show is the body of the physician himself, using a long needle to pierce the arm of a young woman whom he has in his power, the black stature of his coat. And the young hysteric has a "knowing" smile—a smile of consent, as if contemplating the serious nature of the situation, with an understanding of the experimentation on her anaesthetized body, doubled with the procedures of photographic exposure (fig. 66).

"Special" Sensibilities

Of course, the hysteric body is a great riddle of sensations.

What Briquet called "perversions of sensibility"[9] were in the first place, *anesthesias:* skin, muscle, bone, sense organs, "mucous membranes"[10] and so on. Then, secondarily, were the *hyperesthesias,* or "hyperalgia," exactly the opposite of anesthesia, but likewise appearing in all varieties and in all places: "dermalgia," "myosalgia," "cephalgia," "epigastralgia," "rachialgia," "pleuralgia," "coelialgia," "thoracalgia," "myelosalgia," "arthralgia," "nevralgia," "laryngo-bronchial hyperesthesia," "pseudo-croupal suffocation," "hyperesthesia of the digestive track," "nephralgia," "cystalgia," "hysteralgia."[11] Every organ of the hysterical body had its own pain.

The School of the Salpêtrière took description far beyond a simple inventory. A general psycho-physiological theory was being sketched out: the affirmation, for example, that the hysteric's emotivity, her general impressionability, "is but a congenital or acquired weakness in

Figure 66
Régnard, "Hysterical Anaesthesia," engraving "after a photograph
by the author," *Les maladies épidémiques de l'esprit* (1887).

the resistance of the vasomotor centers."[12] Establishing this theory re-
quired experimental verification: above all, *measuring* all the hysterical
sensitivities.

According to clinical protocol, the first step was to order all this scat-
tered phenomenology in a table of so-called special sensitivities. To give
but a brief glimpse: "*Special sensitivity:* the tick-tock of a watch pressed
against the left ear is hardly perceived; it is heard at ten centimeters from
the right ear. Sight: W. . . can distinguish only red on the left; on the right,
she can recognize all colors except for purple. Smell: null on the left,
slightly diminished on the right. Taste: salt, sugar, pepper, and bitter ap-
ple are perceived neither on one side nor the other. Genital sense: sexual

relations produce no sensation; she is accused of being frigid; everything happens in her head."[13] And Charcot defined a distinctive symptomatological characteristic of hysteria, which he called, in fact, "the obnubilation of the special senses."[14]

Even when it was organized, this phenomenology remained somewhat improbable. It therefore had to be "put to work," instrumentalized. Local organizations, morphologies, and especially *symmetries* were identified. It was not a question of defining, but of mapping, *mapping the body:* "dorsal side," "ventral side," medial lines, zones, "hysterogenic" points, well-delineated borders.[15] From this they made standard diagrams, like questionnaires to be filled out by the model clinician (fig. 67).

Remember Augustine: all her anesthesias, contractures, notions of position, disturbances of hearing, sight, smell, her "genital sense" and so forth—all this was riveted to and organized around an insidious but precise line traversing her poor, divided body: every one of her symptoms was "hemi-something."[16]

Note that the study of symmetries was concomitantly a methodology of suspicion. For example, it made it possible for spatial *measurement* to be opposed to the hysteric's too variable and perhaps indeed "simulated" experience of functional disturbances. For example, a certain syndrome of muscular hypertrophia could not stand up to the measurement, in centimeters, of perimeters (of legs and thighs) or even, quite simply, to the orthogonal, demonstrative glances made possible by a well-taken photograph (by Albert Londe): it was thus "pseudo-hypertrophia," because, visibly and according to certain measurements, it was negligible.[17]

This passion for measurement even extended to *movement*—the shake, the convulsion, the "stertor"—invoking "graphic methods" à la Marey.[18] When Augustine plunged into one of her attacks, she was invariably smothered in sensors, myographed, pneumographed—the contour of her slightest breath was a profile of the "great hysteric form" in itself[19] (fig. 68).

Fevers were measured rectally—"R. T."—and vaginally—"V. T." Thermal sensitivity was measured, including the cries from the alcohol flames used in "thermocautery."[20]

Deleria were timed. Count Augustine's at your leisure: 18 seconds of "threat," then ten seconds of "call"; now 14 seconds of "lubricity," 24 of "ecstasy," 22 of "rats" (meaning visions of rats—Richer no longer took the trouble to distinguish between perception of reality and hallucinatory perception), and 19 seconds of "military music"; then, suddenly, 13 seconds of "insolence" followed by 23 of "lamentation," and so on.[21]

Figure 67

Schema of the zones of hysterical anesthesia, *Nouvelle Iconographie* (1888).

Figure 68

Régnard and Richer, pneumographic inscription (with Marey's apparatus) of Augustine's breathing in the "upper costal" region, during an attack, *Revue mensuelle de médecine* (1878).

Experimental Bodies

Chronometry—was perhaps the invention of a sort of technological ritualization of *expectation,* the matrix-method that Charcot saw as the originary point of a whole "school of attentive observers";[22] yes, waiting [*en attente*] for an "algebraic *x,*" as Requin called it, waiting for the authority to decide between the crucial alternatives of "respecting" or "provoking."[23]

Charcot forced the decision with a clear answer, invoking Pinel: one must *experiment.*[24] In this way he substituted a metaphysics of the essence and causes of illness with a *metaphysics of facts,* in the style of Condillac, perhaps, with all its fundamental presumptions: namely, substitution, the addition—as if it were nothing at all—"of what is necessary" to make or remake a fact when the meaning of its origins is lacking. A certain frivolity.[25]

Charcot's style, his teaching, called on experimentation not as a means nor as an avowed aim, but as an ethics of science. Hysteria made a necessity of repetition, even of obsession, and its aleatory deployments forced the ethics to become an aesthetics, precisely so as not to lose its "science-making" aspect.

Well! This patient will allow me to demonstrate what I have proposed. I should tell you, however, that while we are nearly certain of the predicted result, matters concerning the organism are not as precise as the mechanical, and I wouldn't be surprised if our operation does not succeed. It is sometimes said that experiments on animals, when they are performed in public, are not as successful as in the laboratory; what is true in such cases is all the more valid for the clinical experiments we do here. If we don't succeed as we would have liked, you will nonetheless have learned something.[26]

How could he not have suspected the ability of facts to serve as a foundation, which is the virtue of stage direction? Perhaps he forgot this later, when he wrote, or rather, addressed his public regarding a patient right before him (and she was not deaf): "When there are hysterogenic points, one can *make use of them,* if only for experimental purposes."[27]

Charcot was accused of not treating but experimenting on his patients.[28] His disciples blocked this charge, took up their pens, and tried to respond. Their responses were quite strange: simplistic arguments ("a good remedy is one that cures") or ambiguous, negative arguments ("he who, in matters of therapy, has never recoiled from any experimentation")[29] (see appendix 16). But the question goes far beyond this. It concerns the idea, or ideology, of the "advancement" of medical science in this domain. It also concerns the psychiatric notion of *verification;* for instance, how can all the principal themes of psychophysiology be verified—the notion of determinism, the founding schemata, stimulation and reaction, and so on?

The question goes even further to address the fact that an empiricity of the body arouses, or fabricates, an *empiricity of the subject.* Augustine, as a "hystero-epileptic," was therefore an empirical subject; a subject woven and invented from the threads of Augustine's quasi-faces and quasi-poses, in the movement of transference. In inventing itself, the empiricity of the subject became an *aesthetic* modality of existence, celebrated (quite sexually, fundamentally) by the whole institutional and technological organization of the Salpêtrière.

For the hysterical body in the asylum, it was the result of yielding to transference, consenting to the experiment. An automaton—now inert, now thrashing about, modelable in the end because called on, called on by a *legend.*

The body was called on by caresses, even gropes, electroshocks, and penetration, delighting the morality of the toy, and constituting its works, styles, and feats.

Dream Body

One day, Augustine offered of her own accord the ideal situation of a body wholly abandoned to the morality of the toy, meaning a body inert and at the same time functioning at everyone's fancy. "One day she fell into a sleep that lasted until the following morning and from which it was impossible to rouse her, no matter what stimulants, mechanical or electrical, were employed. She was in dorsal decubitus, with a ruddy face, her limbs completely lax, her eyelids closed and fluttering and her ocular globes convulsed downwards with a tendency to internal strabismus. Her breathing was weak and irregular: Breathing: 14. Pulse:100."[30]

Her body fully offered up, Augustine became a Sleeping Beauty. Sleep was like a displacement of belief, as Artaud writes; an embrace was relaxed and tightened at the same time.[31]

What is prodigious in so-called hysterical sleep is that it *simulates a physiological sleep,* in forms that are in fact extremely changeable: often the muscles are rigid rather than relaxed, sleep that is paradoxically both deeper than usual ("so deep that neither the noise of a tam-tam nor the inhalation of ammonia nor the intense faradization of skin or muscles or even the nerve trunks themselves are able to provoke an awakening")[32] and also in a state of alert, meaning that hysterical sleep is an *arrested attack* or, rather, an attack that is indefinitely retarded. Charcot indeed understood it in this way: the "sleep attack" was a *transformation* of the "classic attack," meaning a convulsive attack, the phenomena of which continued to manifest themselves intermittently, "as if in scraps" he said,[33] "thus recalling, although in little, the story of Sleeping Beauty which—between us—is in the end just the story, embellished by art, of a hysteric sought by a young and somewhat featherbrained prince."[34] But let's move on.

What is crucial is that all the benefits of this suspension fell to the prince—to the observer, to the "expectator." His predation of the image, as in the case of tetanism, was truly a delight, for he had "all the time in the world" to contemplate his beauty, as if she were changed into marble (while, for her, the transfinite wait for another Contact and Charm was passing). The expectator could take his time (her time, in fact) to circumspectly focus the image (fig. 69).

Here again expectation was an attested and authenticated iconographic method. When the aptly named "Eudoxie H. . . ," a celebrated case in Bourneville and Régnard's *Iconographie,*[35] fell into this kind of sleep, no one dreamed of rescuing her from what was perhaps a nightmarish torpor; her stretcher would be brought in, or rather, would make an entrance

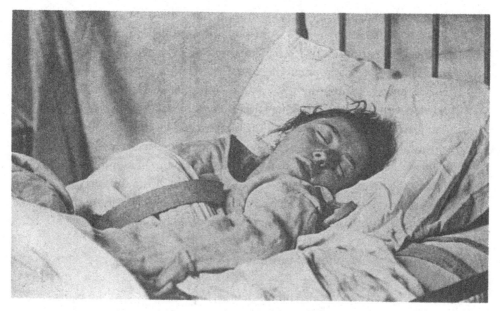

Figure 69
Londe, "Hysterical Sleep," *La photographie médicale* (1893).

on the stage of the amphitheater for the Tuesday Lectures; she was wholly
abandoned to the public's curiosity and the "expectative" commentaries
of the Master on her sleep:

> The patient who has just been placed before your eyes is, according
> to the customary language of this hospice, a *sleeper*. Indeed, this pa-
> tient has been sleeping—if it can be called sleeping—since the first
> of last November, that is, for twelve days. Since then, in reality, she
> has not stopped sleeping, in her fashion of course, night and day,
> without ever waking, and there is good reason to think that she will
> not wake up any time soon. In the service where she has lived for a
> long while one lets things take their own course, without attempt-
> ing to provoke her awakening, knowing through experience that any
> method implemented in this case would be of no avail; and informed
> as we are by what has previously happened in a number of similar at-
> tacks, we watch without anxiety or emotion this singular spectacle,
> with which we have long been familiar, living with the well-
> formulated conviction that one fine day, sooner or later, order will
> spontaneously be restored.[36]

In short, the "attack of sleep" was a hysterical attack that was mo-
mentarily frozen and presentable, affording a fantastic opportunity: often

(despite what Charcot says here) the "momentary" was if not masterable then at least manipulable. The secret: you can let it be, or interrupt it, or else precipitate the attack: "ovarian compression" works quite well.[37]

The symptomatic phenomena of hysterical sleep were, in a more general sense, (already!) the royal road to "knowledge" of hysteria—but knowledge in the sense of taking faithful notes on the *show* of sleep.

Two key phenomena are somnambulism and vigilambulism. These were moments of a pantomime in which a hysteric gesticulated, postured, and *played* her sleep.[38] There was an inscious acting-out of nightmares and dreams, the so-called *second* states (trances), in which the scission of the poor empirical body would once again manifest itself plastically, with the second part of the subject emerging as some delightful *automaton*.

Hypnotic Summons—Subtle Bodies

But all delight is equivocal. And in sciences, in positivities, isn't the equivocal like a *dark continent*? To this effect: "It seems, indeed, that in science there are things that shouldn't be spoken of, things a prudent man would never venture to expose, dangerous subjects that, even when addressed, never result in gain. Somnambulism . . . certainly falls into this category."[39]

In this sense, Charcot took a risk, and a rather radical risk at that. In 1882, in front of all the academic authorities, he presented the phenomena of somniation and, what's more, of hypnosis, as *objects of science*.[40]

Was his positivism wavering? No, for Charcot presented these phenomena as pure *soma:* physiological states incited by certain excitations. This was his perhaps unknowing ruse and risk—his victory, and his error.

He put hypnosis on his "personal" (unofficial) teaching program as early as 1878, continually invoking his expectant clinical prudence:

> I have, in fact, made a few new studies of somnambular and cataleptic states, which will be developed progressively. I'm working prudently, advancing step by step, and I situate myself within a strictly clinical point of view. Indeed, if I want these studies to be taken as far as possible, it is because, to my mind, the progress of nervous pathology is at stake.[41]

With this, he was considered to have reinstated the title of nobility to this technique of charlatans: he made it into a regulated, well-defined technique, "scientific hypnotism" in fact, entirely "subject to scientific description."[42]

More than "nervous sleep" or a phenomenon of "double conscience,"[43] hypnotism was defined, according to anatamo-clinical precepts,

as an intensified form, aptly called "grand hypnotism"—and it was redefined less as a symptomatic phenomenon than as an experimental procedure.[44]

This was Charcot's ruse. The relation between hypnosis and the paradoxical state of "spontaneous" hysterical sleep was not, of course, lost on anyone; but this analogical relation[45] was surreptitiously deflected, in the following terms: in the first place, somnambulism is an unhealthy state, a neurosis in miniature;[46] second, hypnotism is a technique capable of experimentally provoking all the phenomena of somnambulism;[47] third, hypnotism should be considered as a neurotic state par excellence, an *experimental hysteria,* a synthesized hysteria.

It was a clinical feat. Note that the bulk of volume III of the *Iconographie* is devoted to the phenomena provoked by "Hypnotism, magnetism, somnambulism," backed by plates.[48]

It was also a theoretical feat: fourth, hypnotism itself, as a regulated experimental procedure, came to provide the conceptual paradigm for any understanding of hysteria. It became *a model of hysteria.* And this is how, with good reason, Charcot's hysteria definitively ceased—almost ceased, almost—to be a Proteus of science, a thousand forms in none, and so on.

Just one more paradox.

"*Per Via Di Porre*"—Sublime Machines

Experimental hysteria: hypnosis thus became something like a standard or pattern of hysteria; but, to be more precise, it was less epistemological than technical or practical. Hypnosis was in reality and above all a *recipe for hysteria.*

Charcot considered hypnosis to be an outstanding state because it completely disrupted the functioning of the organism, a disturbance that would be triggered on demand, and thus was outstanding for purposes of observation: "Located between the regular functioning of the organism and the spontaneous disturbances brought about by illness, hypnosis clears the way for experimentation. The hypnotic state is but an artificial or experimental nervous state, the multiple manifestations of which appear or vanish according to the needs of the study, as the observer fancies."[49]

The hypnotic state was thus providential for what might be called "experimental pathology." Charcot, however, remained ambivalent, hesitating between what he methodologically delineated—prudish principles—and what he in fact managed to achieve on a daily basis, namely, feats.

He admitted, on the one hand, that "experimental pathology" can only "imitate symptoms" and only "make them appear one after the other in isolation":[50] simulacra, nothing more.

(But doesn't this seem like a definition, in the style of Charcot, of the hysterical syndrome as a partial mimicry of organic affections?)

On the other hand, he pointed to his fantastic experimental success (a cataleptic who, on the stage in front of the audience, comes up with myriad symptoms waiting on him hand and foot) to affirm the omnipotence of hypnosis: "What we have here before our eyes is truly, in all its simplicity, the man-machine dreamed up by La Mettrie."[51] Note that La Mettrie did not conceal the fact that if man is a machine, physicians are his masters: for medicine alone can "change minds and manners through the body."[52]

And it is a fact that Charcot intensely modified his "subjects." He transfigured them, body and soul. He failed, of course, in his desire to theorize this transformation with his neurophysiological muddle of "commissures linking the so-called motor regions of the cerebral cortex with the marrow," "fibers of the pyramidal fascicles," and other "spinal excitabilities": a muddle from which he had trouble extricating himself.[53] But he excelled, to the contrary, in describing and drawing practical consequences from the hypnotic instrument—yes, instrument.

There was one thing in particular that he learned very quickly, and which he prided himself on proving each time, and which seems to us, as it did to him, quite essential: hypnotic suggestion allowed him to *make, redo, or undo* at will, in an absolutely equivalent and thus totally reversible fashion. Provoking a symptom, erasing it, reprovoking it,—this was possible, but it called for absolutely identical procedures. It was an *instrument* to such an extent that it could be modulated: *fugato, crescendo, stringendo, a piacere, ad libitum.* "The paralysis that we *will have made* through suggestion can be modified in its degree, as we like, as well as in its characteristics to a certain extent—and we can *undo* it, also through suggestion."[54]

Charcot *interpreted hysteria,* of course, but like the conductor of an orchestra. *A piacere. Morendo:* dying—who knows?

Another analogy, due to Freud, emphasizes the fundamental point that the technique of hypnosis gave Charcot the freedom of intervention of an artist or a painter, on "material" fully surrendered to him. Hypnotic suggestion, writes Freud, is comparable to the art of painting, in the sense in which Leonardo opposed it to sculpture: it works *per via di porre:*[55] it deposits (like the painter *poses* his pigment), supplements, projects, glazes, frames.

Right from the start, hypnosis had *figurative* validity for Charcot: in his own words, it was an "ideal" technique capable of *redesigning* (meaning reorganizing or discriminating) the symptomatic *tableau* of hysteria that was too profuse when it appeared "spontaneously." Thanks to this

technique, the states of the hysterical body could finally be "perfectly designed and separated."[56]

"Perfectly"—Charcot touched there on the *sublimity* of a genre, as he himself put it. Speaking of a certain case of hysterical paralysis, he confided: "We can artificially reproduce it under certain circumstances; this is the sublimity of a genre and, in fact, the ideal of pathological physiology. The ability to reproduce a pathological state partakes of perfection, for it seems that one possesses the theory when one has the means of reproducing the morbid phenomena at one's fingertips."[57]

The ability to reproduce all the states and postures of a body-machine; the ability to finally "possess" them, "producing" a whole theory; the ability to invent and always have one's theory confirmed by the facts: this was a sublime discovery. Hypnosis was Charcot's grand *style.*— Glances, subtle touches: powers.

Manipulations—Feats of the Body

Hypnosis was an art of contact. *Per via di porre.*

There were a hundred methods: passes, caresses, fixed gazes, brilliant bodies. The subject's eyes would become "vague," "bloodshot," "wet with tears"—then they would close, and that was it. She belonged to him from then on.[58] There was the ordinary method, known as Deleuze's method; "magnetizations by the head"; then Faria's method.[59] Hand in hand, light brushes of the eyelids, confidence. He would have her fix on an object, generally oblong or luminous, a kind of magic wand. Or else he would use pure gestures of mastery, simple signs, without touching her, but still successful: "With a well-practiced patient who hypnotizes quickly, it is enough to abruptly place the hand on her head, and she falls as if struck by lightning"[60] (fig. 70).

In short, a hysterical woman heads straight for total dispossession in hypnotic submission; she is as accommodating in her own fascination as a little bird in front of a snake that is about to devour it: an ideal predation (figs. 71–73).

(Freud, in 1895, admitted that he "could no longer do without it," so "convenient" is the procedure for the "purpose . . . in view." "What I am looking for always appears with the pressure of my hand.")[61]

The ideal predation: a provocation through tenderness. And how very prodigious this tenderness was. One could reprovoke all kinds of sleep or somnambulism, creating sleeping beauties at will. Augustine worked wonders, yet again and everyone gained the most precious of treasures: love. "X. . . says that in provoked sleep, she has no dreams; but

Figure 70
Bourneville, schema of hypnotic passes, *Iconographie*, vol. III.

UN COQ HYPNOTISÉ.

D'après une photographie de l'auteur.

Figure 71
Régnard, "A Hypnotized Cock," *Les maladies épidémiques de l'esprit*
(1887).

PROCÉDÉ POUR FAIRE CESSER L'ÉTAT CATALEPTIQUE
ET POUR RAMENER LA SOMNIATION.

D'après une photographie de l'auteur.

Figure 72
Régnard, "Procedure for Stopping the Cataleptic Attack and
Restoring Somniation," *Les maladies épidémiques de l'esprit* (1887).

PROCÉDÉ POUR LA PRODUCTION DE LA CATALEPSIE.
D'après une photographie de l'auteur.

Figure 73
Régnard, "Procedure for Producing Catalepsy,"
Les maladies épidémiques de l'esprit (1887).

that she feels an affection for the experimenter whomsoever he may be, even though she may have previously felt hatred for him."[62]

Such "responsivity" to hypnosis was rather encouraging. So through other sorts of hypnotic "kneading, friction, or simple pressure," they would "reproduce" hysterical contractures of all kinds—painful or not, it mattered little, for one would constantly be made to follow upon the other, and then it would cease, only to begin again elsewhere: "By lightly rubbing the flexor muscles of the fingers and forearms with the fingertips, one can determine an artificial contracture of the two superior limbs (pl. XIII) [fig. 74]. . . . To stop the contracture, it suffices to knead the contractured muscles or lightly rub the antagonist muscles, being careful not to excite them to such a point that a contracture of flexion is replaced by a contracture of extension."[63] Delicate Augustine: handling her body practically required virtuosity.

(But has it occurred to you that they were reprovoking the same contractures—when they did not occur spontaneously—for which, five years earlier, Augustine had come to "be treated" at the Salpêtrière?)

The virtuosity and morality of the toy, then. Everything was worthy of being *reproduced*—achromatopsias, stigmata, attacks, deliria, auras[64]— all *artificial,* as they said. For the hysterical body was invested with at least two prodigious qualities.

In the first place, it was a trigger-body. Push, command, and off it goes (not always: occasionally the rubbing of hypnotized flesh would provoke the opposite effects, contractions or resolutions, but they were still effects, after all).[65]

The body could also be *articulated* at will, endowed as it was with an incredible *plastic submission* (a submission that also allowed Régnard to correctly adjust his lenses, diaphragms, distances, and exposure times):

Either it was totally rigid:"X. . . fell asleep again. Her head is pressed against the back of a chair, then the muscles of her back, thighs and legs are rubbed, and her feet are placed on a second chair: the rigid body remains in this position (pl. XIV) [fig. 75] for a rather long time (the experiment has never been prolonged for more than 4 or 5 minutes); it is possible to place a weight of 40 kilograms on the stomach without causing the body to bend."[66]

Or else it was totally flexible: "X. . . is put to sleep by surprise. . . . The body can be positioned in an *arc* (pl. XV) [fig. 76], etc."[67]

Yes sirree, etc., as the ringmaster would say.

Planche XIII.

LÉTHARGIE
CONTRACTURE ARTIFICIELLE

Figure 74
Régnard, photograph of Augustine ("Lethargy:
Artificial Contracture"), *Iconographie,* vol. III.

Planche XIV.

LÉTHARGIE
HYPEREXCITABILITÉ MUSCULAIRE

Figure 75
Régnard, photograph of Augustine ("Lethargy: Muscular
Hyperexcitability"), *Iconographie*, vol. III.

Brushstrokes—Galvanized Bodies

This *plastic submission* also allowed the hypnotic phenomenon itself to be
truly made into a *tableau,* in the exact image of the model that had been
fabricated to account for the hysterical attack.

Making into a *tableau,* periodizing, dividing into phases; a law of
"three states," as Charcot, avid reader of Comte, would say. He thus pro-
duced a complete iconic tale of *catalepsy,* relayed by *lethargy* and then *som-
nambulism.* It is significant that this model of tripartite progression was, at
the same time, the story of the transfer of power from the *gaze* to *move-
ment* (a kind of hypnotic "motor language"), which, in a sense, is also the

Planche XV.

CATALEPSIE

Figure 76
Régnard, photograph of Augustine ("Catalepsy"),
Iconographie, vol. III.

(supposedly) precise story of the mystery of hysteric conversion. In a subject plunged into catalepsy, the eyes remain open, and the physiognomy and gestures are already in constant and reversible relations of influence; in lethargy, the eyes close; in somnambulism, writes Charcot, invoking Azam, "the muscular sense . . . seems . . . to replace sight."[68]

But making a *tableau, per via di porre,* is not simply arranging series. It is also playing with motives, testing morphogeneses and singularities, down to the last detail.

At the Salpêtrière they attempted to approach hypnosis through a veritable *syntax of discrete elements,* on the basis, notably, of a remarkable phenomenon of neuromuscular hyper-excitability during the lethargic phase. This was the height of the trigger-body: if you touch the muscle, the muscle itself—though perhaps only slightly, and independently from the rest of the body—the muscle will answer, it will contract. The same is true of tendons and nerves.[69]

I must stress the verificatory and syntactic aspect of this instrumental problematic. It was a matter of updating, or "implementing" as Claude Bernard would have said, and mastering the "elementary" laws of the causal relation between the *simple tact* of a muscle and the *specific contracture* that could be inferred (fig. 77). It was a matter, moreover, of measuring everything—recording each muscular inflection with a myograph, for example.

This was typical, orthodox "experimental" procedure. Claude Bernard had done the same experiments on the facial nerves of rabbits.[70] For the occasion, he called on a touch more delicate than simple mechanical friction. For his own "experimental contractures," he used extremely precise, lancinating "electric tongs."[71]

But the master of the syntactic genre, as Charcot himself liked to say, was Duchenne de Boulogne. He armed himself with a "rheophore," a very subtle gadget linked to a "volta-faradaic apparatus" that allowed the skin to be charged *locally* with electricity, thus allowing him "to see the smallest radiations of the muscles drawn by the instrument."[72] For Duchenne it was the ideal instrument of "veritable living anatomy," for the contraction of muscles by the little electric rheophore revealed "their direction and location better than the anatomist's scalpel ever could."[73] (See fig. 22.)

Moreover, electricity became a *panacea.* Duchenne de Boulogne claimed to cure hysterics with his little rheophores, or at least he claimed to cure them of all their "muscular affections," paralyses, contractures, and even "disturbances in phonation."[74] Charcot himself prescribed "the use of static electricity in medicine"[75] in this way—from then on the Salpêtrière

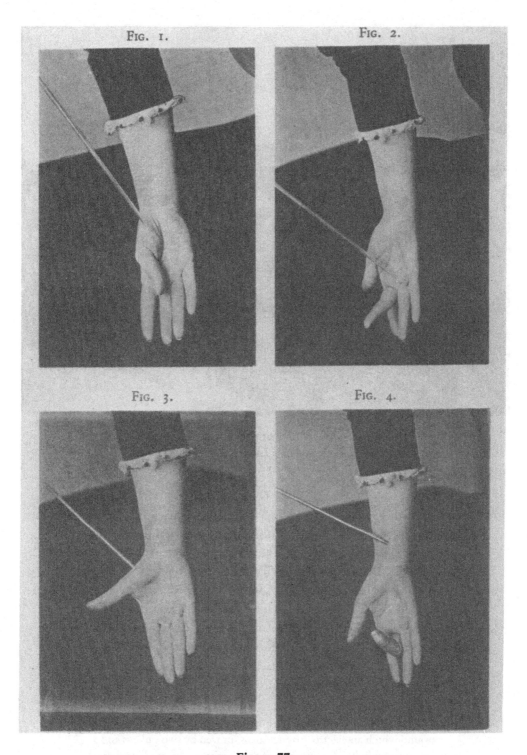

Figure 77
Pitres, "Effects of mechanical excitation of several of Marie-Louise
F. . .'s hand muscles in the state of catalepsy," *Leçons cliniques* (1891).

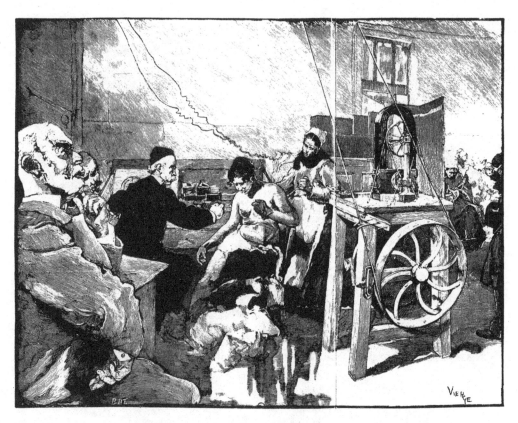

Figure 78
Vierge, "The Electrotherapy Laboratory of the Salpêtrière,"
Le monde illustré, August 14, 1887.

was possessed of "electrostatic baths," "Holtz-Carré machines," all sorts of "galvanic" methods, and so on. At this time, the electrical *studio*—the little body factory where forerunners of electroshocks were mass-dispensed—was always full, thanks to Doctor Vigouroux (fig. 78).

A whole technique was being lavishly developed, in every direction. It was a golden age (as for photography). Electricity was combined with a hundred possible or imaginable magnetisms. An industry—a commerce—was developed; consider, for example, what is practically an advertisement for the "induction machine" recommended in the *Revue photographique des Hôpitaux de Paris* in 1874:

> This apparatus is composed of a horseshoe magnet, in front of poles around which an electro-magnet turns, moved by two pulleys and a transmission belt. The intensity of the shocks can be graduated easily by simply bringing the poles of the magnet closer or further from

the soft-iron contact; by moving the contact further away, the maximum effect can be obtained, resulting in unbearable shocks. This induction machine has a graceful aspect, and its moderate price places it within reach of all practitioners: the administration of our *Revue* can obtain it for the price of 30 francs.[76]

Kudos for the innocent cruelty of the two words in collusion: "unbearable" and "graceful." Note also that Charcot, like Duchenne de Boulogne, gave the name of "electric paint brush"—evidently—to the little miracle-machine that I called a "rheophore" above.[77]

"Expressive Statues"

I am interrogating the extension of something evident, above and beyond experimental evidence, which is itself a regulated extension of clinical evidence.

Beyond the problematic of performing anatomical studies "on the living" and of the therapeutics of a few neuromuscular syndromes, Duchenne's great concern, his desire I should say, was quite exactly the classical problem of painting and anthropology, which has already been mentioned: the problem of an *alphabet of the passions*. In the hyperdetailed study of surface muscular reactions, Duchenne was looking for "the laws that control the expression of human physiognomy"; he was seeking the law of the relation between "the soul" and its "expression," in the most infinitesimal variations of "muscular action"; he sought to define, quite simply, the "*orthography of physiognomy in motion.*"[78]

He deemed, of course, that he had contributed a great thing to science with his analysis of "primordial" or "complex expressions" and his synoptic table defining the "muscles that produce them."[79] But he took even more pride, perhaps, in the "aesthetic section" that closes his work like a *telos:* the photographic plates that are an attempt to establish a kind of syntactical catalog of the face. He deemed, in all simplicity, that those photographers were "responding to the desiderata of art."[80] I will say no more (for the moment).

Recall, at this point, that Charcot was far from impervious to the muscles' ability to "completely paint, in an isolated action, an expression appropriate to them."[81] Charcot thus taught his neurology students the "orthography of the expression of the passions" established by Duchenne.

It was a language of skin and muscles, prepared for the imminent technologies of tests, electroshock, criminal anthropology, behaviorism, and so forth. For electricity is also "a body, a weight/ the pestling of a

face/ the compressed magnet of a repressed surface from the outside of a blow [coup]/ at the outskirts of this blow."[82]

This is why I referred to electric brushstrokes [*coups de pinceaux*].

The practice of faradization at the Salpêtrière fell within in a sort of methodological interstice, however. On the one hand, it was "improving," if this can be said ("In certain experiments we replaced the olivary exciter with a little needle implanted directly in the muscle".)[83] On the other hand, such practices complicated the strict iconographic procedure, if this procedure indeed had the aim of demonstrating the intrinsic, prodigious capacities of the hysterical body. This project was ambiguous, of course, as the following account testifies: "With the help of ordinary olivary exciters from Dubois-Raymond, we were able to make a facial muscle contract; the physiognomy received the impression, and a gesture followed. Once this result was obtained, we *removed* the exciters and the photograph could be taken immediately."[84]

The essential generosity of hysterics made it unnecessary to resort to such doctoring too often. In fact, a body in a state of lethargy, for example, reacts to the least mechanical contact in an manner that is exactly analogous to the way a "normal" subject reacts to intense faradization. Bourneville and Charcot could not of course resist demonstrating this at length in prodigious series of pictures[85] (figs. 79–81).

The hypnotized body is also endowed with an additional, stupefying property that far exceeds simple "cataleptic plasticity" (in which every limb firmly retains the position "imprinted" on it):[86] a gesture "imprinted" on the hypnotized subject spontaneously induces a *concomitant facial expression*. This was called "epiphenomenism" or "cerebral automatisism."[87] It was the neurophysiologist's proof that the expression of emotional turmoil is purely a question of soma.

But it was more than proof; it was a gain, a supplement; the subject, says Charcot, is present like an "expressive statue"—no more, no less—a canonical form, "which artists can, most certainly, turn to the best account"[88] (see appendix 17). As can photographers: "The immobility of attitudes obtained in this way is highly favorable to photographic reproduction" says Charcot,[89] who had the published edition of his lectures accompanied by the suggestive plates obtained by Londe (figs. 82, 83).

It was Albert Londe—Londe again—who described the prodigious powers of the cataleptic body with such delight:

> If one positions the upper limbs of the patient into an expressive attitude, the gesture will then be complemented by an expression of the physiognomy. In this way, a tragic posture imprints a harsh ex-

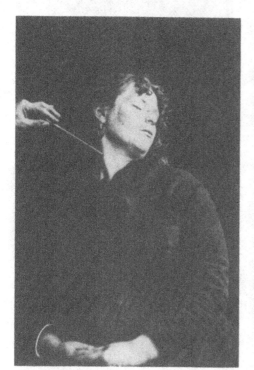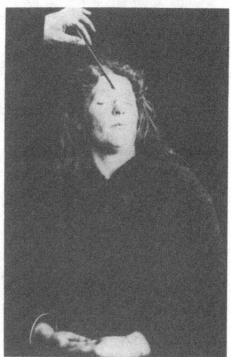

Figures 79 and 80
Régnard, "Lethargy. Contraction of the sterno-mastoidian
frontal muscles," *Iconographie,* vol. III.

pression on the physiognomy, and the brow contracts. On the other
hand, if the two hands are brought to the mouth as in the act of
blowing a kiss, a smile immediately appears on the lips. The action
of gesture on physiognomy is manifest; simply by altering the atti-
tude of the hands, one can see, in turn, ecstasy, prayer, anger, sadness,
defiance, etc. *being painted on the face.*[90]

"Et cetera," says the ringmaster—yes, you will continue to take the
magical display of your body-phenomena even further. Now show us the
opposite: that expression induces gestures and attitudes![91] And reposition
it for us, into your favorite symmetries, in the regions of your preference:
for "the phenomenon can be unilateral, and, if one of the arms is brought
forward with a clenched fist, while the other arm brings the hand to the
corner of the mouth, one of the sides of the face will present an expres-
sion of anger, the other a smile."[92]

That is to say that the hysterical body allows itself to be forced into
a configuration of partitions, in which its desire procrastinates. In this
way it is magical and prodigious. The "plastically figured contradictory

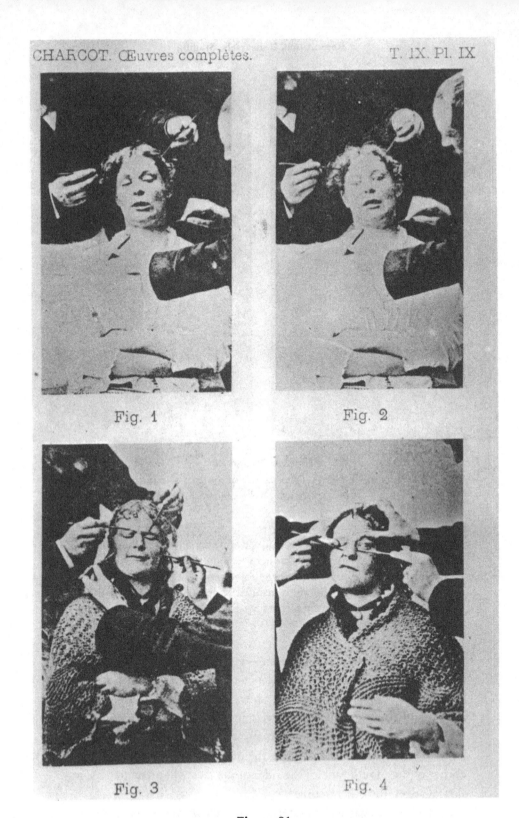

Fig. 1

Fig. 2

Fig. 3

Fig. 4

Figure 81
Londe, "Excitation of facial muscles during hypnotic lethargy,"
in Charcot, *OC*, vol. IX.

simultaneity" is its mode of operation. Here you see Augustine posing for Régnard, hemi-lethargic on the right, hemi-cataleptic on the left, a partition she indicates to us with an obliging wink of the eye (fig. 84). And of course, one could have done the opposite, infinitely varying the tropes of these acrobatics of transference and conversion.[93]

Dazzling and Deafening—*Tableaux Vivants*

These acrobatics were imposed configurations. Here, for instance, is the kind of surprise Bourneville had in store for "his" Augustine: "After the patient was awakened, she was led to a dark office and a Bourbouze lamp was lit with a great flash of light. She immediately fell into catalepsy (Pl. XVII)" and snap, a picture was taken[94] (fig. 85). A remarkable phenomenon: the hypnotized hysteric *realizes to the extreme* every suggestion or murmur, anything that is sketched out for her. She is dazzled, engulfed in a state of vertigo; she becomes entirely blind, and goes into raptures in her "double" conscience.

Such were the effects of the "hyperesthesia" of the sense of sight. For Augustine, the most banal change in the visible was a full-body catastrophe.

And there are numerous plates in the *Iconographie* that thematize, almost cinematographically, the crucial, spectacular passage of a body surrendered to gravely wounded sight and space. But this passage is given to us only with the turn of the page; its temporal value of immediacy *passes into fiction:* for all that remains of this immediacy is a duplicitous structure, a before and an after (figs. 86, 87).

I mean that we can know nothing of this passage, as such. Of course. The photographs, as a representative system of states in which a temporality is delineated, can only serve as the probation of the event: the time of proof [*preuve*] (before: this; after: that), not of the ordeal of the print [*épreuve*].

This closure was not a barrier to experimentation—quite the contrary. There were abundant tests of the distressing effects, on the hysteric, of these varied, even iridescent, visual solicitations: like crystal balls that, depending on their color, could attract or appall a patient in lethargy.[95]

What was supposed to be accomplished? The invention of an instant, the refabrication of the meteoric power of time to which a hysteric is, or one day was, subjected. It was a question, then, of *reinventing the time of the trauma* through an abrupt fiction—of replaying, that is, *restaging* a supposed "first scene." Whence the "experimental" efficacy of anything like an explosion, shock, or surprise: the *dustuchia,* an always unpleasant surprise, reprovoked.

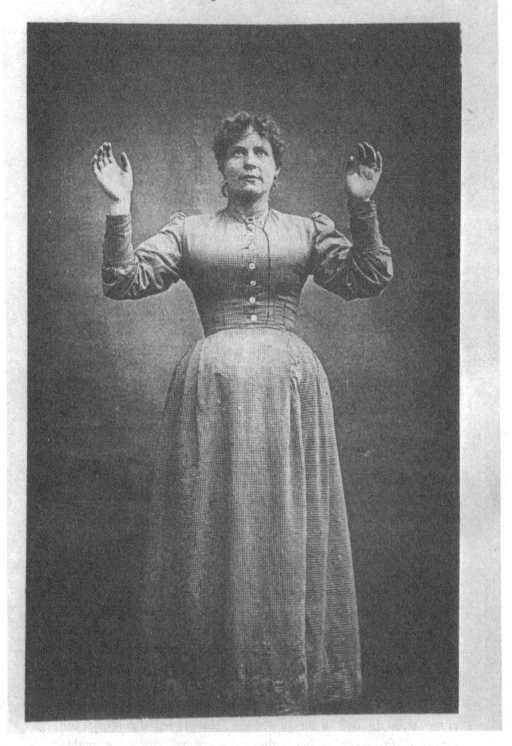

Figure 82
Londe, "Cataleptic state. Suggestion through gesture: surprise,"
in Charcot, *OC*, vol. IX.

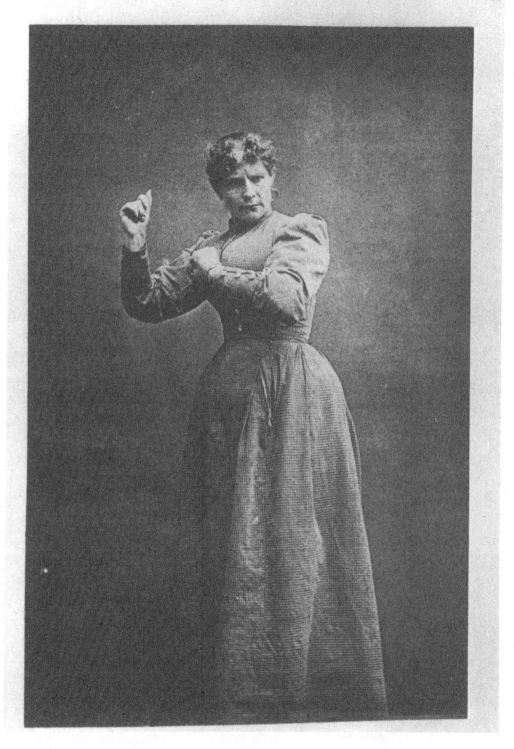

Figure 83
Londe, "Cataleptic state. Suggestion through gesture: anger,"
in Charcot, *OC*, vol. IX.

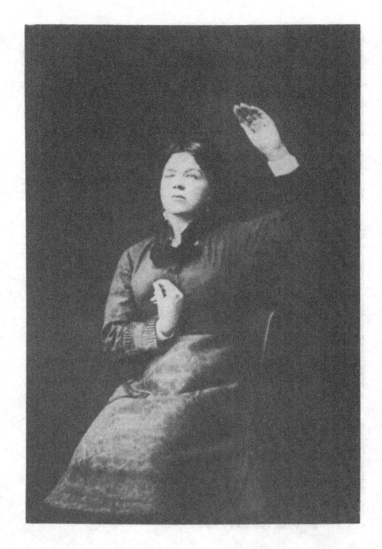

Planche XVI.

HÉMI-LÉTHARGIE ᴇᴛ HÉMI-CATALEPSIE

Figure 84
Régnard, photograph of Augustine ("Hemi-Lethargy
and Hemi-Catalepsy"), *Iconographie,* vol. III.

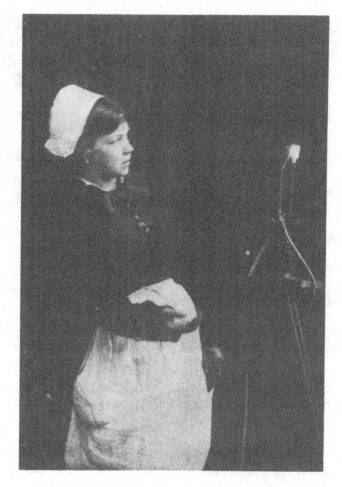

Planche XVII.

CATALEPSIE

PROVOQUÉE PAR UNE LUMIÈRE VIVE

Figure 85

Régnard, photograph of Augustine ("Catalepsy: Provoked by a bright light"), *Iconographie,* vol. III.

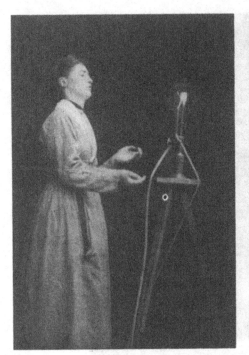

Figures 86 and 87
Régnard, "Catalepsy provoked by a bright light" and "lethargy
resulting from the abrupt suppression of light," *Iconographie,* vol. III.

Thus packages of gun-cotton were exploded under Augustine's
nose, and they did indeed disturb her! She would fall into catalepsy, be-
come aphasic, and so on.[96] To this effect they would use magnesium
flames, "Dummond lights" and many other extraordinary gadgets:[97] the
physicians of the aptly named Salpêtrière [powder factory] became fire-
workers [*artificiers*] for the occasion.

Deafening the hysterics was no less effective. A stroke of the gong
would conjure up catalepsy (fig. 88). Such miracle-noises could create
tableaux, veritable *tableaux vivants:*

> One need only surprise the subject with a sudden noise, that of a
> Chinese gong for example—and you know how disagreeable that is:
> the patient will make a gesture of fright and then remain pinned in
> her place. It was possible for me to provoke the same effects in a
> rather interesting form as I will recount to you with a few details. Six
> hysterics were placed in front of a camera, and I told them that they
> were going to have their portrait taken as a group. Suddenly there
> was a violent noise in the other room. The six patients made gestures

CATALEPSIE PRODUITE PAR LE SON BRUSQUE D'UN TAM-TAM.

D'après une photographie de l'auteur.

Figure 88
Régnard, "Catalepsy provoked by the abrupt sound of a tam-tam,"
Les maladies épidémiques de l'esprit (1887).

Figure 89
Left: Régnard, "Catalepsy provoked by an intense and unexpected
noise" (after a photograph), *Les maladies épidémiques de l'esprit* (1887).
Right: Richer's experiment with the same phenomenon,
Etudes cliniques (1881–1885).

of fear and were frozen in catalepsy in the very attitude the shock had
produced in them. The camera was immediately opened and we ob-
tained a picture, the reproduction of which I am presenting to you
today [fig. 89].[98]

And no one could resist provoking and reprovoking all the accidents of
this kind[99] (see appendix 18)—skillful staging unbeknownst to the ac-
tresses; deceptions and machinations. What was essential was that the
experimental "blow" [*coup*] produce an *attitude,* and that the attitude pro-
duce a *tableau.*

Londe himself admitted the questionable nature of such experi-
ments, in a way: "We have not yet discovered the clinical value of the par-
ticular attitude of each subject, but perhaps it exists, and by gathering
together a large number of prints of this kind, we will doubtless obtain in-
teresting results."[100] He makes an admission of experimental gratuity, only
to mitigate it through the sensible methodology of expectation, that is,
through a call for more and more experiments.

Escalations, Inductions, "Transference"

The experimental stakes were progressively, and vertiginously, revised. *Inducing* was the byword of these repeater procedures. Inducing: leading a hysteric toward the plastic quintessence of the symptom, even more visibly. For this, mediations, techniques, ingredients, and strategies were escalated, always more subtle: an art of making-visible.

Shocking them (dazzling, deafening) soon became unnecessary; it was enough to excite them, to make an *impression,* however imponderable the impression might be. As for the hysteric, *all her senses were convoked.* I will simply summarize their techniques.

First, simple tuning forks producing delicate resonances: "I have these two hysterics take a seat on the sound box of a large tuning fork. As soon as I set the fork vibrating, you can see that they fall into catalepsy. When we stop the vibrations, they fall into somnambulism. If we begin new vibrations with the tuning fork, the catalepsy reappears. Is this strange fact, noted by Monsieur Vigouroux, due to the excitation of auditory sensitivity, or that of sensitivity in general? We don't know"[101] (figs. 90, 91). Since we don't know, let's dig deeper, induce more responses: let's place a tuning fork vibrating at G-3 near a hysteric's left ear. What do we find? —that, if the young woman sticks out her tongue at us, it irresistibly veers *to that same side* and remains there, contractured, "hard to the touch, swollen, bluish, . . . for 55 to 80 seconds"[102] (fig. 92).

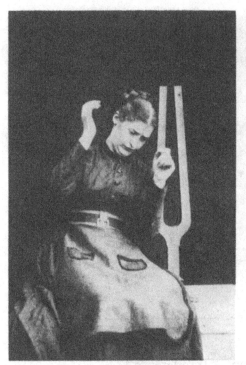 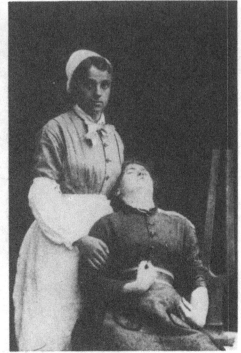

Figures 90 and 91
Régnard, "Catalepsy provoked by the sound of a tuning fork"
(fig. 90) and "Somniation with an artificial contracture" (fig. 91),
Iconographie, vol. III.

Second, a whole arsenal of *magnetic contacts* were employed, a technique that Burq's experiments of 1850 had placed on the agenda of official science.[103] Charcot was part of the scientific commission, named in 1876 by Claude Bernard, that was charged with verifying the powers of magnetism alleged by Burq. These powers were thus verified and confirmed. If one places a magnet on the fully anaesthetized arm of a hysteric, there is a strange tickling sensation, and then it recovers all its feeling. Soon, a bit of neutral metal suffices; soon "contact at a distance" suffices. This was called "metallotherapy." Now one need find only the singularity of the "metallic power" adapted to each case—for each hysteric has her favorite metal, as she has her favorite color. Augustine had a predilection for gold! (part of her penchant for finery, obviously).[104] Myriad napoleans were thus placed on hysterical bodies, the bids ranging from 20 to 1,000 gold francs. And the hysteric, covered in fine metal, like a Chrysostomic idol, loudly rediscovered sensation, that is, she rediscovered the simple pain of the slightest contact.[105] Variants on this process soon

NOUVELLE ICONOGRAPHIE. T. II. PL. XXXIII.

Phototypie Berthaud

CONTRACTURE DE LA LANGUE PROVOQUEE A L'ETAT DE VEILLE
CHEZ UNE HYSTERIQUE PAR REFLEXE AURICULAIRE

LECROSNIER ET BABÉ, ÉDITEURS

Figure 92
Laufenauer, "Contracture of the tongue provoked by the
frequency of a tuning fork," *Nouvelle Iconographie* (1889).

followed: portable plates for "permanent metallotherapy," little bits of metal stuck between the shoulders, on the wrist, on the heart, and so on;[106] "internal metallotherapy" in a dissolvable form, "with doses progressively augmented. We prescribe no other medication."[107]

Nonetheless, from one feat to another, while the use of metals and their various magnetisms did not hold disappointments in store—to the contrary—it did produce, let's say, counter-feats:

> A magnetic bar is brought within a half-centimeter of the anaesthetized part of the arm, for example, and in order to be sure of avoiding any contact between skin and magnet, a piece of paper is inserted between the two. The first effect felt by the patient is an impression of coldness, in the portion of the skin nearest to the magnet; at that point the skin is already slightly red; a moment later, *sensitivity is restored* in the points where the impression of coldness and redness of skin were manifested. If one then examines *the symmetrical portion* of skin, on the other side, one sees that this part *has become anaesthetitized,* however sound it had been previously.[108]

A territorial feat, a morphogenetic feat, a feat of symmetrization! Charcot admitted that the application of metals *did not cure the symptom, but displaced it.*[109] He admits this, of course. But having admitted it, he is immediately fascinated by the mystery of these displacements, not so much by the nature of the phenomenon as by the cartography of its course. He baptized this mystery "transference"—what a coincidence—and then set off again convocating, calling imperiously and "inducing" other "transferences" that were always more exemplary, for they favored him with a thousand rare forms.[110]—But these thousand forms were induced, accepted, a thousand forms *in one form*—finally—the great form par excellence, manipulable, measured, "implemented"; the representative structure of the procedures, henceforth canonical, for staging the *experiment.*

Third, there was an attempt to put the finishing touches on the reproduction and experimental mastery of hysterical singularities by inducing the form, and even the content, of deliria. How is this possible? Isn't the content of delirium essentially undeducible, and a fortiori, essentially uninductible? Well, no, says Charcot.

How is it possible to induce the form and content of deliria? Here lies the secret of his *magisterium,* the providential word of transference in the Freudian sense, because it designates not only the absolute claim of a moral, doctrinal or even celestial authority, but also the pharmaceutical preparations of the past, which were indeed attributed with "sovereign" virtues.

Magnan had already delighted in instigating "hallucinations and epileptic attacks" in dogs, injecting them with essence of absinthe.[111] Claude Bernard had intoxicated his little rabbits with ether, to confirm certain hypothesis about the "pathology of the nervous system."[112] Based on this model, hysterical intoxications and vertigos were reinvented at the Salpêtrière.

First certain inhalations were attempted, with the aim of interrupting convulsive attacks; of such inhalations, Charcot initially said that "it seems rational to us to give them a trial given the current circumstances. We will have recourse to ether, and then to amyl nitrate if the first does not succeed, and we will not fail to keep you apprised of the results as we obtain them."[113] Ether and amyl nitrate are indeed effective in suspending choreas and shakes, but, once again, *the symptom is displaced,* "transferred," transferred in time, passing into an ulterior phase of the "classic" attack: a *delirium is induced,* "a delirium resembling that observed during the series of attacks: loquacity, involuntary confidences, hallucinations, various modifications of the physiognomy, etc."[114]

As if by coincidence—the coincidence of "transference"—it was almost always question of loquacity and deliria with a sexual content: ether made Augustine "gently sway her legs and pelvis" as she aggressively recounted the details of her rapes and loves, showing Bourneville everything: "That's how you make babies," she "confided" to him.[115] And how did Bourneville respond? He escalated all demands (Augustine's and his own) by suggesting that the young woman put it down in writing: "after reiterated insistence," he admitted,[116] Augustine pretended to resign herself to it, flirtatiously, and signed long confessions in which she admitted that she dreamed of other men, of revolutions, of fleeing far from the Salpêtrière. She "fully" confided herself, but added: "P.S. I've told you everything you asked, and more; I'd speak to you more openly if I dared; but I'm afraid it would be in front of everyone."[117]

Augustine was well aware of the fact that, despite the "gain from seduction," the platforms, amphitheaters, and cameras also entailed a kind of show business cruelty. However, as Bourneville said, it was a period "during which she was fairly easy to handle"[118] (see appendix 19).

These inhalations of ether and chloroform became part of Augustine's daily experience, and I mean daily; continually, the novice drug addict would loudly clamor for the drugs, steal them, nearly overdose on them. On "March 3rd she inhaled 125g of ether. From that day until March 8th, she was faint, with strange ideas in her head, etc. Last night, from seven to eight, she had 17 *epileptiform attacks,* followed by eight hystero-epileptic attacks. When she woke up this morning, she said she felt like a drunken woman."[119]

Facial neuralgias assailed her, so she was injected with morphine.[120] All kinds of bromides (camphor, ethyl, potassium, sodium) were also in wide use at the Salpêtrière.[121] Even tobacco smoke was employed;[122] recall, in passing, the role of such smoke in Dora's shady transference.[123] . . . Or recall instead our own intoxications; let us not forget that intoxication is never meant to cease. A large number of hysterics died addicted to ether, alcohol, or morphine.

The Reprocessing [*Retraitement*] of Deliria

But the opportunity was too good to be missed—I mean the iconographic, theatrical opportunity. By combining hypnosis with all kinds of inductions (inhalations, injections, and so on), they were able to give a true direction to delirium and its operation. Directing the actress unbeknownst to her was the ultimate achievement of a director who dreams of being a deus ex machina.

Doctor Jules Luys, at the Charité hospital, was, notably, the skillful artisan—I ought to say the *chef*—of the deliria of "Esther," his favorite case; he concocted a thousand and one recipes based on essence of thyme, spruce powder, cognac, "simple water," "ordinary pepper," fennel, valerian, anise, garlic, and onion, plus a few rose petals; but also on tobacco, hashish, eau de Cologne, sparteine and atropine sulfates, and morphine hydrochlorates. Depending on the seasoning of the day, we see Esther (each of her deliria was photographed) laughing, crying, squinting, completely distended in contractures, going into ecstasy, looking for imaginary fleas, being persecuted by migraines, verging on intoxication, becoming alarmed (this indeed is the effect of the "simple water,") merry (pepper), lascivious (fennel)—and I'll stop there, quite arbitrarily[124] (fig. 93).

Certain scientists attempted to deny any factor of psychic suggestibility, hoping to uncover a pure dialectic of the sensorial.[125] But in a certain sense this was simply to raise the doctrinal stakes, out-Heroding Charcot. For Charcot did not quite stand his ground in his efforts to de-psychologize hypnosis. Hypnotically eliminating a paralysis, Charcot ultimately admitted that "it's by acting 'on the mind' that paralyses can be healed."[126] Note his prudence, the insecurity of the quotation marks.

Why?—Because it was already clear that the therapeutic efficacy of hypnosis—and here, indeed, lies the problem—still had to be placed in quotation marks. "There is still much to do," said Charcot, "in clinically regulating the therapeutic applications of this method, and in specifying its indications and contraindications."[127]

Pending an always differed "regulation," the therapeutic method consisted in experimenting, and experimentation consisted in *reinforcing visibility:* thus, reprovoking an attack (its spectacle, in front of everyone, in the amphitheater) could function, as Charcot tells us without much explanation, "in a way, as a means of therapy."[128]

Chariot employed a simple technique of reproducibility, then; an instrumental catharsis, the artifice of repetition. The essential was not perhaps to treat, but to *reprocess [retraiter] hysteria*—like matter, split a hundred times, that emerges from the ashes, taking on a form with well-calibrated facets. A form was remade, then, to produce splendor with no surprises.

If attacks and deliria were not to be entirely directed—"at least their course should be modified by different procedures";[129] thus imposing a "course," a time, a form, on delirious hysterical thought.

Lark-Mirror (The Art of Fascinating)

Imposing a form requires a technique, *téchnē:* a whole art. A classical method, once again.

One must begin by *choosing one's subject:*

> The moment has come to acquaint our readers with the procedures employed at the Salpêtrière. One must first choose one's subject; few women cannot be hypnotized; there are even certain men who make the task quite easy. But it is quicker and more reliable to select a hysteric. Among them, the younger ones are preferable, since they are more sensitive, more impressionable. Some of them are great readers of novels, and have personalities that are not without a certain sentimentality: they are preferable to the brutal, openly lascivious and lewd ones.[130]

Then, says Bourneville, one must subjugate one's subject, *appropriate her for one's self, take her gaze:*

> One fixedly gazes at the patient, or has her look at the tips of her fingers. From that point on, the subject will follow you everywhere, without taking her eyes off you; she'll bend down if you bend down, and will swiftly turn to find your gaze if you yourself turn. If you move forward quickly, the subject will fall back, stiff and rigid. This experiment must be performed with the greatest possible precaution; the patient does nothing to parry shocks, and would fall straight on her head if an aid did not hold her back. In this state of *fascination,* the hypnotized subject belongs absolutely to the *fascinator* and violently rejects anyone who tries to intervene, unless this person

Figure 93
Luys, "Emotions" induced by olfactory stimulation,
Les emotions chez les sujets en état d'hypnotisme (1887).

Fig. 21. Fig. 22

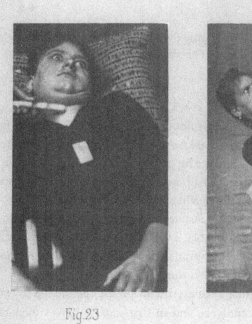

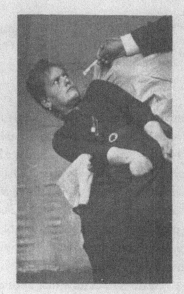

Fig. 23 Fig. 24

Georges Luys p.t Photogl. A. Lemercier

Librairie J.B. Baillière et Fils

 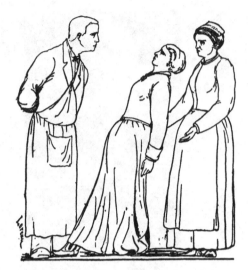

Figure 94
Bourneville, schema of hypnotic passes, *Iconographie,* vol. III.

himself performs the necessary maneuvers, and, as the specialists say, *takes the gaze* of the subject with his eyes, beginning the fascination for himself [fig. 94].[131]

Thus Augustine would blow kisses, as suggested to her, to someone whom the "fascinator" could hardly not have identified as himself[132] (fig. 95)—for, as I have already mentioned, Augustine "has affectionate feelings for the experimenter, whoever he may be,"[133] to the point that, admits Régnard, "persuaded that I had a particular power over her, [she] would fall into hypnosis no matter where she encountered me."[134]

An aggravated dialectic of transference—a most serious seduction. The photographer, despite his big black veil, despite or thanks to his distance, is a significant partner, who thinks he is pulling the strings (most often he is not wrong—though he is sometimes).

"She does not know that I possess this image and therein lies my falsification. I obtained it secretively, and in that sense I have stolen her heart."[135]

Luys, perhaps less of a Don Juan than Régnard, fascinated his hysterics with a real *lark-mirror,* placed on the pedestal of his photographic boudoir; having brought them to catalepsy, he would start to "pinch their skin, and excite them through various procedures," and so on[136] (fig. 96). In short, the fascinated bodies utterly belonged to him.

Planche XVIII.

CATALEPSIE
SUGGESTION

Figure 95
Régnard, photograph of Augustine ("Catalepsy: Suggestion"),
Iconographie, vol. III.

Figure 96
Luys, "Group catalepsy using a lark-mirror,"
Leçons cliniques (1890).

Occult Pavane

But something remains unsaid.

Let me return to plate XVIII, Augustine's "suggestion," Augustine's kiss (fig. 95). Bourneville's commentary is filled with the "taking" and "modification" of Augustine's gaze, filled also with the prodigious "automatism" of the body in catalepsy, thanks to which, "according to the attitude imposed on the patient and the gestures she is made to perform, the physiognomy changes and comes into harmony with the attitude." Thus: "If one places the index and middle fingers on her lips, as in the act of a kiss, amorous pleasure is painted on her face (Pl. XVIII)."[137]

It may be magnificent, but something is still denied, something is forgotten here in the image. Something, I repeat, has been driven outside the frame, but is nonetheless described: the kind of dance that the experimenter must have been obliged to perform so as to lead his partner—what else can she be called?—through one figure or another.

Try to imagine it, from this transcript of a session:

c)—The experimenter abruptly moves toward her with a threatening mien: X. . .'s eyes fill with fear; her eyelids open wide: she

falls back like a block (an aid catches her and prevents her from in-
juring herself).

d)—The experimenter takes her gaze and moves away. The
patient walks towards him, violently pushing chairs out of her way,
and with surprising force pushes between two assistants standing
back to back. If someone tries to take her gaze, she jostles him, fights
back, and seeks out the primal experimenter.

e)—The experimenter simulates the movements of an animal
running. Laughing, X. . . searches for him, bumping into every-
thing, and then throws herself under the bed; she seems to be trying
to catch the imaginary animal.

f)—The sky is pointed out to her, and her hands are pressed
together. She sinks to her knees and is questioned. "What do you
see?—The good Lord.—What else do you see?—The Virgin.—
What is she like?—Her hands are clasped . . . there's a snake beneath
her feet . . . a rainbow over her head. . . . There's a beautiful light be-
hind her . . . red, white . . . I thought there was only one Jesus . . .
there are loads."

g)—The experimenter lowers her eyelids, spreads her arms
again, then opens her eyes, takes her gaze, and, pointing toward the
floor, draws the simulacrum of a snake and takes on a frightened ex-
pression: immediately X. . . 's physiognomy expresses fear, she wants
to crush the animal that is scaring her, and grabs a chair for this pur-
pose. Her movements are so violent that she has to be put back into
lethargy (to do so, it suffices, as is well-known, to lower her eyelids)
so as to calm down.[138]

And so on.

The bodies are attracted and distanced, in a kind of *display,* and each
one is playing, each one is simulating, each one forgets himself in the sim-
ulation, each one shows the other a hundred extraordinary objects, birds,
snakes (fig. 97). It is like a symbolic dance, almost a trance ritual. I imag-
ine a *pavane,* that slow and solemn dance; or else a waltz, in which our
couple endlessly turns around a subtle, unrealized point that links the
bodies; or else what is called a *branle,** the dance that a leader or the mas-
ter of ceremonies must know how to lead. And how does he draw his
partner into the pace of his will? By captivating her, with the shine of a
knife, for example (fig. 98).

The framing of the photographs in the *Iconographie* shows none of
this. For that would have meant explicitly staging the risk taken by the di-
rector when he is obliged to come on stage to tell the actress exactly what

*[*Branle* designates a swinging motion, but the verb form *branler* is also slang for mastur-
bating.—Trans.]

 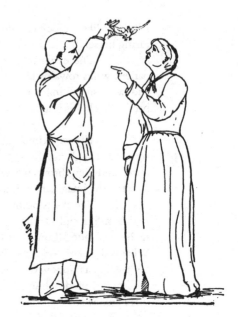

Figure 97
Bourneville, schema of hypnotic passes, *Iconographie,* vol. III.

he wants from her. It would have meant making an image of the definite risk a physician takes as he approaches the hysterical body in transference. The image despises this approach in which it is nonetheless founded and formed.

In this way, Charcot attempted to participate in transference only in an absolute sense, that is, as a categorical imperative of hysterical desire. He tried to participate only through his *magisterium,* meaning, in the first place, through the proper name, which he attached to syndromes of his own invention: "While she is in the state of somnambulism, I can make her do little things by *soliciting* her. I do not claim to be able to make her see or read through the epigastrium, but I can make her rise up from her seat if I ask her repeatedly; I can tell her to sit at this table and write 'my name, my first names' (which she knows), and you see that she did indeed write them on this piece of paper: 'Charcot (Jean-Martin)'. . . ."[139]

Ah, the name of the director, writ large on the marquee, although his body tried not to appear, tried to remain lateral to the stage.

The Fulfillment of Theater

And the script? The script of the roles? The author of the induced deliria? What prompts were the hysterics being whispered?

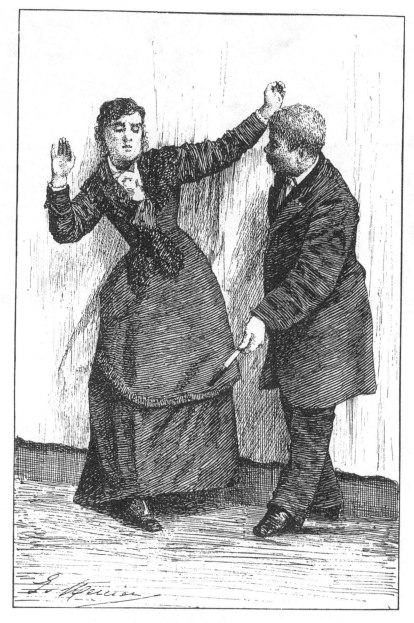

HALLUCINATION PROVOQUÉE.

D'après une photographie de l'auteur.

Figure 98
Régnard, "Provoked Hallucination," *Les maladies épidémiques
de l'esprit* (1887).

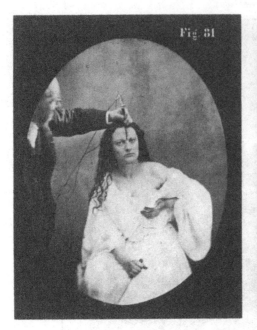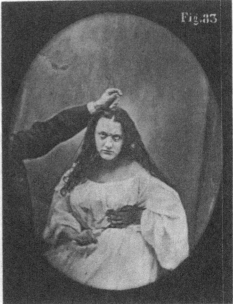

Figure 99
Duchenne de Boulogne, two typical imitations of "Lady Macbeth"
(cruelty), expressions induced with electricity,
Mécanismes de la physionomie humaine (1862).

Duchenne de Boulogne, the electric director, built up his repertoire
by invoking the phoenix of dramaturges, William Shakespeare himself.
Duchenne's "electro-physiological experiments represented in photogra-
phy" give us an example of a "Lady Macbeth, with an *expression of cruelty,*
in three different degrees"[140]—three electrical intensities determining
three styles of mimickry, her odious project progressively disrupting the
"pyramidal [muscle] of her nose" while she clutches her criminal breast
more and more tightly; look (fig. 99) and recall act I, scene V:

> Come, you spirits
> That tend on mortal thoughts, unsex me here
> And fill me from the crown to the toe topful
> Of direst cruelty! Make thick my blood,
> Stop up th' access and passage to remorse,
> That no compunctious visitings of nature
> Shake my fell purpose, nor keep peace between
> The effect and [it]! Come to my woman's breasts,
> And take my milk for gall, you murth'ring ministers,
> Wherever in your sightless substances
> You wait on nature's mischief! Come, thick night,

And pall thee in the dunnest smoke of hell,
That my keen knife see not the wound it makes,
Nor heaven peep through the blanket of the dark,
To cry, "Hold, hold!"[141]

(And Duchenne was not daunted by the complexity of the role; he proposed to "show that Lady Macbeth's homicidal fury was moderated by the feeling of filial piety that swept through her mind, when she discovered a resemblance between Duncan and her sleeping father.")[142]

As for the dramaturgical passion of Charcot (he, too, a great reader and tireless citer of Shakespeare) and his disciples, it was along the same lines. Along with the photographic series, we still have a few little *thesauri* of a veritable theatrical language of gestures—a conventional language, all things considered (a convention that should be reinterrogated)—that take advantage of the famous "cerebral automatism" of subjects in a hypnotic state: figurative calculations, then, and intentionally so, of surprises, pouts, disdain, tears, threats, ecstasies, and so on.[143]

Paul Richer confessed to his temptation to "push the experiment even further"[144] and did himself the sweet violence of giving in: "The patient can also be transformed into a bird, a dog, etc., and she can be seen trying to reproduce the look of these animals. She will speak, however, and answers the questions put to her, without seeming to notice what might be contradictory in the fact of an animal using human language. And, nonetheless, the patient claims to be perfectly able to see and feel her beak and feathers, or her muzzle and fur, etc."[145] Richer had his zealous actresses play *all roles,* based on simple "verbal suggestion":—the peasant woman (she milks her cow and refuses the advances of Gros-Jean, but says "Ah! Yes, yes! Later"); the army general (hand me my telescope . . . Onwards! Ah! I'm wounded . . ."); the priest (and "her voice is of an unctuous, drawling sweetness"); the nun ("she immediately sinks to her knees"); and even the actress ("For my part, I think the shorter the skirt, the better. There's always too much of it. Just a fig leaf. My God, that's plenty"[146] (see appendix 20).

We must admit that this is how the *Iconographie photographique de la Salpêtrière* manages to leave us speechless before the beauty of certain images, in which light, too, seems to take part in the role itself, as the intrinsic material of the drama. It is a little like the uncalculated part of Régnard's tact—a devotion to affects (fig. 100). Later, Albert Londe may have understood the connivance of the actress fully absorbed in her role and a certain emotion in the shot, if only in the often improvised scenography of light sources: he would systematically crush his hysterics between the platform

Figure 100
Régnard, "Theatrical" suggestions (of contracture,
"declaiming", "fear," and "terror"), *Iconographie,* vol. III.

(more like a pedestal) and an ostensibly neutral light, a light full of hatred
for the mystery, the great theatrical mystery, of catalepsy (fig. 101).

I must return to this voracious dramaturgical passion of the physi-
cians of the Salpêtrière, this *desire to have all the roles played,* which strikes
me as so crucial. It tends to *fulfill,* in all senses of the word, the paradox of
the actor, what Artaud calls "affective athleticism,"[147] long after Diderot
was astounded by the actor Garrick who would pass so quickly from one
affect to any another, as if playing a scale on a musical instrument.[148]

But we know the shocking conclusion that Diderot's "first speaker"
wanted us to draw: "Suitable for too many things," "too busy looking, rec-
ognizing and imitating," *acting bodies are the least sensitive,* the least "affected
within themselves";[149] they have so little soul, if any. In a sense, the neuro-
physiologists of the Salpêtrière wanted to lead us to the same conclusion.

The hysteric *declaims* so very well.

But then one of the following must be the case: either she is truly in
"sympathy" with her role—and isn't that because her own suffering [*pâtis*]
proves to be so unsubstantial?—Or else she is miming, wholly deprived

of affect (although with great virtuosity), and the pain she *proclaims* might also merely be mimed?

In short, hypnotic experimentation was digging a little deeper in its attempt to understand a hysterical subject, the question of the *subject of simulation*. The hysterics of the Salpêtrière were so "successful" in the roles suggested to them that their suffering had lost something like its basic credibility. They were so "successful" as *subjects of mimesis* that, in the eyes of the physicians who had become the directors of their fantasies, they entirely lost their status as *subjects of distress*. This is another paradox, not as classic but so simple, of the actress.

It was a paradox that allowed for a clear conscience, even an aesthetic conscience, and a beautiful soul, too, regarding the experimental tragedies of a few automaton-bodies—tragedy being a reunion with convention (in its attitudes), and a neuromuscular schema (in its production).

It is said that tragic heroines are torn: torn between hatred and love, love and the father, and so on—this is a metaphor. I would say that Charcot attained the fulfillment of theater in the sense that his goal was to give body to this metaphor. Not only did he invent terrible tensions between a number of hysterics, placing them on the same platform, for example, with a symptom scuttling between them at will (at Charcot's will), "transferred"

FIG. 1

FIG. 2

FIG. 3

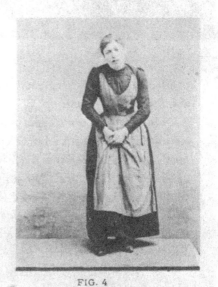

FIG. 4

PHOTOTYPE NÉGATIF A. LONDE. · · · · · · · · · · PHOTOCOLLOGRAPHIE CRÊNE & LONGUET.

SUGGESTIONS PAR LES SENS DANS LA PÉRIODE CATALEPTIQUE
DU GRAND HYPNOTISME

Figure 101
Londe, photographic series for an article by Guinon and Woltke
in the *NIS* (1891).

FIG. 1

FIG. 2

FIG. 3

FIG. 4

PHOTOTYPE NÉGATIF A. LONDE.
PHOTOCOLLOGRAPHIE CHÉNE & LONGUET.

SUGGESTIONS PAR LES SENS DANS LA PÉRIODE CATALEPTIQUE
DU GRAND HYPNOTISME

from body to body[150]—but he also invented a way of tearing them, through contradictory hypnotic attractions:

> While the patient is being plunged into somnambulism by the rubbing of the vertex with any given object, two observers enter and, without any resistance on her part, each of them takes one of her hands. What will happen? Soon the patient presses the hand of both of the observers and refuses to release either one. The special state of attraction is exerted by both simultaneously. The patient finds herself divided in half, in a way. Each observer possesses the sympathy of only half the patient and she resists the observer on the left when he tries to grasp the right hand as forcefully as she resists the observer on the right when he tries to grasp her left hand.[151]

Ideal Repetition

Why did hypnosis ultimately become, for Charcot, "the sublimity of the genre and the ideal in fact of pathological physiology"?[152]—Because it made the virtual element of a *representation* coincide with the actual pathos of the event of a symptom. Was it a signifying event, then?—Yes and no. In any case, it was "the ideal in fact."

Or, in other words, it was the exact—I also mean exact in the sense of "beyond the act"—*repetition of a "first time"*; Charcot laid claim to "a faithful reproduction" of the "local shock"[153]—his name for the trauma in hysteria, the act.

It was almost the irruption of the past act "in person," the raw, gesticulated hallucination of the act out of a simple suggestion to remember. A *theater of the return of memory* [*retour de mémoire*], then, like flames rekindled [*retour de flamme*], as one reads in Shakespeare: "Yet here's a spot . . ."— "Out, damn'd spot! out I say!—One, two: why, then 'tis time to do't!— Hell is murky,"[154] and so on. While the same Lady Macbeth so notoriously reiterates her crime and her guilt, a little doctor, in the shadows at her side, says: "Hark! she speaks. I will set down what comes from her, to satisfy my remembrance the more strongly."[155]

And indeed the doctor is a full partner in this abrupt rekindling of memory in "his subject." He is the partner and actor of transference, and the figure of the Master. This is why he needs more than the signifying *deposition* of the event (his hypnotic touch, *per via di porre*); he needs, in addition, *mastery over the reproducibility* of this deposition (its theater reproduced and repeated in photographic procedures).

At the Salpêtrière, this mastery over repetition was already highly instrumentalized—and in that sense it was almost ideally accepted—on

these hysteric bodies that had become nearly transparent representative agencies, deprived as they were of resistance. They consented. Note the exemplary feat of the so-called somnambulic writing: for the patient, "everything is happening in the head," says Charcot, nothing more; the patient acts, without producing an act from the effectiveness of this acting; all effectiveness falls to the master of sleep; for he has full power over the materiality and the final configuration of the act; over what is written, finally. A problem emerges: if writing has a subject, who is it, in this case?[156] (See appendix 21.)

Yes: bodies deprived of resistance. This, moreover, is precisely how Freud defines the "ideal" in question in hypnosis as a technique of repetition: "the ideal remembering of what has been forgotten which occurs in hypnosis corresponds to a state in which resistance has been put completely on one side."[157]

Being hypnotized is like being constrained to collaborate, body and soul, with the "suggestions," desiderata, or even desires of the practitioner. Moving beyond Breuer, who accounted for hysterical alienation simply in terms of "hypnoid states,"[158] Freud questions the relationship between *reality* and *representation* in hypnosis, by making the simple point that the suppression of resistance, the submission, and the total abandon of the hypnotized subject bespeak an amorous dialectic: a *charm*.

Freud describes the hypnotic process as the "unlimited devotion of someone in love,"[159] a subject faced with a "master" so invested in power and mastery, that he comes to take the place and space of the *Ichideal,* the ideal of the ego in person. This explains the failure of the test of reality itself (no, I am in fact neither bird nor snake, nor priest, *nor even actress*) when faced with the injunctions of the hypnotizer.[160]

In that text, Freud draws a line, dotted but imperturbable, from the amorous state to hypnosis, then to the structure of the group, and finally to neurosis.[161] He speaks of hypnosis now as *love,* now as *thaumaturgy,* and almost always as *violence:*[162] a certain idea of art, between charm and cruelty.

On the Brink of a Perfect Crime

A *gestural language of fantasy,* or rather of the connivance between the hysterical fantasy (summoned hypnotically) and a fantasy of staging (summoned as an experimental theme)—a gestural language of fantasies has a fatal encounter with fantasies of death, aggression, and cutting to pieces.

What is the gestural language, under hypnosis, of a fantasy of a fatal attack? Is it the simulacrum of a crime, or is it in fact a crime (because the hypnotized subject is wholly obscured in this "test of reality")?

I will briefly mention only that this question, the question of the *hypnotic crime,* became entrenched in everyone's mind after Charcot's report of February 13, 1882, presented to the Academy of Sciences, put the practice of hypnosis on the agenda, and even made it fashionable. This is the starting point of the story of the rivalry between the schools of the Salpêtrière and of Nancy, Charcot versus Bernheim.[163]

I mention in passing that the rivalry around this question was always exacerbated in regard to two themes: sex (seduction, rape) and blood (crime). And it was always exacerbated under two circumstances: competing experimental procedures, and divergent expert opinions in the great courtroom trials (the Chambige affair in 1888, the Bompard affair in 1890: sex and blood). This contiguity is already an indication of a very subtle and effective passage that hypnosis put into action, in which charm casually turned to rape, and "experiment" ("just to see") turned to crime.

Hypnosis *alters* the subject, her "personality": no one ever denied this.[164] Strictly speaking, it is a blow against a kind of integrity; it is therefore not, said the doctors, and rightly so, "free of danger."[165] But a very, very subtle and effective passage was effected at the heart of experimental methodology itself, as if it were hallucinating, in a way; and this passage consisted in developing a passion for the hypothetical *measurement of this alteration.*

Measuring in this case can only be a *pushing to the limits:* see how far we can go. And this is how the theoretical rivalry between Bernheim and Charcot took on the diabolical appearance of an obstacle course, an experimental course in which the rising stakes of reports, procedures, and always incredibly punctilious transcripts, cannot help but suggest Sadian logic. In Nancy, Bernheim's subjects signed acknowledgments of perfectly exorbitant debts, took relish in eating the vilest refuse, unknowingly participated in stripteases and, finally, committed what were then called "laboratory crimes" with unloaded pistols, imitation arsenic, and so on.

In Paris, Richer tried to make a hypnotized Bonapartist cry out "Long live Gambetta!"[166] and Ballet also experimentally increased disgust and horror, but in order to certify, in accordance with Charcot, that total hypnotic submission is impossible. Some good will is required. She was raped under hypnosis?—she consented at least a little ("In my opinion, a woman who gives herself to a man during or after hypnotization, would have given herself to him just as readily outside these experiments of hypnotism")[167] (see appendix 22). This debate lasted for years.

However, in Clermont-Ferrand, a young professor of philosophy, twenty-seven years old, raised a faint voice, a discreet appeal for self-

critique on the part of the experimenter: "Also unconsciously, we our-
selves suggested this recourse to illicit means by giving him an order that
he is incapable of carrying out in any other manner."[168]

Bergson here revived the question of the limits of hypnotic acts, re-
stating the question of the *simulating subject* by adumbrating, in all its per-
tinent symmetry, *the hypothesis of the Master's desire.*

Beautiful Soul, Monopoly of the Spectacle

The desire of the physicians of the Salpêtrière was, fundamentally, a de-
sire that dared not speak its name. Therein lies its perversity, if not its per-
version. Therein lies its unhappiness, in a sense, perhaps the anxiety of the
"medical body," or rather the rejection and corruption of a rising anxi-
ety—also the movement of the beautiful soul.

Theirs was an *indecisive desire,* somewhere between a continual rais-
ing of stakes (the childish morality of the toy) and prudence (an ageless
deontology).

The stakes were raised by multifarious means. The "image" of hys-
teria in the nineteenth century—and certainly something of it remains
with us today—the vulgarized image of hysteria was the one produced
and proposed by Charcot. The same goes for hypnotism: as early as 1890,
Charcot entered the little pantheon of a "Library of Wonders,"[169] and that
says something. We know that in his Tuesday Lectures, Charcot delighted
his largely nonmedical public. He went so far as to invest each spectator
with powers of mastery over the hypnotized subjects:[170] "Here, Monsieur,
over there perhaps, yes, you, over there, go ahead, order her to do some-
thing, yes, anything at all." Charcot temporarily lent out his "supposed
knowledge," the motor of transference, to prove he wasn't cheating—as
if at a circus. On the other hand, the magicians and magnetizers of the
time were beginning to display a certain gravity in their presentation, ad-
vertising with slogans such as: "Based on Professor Charcot's experiments
at the Salpêtrière."[171]

And that is where the shoe pinches, of course—for Charcot. The
shoe pinches when a structural modality—unknown, but hardly so—re-
veals itself out in the open, though displaced, in the boasts of a mounte-
bank: when a veritable entertainer comes to take himself for Professor
Charcot, because he quite simply has the intuition that the Salpêtrière can
teach him new things about his own profession; because he has an inkling
that the Salpêtrière is a center for magic and conjuring, a fair of mon-
strosities. Beyond its museum (and this is how all the writers saw it), the
Salpêtrière was the capital of smoke screens, the capital of sandmen.

The backlash of this reputation was one disparaging word: *vulgar-ization!* The response was a sincere imitation of deontological *prudence*—here anticipating critical mutterings,[172] such as Charcot's allegation of his "prudence," previously mentioned.[173] There, following on such critiques as in the disciples' massive, ungrateful denial of the Master after his death. Charcot's interest in hysteria and hypnosis was mocked as a fatal "third career"; his "carelessness of old age" is suggested; he is accused of faltering "slightly" and of being guilty of "the worst audacity."[174] The guilt was attributed to abstractions, and there were accusations against philosophy, the pure thought of bodies, or even against the thought of thought—against domains beyond medicine, in any case. "It appears that at a certain period in his life, Charcot . . . was attracted by philosophy and psychology, and by the study of the intimate mechanism of cerebral functions. Thus, in addition to his interns in Medicine, he selected collaborators affiliated with the philosophical disciplines."[175]

Others cite attenuating circumstances, inciting squabbles over responsibility: Charcot was said to be "outmatched" or even exploited, less by his ideas than by the zeal of his own collaborators, who so ardently offered him what they could tell he wanted to see on a silver platter. And then, "the hysterics voluntarily lent themselves to experiments so as to make themselves interesting,"[176] and he—naive scholar—believed them! What is more, word went round that Charcot kept his hands clean, never "personally" hypnotizing a single patient, always delegating this task to assistants, and so on.[177] I will not enter into this imbroglio.

What I am concerned with here is the wave of guilt that nonetheless spread through the rising experimental stakes in this center of medicine.

Psychiatric ethics got hold of itself again, and even became a bit more staunch: there was a loud hue and cry over the "serious hysterical accidents occurring after hypnotizations practiced by a magnetizer in a stall at the public fair,"[178] and other cases of this kind.[179] Every attempt was made to disown, though it was patently obvious, the historical role of fair magnetizers (the famous Donato, for instance) in the emergence of the scientific interest in this question in the nineteenth century.[180] Moreover, all precursors were denigrated, including Mesmer (though excluding Braid, at least), who were claimed to be "truly sick," with nothing but a "love for the extraordinary": they were hysterics, all in all.[181]

And this is how an ethics of therapeutic precaution came to reaffirm its rigor: it claimed a monopoly.

You have asked me to express my opinion concerning the restrictive measures recently adopted in Italy, in relation to the public perfor-

mances of magnetizers. I admit that I'm not sorry to take this opportunity that you are offering me to declare openly that, in my opinion, the suppression of this type of spectacle is an excellent thing and entirely appropriate. This is because for the subject involved, the practice of hypnotization is not, in fact, as innocent as general belief would have it—far from it. . . . In the name of science and art, medicine has finally taken definitive possession of hypnosis in recent years; and it has done so with justice on its side, for medicine alone knows how to apply it properly and legitimately, both in the treatment of patients, and in physiological and psychological research. In this recently conquered domain, medicine wishes to reign henceforth as an absolute Mistress, jealous of her rights, and formally spurning any intrusion. Yours faithfully, Charcot.[182]

Rights, jealousy, faithfully yours: a form of denial. And the physicians did not fail to reassure themselves with one last I-know-but-still:

Recently observed events, principally in Italy, would seem to indicate that the practice of hypnosis is liable to lead to permanent nervous disturbance. Ought one to deduce from this that such experimentation should be prohibited? This would be to admit that there are truths that ought to remain unknown. . . . One can accept experimentation on man, who, incidentally, has nothing in him that should shock. Indeed, it is something of a daily practice: in laboratories and hospitals, numerous patients and students voluntarily submit themselves to such experiments.[183]

Prudence, yes, but science is still obliged to make spectacles: "This"—hypnosis as a "faithful reproduction" of the trauma—"this is absolutely accepted and I will show you its spectacle one of these days,"[184] Charcot promised his doubtlessly listless audience.

The Tamer of Past Things

How did Charcot run his stall for this demonstration? How did he put on his shows and dispense his words? How did he control his hypnotic fair? Listen first to its most intimate sales pitch:

No sign will treat you to the interior spectacle, for there is now no painter able to give even its sad shadow. I bring you, living (and preserved through the years by sovereign science) a Woman of bygone days. Some naïve and original madness, an ecstasy of gold—I know not what!—that she calls her hair, folds with the grace of cloth around a face illuminated by the bloody nudity of her lips. In place

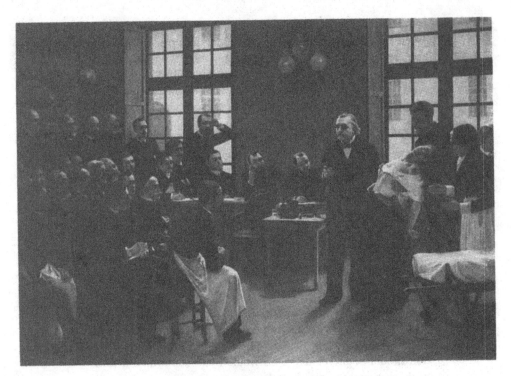

Figure 102
Brouillet, *A Clinical Lecture by Charcot.*

of vain garments, she has a body; and her eyes, resembling rare
stones, are not worth the gaze emerging from her happy flesh: from
breasts lifted as if they were filled with eternal milk, their tips to the
heavens, to smooth legs that retain the salt of the first sea.

Remembering their poor wives, bald, morbid and filled with horror, the
husbands throng about her.[185] This is the spectacle of the Tamer of Past
Things.

Consider Brouillet's painting of the Tuesday Lectures[186] (fig. 102),
which, like all the representations of the time, is more or less hagiograph-
ical: a "queen of the hysterics" swooning—no, in contortions, her neck
bared to the staring assistants, seventeen of whom are quite recognizable,
and official, in a sense.

Imagine Charcot giving a lecture on tremors, for instance, three or
four choreatic or hysterical women would be brought into the am-
phitheater, bedecked despite themselves in feathered hats, the discussions
and measurements thus following a colorful shudder, easier to master than
an insane vibration of all the bodies. It was almost art criticism. And the
bodies, indeed, were there on the platform, like the poor remnants of a

concept, of a proper name—Parkinson or another—remnants of a diagnosis, of a sentence swirling above their skulls, without them knowing anything about it.[187]

Consider, too, the fact that a teaching method that used photographic projections had what it took, at the time, to create a true "sensation," as the great events of our theatrical seasons are called.

The Tuesday Lectures were strictly "organized so as to provide, in particular, an image of the daily clinic, of the policlinic *imaginem belli* with all its surprises and in all its complexity," writes Babinski as a preface to their first publication.[188] He is citing "the Professor himself," citing Charcot's clinical idea: *imaginem belli*.

Charcot thus used the hospital's status as a *collection* (the "living pathological museum") to conjugate a *style* of transmitting knowledge, capable of "already exercising a fortuitous influence on the minds of its audience, particularly those with ambitions of undertaking new explorations in the attractive domain of neuropathology."[189] Charcot thus paved the way for an *attraction* [*attrait*], *Reize,* an attraction of nervous illnesses, for the henceforth aesthetic consciousness of pathology.

And everyone was interested in this attraction, let us not forget; let us forget neither charm nor consent: "I saw," reports Daudet, "clients of Charcot who were quite embarrassed when a sign or a reflex, which they knew to be particularly dear to Charcot, disappeared: 'What will he think of this? He won't be interested in my case anymore! How should I act, now, at consultation?'"[190] It was thus essential in a sense: to *make the right impression* with one's own illness—a dialectic of inciting good form.

Charcot not only prompted symptoms to something like a perpetual mimicry of themselves, he also inspired them, like a model, summoning "transferences" by throwing himself into a pantomime of symptoms before his audience.[191]

In this way he displayed all the virtues of the *actor,* in addition to those of the *auctor:* the author (master and guarantor of forms), augur (master of time), instigator of acts (the *auctor* is he who literally pushes one to act), director of the actresses of Hysteria, his concept. This is what I also call, without moralism, but failing another term, the know-how of *hypocrisy.* This know-how thus glorified hysteria as a "grand form." At the same time, it lent credence to a real "body" of hysteria.

The Miracle Worker

A real body of hysteria: a body on which knowledge, Charcot's supposed knowledge, worked miracles, and I do mean miracles. Called to the side

of a young nun in a convent who suffered from functional paralysis, Charcot came and said: "Rise and walk!" The patient obeyed—it was a miracle—and the Church was seized, in all senses of the word.[192] The so-called miraculous healings at the Salpêtrière made the headlines of *Religious Week* as often as the healings at Lourdes.[193] Occasionally witnesses would bare their heads and cross themselves in front of Charcot.[194]

Take Charcot's hysterical amnesiacs, for example, who could clearly not remember anything:

> D.—Do you know where you are? R.—I don't know. I don't know this room. D.—Do you know the Salpêtrière? R.—I've never seen it, but I've heard of it. D.—Do you know these two women (her two roommates). R.—No, Monsieur. I've never seen them before. D.—And this gentleman (M.S. . . , the intern of the service)? R.—Not in the least.

They could remember nothing, *except Charcot:*

> D.—And me, do you know me? R.— (after a brief reflection) . . . *Yes, you're Monsieur Charcot!*[195]

This relation is nonetheless a dialectic of seduction, in which the hysteric *felt and believed* that Charcot knew everything with his senses, she who knew nothing; and in which he *did not believe and yet still believed* (positivist on the one hand, still fascinated by his own efficacy) in his miraculous charm. I imagine it like this: "Today my eyes have rested upon her for the first time. It is said that sleep can make the eyelids so heavy that they close by themselves; perhaps this glance could be capable of something similar. Her eyes close, and yet dark forces stir within her. She does not see that I am looking at her; she feels it, feels it through her entire body."[196]

A dialectic of mastery, then. Charcot decided, for example, to intern a certain young anorexic—the only possible therapy, in his eyes. Consent from the parents was difficult "despite all my remonstrances"; finally, "isolation" is effected: "The results were quick and marvelous." Why? The girl herself gave an analysis of it: "As long as Papa and Mama didn't leave me, in other words, as long as you hadn't won—for I knew you wanted to shut me up,—I believed that my illness wasn't serious and, because I loathed eating, I wouldn't eat. *When I saw that you were the master, I was afraid,* and despite my disgust, I tried to eat and it worked little by little." The emphasis is Charcot's. He then provides a coda, his modest commentary: "I thanked the child for her confidence that, as you will understand, contained an important lesson."[197]

The lesson?—Perhaps it was this: *charm and the mastery of charm.* Creating "enchanted" patients, elevating Charcot "to the heights of Olympus."[198] Such things tend to fabricate a *personage,* the symbolic identity of Father, Judge, Healer, uniting all the figures of, say, omnipotence.

This omnipotence speculated and acted on neurotic misrecognition, the neurotic illusion from which transference is woven, throwing smoke screens before the patients' eyes. Omnipotence is denied (everyone knows about it, but still it is used blindly), even in the theoretical teachings. Transference was thus renewed in every which way, the fantasy of scientific omnipotence. Smoke screens are thrown also before the public's eyes. The personage is definitively founded: magisterium. Freud, at the time, began his letters to Charcot in their way: "For the past two months I have been fascinated by your eloquence."[199] Elsewhere he confided himself in these terms on the subject: "Despite my taste for independence, I was very proud of this mark of attention, since he is not only a man to whom I have to be subordinate, but a man to whom I am gladly so."[200] And what Freud brought back from Paris to Vienna were veritable ex-votos, effigies, embroidery.[201]

Magisterium. The subject-supposed-to-know of a whole epoch. Hagiography, even. As I have already mentioned, Charcot was considered to be a true "apostle,"[202] the "consoler of his century,"[203] and a great philanthropist. Anecdotes abounded:

> All the refuse of terror, heredity, debauchery, and alcoholism gathered at his feet, like the refuse of Paris gathering at the mouth of a collecting sewer: he would make or remake it into men, women, mothers! This is the miracle. One day I saw him demonstrating to some magistrates, through a living experiment, that a when poor hysterical girl is dominated and steeped in a superior will, she can become irresponsible. It was summer, and the glass ceiling was warmed by the sun. An old judge, fat and red and rather excited in fact, fainted, and Charcot quickly roused the poor hypnotized girl to tend to him; in but a moment, she had rushed over to the magistrate, giving him sugar water, and had been transformed from a patient to a nurse. — "Thank you, thank you," repeated the man in his sixties, in danger of apoplexy. In this affair a whole symbol was at work. Charcot managed to demonstrate a truth to the magistrate, and, at the same time, made of a poor girl shaken by hysteria a devoted servant able to save, a collaborator in his immense oeuvre: combating Evil, consoling Life.[204]

"Trust in me then, faith soothes, guides, cures. . . ."

He could have said: "I shall unveil all the religious or natural mysteries, death, birth, future, past, cosmogony, nothingness. I am the master

of phantasmagorias. Listen! . . . I have all talents!" Or: "Trust in me then, faith soothes, guides, cures. Come, all of you—even the little children—so I can console you. . . ." Or: "I should have my hell for anger, my hell for pride . . . and the hell of caresses: a concert of hells." Or: "Ah! To come back to life! To cast eyes upon our deformities. And this poison, this kiss a thousand times cursed! My weakness, the world's cruelty! I am hidden and I am not hidden."[205]

Faith soothes, guides, cures. The curing of hysterics at the Sal-pêtrière was what it had always been: a miracle, a magical operation founded on an indecipherable complicity between the hysteric and her physician, perpetually reinvented.

This complicity could also be called *confidence,* quite simply: the to-tal abandon of bodies to a belief, a power, a magisterium. "*The cure* is a demand that originates in the voice of the sufferer, of someone who suf-fers from his body or his thought. The astonishing thing is that there be a *response,* and that throughout time medicine, using words, has hit the bull's-eye."[206]

What did Charcot believe, when confronted with the efficacy of his own techniques? One of his very last works is called, in fact, *The Faith That Cures.* In it he evokes sanctuaries, statues, *ex-votos,* everything that, since Asclepius of Athens, had provided those suffering from innumerable ills with what Charcot called "faith-healing," in English: healing-on-credit, I would say, confidence plus belief.

These phenomena, he says to begin with, "do not escape the natu-ral order of things. The therapeutic miracle has its own determinism."[207] He previously sought a kind of theoretical schema of this determinism through cerebral localization.[208] But here, only the factor of *suggestibility* is advanced, insofar as he is defining "the hysteric mental state" par ex-cellence. In this state, the spirit "wastes no time in dominating the phys-ical state."[209] Here then is a wholly psychic part, *motu proprio,* of illnesses (note that elsewhere this is denied, because it in fact threatens a schema that grounds neurophysiology). There is a wholly *imaginary* part to hyste-ria, then. "Psychic illness requires a treatment of the same nature," as Gilles de la Tourette admits, "the so-called *medicine of the imagination*": fulminat-ing pills composed of breadcrumbs or methylene-blue "that, by coloring the urine, vigorously disturb the patients."[210] Psychological medicine, as a strategy, plays on what is *unbeknownst to the patient.*

Charcot nonetheless admitted that the therapeutic miracle is impli-cated in a feat of which *bodies, insofar as they are hystericized,* are capable. Their miraculous healing is not a cure but a symptom—*a hysterical symp-tom,* of course. And Charcot almost seems to admit that this feat, while

being symptomatic, is no less *dialectic,* inventing itself each time in the drama of transference (in both Charcot's and Freud's sense of the term), that is, in the drama of a *reciprocity* that can go quite far: "It is curious to note that some of these thaumaturges themselves suffered from the same illness the manifestations of which they would later cure: Saint Francis of Assisi, Saint Theresa, whose sanctuaries rank high among those in which miracles are produced, were themselves undeniably hysterics."[211]

But his thought stops there. It stops with what I would call an *alibi,* with what is absent from the story. Does he retain the English word *faith* to protect himself from what "confidence" and "belief" might presume about an intersubjective dialectic into which every physician of hysteria, positivist or not, is thrown?—In short, his thought stops, in denial. Sometimes it even takes the form of a problem, an aesthetic problem. For Charcot did not identify with the saint; he went much further, identifying with the artist: that is, someone who can also afford the luxury of being satanic.

One day when a patient begged him to heal his tortured hands, to "be like God" for him, Charcot replied, "If I were God I should be eternal, I should have neither beginning nor end and that would ultimately bore me. And as the Almighty, when everything had been done, what should I do afterward? I should amuse myself by undoing perhaps."[212]

Theater against Theater

Doing and undoing: this is precisely the freedom a director has in his rehearsals. The Tuesday Lectures, moreover, are written, or rather rewritten, just like plays, with lines, soliloquies, stage directions, asides by the hero, and so on.[213]

The "hysterical mental state," which I have vaguely called the *imaginary part,* is often understood only within the parameters of the sarcastic sense that Molière gave the term. Imagine Charcot faced with the problem of hysterical simulation, but finding only *The Physician In Spite of Himself* [*Le Médecin malgré lui*] to come to his assistance:

> In general, gentlemen, and one might even say necessarily, the simulator is an eccentric. He readily uses his imagination to embroider and embellish. Recall Sganarelle's consultation of Lucinde, who can be considered a perfect simulator.

> *Sganarelle* What's wrong? What ails you? What do you feel?
> *Lucinde* (replies with signs, bringing her hand to her mouth, head, and under her chin) Ha, hi, ho, ha.
> *Sganarelle* What are you saying?

Lucinde (continuing the same gestures) Ha, hi, ho, ha, hi, ho.
Sganarelle What's that?
Lucinde Ha, hi, ho.

Well, gentlemen, these ha, hi, ho, ha's are clearly excessive and indicate simulation. The legitimate mute remains silent.[214]

(But notice that Charcot omits a detail immediately following this citation: Sganarelle found no better response than to *counterfeit* Lucinde in turn—"ha, hi, ho, hi, ha"—so as to make his *questioning* more precise: "I don't understand you in the least. What the devil kind of language is that?" But perhaps it was neither speech nor a sense of the impossibility of speech that Charcot was interrogating in his own mutes.)

The Tuesday Lectures were also, perhaps, scenes of catharsis (for the actresses even more than the spectators), in the sense in which tradition speaks of the catharsis of *humeurs peccantes,* which comes from the verb *peccare:* to sin, to fail, to commit evil and trick others. Does this mean that Charcot invented a theater against hysterical "theatricality," so as to denounce the latter as a simulation, as the *excess and sin of mimesis*?—Quite possibly.

At this point I propose to consider the psychiatric theatricality of the Salpêtrière as a specific attempt at *reconversion,* an ungainly word. They reconverted spectacular hysterical "conversion," and, in place of a dazzling temporality of repetition [*répétition*] (in the sense of the Freudian *Widerholungszwang,* and perhaps the point where this rejoins what Artaud expressed about the theater), in place of the dazzling temporality of hysterical symptoms, substituted another, regulated temporality: the temporality of their hypnotic rehearsal [*répétition*] (in the sense of theatrical performances).

Hypnotic theater, insofar as it is "mastered" by the "fascinator," *demarcates and intensifies the symptom:* it constrains the symptom to the perfection of a drawing, which, in its *artifice,* provides something like the truth of the symptomatic event in itself. When this event is spontaneous, it must be checked; once it is checked, it must be methodically reprovoked. It is a theatricality that searches for a kind of crystallization of the aspect in *theory* and, by a restaging, also something like a refabrication of its *evidence.* This particular theater is also the theater of the classification of words, the classification of subjects; it is the theater of the power of *fabricating taxonomies of suffering bodies.* It tends, in fact, to exorcise the symptom with the experimental, hypnotic repetition of the symptom.

No less than other theaters, this theater entails a gain from seduction, for this theater knows well how to knot together charm and knowl-

edge. But it is also like a mystification of love, in which she who is mystified is, most importantly, also the star of the spectacle: for she believes she is uniformly adulated. And yet "what is at stake is the honoring of an *imaginary contract* (I ask you to ask me for the image that flows from our mutual demands . . .)."[215] It is a theater in which the staging, in fact, is the *distancing and delay* of the "object,"—the object being hysteria itself—I mean a certain simple and strident claim of a certain body in the throes of certain symptoms.

This imaginary contract extends to the whole amphitheater. In its extension, it gives rise to a fundamental mistake: the "misunderstanding, that can nonetheless establish itself between the goggling onlookers and the master"—a misunderstanding that is, thus, the misunderstanding of supposed knowledge.[216]

And those assisting at the séance are, even so, somewhat more than onlookers: they do indeed assist; in a way, they help the symptom to show itself, wholly expose itself, through a very intimate but very effective exhortation. This is why such a theater, however ignoble it may be, resembles any other theater in its fictional quality; it is well known that "staging is the evident foyer of pleasures shared in common, also and after careful consideration, the mysterious opening onto the mystery, the grandeur of which one is in the world to imagine."[217] For in the quite shocking movement of its pedagogy, the Salpêtrière-theater offered something that one is almost always pleased to be offered in the theater: *luster,* "a beautiful object, crystalline, complicated, circular, and symmetrical."[218] The luster of hysterical bodies pirouetting on the planks of the Tuesday Lectures.

At this moment, then, when hysteria was staged and tended to represent itself as a *conceived image,* there was an agitated effervesence of contentment, worldliness, hearsay, "all-understanding": let us say idle talk.[219] It was like the socialized effect of a fundamental curiosity regarding hysteria—the equivocality of "seeing to see" adopting the alibi of "seeing to know"; *concupiscentia* with, or lacking, the alibi of *scientia.*

Beauty

This *concupiscentia,* this desire "to exhibit things in an imperturbable foreground, as peddlers, activated by the pressure of the instant,"[220] was transformed by the physicians of the Salpêtrière into production and reproduction, a collection, a *corpus.*

The *Iconographie photographique de la Salpêtrière* is in this way like the corpus of a fascinated attention or even expectation. It was fascinated by

the extreme narcissism on account of which the hysteric consents to the staging of her body; this extreme hysterical narcissism is fundamentally fascinating,[221] bearing within it something that may very well be called *beauty*. Kant writes: "We *dwell* on the contemplation [*Betrachtung*] of the beautiful because this contemplation strengthens and reproduces itself. The case is analogous (but analogous only) to the way we linger [*Verweilung*] on a charm in the representation of an object which keeps arresting the attention, the mind all the while remaining passive."[222]

The *Iconographie* is thus like the *collection* of such lingering, such delay. Always look twice: this was Charcot's methodology of the visibility of symptoms. See and measure. See and remake through hypnosis. See and photograph.

Take Augustine's "contracture," worthy of two photographs, plates XXIX and XXX of the *Iconographie*, volume 2 (figs. 103, 104). A hint of beauty is certainly not lacking, and, by virtue of the always duplicitous doubled gaze, enables the passing of the contracture, a misfortune of the body ("all joints are rigid; the fore-arm is in exaggerated pronation, the fingers are energetically flexed on the palm of the hand, the thumb is placed between the ring finger and the middle finger. . . . The pain in the right leg remains intense and the contracture of the limbs on the right is as total as possible")[223]—passing into the ineffable charm of the pose, skilfully draped, indiscreet, but not too indiscreet, a chair on the verge of tipping over, as if your very gaze flustered the bearing of the body. And then all the white flesh in the foreground. Ravishing?

Aren't these photographs images of sin? Images of a body saturated with sexuality. But they are false images, *passing into fiction*. Even though they are real photographs, they are wholly distorted, because they are created from a fatal commerce of the time that they impressioned. And this time cannot be seen, or else it becomes suspect (an almost-seeing, an anxiety) when one is aware of Augustine's severe contracture at that very moment, her loss of movement on her whole right side, the occasional hemiplegia, the anesthesia that, as you recall, "also affects the mucus of the right half of her body (ear canal, eyelids, eye, nostrils, mouth, tongue, palate, vulva)."[224] They are photographs of someone for whom the notion of position no longer existed on her right, someone who spoke of a half-tongue, who had lost all notion of color, who "was learning to be a lefty," as she said. A sinister beauty.

The image thus dissimulates the infirmity it was supposed to show, while the legend tells us that it is indeed shown, in the foreground no less: an arm, a leg. But a style insciously intervenes, producing a poignant *gain in beauty*. The image is crafty, simultaneously becoming closer and more

distant. The drape hides the body (rare, for the "medical style" of the time) but the frame grips "the subject" all the more tightly, arousing curiosity, the desire to "complete."[225] The image maintains itself in proximity to the body, but primarily so as to muffle the distress, make this distress into a form. Through this dialectic, a *dialectic of waiting*, the fabrication of images takes the hysterical demand to its height, perfection, and cruelty. Faced with this *oculus* (also perhaps a word of love: *in oculis aliquem ferre* is *to love* someone), the eyepiece that always comes closer, the hysterical demand succumbs to the delusion that the ear is near; after the eye approaches the ear will listen. An error—a error that was never evident. The hysterical demand thus becomes infinite, as does its consent to everything, as does its symptom.

In its ever-renewed reification of bodies, in the maintenance and mastery, and even *jouissance* of the distress of madwomen, the psychiatric authority of sight wanted to suspend time and keep madwomen mad.

In this way it fomented a *perverse relation*. The physicians at the Salpêtrière were, in the course of their experimental procedures, constantly asking themselves, in a certain way, the ultimate perverse question: "Of what corporeal substance is a woman made?"[226] They instrumentalized their question to an even greater extent, ceaselessly reinventing the hysterical body as an experimental surface of *triggers,* always searching for a substantial principle, a procedural description of the kind of *jouissance* a hysteric displays, or seems to display, even as she is suffering. Confronted with this quest, the hysterical body consented to an indefinite reiteration of symptoms, shreds of responses, a maddening reiteration. For a perverse authority, it was titillating. Iconographable.

Consent lies at the crux of a fundamental process, which Freud described in these terms: "*Neuroses are, so to say, the negative of perversions,*"[227] and I would say that, in a sense, neurosis and perversion can always find their connection in a *face-to-face* encounter. There is a kind of reciprocity, but it is marked by the negativity and finality of which the photographic situation at the Salpêtrière seems exemplary.

There was thus a paradoxical connivance. "The content of the hysteric's unconscious phantasies," writes Freud, "corresponds completely to the situations in which satisfaction is consciously obtained by perverts."[228] He is saying that in the first place, *this connivance is dissymmetrical,* placing perverted (supposed) knowledge face to face with the (hysterical) distress of knowledge. Still, it was connivance.

Planche XXIX.

HYSTÉRO-ÉPILEPSIE

CONTRACTURE

Figure 103
Régnard, photograph of Augustine ("Hystero-epilepsy:
Contracture"), *Iconographie,* vol. II.

Planche XXX.

HYSTÉRO-ÉPILEPSIE

CONTRACTURE

Figure 104
Régnard, photograph of Augustine ("Hystero–epilepsy:
Contracture"), *Iconographie,* vol. II.

Contract

A connivance—or a contract.

Charming Augustine—the charmed and the charmer: this charm took the form of a contract. In a single movement, it encompassed the *exercise of a law*—depending not on the body but on the status of its *appearance,* poses, *attitudes passionnelles*—and also something that was always *destined to be repeated.*[229] Consider Augustine's costume, quite simply. In two series of shots (of images), volume 2, and then volume 3 of the *Iconographie,* Augustine changed costumes, trading her simple inmate's shirt for the neat and tidy outfit of a nurse's aid. I imagine that this uniform was granted to her in exchange for the "regularity" of her hysteria; she would go into contortions and hallucinations at fixed times, as it were, the times fixed for hypnotic sessions or lectures in the amphitheater. Those were the golden days of the contract.

It was a period during which Augustine concurred with Bourneville, the stenographer of her deliria provoked by amyl nitrate, accepting the fact that "words pass away, writing remains."[230] But Bourneville—through his notes, photographic predations, and hypnotic "revivals"—was searching for "the" hysterical woman. For this very reason, he was stranded in a kind of perversion. He insisted on merging Augustine's poses and *attitudes passionnelles* into a *unique object*—or, in a certain sense, an inanimate object, a *tableau.* He ardently attempted to fix Augustine to a typical existence, to ascribe Augustine's every act, every word, every laugh to the categorical (but imaginary) imperative of his concept of hysteria. Bourneville, Régnard, and Charcot *fetishized bodies.*

"Fetishizing" is the name, in the first place, of a "know-how" [*savoir-faire*],[231] or what I would rather call the *know-how to have-done* [*savoir-faire-faire*] of the stage director. In Augustine's symptomatic acting, a rigorous *cut* was made, the only effect of which was to accentuate and aggravate her *unknowing how-to* [*faire-sans-savoir*], the major inscience of a star.

I call this imperative imaginary because, as a reprocessing [*retraitement*] of hysteria, it functioned as an *imposition of a fictional structure:* roles, hypnotic rehearsals, experimental procedures on demand, regulated by some ballet master. This fiction was so strongly imposed that it censured and rejected any other fiction: hysterics were forbidden the subtle turmoil of novels and melodies, the better to strike them with flashes and gongs.

And note that the fetishization of bodies, of their "attitudes," rather, is implicated in an emblematics of *law* in the imaginary as in an instrumentalization of *pleasure.* An intimate connivance. This, then, is the reformulation of the knot of paradoxes, always the same, of which the

Salpêtrière was the theater. Putting it another way: a desire dared not speak its name, and this was its dazzling force, genius, cunning, and *mastery;* but at the same time, it condemned all perverse desire to an irremediable *precarity.*[232] The "aim," as Freud writes, "seems unattainable"; there is only a *clinamen,* an endless declination toward the "object," a perpetuity that brings desire to risk desire's death.[233] The hysteric, I repeat, always remains in *connivance* with this risk. Desire's death is her lot.

Such is the contract, the critical moment when an actress is engaged by a director, who unctuously promises to make her a star, on the condition that—. But the conditions were unwritten, indeed; the contract was *tacit.*

The contract was tacit so that the *constraint* would be silenced, as would the *precarity* of the perverse desire that succumbs during the spectacle, to a "contradictory fear or wish to see too much and not enough," which "demands a prolongation,"[234] writes Mallarmé—here in the indefinite prolongation of experimental rehearsals [*répétitions*] for example. This indicates how, in the spectacle, there is finally a knotting together of the imaginary contract and pure pleasure—or rather, almost pure pleasure, a contract and a pleasure peculiar to *the stage.*

> Art that disquiets, seduces like truth from behind an ambiguity between the written and the played, but neither; it lavishes, the volume almost omitted, the uncustomary charm of the footlights. If the perfidious and dear present of subjugation to another's thought, more! to writing—that is the talisman of the page; one does not feel oneself here, moreover, to be captive of the old regilded enchantment of a hall, the spectacle implicating I know not what directness or yet the quality of emerging from everyone in the manner of a free vision. The actress avoids scanning the pace of the dramatic ritornello, but spans a silent carpet, on the sonorous rudimentary springboard of step and leap. An infinite cutting-up, until the delight—of what should, in contradiction to a celebrated formula, be called *the scene not to be made.*[235]

The Scene Not to Be Made

The cutting-up of a scene, the scene not to be made: even its advent—astounding. The ultimate moment in the hysterical drama: *the fulfillment of consent.*

> If I say it
> as I know how to say it
> immediately

you will see my present body
fly into pieces
and under ten thousand
notorious aspects
a new body
will be assembled
in which you will never again
be able
to forget me.[236]

The fulfillment of consent, in fact, redeprives any spectacular sei-
zure. It is an almost wholly structural revenge: *making-a-scene* [*faire-une-
scène*] versus *directing a scene* [*mettre-en-scène*]. It is a violent return of the
symptom's public remonstrances, of hypnotizations, for example—the "im-
perturbable foreground" of the curious viewer comes yet a little closer;
too close; dangerously close.

It is a *challenge of the excess* in consent. "You want to look? Well then,
look at this!" The actress is unpacifiable, even beautiful, when she is far
too close. For if she offers something up to the eye (something the spec-
tator is quite tempted to call "her whole body"), she invites—no, she
obliges the gaze to a full deposition, to such abandon that, even believing
itself Apollonian, it can no longer continue. The spectacle becomes "sub-
mission" ("You want to devour me with your eyes? Go ahead, eat me
then, I want it!") to such an extent that submission passes into subversion,
cruelty; a kind of matter—not a substrate, but a too-much-matter, such
as Antonin Artaud, again, envisaged: "The knowledge that a passion is
substantial, subject to the plastic vicissitudes of matter, gives him control
over his passions," a control mastered by the actor and actress in the final
analysis, to the very last.[237] This is not the mastery of a prince, but of a
tightrope walker. Set onto the wire by her photographer, Augustine
flaunted the fixed distance and arrayed herself in it, as she liked and thus
too much (for his liking). She truly played, and thus truly played too
much. In this she fooled no one. She was only playing with the imposed
distance, but she played with luxury and debauchery; she, too, wanted to
witness the blossoming of her own thought. Her gesture-making exulted,
staggered, collapsed—madness!—splashing back on the spectating gaze,
almost *haunting* it.

Why haunting?—Because her gesture-making was merely the *os-
tentation of a failure,* failure par excellence: the sexual relation, always at-
tempted, always contradictorily figured in a thousand and one *attitudes
passionnelles,* and always made present as pure inanity, the shady and cla-
mant vacuity of an empty embrace. This is the monstrosity of the *act aban-*

donded to the simulacrum. Overrepresentative, disparate, exorbitant: already bearing within itself, as an immediate element, a difference of difference.[238] This signifies that a disparate identification *possesses the body,* immediately, not hesitating to force ostentation into the kind of deadly risk I mentioned. This means that the scene not to be made becomes agitated, furtive, and fulminating at the same time, like a scene seeking its theater beyond repetition—and thus it becomes an unhappy, desperate hysterical visibility.

The ostentation of the failure finally describes the *acting of a mime,* an allusion that is always produced (never reproductive), violent in a sense, but an allusion to nothing—the "nothing" of the attempted "relation." The actress mimes and indicates: "I am pure of what is happening here,"[239] *here* naming the simulacra and *attitudes passionnells* of the *jouissances* that Augustine graciously made as an offering.

The temporality of this acting is first its suspense, the inanity of a central present; then its undecidability; "here preceding, there recollecting, in the future, in the past, in the false appearance of the present,"[240] always. In this sense, the hysteric pantomime is but a *countereffectuation:* "The dancer *is not a woman who dances,* for these juxtaposed reasons: she *is not a woman,* but a metaphor summarizing one of the elementary aspects of our form—sword, cup, flower, etc.; and *she does not dance,* suggesting, by the feat of shortcuts and leaps, with a bodily writing that would require paragraphs of prose in dialogue and description to express, in a composition: a poem freed of any scribe's apparatus."[241] An other body, intimately disengaged from any director's apparatus—an affective course is driven inward.[242]

Extreme Patience

I call this disengagement intimate because the director is always there, facing her, with his same tyrannical demands. Then the countereffectuation of the hysteric clenches up, all the more impossible to pacify because it induces a relation, more or less clandestine but ineluctable, of a *quasi battle to the death.* It is the image's battle to make itself a hysterical body, to make itself out of the hysterical body, this fiction. Both hysteric and director want to believe in the existence of this body: a shared will, connivance, mutual consent. But how can the content of this belief be shared to the end? Thus, in the end, there is a battle, a quasi battle to the death.

Everything I have referred to as *consent,* let us now call *patience:* the suspense of some ineluctable disaster through which this battle appears in the light of day. Everything is done to mask this battle, for it brings extreme

harm to each party, shattering an inhabitable structure. But it is ineluctable, and makes its way, slowly, through gazes, staging, and consent.

The hysterics were constrained to patience, in a sense *waiting for the representation,* so as to be relieved. Charcot, for example, deferred the faradization of a paralyzed hand, "because any attempt of this kind would, perhaps, bring about the return of motion and heal it, and he intended for his audience to witness whatever might come about";[243] thus he did his healing at fixed show-times, which allowed everyone to congratulate themselves on the miracle, with the patient, after being electrified in front of everyone, "vigorously shaking the hands of audience members who wanted to grasp the reality of the phenomena that had just occurred before their eyes."[244]

Patience also in the sense of *waiting for the session before replaying the symptom,* before re-suffering. Charcot would produce, for his audience, "pains from the imagination," that is, pains that were hypnotically suggested but which produced very real cries; he would reprovoke every pain, contracture, anesthesia, and so on for his public, specifying, however, that "these phenomenon must not be allowed to continue; don't amuse yourself in letting them persist for two days nor even for a day, for you won't be able to make them disappear"[245]—so be prudent! But such an "accident" did occur with Augustine one day:

> Nov. 24.—At his lecture, Monsieur Charcot provoked an artificial contracture of the muscles of the tongue and larynx (muscular hyperexcitability during somniation). The contracture of the tongue was arrested, but that of the muscles of the larynx could not be eliminated, such that the patient remained *aphonic* and complained of *cramps* in the neck. From November 25 to 30th, the following were attempted in succession: 1° the application of a powerful magnet, which had no other effect than to make her deaf and produce a contracture of the tongue;—2° electricity;—3° hypnotism;—4° ether: the aphonia and contracture of the muscles of the larynx persisted. An ovarian compression applied for thirty-six hours was no more successful. A provoked attack did not modify the situation in the least.[246]

Thus the theatrical constraint was interiorized as a constraint of the rehearsal [*répétition*] of the symptom, a cruel dynamic of auto-mimetic disequilibrium. *Patience became disguise,* arraying itself in pain and in the symptom. And this went very far; extremely serious hysterical attacks were "performed" at the clinical lectures by "several of these women, excellent actresses, with absolute precision," if not truthfully, *for a fee*—I mean, for a few cents slipped to them by the intern.[247] And patience adapted itself

to all rhythms—weekly subscriptions or gala evenings—such as "the spectacle of the so-called demoniac attack" that "the most senior of our hysterics, the girl L. . ." would give once a year.[248]

But as it turned inward, *the disguise proved to be pathos,* wholly internal to the mime, like an anxiety over the contract or the rise to stardom itself.

This is how the exemplary situation of patience became torment, *the simple torment of the theatrical situation:* "A simple emotion—for example, the fact of entering the amphitheater of the Salpêtrière for the lectures Monsieur le professeur Charcot presents to his audience—is enough to provoke an attack."[249] That is, mere stage fright was enough to produce the very *role* that was demanded, the spectacle of the illness, the illness itself. An extreme moment, to my mind, of consent becoming patience. The extreme feat of transference, the *prodigy and pathos of repetition,* because "transference is itself only a piece of repetition."[250] An extreme manipulation of the hysteric's time: making repetition or temporal martyrdom into a controllable spectacular convocation, always figured plastically, and always photographable.

The hysteric, constrained to exist only as the actress of her symptoms, simultaneously becomes *ideal and martyr,* which is Baudelaire's formula for the art of the actor, and for the genius himself, in the sense that "the genius can perform a comedy at the edge of a tomb with a joy that hinders him from seeing the tomb."[251] But for the hysteric, this genius was as intrinsic as it was imposed. This is why the extreme feat of transference forms the core of countereffectuation, producing the greatest resistance, fight, refusal, and countertransference. "Geneviève" would pour out—would scream out her refusal: "I'm not going to the Salpêtrière anymore . . . They put me in a cell. They put a dirty cloth on my face . . . My neck was cramped . . . I'm suffocating . . . My God! [. . .] I want to leave. I don't want to go to the amphitheater anymore. [. . .]" Then Bourneville writes: "We stop the ovarian compression. Immediately, as if in a *coup de théâtre,* her speech ceases; her facial features become immobile; the patient seems to have suffered a shock; her face bears to the left and the muscles convulse; her whole body is overcome with an extreme rigidity."[252]

Any attack, convulsion, or tetanism is better than a word of refusal.

The Theater in Flames

And one day, Geneviève was driven to the most extreme refusal. "Mortified" by a "lively reprimand" from Charcot, wholly traumatized, *she stopped being hysterical.* "Under the influence of this strong emotion, the rachialgia completely disappeared and attacks can no longer be provoked."[253]

The hysteric had given too much. The jumble of symptoms, "theater of the impossible," obscenity, charm: it was all too much. The hysteric gesticulated too much in her demand for nothing. She gave too much of what she did not have. She was far too often split, offered as a "woman" [*femme*], defamed [*diffamée*] in public.[254] She lent herself too much to transferential manipulations. Transferential love, writes Freud, makes something like a *cleft stick,* often,[255] a vicious circle that often comes to a sudden end, that *turns into disaster.*

The disaster of a contract reveals the contract and its nature. Here, distancing took on the pretext of seeing everything; the hatred in the encounter masqueraded as a link, an appeal to confidence. The hysteric believed in this masquerade, this promise of an encounter. She tried to encounter it, and found only the stage's footlights. She thus had no choice but to *hasten the encounter.* She did so in a kind of leap, an *insurrection* of her body, an untimely suspension, an acting-out of countertransference, an insult to the contract of representative propriety. *Insultat* (from *insultare*): she leaps, desperately. Charcot maliciously calls this "clownism." *Insultat,* she thrashes about, violently, insolently, defying the contract and, rather than performing the classic *attitudes passionnelles,* she executes the rarely photographed "illogical movements."

With this insult, she recovers herself and falls at the same time. She is exulted and distressed, gesticulating a hatred of the theater on the very stage where she is maintained as a *prima donna.*

Augustine went through the ordeal of this theatrical distress on the day when, from among the spectators of the clinical lecture who had come to watch her reiteration and pantomime of an antiquated but always present rape, she recognized the rapist in person, who had come to eye something he might very well have considered, for a moment, to be his "own work." Augustine was utterly terrified, and had one hundred and fifty four attacks in a single day. Deliria: "I don't want to feel you near me [. . . .] Why was I hiding my face at the lecture? . . . Because of you. . . ."[256]

Her ill (her memory) attacked her like reflections in a labyrinth of mirrors. It was multilocal, and exacerbated in the clinical theater. How could she have done something like recover? "You told me you'd cure me," she said, "you told me you'd do something else for me. You wanted me to *sin.*"[257] Who was she addressing, thus positioned at the crossroads of two gazes, symmetrical despite themselves, that of "Monsieur C. . ." and Charcot?—The fact remains that her own response amounted to this: "I think you're trying to worm it out of me. . . . Insist as you will, but I say *no.*"[258]

This *no* is the crux of the drama. And it is less the acme of the fiction underway, than a moment of the *rupture of the fiction,* the interruption of the spectacle itself. It is the fulfillment of transference, I repeat, which Freud compared to a *theater in flames:* the patient "gives up her symptoms or pays no attention to them; indeed she declares that she is well. There is a complete change of scene; it is as though some piece of make-believe had been stopped by the sudden irruption of reality—as when, for instance, a cry of fire is raised during a theatrical performance. No doctor who experiences this for the first time will find it easy to retain his grasp on the analytic situation."[259] But why should it be so hard?

8

Show-Stopper

Cries

The insult and rupture of a fiction, its crux, is *a cry*. The images are rare; they are a cramping of the imaginary. Augustine is wholly disfigured, even horrific (fig. 105). Are such images rare? A nightmare. A dream, for our eyes, today, but "a dream that eats away the dream."[1]

A description of such images is attempted: she "utters a choked *cry;* her mouth opens wide; sometimes the tongue retains its natural position (PL. XV), sometimes, to the contrary, it extends, as if hanging (PL. XXVIII). Before the cry, tremors, hiccups, and suffocation are sometimes observed."[2]

An attempt: "The cry has a very particular nature. It is piercing, like a train whistle, prolonged and sometimes modulated. It is repeated several times in succession, most often thrice. The patient sinks into her bed or curls herself up to cry out. It occurs before the great regular movements, between two great movements, or subsequent to them."[3] Richer tried to finesse the question, claiming that Augustine "utters some guttural 'Ah! Ah!'s," "noises" that do not qualify as "cries." Elsewhere, he refers to a "laryngeal noise that imitates a cock's crow."[4]

Why? Why attempt or insist on the *relegation of a cry to the dialectic of imitation*? Briquet, too, was unsatisfied with the simple, bitter word, cry; he was looking for simulation, and affirmed, with Willis, that hysterics "can simulate the barking and howling of dogs, the meow of cats, roars and yaps, the clucking of chickens, pigs' grunts and the croaking of frogs."[5]

I believe that Augustine was not imitating any particular animal. She was wailing, madly crossing her legs, ripping at her straitjacket,[6] and was simply doing such things like an animal—perhaps like you or me, one day—embraces the invisible blow it has been dealt. And in a sense, she would curl up within this blow and cut herself off. A cry was the last place she could turn.

Planche XXVIII.

DÉBUT D'UNE ATTAQUE

CRI

Figure 105
Régnard, photograph of Augustine ("Onset of an Attack: the Cry"),
Iconographie, vol. II.

Jolt

The cries of hysterics never ceased to be suspect; they were suspected of being only *turns,* in fact, but turns in the sense of tropes (a rhetoric), or pirouettes (clowning around)—in the sense, finally, of simulacra (lies).

Surrendered to the mad tremors of the fit, Augustine would laugh. "Protraction of the tongue."[7] She would cry out, and stick out her tongue (see fig. 105). Was she mocking the photographer? Was she in pain?— Both, perhaps. Augustine would vociferate, laugh, and vomit, all at once. She would rave: Love, threat, and attack—everything at once, everything and anything. What "part" should be believed, they asked, what detail of her attitude? She was observed, notes were taken, the pertinent turn was sought, and she—facing them, abandoned to her tremors, a martyr of suspicion—she would attempt to respond to their suspicions; she would attempt an *impossible explanation of her body's jolt:* "She feels something pulling on her fingers, on her tongue, etc. Her *speech* is awkward, and the words are cut off: "It's . . . like . . . I'm being . . . jolted . . . or something . . . when . . . it . . . takes me." Her head is abruptly thrown back, her mouth sometimes opens wide, the tip of her tongue rises."[8] Her tongue rises and clicks: in mockery? What to believe? Richer also took notes, and what he reports to us are only the mad movements, the incredible back and forth, ebb and flow, of *pain and pleasure.*[9] And this is precisely what cannot be deciphered—the aberrant, useless athletics of the heart and the passions.

Moreover, Augustine seemed indifferent—utterly phlegmatic—to pauses in the most serious symptoms; and then, inversely, she would be terrorized, "make a drama," as they say, over a detail such as a color. The same recess of her body played *a double role,* as Freud says, in an intolerable intermittence of pleasure and displeasure that no one was ever in a position to elucidate. Freud calls it *conversion* (adding that this clears up nothing, and its very obscurity nearly encourages one to flee since, he says, it "affords us a good reason for quitting such an unproductive field of enquiry without delay").[10] As for Charcot, he called the same phenomenon suggestibility, *imitation.*

Thus hysterical theater was pitted against psychiatric theater, producing tensions, and soon detestation. What follows are the notes from a session during which the patient, who was supposed to give a demonstration (triggered by ovarian compression) of the "classic" sequence of the attack, insulted Charcot's masterful commentary and interrupted the transmission of knowledge. The insult, noted in parentheses, was a mere cry—mere fright.

A hysterogenic point has just been pressed again and the epileptic attack is now being reproduced. The patient occasionally bites her tongue, though not often. Here, now, is the famous *arc de circle* so often described.

(The patient suddenly cries: "Mama, I'm afraid!")

Now come the *attitudes passionnelles;* if we allow things to continue, we will encounter the epileptiform attack again.

There is a kind of resolution, followed by a sort of contracture. This is occasionally an auxiliary phenomenon of the attacks.

(The patient cries, "Ah, Mama!")

You can see how hysterics scream. One might say that it's much ado about nothing.[11]

To my ear, this last phrase rings like *hatred for the unexpected, or the invisible*—the invisibility of causes.

On another occasion, Charcot tried his hand at demonstrating the awakening of an "ovarian" hysteric, who, for the sake of pedagogy, had been left to the nightmare of her "attack of sleep":

Monsieur Charcot approaches the bed where the patient is lying; on her left side, which has been denuded, he places the four fingertips of his right hand just above the fold of the groin; he then guides his hand towards the lower pelvis, applying a progressively stronger compression of the abdominal wall. Soon the patient gives out a piercing cry, opens her eyes, and immediately begins a convulsive attack: first there are several grand movements of "salutation" similar to those that had, previously, been spontaneously demonstrated during the sleep; then the position of the *arc de circle* occurs two or three times. Monsieur Charcot, who had maintained his hand on the left ovarian region this whole time, addressed himself to the audience: "This, Messieurs, is not quite what I was trying to bring about."[12]

Of course not. A cry can never be anticipated in a therapeutic staging. And then, beyond the fact that it is unpredictable, the cry, I repeat, brings into presence the ridge where *pain and pleasure draw absolutely close*. This is unbearable to the physician, for whom a symptom could not cause exaltation one moment and a cry the next unless it is a simulacrum. Now, the symptom is indeed concerned, here. It is unraveled and distressed, spectacularly, through a jolt of the body, which can be understood neither as a pure psychic symbol, nor as pure physiological discharge.

To account for this pain and pleasure of the symptom, psychoanalysis calls on "mythical entities, sublime in their indetermination,"[13] writes Freud: drives. Insofar as they are spatialized, drives gesticulate. Lacan writes that "the hysteric plays to the extreme with the feeling of elasticity,"[14]

which is to say that in Augustine's cry there is something like an almost mortal game with what is supposed to be *an organ,* which "should be called unreal," and which she "evaginates coming and going,"[15] spasmodically, until she is extenuated, or faints. The terms—yes, the terms of pleasure and of pain.[16]

The *hysterical* body—not "the body"—once again raises and re-hashes its exhausting question. It is the question of a language of gestures, a hundred spontaneous gestures mixing love and aggression, the question of the multiple presentation—*Darstellung*—of an object of anxiety in the gestures of a *jouissance*—the *jouissance* in which everything is there—presented, open, offered. Inaccessible.[17]

An open and offered cry. But a cry of "that's not it!" cruelly undermining every expectation; the abyss between *jouissance* expected and *jouissance* obtained, there, in the act, strikes down any expectation, under the eyes, the nose, the beard of the director or the photographer. Didn't they guess, at this particular moment, that *the act takes the place,* meaning that it takes place, violently of course, extremely violently, as a cry—but it *takes the place of something else?*

Mask

In this sense alone, Augustine's cry is a *mask;* in the sense George Bataille gave the mask, a "nocturnal terror" linked to every masquerade, the apparition "at the threshold of the light and reassuring world" (but how could the "laboratory" of medical photography have been reassuring, even if it was light?), the "apparition of an obscure incarnation of chaos"; "the very thing that is normally reassuring suddenly takes on an obscure will to terror—when the human is masked, only animality and death are present." For, writes Bataille, resorting to capitals: "A MASK IS CHAOS TURNED FLESH."[18]

"Mask," here, denotes an energy, the energy to which a theater might expose itself, putting itself in danger of no longer being representative of anything frameable whatsoever—only *an energy of bodies.* A "desperate claim," breath, "combined contraction and decontraction," "prolonged feminine time," as Artaud writes, for he questions the feminine, in this (theatrical) case, as one would question an energy: "That which is feminine, that which is abandon, anxiety, call, invocation, that which strives towards something with a gesture of supplication, also relies on points of effort, but like a diver who spurs submarine shoals so as to return to the surface: there is something like a spurt of emptiness there where the tension was."[19]

Artaud invokes: "a thundering and terrible feminine"; he invokes, "A pure theatrical language."[20] I myself call on it, as if forsaken by other potentially possible words (and this call identifies my inexperience).

The fact that the hysteric could be described only with words from painting, theater, and dance should not cause an essential limit to fall into oblivion: at the heart of these gesticulations, attitudes, hysterical inventions, there is a crucial experience of idleness—doubtless the most masked of moments, the moment of a major, intimate risk.[21]

Is the time of a cry representable, *workable* beyond this shrunken fringe, between a half-second and a second and a half, the time of the photographic shot, the indecision of which, moreover, left the image of Augustine rather blurry [*floue*], or cheated [*flouée*]; in any case it required *retouches, corrections* with a brush and a straitjacket?

(Lessing had already forbidden the cry to the painter, for an image of a cry arrests the imagination; either the imagination inverts it, by sweetening it into a moan, or it is changed into the inertia of a cadaver: "When, therefore, Laocoön sighs, the imagination can hear him shriek; but if he shrieks, then she cannot mount a step higher from this representation, nor, again, descend a step lower without seeing him in a more tolerable and consequently more uninteresting condition. She hears him only groan, or she sees him already dead."[22] As if the cry would thwart every protention.)

The time of the cry is like a *double constraint* of negativity, in relation to the visible. The face is its theater, and presents spectacular evidence, but too much of it. The representation (repetition, frame, portrait) is ruined, as it were. The mouth is merely the opportunity for human bestiality, an inordinate organ, front-most in the body, furious, atrocious, an inordinate organ of rictus, or nausea.[23] The gaze is but a black spot, *macula,* the height of horror.

The horripilation, then, of the face. "There was a black spot," writes Artaud,

There was a black spot
Where my destiny converged.
It remained there
Frozen
Until the times
Were resorbed.[24]

Resorbed in what? What does *resorb* mean?

Throes

Resorb means to swallow again, force down, breath in, even absorb, pull back like the sea, an ebb. It is a paradoxical time of presence. The time of the cry is, here, like *the ebbing of all fears;* a convergence of destiny, through— I repeat—a fear, through a retraction before movement, through an unconscious disarray of gestures, movements, muscles as if raw, an astounding, central fatigue, a kind of aspirating fatigue, a fatigue of death.[25]

Augustine's cry itself was already struck down, as it were, and for her to have cried out in this way, there must have been a kind of enormous fall, a convergence with destiny. Freud speaks of symptoms as a protection against anxiety; he asserts that anxiety comes first, arousing or even provoking repression.[26] The cry, here, seems to me like a moment, the limit of the *seizure*—a strong word—the seizure of the subject *between the symptom and the object of anxiety.* It is not a symptom in the strict sense. It is something so much simpler, less symbolized. It is a response not to the undoing of repression, as they say, but to its collapse. And an apparition, at the same time; something verging on hallucination. A revelation of being-there; something that, suddenly, no longer deceives. *Anxiety* itself.[27] Anxiety has two specific characteristics, where hysteria is concerned: a kind of *exact limitation,* both organic and temporal, and an *excessive intensity.*[28]

The commotion is thus totally singular: the link between drive and presence is an *agony.* It is paroxysm, understood not only as a dreadful suspension of time, but also a dreadful *can-be:* time seeking time, the aspect seeking its explanation and, perhaps, its decision, but still crucified in the moment of the paroxysm, still crucified because it imposes a *time of desire.*[29]

The cry is there as a surprise, Ursprung, an "excessive bound around a stop," wrote Mallarmé, a leap, the gushing-out of a destiny in an instant, an origin in action, in brief gesticulation. It reveals everything in a blow, and thus it deprives and blinds. But what does it reveal, again? Repeating: being-there, "as such"?[30] Saying: "the center of night in the night"?[31] Perhaps, indeed, it is because a cry and a crisis face up, under siege, to something like the "absolute master," death. And there is more. In front of Augustine there was also a master, no less concrete than death, sometimes even the image of death, perhaps; an absolute master, sometimes, fundamentally relative: one or several masters—her physician, Bourneville; her photographer, Régnard; and the master of them all, Charcot. Hysterical anxiety first faces up to "the sensation of the desire of the Other,"[32] as the slave faces up to the master in the fight to death, a slave who is himself also constrained by the major risk, the "risk of life." This sensation was perhaps, at a certain moment, her sensation of the photographer's face, camouflaged

by a black veil, or that of the face of a certain "Monsieur C. . ." camouflaged in the audience of an amphitheater: her "sensation" of the gaze of the Other; her "sensation" of being-there; her "sensation" of death.

What this sensation produces, what "it gives," *Es gibt*—what it gives is perhaps the simple taking-place of this cry, the gift, *Gift*, the poison of hysterical anxiety, infected with the visible.

It was a profound gift, voracious, noisy, mouth facing forward, a gift of something like *throes*. This is how the image of Augustine would indecide itself from plate to plate—now a pretty little face, making a good impression, the beautiful face of the *femme fatale;* now, *a hideous face.*

Nails, Crosses

There is also something like an epiphany, but a masked epiphany, implicated in the Dionysian, perhaps even central to the Dionysian:[33] love's passage into the diabolical.

Not only is the visible infected, but within it is an insurrection; or, the visible itself becomes a place of insurrection. For beyond the classic *attitudes passionnnelles,* there are the innumerable, uncatalogable, rarely photographed "illogical movements" and other "clownisms." There is the *arc de circle,* notably, which is more typical but no less enigmatic (fig. 106), which Freud, according to the principle of "antagonistic inversion," saw as an "energetic repudiation. . . , through antagonistic innervation, of a posture of the body that is suitable for sexual intercourse."[34] It is still a posture of *jouissance,* but topsy-turvy.

Thus spectacular evidence exceeds itself in overrepresentations, but masks itself to the same extent, because these overrepresentations are intrinsically contradictory. And this is precisely what gives *impatient* and unhappy hysterical theatricality its specific turn, the temporal turn; it is also what gives a turn to the *impotent* and unhappy dialectic of hysteria and perversion.

(Your eyes should fall on this as if by chance, like the impossible confidence of the partner, impossible because never spoken:

> She wanted the impossible from me, but in the movement that carries her, she pushes aside what she already knew: what troubles me about her is this impatience. I imagine a large nail and her nakedness. Her movements carried away in flame give me physical vertigo and I'm sticking a nail into her that I cannot leave there! As I write, unable to see her and with a hard nail, I dream of enlacing her loins: it's not happiness but my impotence in attaining her that stops me. She escapes me in all ways, the sickest thing about me being that I want

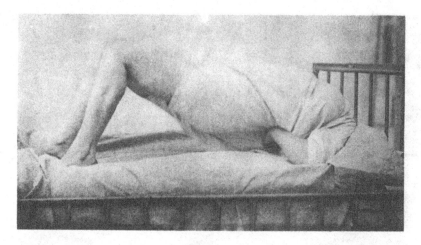

Figure 106
Régnard, "Hystero-epileptic attack: *arc-de-cercle*,"
Iconographie, vol. III.

it like this and my love is necessarily unhappy. I am no longer in fact seeking happiness: I don't want to give it to her, I don't want it for myself. I want to touch her *to anxiety,* always, and I want it to make her faint: she is as she is, but I doubt that two beings have ever communicated more deeply in the certainty of their impotence.[35])

The "nail" corresponds so well to what a witness of a hysterical crisis imagines that it occupied a choice place in the traditional vocabulary of hysterical pain: *clavus* is mentioned, and also *ovum,* egg, the pain being supposed to traverse the subject starting from her erratic and insistent womb.[36] Sometimes Augustine was pierced through. The nail was measured. Augustine was disfigured by winces. "*Hysterical nail,* situated on the median and right line, with a width of about two centimeters. At this level there is a spontaneous pain that is pungitive. If one presses firmly, a sharp pain is produced 'like the pain in the ovary' and the face grimaces."[37]

For the hysteric's body, the "nail" is like a metaphor so well grafted that, in this case, spinning it out is far from being the dreamy distancing of a concept, but is a more precise reunion with or approach to the hysterical language of gestures, *jouissance,* and pain. Hysteria in fact seems to *call* on the metaphor, so that it passes or *metamorphoses* it into acts. Thus nail, thus cross, thus Christine body, tortured body, "Christ! O Christ, eternal thief of energies, God whom for two thousand years you destined to your paleness, Nailed to the soil, with shame and cephalalgia. Or inverted, the brows of women of pain."[38] And Augustine did not hesitate—what a sense of mystery!—to follow the episode of *crucifixion* on the "nail" that

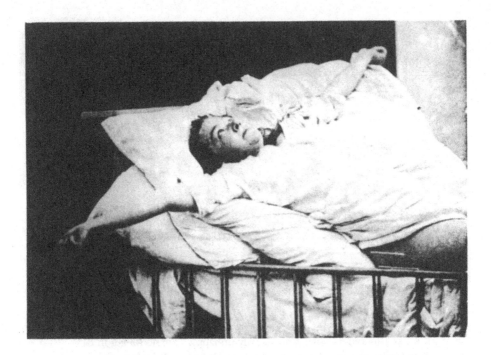

Planche XXV.

ATTITUDES PASSIONNELLES

CRUCIFIEMENT

Figure 107
Régnard, photograph of Augustine ("*Attitudes passionnelles:*
Crucifixion"), *Iconographie,* vol. II.

pierced through her with the suffering of one who has been sacrificed (fig. 107). "I thought," said the subwarder, "that she was going to die."[39]

Sacrifice

Did Augustine go so far as to sacrifice herself to the image?—She would come and go in all senses, extremely, in the gift of herself.

Note that the episodes of "crucifixion" immediately preceded the famous *attitudes passionnelles* of "eroticism" and "ecstasy" (see figs. 57–64):

For a few instants she remained with her arms in a cross (*crucifixion*). Then *delirium:* "What do you want (repeated) . . . Nothing? Nothing? . . ." (Smiling physiognomy). "That's fine . . ." (She looks to her

left, half rises, makes a sign with her hand, blows kisses). "No! No! I
don't want to . . ." (More kisses . . . She smiles, makes movements
with her stomach and legs). "You're starting again . . . That's not it
(repeated) . . ." (She complains, and then laughs). "You're leaving!"
Her physiognomy expresses regret; X. . . cries.—V. T. 38°. Abun-
dant vaginal secretion.[40]

She cried and laughed, life and *jouissance* were her lot, "as inexorably
[her] lot as death is that of a condemned man."[41] In this sense, her gestic-
ulation was almost like what Bataille called "the practice of joy before
death"; I mean that Augustine was dancing, in a way, with the same time
that condemned her.

In gestures of the *spasm,* this came to be associated scandalously with
the Christian metaphor of *sacrifice,* the crucifixion. Augustine twisted her-
self like an ignoble and ridiculous worm ("clownism"), and offered her-
self up crucified; and at the same time, or nearly so, she was sublime, fully
extended, frozen, calling to the great Absent (*attitudes passionnelles*). The
grand word *mystic* was summoned—but for now, I will leave aside the
hundred questions it raises.

(And another text hits the nail on the head, terribly:

> Down, she writhed, shaken by respiratory spasms. I bent over her
> and had to rip the lace from the mask, for she was chewing and try-
> ing to swallow it. Her thrashings had left her naked, her breasts
> spilled through her bolero. . . . This nakedness now had the absence
> of meaning and at the same time the overabundant meaning of
> death-shrouds. Strangest of all—and most disturbing—was the si-
> lence that ensnared Edwarda—owing to the pain she was in, further
> communication was impossible and I let myself be absorbed into this
> unutterable barrenness—into this black night hour of the being's
> core no less a desert nor less hostile than the empty skies. The way
> her body flopped like a fish, the ignoble rage expressed by the ill
> written on her features—cindered the life in me, dried it down to
> the lees of revulsion.[42])

However, I cannot fail to evoke the link between this *sacrifice* and
what I have called photographic *predation.* It is as if Augustine were sacri-
ficed to light itself, as if her cry were a response to a simple, perforating
attack of light that made an impression not only on the plates but on her
whole body, drumming it, convulsing it. Augustine was thus a victim: ac-
cursed and consecrated, tragic, disgusting (contorted body, foaming lips,
multiple secretions). And her cry seemed luminous—The link between
light and sacrifice, light and blood.

Blood: Secrets

This link perhaps describes a *secret* of images, beyond their spectacular evidence, at the point where evidence becomes excess, becomes intolerable in a sense, although obscenely "tempting."

The "kind of woman" the hysteric was always showed too much and not enough, for she gave an *apparent picture* of her narcissism, and how apparent it was!—but still her desire remained impenetrable. This is exactly why she summoned all the techniques of visibility, always raising the stakes, even as the visibility of her body remained paradoxical and disconcerted.

This link also reveals the problem of what is in that which can be seen and in that which cannot be seen. "Being cannot be seen," writes Artaud; to see "is to make reality obscene; clairvoyance having come from something obscene that wanted to believe in what it was," in what it saw: "for nothing is more obscene or, moreover, more tempting than a being."[43] It also raises the question of the secret of obscenity.

How can one conceive of the secret of these images of Augustine, in which her "case" was supposed to be fully exhausted? I would suggest that the secret was a passage, the only passage to which photographic technique of the time could not lay claim, nor integrate into its pretensions to veracity and authentification: the *passage into color.* I imagine the "secret" of the portraits of Augustine to be a certain mode of *impossibility of a passage into red,* or, more precisely, like the trembling of white time and red time.

Red was at the heart of Augustine's deliria, always associated with the gaze. Heavy gazes, desires that were not shared, rape. Loss of blood. Suffering. The terrible secret that must be silenced. Paleness. "Threatening gazes, to impose silence." Vomiting. Cat eyes, terror, cry, bleeding from the nose. The first hysterical attack.[44] Then later, at the Salpêtrière, Augustine's first menstrual blood, along with the fact, carefully considered in the *Iconographie,* that she had been dreaming of red at the same moment: "From 5 to 7, she slept, dreaming that she was in a slaughterhouse, watching beasts being killed and blood flowing. When she awoke, she was *menstruating for the first time.*"[45]

Bourneville's meticulous, underlined record indicates the line of questioning he used to introduce Augustine's history: the account of her case opens (and closes) with the problem of the *link between hysteria and menstruation.*[46] From this point of view, Augustine's case is exemplary, rich in theoretical instruction. But it remains, in the end, a quintessential riddle.

Augustine's case is exemplary in the sense that her first attacks took place before the appearance of her first menses, a fact that tends to reject the thesis of hysteria as a "metric neurosis" as impertinent.[47] It must nonethe-

less be remarked that Augustine's pains and cries after her rape were persistently attributed to the appearance of her menses—a comforting hypothesis in one sense and almost instinctive; and then they said that "the attacks must have coincided with the development of the breasts and the hair of the mons veneris."[48] On the other hand, Bourneville's theoretical affirmation did not prevent him from constantly referring (as suggested by the most "classical" clinical procedure) to a kind of *coincidence,* again, between her periods of menstruation and the periods of her attacks, a coincidence so striking, they said, as to transform Augustine's personality in those moments.[49]

In short, this coincidence surreptitiously introduced doubt and *indecision* into the theory: "We're well aware, but still." This indecision can be seen in Landouzy or Briquet, the indecision regarding the feminine, ovarian, uterine nature of hysteria.[50] Charcot was more brilliant when faced with indecision, but in a sense he was no less ambiguous. He commented in this way on Augustine's case: taking into account the fact that "the appearance of menses . . . in no way modified the essentials of the clinical *tableau,*" he came to insist, not on the absence of a causal link, but on a hypothesis according to which "the activity of the ovary is far anterior to the menstrual function, and survives it."[51] For Augustine's "hystero-epilepsy" was indeed "ovarian," which, warns Charcot, does not necessarily mean that it is fundamentally of a "lecherous" nature[52] (it was necessary "to save hysteria" at any cost, meaning to distinguish it from desire, so that it could exist as a science, just as physics had already given itself the task of "saving phenomena").

This casuistry indicates, in any case, a persistence of the riddle and neurophysiological positivism's difficulties in escaping embarrassment when confronted with the hysterical ostentation of the red mystery of the feminine.

Secretions

The difficulty and indecision that arose from the mystery were relieved by a new passion for measurement, a perverse routine. All secretions and hysterical moisture were thus measured, in the belief that some secret of the body was being touched.

It was like a remake of the medieval theme, modified into a classic, of a "capacity of women [*fames*]"—"*femina, fex Sathanae, rosa fetens, dulce venenum*" (woman, feces of Satan, foul rose, sweet poison)—the moist and hot woman, and preeminently the hysteric.[53]

Landouzy's incomparable statement is well known: "There are hysterics who cry in abundance; some of them urinate copiously at the same

time; there are others, finally, who—how shall I put it?—cry through the vulva."[54] They thus established an endless *tableau*, a catalog of secretions of all kinds, saliva, drool, foam, sweat, "milky secretions," tears, and urine, "blood sweats": and finally what was called "vaginal or uterine hyper-secretion"—it got rather hazy at this point.[55] The obvious converse of se-cretion was commonly exploited, in the thousand treatments of hysteria that consisted in *fully exudating the body* (curing an ill with the ill), pushing its propensity to seep to its extreme. The body that secretes *everything* also secretes the secret of its ill, its matter. Recall Pomme's hysteric, immersed in "baths, ten to twelve hours a day, for ten whole months" until "mem-branous tissues like pieces of damp parchment" managed to "peel away with slight discomfort, and these were passed daily with urine. . . ."[56]

But sometimes the hysteric dramatically resisted this tenderness, in her vocation of refusal. Landouzy's observation number sixty-nine relates the case of a hysteric whose menses suddenly disappeared, after a "great fright," and who died, "despite three hundred bleedings," a heroic effort for a good cause.[57] Charcot gave the name of *ischemia* to this contradic-tory hysterical propensity to "retain blood" (the convulsionaries of Saint-Médard, he reports, refused to bleed even under blows of the sword).[58]

It nonetheless remains the case that Augustine's tears, blood, and "white flows," whether retained or not, are extensively recounted to us in the *Iconographie*, even down to their smell (a particular vaginal secretion, one day, was "very foul"). They are described, among other times, dur-ing the moments (episodes) of crucifixions[59]—her vocation of stigmata.

But, do not forget that my questions continue to revolve around the notion of the *portrait*, around an atrocious extension of the notion of the portrait. This infernal passage to red also touched Augustine's face. In the absence of a technique of visual reproducibility, it seemed to demand Bourneville's particular talent of making fine distinctions between nu-ances, even in the most tempestuous moments of Augustine's attacks:"The face, lips, and palpebral conjunctiva take on the color of *vermilion red*, and not a *burgundy* as with amyl nitrate."[60] Elsewhere, regarding "Geneviève," he writes that "the face is red, purplish; flowing simultaneously from mouth and nose is an abundant foam that is white at first, then heavily mixed with blood."[61]

White foam and drool, expectorated blood. Henry Meige reports the old story of another Geneviève, who also excreted blood from her mouth instead of words: "During the last quarter of each moon, she would repeatedly vomit blood over a period of two or three days. Other times, she would lose consciousness, falling on the ground with stiff limbs, or else struggling furiously and loudly screaming. When these accidents

came upon her in the fields, they could be stopped by a technique that was very strange, but always crowned with success: Geneviève would be hung by her feet, upside down."[62]

Simulacra and Torment

This turning upside down of the body reminds me of the action rendered by the Latin *torquere:* turning until it twists, testing through torment. Torture. *Tormentum* designates the machine, the instrument of this test. In the first place, it is a machine of war that performs feats. Cords are slowly rolled around a cylinder and then relaxed: *shafts [traits] are launched.* It is also a machine of torture, the particular virtuosity of which is based on the same principle: it bends, pulls, twists, slowly quarters, and then in one blow dismembers the body. Even if the subject does not speak, he will at least cry out his death. I invoke this as the camera's imponderable manner of functioning in the *Iconographie:* an invisible torture that makes bodies always more visible, that adequately renders (according to *adoequatio rei et intellectus*) their suffering; and, for this purpose, more or less invisibly dismembering them. Through machinery, through a technique, through machinations, ruses, and charms that aim at consent. The *Iconographie photographique de la Salpêtrière* instrumentalized bodies, schemed against bodies—hysterical *simulacra-bodies*—with a view to conceptual truth. It schemed against ostentatious hysterical "place-holders." But in order to "wittingly" instrumentalize, to obtain the "true aspect" of a symptom through a ruse, the *Iconographie* was constrained to appreciate further, escalate, and magnify a simulacrum—another simulacrum, one of its choosing, always manipulable. It mattered little whether it was obtained by consent or by *extortion,* so either way it amounted to the same thing, in the end. The *Iconographie* pushed the concept and use of the simulacra to their *sacrificial* and *retaliatory* meaning, the meaning of the word *simulacrum* as used by Caesar in the course of his bloody and warlike itinerary. Beyond "image" or "mnemonic representation," *simulacrum* designates the wicker mannequins in which carefully selected victims were imprisoned, and who, in honor of the gods, were burned alive.

Hysteria and response, retaliation for hysteria, are in a sense both *flares-up of simulacra.* Each of them sacrifices the body to the image, each consumes the body in the image. Consent and patience were thus also names for *torment.*

What remains difficult to fathom is that the torment was consensual. The hysteric makes the simulacrum into a time of torment, even as she enjoys [*jouit*] it. The simulacrum, attack, *attitude passionnelle,* symptom—

the simulacrum besieges the hysteric in the intermittence of an enigmatic period. Once again, a *temporal passage* describes the secret of spectacular evidence as the secret of visibility and its embarrassment: so often invoked here, the time of the menstrual flow, once again,[63] the temporal, periodic passage of the bloody secretion in the *similitudo,* resemblance. Remember Aristotle, again: "It is said that red is produced when women look at themselves in a mirror during their menses, because a bloody cloud appears on the mirror and is thus the disturbance of the image: the reason being that a body, given over to its quantity of humor, is but a changed place. Color *swallows* in this fiction: that which would remain of a body diverted from its figure."[64]

Fugue*

The radical extension of the simulacrum as an existential position common to both hysteria and its countersubject, perversion—this extension once again designates an even crueler link of *figuration to temporality.* Listen to the word simulacrum: within it is *simul,* meaning "at the same time"; *simul* is the common root of two rather contradictory trajectories of meaning: *similitude,* meaning *resemblance* or imaginary proximation; and *simultas,* reciprocal hatred, *rivalry.*

My hypothesis amounts to the following: that the fabrication of images of hysterics at the Salpêtrière was an operation of *similitude* turned to *simultas,* simultaneously having the temporality of a dialectic with a hysterical structure (body for image and image for love) and one with a perverse structure (body for image and image for knowledge). Thus *charm* (the mutual and concerted summoning of the semblant) *turns to hatred* (when the desires recognize and disconcert each other).

Temporality: in the interstice between absolute charm and absolute hatred, the hysteric hesitated, remaining in a kind of trembling expectative: the wait for something that would have decided or fixed her image for the desire of the Other. A knot of awaiting. Augustine said, "When I'm bored, all I have to do is make a red knot and look at it."[65] Her narcissism was always seeking the *dénouement,* the always imminent *dénouement,* and thus her narcissism was infinitely extended. A fear took over, taking the place of a quintessential alterity. She settled into fear, with the intense sensation of a *defect.* Recall that *Ustérizein,* in Greek, means always arriving

*[In addition to the musical form, *fugue* in French signifies the act of fleeing or running away.—Trans.]

too late, remaining behind, lacking, *depriving of.* At the Salpêtrière, the hysteric went on hystericizing herself, always to a greater extent: the logic of the system.

But what is happening when a symptom flares up the simulacrum on the hysteric's body, scintillating the wait, when she feels things like: "'I have a sounding-board in my abdomen . . . if anything happens, my old pain starts up again'"?[66] A *return of memory* has created a *drama:* the acting (*to drân*) of a destiny, in the blink of an eye. Quite suddenly, in a precipitation of the expectative, spectacular evidence modulates itself, perhaps like all evidence, to the temporal dialectic of a presumption, or an *anticipation* (thus fiction) and, suddenly, to the dialectic of a *haste,* of a suddenness of the present.[67] The proof of hysteria's spectacular evidence, for the physicians of the Salpêtrière, thus involved something like finding a prize in the time of a surprise: that which is *unforseeable,* and thus *devoid,* in the loss. And what of the "true aspect"?—It is quickly pushed back into an infernal underneath. And what of the hysteric "seen as she is in person"?—Eurydice lost twice. Everything has been seen?—everything has fled, already, forever—who knows?

Charcot put all this to the test, namely with Augustine. He tested the unpredictability that suddenly drains out, becomes visible, evident, and then flees. This is why Charcot's clinic was simultaneously expectant and hurried—like hysteria (was the clinic forced to hysterize itself, to embrace hysterical time?). It was obsessed, in any case, with the "true instant" of a "revelation" of a "real body": "The phenomena in question have persisted for a few days now, but it may so happen that tomorrow, or even in an instant—nothing can be foreseen, in this regard—they will cease to exist. The opportunity is therefore urgent; it is crucial to seize it."[68]

But the hysterical body extravagates any concept of the "real body." Even Augustine, breaking with "classical" poses, yielded to what Bourneville in fact called "extravagant acts"; Augustine jumped out of windows, climbed trees, scaled up the roof of the Salpêtrière, "performing all this with a truly surprising agility," and, as Bourneville insists, with utter contempt for danger[69] as for propriety (her shift was disheveled, and rather revealing).

Augustine had hallucinations of running and escaping[70]—of refusal, in the final analysis. One day, "W . . . ," Augustine's friend, let the cat out of the bag in her delirium, perhaps revealing a complicity of refusal, miserably exhibiting her will to dissimulation and her hatred of the clinical theater (at the very moment when the clinical theater wholly encompassed her): "I know your story well; be calm, don't cry . . . Everything you confided in me is engraved in my heart . . . It's like with you; I believe that

you'll keep everything I told you a secret . . . If they torment you too much, tell them it doesn't concern them."[71]

Augustine went into rages, at the very moment when something of her "secret" "was appearing," as Bourneville notes: "March 20. Menses appeared yesterday. Fit of rage, following a great vexation, L. . . , barefoot and wearing only her shift, went for a walk in the courtyard in the pouring rain. She had to be brought back inside by force and have a straightjacket put on, which she ripped apart; she threw everything in her reach at people's heads."[72]

This movement, this hewing of charm into refusal and hatred, insidious or explosive, can be described as the musical figure of the *fugue*, from the Latin for flight: "subject" (*dux*, that is, conductor and master) and "response" (*comes*, or the accompaniment),—and a play of surprises, "countersubjects," and so on. Fugue is a suitable name for this movement because it is a word of structure (counterpoints and obstinate *ricercari*), and also a word that figures in dramas of love, of the ruptures of constraints or of filial piety.

Augustine's story ends, in the *Iconographie*, with such a drama. "X. . . has relapsed," admits Bourneville, rather disconcerted. Augustine "relapsed," meaning that she returned to a mad hysterical intermittence, renouncing "the improvement" (the body's wisdom) thanks to which she had become a nurse's aide. "1880. April 6.—X. . . has relapsed; she has been returned to the service as a patient. The compressor, ether, and chloroform are used to suppress the attacks. On several occasions she is seen to have periods of agitation, during which she breaks and shatters windows, rips the straightjacket, etc. On June 11, as her agitation had become more violent, X. . . was put into a cell."[73]

Put into a cell. After charm and the rupture of charm comes the inevitable retaliation. Bourneville, author of the philanthropic *Nurse's Handbook*,[74] perhaps gave up on "saving" Augustine. As for Augustine, she perhaps gave up on her classical ecstasies.

So she herself put an end to her existence as a "case"; she disguised herself as a man (how ironic), and fled the Salpêtrière. Her guardians, though attentive, fell for it. *Fugue:* the end of nonreceiving.

Disconcertment and the Image in Return

This fugal end is thus not an end. Except perhaps for the *quasi-Augustine* I spoke of, who perhaps became simply Augustine, perhaps not. As for myself, I interrupted the unfolding of my question at a point that does not go without saying. For it is indeed the knot of the drama. It remains sus-

pended on a charm that *did not fully take*. "The thing is fixed,* in a word," Augustine said one day, in a premonition.[75]

What is fixed or stopped is the vicious circle of transference. Each was asking for too much: the physician, with his experimental escalation and his director's vertigo, believing he could do, undo, and redo anything with the bodies yielded to him; the hysteric, with her escalation of consent, in fact demolishing all the reserve and graciousness of representation. What stops there is indeed the reciprocal operation of charm, the death of one desire, if not of two. *Disconcertment:* deception put out of countenance, the rupture of a rhythm by which a structure could be effusive.

But this stopping is not an end, which is why I speak of suspense. Consider that with or without charm, the fabrication of images and clinical and experimental procedures was supposed to continue to function at the Salpêtrière, in spite of and along side the hatred. How?—This continuation would require my own tale to continue [*se reprendre*], to "pull itself together" [*se reprendre*] too. This arrest is not an end, but an *exasperation:* the moment in the fugue called the *strette* or "compressed imtation"; an answer no longer waiting for the repose of the subject; an imitation hastening along; the structural moment of a danger; the structural moment, as well, of *distress.*

With the hysteric, there is a *distress of the image*. It is the moment when a death is transmitted, in the theater itself, and although this moment is obsessed with an absence, it does not make anything plainly absent; quite to the contrary, it *presentifies,* actualizes something very intensely—not an object, but its clamoring and *absolute imminence*—the drive. And for this purpose every metaphor is shattered and smashed in the gesticulation of mixed refusal and call. A moment of holophrasis. Cry, convulsion: an imaginary break-in, and so prompt, so virulent that it *dislocates* the imaginary and its beautiful organization on the spot. Isn't the opposite of the wait for an image the very thing one expects of a spectacle: its haste, finally?

Thus it is a catastrophic passage, of which the hysteric's intense narcissism was merely the subtle retention. And now we have a failed encounter with the ideal, a far crueler encounter with a side of the real. The failure of charm is always a kind of horrified awakening. At bottom it is an intense self-punishment of the hysterical fantasy, the talion of the image. One last simulacrum: that of a suicide, perhaps. In it, for a brief moment, the image attains something like its own limit, becoming *the dislocation of*

*[*Chose arrêtée* is a colloquial expression meaning a settled matter, but literally means "a thing stopped."—Trans.]

the image into action and gestures, and thus, in a contradictory fashion of course becoming figurative. This is nonetheless the aporia in actuality of hysterical visibility, a convulsive clenching of the imaginary itself into dissemblance itself. The image then exists as something that could "frighten" a hysteric "to death."[76]

We who look at these photographs of the Salpêtrière, fixed images of gesticulated images,—this fear assaults us deeply, it *alters* us. It ruins but renews our desire to see; it infects our gaze, meaning that our gaze is devastated, but holds on, resists, returns. *Fascinum:* charm, meaning evil spell, ill fate. A kind of haunting takes hold of us. Also for this reason, which exceeds the photographs, we imagine this old hysterical "theatricalism" to be an authentic practice of cruelty, the multifarious epidemic of hysterical fantasies that, however, are themselves in distress. We devour hysteria with our gaze, hysteria devours our gaze in return. Note the extreme peculiarity of "hysterical laughter," an expression that has passed into common language, meaning "unbearable." Mimicry and countereffectuation here stand in for the murder of the gazer. *Ad facinus accidit:* he resorts to crime, she resorts to crime. The hysteric loved with the image, waited with the image, hated, died, and assassinated with the image. The story goes that that on the day Charcot died, several hysterics of the Salpêtrière had dreamed of his death.[77] A play in the *Theater of Horror* by André Lorde, dedicated to the great psychologist Alfred Binet and performed in the Grand-Guignol of Paris, brought the curtain down on the hysteric's revenge, with the *dissimilar* returning to the physician: "Claire" flung efficient, disfiguring vitriol, in her experimenter's face.[78]

I repeat that to hasten her distress, the hysteric awaits her hour, which is unknown to her. This wait hollows out the time of mimicry, which can no longer be called an "as if," but an *as if . . . as if,* a wavering. The hollowed out rehearsal [*répétition*] of a drama, the mysterious wait, sometimes the expectation of the howling haste of a mystery, or insinuated haste, or haste enveloped in irony or a cloud of merriment and horror, always fluttering around a chasm, always distress.

Faced with this never-ending distress, knowledge can only be exacerbated. This exacerbation, too, was never-ending, and did not know what mask to wear—the undecided exacerbation of the forms of its power and its efficacy.

This indecision did indeed become, at some propitious moment, a *hatred of the image,* an effect of deceptions and paradoxes of evidence. It was the hatred of all that held, resisted, and returned as the real in hysterical images, poses, attitudes, and deliria. "Curing" [*curer*] hysteria amounted to offering its thousand imaginary productions, its "specters," as quarry

[*curée*]. First feeding on them, then reproducing them and mastering their reproduction, finally, warding them off and exorcising them forever. Freud did not share this kind of hatred, although "getting rid of images," their *disappearance without return,* like a "ghost that has been laid," as he said, was his hope,[79] at least for a moment, just before his theory of fantasy reintroduced the tread of phantoms who were not so easily ransomed, for they come from within.

At the Salpêtrière, a form imposed itself: Hysteria. Sometimes women hired as simple "maidservants" would become hysterics within a few days, and would even attempt suicide, as if out of desperation over this form.[80] It was not all consensual. The form feeds on, tests, and finally *detests* images, when images are too dumbfounding, or when they lose their beauty. But they never stopped fabricating other images, in the perverse hope of finding an image adequate to the form.

The invention of hysteria thus went on exacerbating itself, in two senses: as infernal management, if I may say so, as *tyranny,* bringing hysterical fantasies and hysterical bodies more strictly to heel, and raising the stakes of retaliation. But also, and *at the same time,* it was managing images with an eye to forms, that is, an *aesthetic.* Its paradigm went beyond photography and theater, to painting. For Charcot attempted, as if offhandedly, to finally subsume the "thousand forms" of hysteria under the hypothesis, or the historical and aesthetic canon, of what he called *Demoniacs in Art*[81]—with a certain notion of Baroque art, a certain use of iconography understood, this time, in its most traditional meaning of pictorial representations.

This call to painting was an ultimate call. An anxious call, doubtless ("and when you look long into an abyss, the abyss also looks into you,")[82] but an anxiety attended by the cruelest effects. For the link between the love of art and revenge (revenge on hysterical women incapable of raising themselves to the full dignity not of artists but, I would say of art objects), this link opens up a new paradox of atrocity, a question at the very least: what is the particular nature of this hatred that experiments, invents and produces images—this *hatred made into "art"*?

Appendixes

1 The "Living Pathological Museum"

This great asylum, as you are all surely aware, contains a population of over 5,000 people, including a great number called incurables who are admitted for life, as well as subjects of all ages suffering from chronic illnesses of all kinds, in particular those illness with their seat in the nervous system.

Such is the considerable material, necessarily of a particular nature, that forms what I would call the old collection, the only one which, for a long time, we have had at our disposal for our pathological research and clinical instruction.

The services that can be provided by the research and instruction performed under these conditions should certainly not be disregarded. The clinical types are offered to observation in numerous copies allowing the affection itself to be considered at the same time in a manner that might be called permanent, for the gaps that occur through time, in one category or the other, are soon filled in. In other words, we are in possession of a kind of *living pathological museum,* the resources of which are considerable.

Charcot, "Leçons sur les maladies du système nerveux," in *Oeuvres completes* III, 3–4.

2 Charcot's Clinical Lectures

. . . Charcot's clinical lectures took place on Friday mornings in the amphitheater, filled to the very last rows; he stood on the stage surrounded by his students. Despite his apparent impassivity, Charcot arrived in the amphitheater with a certain timidity. He was not a brilliant speaker, and loathed grandiloquence as much as he despised clichés. He spoke slowly with impeccable diction; he did not gesture; sometimes he sat and sometimes he stood. His presentation was always remarkably clear. He gave the impression of wanting to instruct and convince.

He would habitually bring several patients suffering from the same illness to the amphitheater at the same time; he would go from one to the other, showing the same symptomatic particularities of each of them, the same expressions, the same gait, the same deformities. In other cases, he would group patients presenting different varieties of tremors or motor disturbances to show their dissimilar characteristics. Charcot himself, during the lecture, would often mimic this or that clinical sign, for example the deviation of the face in facial paralysis, the position of the hand in a paralysis of a radial or cubital nerve, or the rigid position of a subject suffering from Parkinson's disease. On the platform behind Charcot were numerous plates, synoptic tables, graphed curves and also statuettes and casts. With different colors of chalk, Charcot would draw schemata of the most complex anatomical regions of the nervous system on the blackboard, which he made comprehensible to his listeners with luminous clarity. I should add that Charcot was one of the first to use projectors in his lectures. . . .

From Guillain, J.-M. Charcot, sa vie, son oeuvre, 53–54.

3 Consultation

It is a nearly indispensable cog in the service. Moreover, it is a very important element in the studies of all physicians and students attached to the clinic. Indeed, after a few weeks one has been able to see more than one could in several weeks elsewhere, and the repeated examination of the professor, of the difficult cases in particular, is a precious aspect of instruction for all the students who attend the service.

The service, moreover, is organized in a very particular fashion, allowing everyone to benefit from the multiple aspects of the work there. On Tuesday mornings, the day of consultation, when the patients have begun to fill the waiting room, Messieurs the interns of Monsieur Charcot perform the initial exam. The patients are already sorted into two categories, those who have been previously consulted and are in the course of treatment, and those who have come for the first time. The latter are immediately examined by Messieurs the interns, who establish an initial diagnostic list with the greatest possible precision.

When Monsieur Charcot arrives at the hospice, he finds this list prepared and, from the cases deemed most interesting at first sight, he selects the patients who will provide him with part of the material for his lecture that day. Once the lecture is over, the work is turned over to the head of the clinic who, assisted by some physicians external to the service,

completes the consultation, meaning that he performs the examination and institutes or changes the treatment of all the remaining patients, both old and new.

As the number of patients is always considerable (there are always at least 60 or 70, and sometimes 90 or more who remain), it must be conceded that it is impossible to give each of them more than a very brief period of time.

Charcot, *Clinique des maladies du système nerveux,* II:430–431.

4 Preface to the *Photographic Journal of the Hospitals of Paris*

The journal that we have the honor of offering the medical public has the object of publishing the most interesting cases collected in the hospitals of Paris.

A mode of illustration, entirely new to medicine, has allowed us to accompany this journal with plates, the truth of which is always superior to that of any other iconographic genre.

The advantages of photography applied to medicine have resulted in total success in the photographic clinic of skin diseases, by Messieurs A. Hardy and A. de Montméja. We hope that our journal, joining the same advantages with those that may result from wider experience, will be worthy of similar favor.

Monsieur the General Director of Public Assistance has kindly placed this new journal under his patronage, and has had a magnificent photographic studio built at the Saint-Louis hospital, which is the gathering place of all that is most interesting and rare in pathology.

Montméja and Rengade, Preface to the *Revue photographique des Hôpitaux de Paris,* I (1869).

5 Preface to the *Iconographie photographique de la Salpêtrière* (vol. I)

In submitting this first volume of the *Iconographie photographique de la Salpêtrière* to the assessment of the medical public, it seems necessary for us to say why and how it was conceived and executed.

Many times, in the course of our studies, we have regretted not having the means at our disposal to perpetuate through drawings the memory of cases that we have had the chance to observe and that are interesting for very different reasons. This regret becomes all the more acute as we see, in the example of Monsieur Charcot, what great gain can be derived from such representations.

Later, during our collaboration with the *Photographic Journal,* we had the idea of photographing the epileptic and hysterical patients whose constant presence at the special services of the Salpêtrière frequently allowed us to see them in the midst of their attacks. Because we were obliged to turn to an external photographer, our first attempts bore little fruit: often, by the time the camera operator arrived, it was all over.

In order to achieve the goal for which we aimed, there had to be a man within arm's reach at the Salpêtrière itself, a man who knew photography and was devoted enough to be ready to respond to our call whenever circumstances required.

We had the good fortune of finding the devoted and skillful man that we wished for in our friend Monsieur P. Régnard. When he arrived in 1875 as an intern at the Salpêtrière, we apprised him of our idea which he eagerly embraced. It is therefore thanks to him that we could use, in a striking manner, a portion of the materials that we have assembled.

In the first place, Monsieur Régnard and I composed an *Album* of one hundred photographs, and perhaps we would have stopped there if our excellent master Monsieur Charcot, who was following our clinical work and our photographic endeavors with his customary benevolence, had not encouraged us to publish the observations gathered by us in his halls, illustrating them with photographs taken by Monsieur Régnard. We have taken his advice: it is now up to the readers to decide if the work, which is now a collaboration with Monsieur Régnard, is useful and worth pursuing.

Bourneville, Preface to the *Iconographie photographique de la Salpêtrière* (1876/77), I:iii–iv.

6 Preface to the *Iconographie photographique de la Salpêtrière* (vol. II)

As promised at the end of the first volume of the *Iconographie photographique de la Salpêtrière,* we have consecrated the first part of the volume you are about to read to the description of a particular kind of epilepsy, *Partial Epilepsy* and its variants.

In the second part, we have pursued the task begun in the first volume, namely, the *description of hystero-epileptic attacks.* Our readers will find in the new observations, no less interesting, believe us, than the precedent, increasingly specific information about the attacks.

A word now on the mode of illustration. The recent progress in photography has not yet been widely introduced in scientific works. Monsieur Régnard kindly agreed, for the second volume of the *Iconographie,* to use a photographic procedure that produces prints run off in

printer's ink and therefore unalterable. *Photolithography,* which we are using today, consists in simply transferring the negative obtained in the camera obscura to a stone. The printing is then carried out by a press. This procedure therefore has all the guarantees of veracity inherent to photography, at the same time as the advantages of printing with oil dye.

Finally, Monsieur Régnard and I must thank Monsieur Michel Möring, Director of the Administration of Public Assistance, for agreeing to annex a photographic studio to Monsieur Charcot. It is thanks to this perfectly adapted installation that we have been able to obtain plates superior to the previous ones.

Bourneville, Preface to the *Iconographie photographique de la Salpêtrière* (1878), II: i–ii.

7 The Photographic Platform, Headrest, and Gallows

The platform we use at the Salpêtrière can be divided in two and thus fill the whole width of the studio. This device is useful to us when, for example, we wish to photograph a patient walking: the patient can thus take a few steps, which is sufficient in a majority of cases.

It is necessary to have a solidly installed headrest, although we do not recommend the use of this instrument in the practice of medical Photography, for it results in poses that are too stiff and unnatural.

Indeed, the speed of the current procedures makes the use of this accessory, widely used in past photography, less and less necessary. It must still be employed when the patient cannot remain immobile and when the lack of light prevents an instantaneous exposure from being taken. The same holds when one is operating at very close range and one wants to make a large-scale photograph of the head or some of its parts: eyes, mouth, nose, or ears. In this case, the large dimensions of the image require a longer exposure time than usual and, on the other hand, the complete immobility of the subject is even more indispensable. However, when the position and attitude of the patient are characteristic, the headrest must be absolutely prohibited.

Finally, in certain cases, we use an iron gallows that is intended to suspend patients who can neither walk nor hold themselves upright. This mobile gallows on an axis is normally folded up along the wall of the studio. The patient is maintained upright with a suspension apparatus that holds his arms and head; this apparatus is along the same lines as the one that serves for the method of suspension.

Londe, *La photographie médicale,* 15.

8 The "Observation" and the Photograph at the Salpêtrière

When a patient enters the hospital, the medical personnel is charged with establishing a sort of report, called the *observation*. This document amasses all the information concerning the patient's history and current state. As modifications occur, they are noted with the utmost care until the patient is cured, if that occurs, or until his death, if it should arise. In a good number of cases, the observation is sufficient for the physician, but in other cases there are advantages to supplementing it with iconographic documents.

If any kind of deformity, wound, or injury are in question, however perfect their description, a good print will tell far more than a lengthy explanation.

In certain illnesses the general aspect, attitude, and face are most characteristic, and here again the print conjoined with the observation is an adventitious complement. In the same way, in order to retain the trace of a passing state, nothing is more convenient than taking a picture; in a word, whenever the physician deems it necessary, a photograph of the patient should be taken when he enters the hospital.

Each time a modification in his state arises, a new picture is necessary; in this way the progress of the cure or illness can be followed.

In the case of paralysis, contracture, atrophy, sciatica, etc., it is essential to retain the aspect of the patient before treatment. In the study of certain nervous affections, such as epilepsy, hystero-epilepsy, and grand hysteria, where attitudes and essentially passing states are encountered, photography is the obvious means of preserving the exact image of phenomena that are too short-lived to be analyzed in direct observation. According to certain hypotheses, the eye itself cannot perceive movements that are far too rapid; such is the case in epileptic fits, hysterical attacks, the gait in pathological cases, etc. Thanks to photochronographic methods, the eye's impotence can be easily supplemented in the particular case and documents of great value can be obtained.

After having studied the whole, the attention should be turned to the various limbs that may be affected in isolation, or which in the case of a general affection demand to be reproduced on a larger scale.

Likewise, after having analyzed the face, one may decide to reproduce the different particular organs that comprise it.

One need not always limit oneself to noting the exterior aspect of the patient; in certain cases, one must also examine the interior of certain accessible organs. Today, by means of most ingenious instruments, one can easily explore the individual's various cavities. This exam can obvi-

ously only be brief: there are thus advantages in these particular cases to photographs which, beyond their sincerity, have the advantage of reminding the observer of what he saw, and allowing him to study an indisputable document at his leisure. Unfortunately, as we will see later, the practical difficulties that must be resolved are numerous, and few applications of this sort of idea have yet been made.

Londe, *La photographie médicale*, 3–4.

9 The "Photographic Card" at the Salpêtrière

In a medical service, where pictures accumulate in large quantities, it is necessary to classify them in the strictest order.

This is how we operate at the Salpêtrière. When we accept a patient, we record the following information on a special card: name, age, residence, hospital room and bed number, photograph number. Below is the model form we have had printed.

<div align="center">

Photographic Service
Voucher for the photograph of M. Dubois

</div>

Room: Duchenne de Boulogne	Photograph no.: 1510,1511,1512
No. 10	Stereoscope
Age: 27	Projection
Residence: rue de l'Entrepôt, 72	Proofs: 2 on each side

<div align="center">

Diagnosis
Hysterical Contracture

Information
The contracture has been present for two months.
Occurred following a violent emotion.
Obtain, if possible, a previous photograph of the subject.

</div>

December 6, 1891	Physician,
	Charcot.

Londe. *La photographie médicale*, 177

10 Technique of Forensic Photography

1.—Each subject must be photographed 1. frontally, and 2. in profile, from the *right side,* under the following conditions of: a) *lighting,* b) *reduction,* c) *exposure,* d) *format.*

2.—The full-face pose is lit by a projector from the subject's left, the right half remaining in relative shadow.

3.—The profile pose is lit by a projector falling perpendicularly on the subject's face.

4.—The scale of reduction to be adopted for the forensic full-face portrait, like that of the profile, is *one seventh.* In other words, the number of the lens should be chosen and the distance separating the lens from the posing chair arranged, such that a distance of 28 cm moving vertically from the outside angle of the photographic subject's left eye results, in the picture, in an image reduced to 4 cm, to within one millimeter larger or smaller ($4 \times 7 = 28$).

5.—For the full-face photograph, the camera should be focused on the *external angle of the left eye,* while for the profile shot the focus is on the *external angle of the right eye,* these two parts respectively corresponding to the most illuminated central placement of each pose. . . .

6.—To avoid fumbling during future sessions, it suffices to affix two small brackets to the studio floor once and for all, allowing the chair and camera to be immediately returned to their respective positions.

7.—It is absolutely indispensable that the two poses of forensic photographs for purposes of identification be taken of the subject with his head bared.

8.—If for reasons specific to the preparation of a case the subject must also be photographed *with a hat on his head,* this final pose must be the object of a third portrait, which is better taken full-length, in conformity with the prescriptions to be given in paragraph 25.

9.—For the full-face pose as well as the profile, take care that the subject sit squarely forward, with the shoulders at the same height insofar as it is possible, the head resting against the headrest, and the gaze *horizontal,* directed straight in front of him.

10.—For the full-face pose, the subject's eyes should be brought to fix on the lens, which generally poses no problem. For the profile shot, a shifting of the eyes to the side, in the direction of the operator, should be avoided by inviting the subject to look at a target, or better yet at a mirror placed in the direction of the profile as far away as the width of the studio allows, and at the same height as the lens, about 1.2 meters above the ground.

11.—*Leveling the image.* The acts of "plunging" and "lifting the head" at the lens are formally forbidden. . . .

12.—Hair should always be cleared away from the ears and the profile, as from the face.

To obtain this result in the case of certain uncultivated and rebellious heads of hair, it will sometimes be necessary to secure the hair either with a string or an elastic band (only for the profile pose).

13.—The *profile* photographs in which the shape of the ear does not appear in entirety must be retaken. . . .

14.—*The pictures should not be subject to any kind of retouching,* with the exception of holes or punctures in the gelatin making black spots on the print that resemble a beauty spot or a scar. The act of beautifying the subject and making him look younger by erasing wrinkles, scars, and skin blemishes is strictly forbidden.

15.—At the photographic service of the Préfecture de police, in order to avoid confusion in the transcribing of civil status and to facilitate subsequent classification, each picture will be given a provisional number, corresponding to the inscription number on the daily list of photographs to be taken. The numbers, printed on loose tickets of 3 centimeters on each side, are successively slipped into a pouch placed at the top of the chair back, seen from the side.

16.—The information reproduced in the photograph itself allows the name of the subject to be immediately located, by referring to the daily list. The name is then inscribed in inverted writing on the gelatin beneath the profile. Written immediately below this are the date the picture was taken, stated in numbers in the usual order: *date, month, year.* Finally, further to the right, under the full-face portrait, the number of the general order is engraved, and determines the definitive placement of each photograph in the archives.

Bertillon, *Identification anthropométrique. Instructions signalétiques,* 130–132.

11 The Portrait's Veil, the Aura

Vital force, specialized through division.—Photograph taken at 11 o'clock in the morning in half light, 15 min. exposure; at 1.5m, with camera, no electricity whatsoever; stop 94.

I wanted, once again, to obtain the vital effluvia of a group of two very sympathetic and nervous children, as I had already obtained several times. I caught them on their hobbyhorses while they were being quite mischievous, and stopped them short in their antics with a sharp word; a veil that hides them and covers the photo was produced.

They experienced a kind of shiver, a suffocation, and a call modifying the peripheral atmosphere with enough intensity for the plate to be imprinted at a distance of 1.5m, the distance at which these phenomena, invisible to the human eye, were produced.

One can thus observe a luminous *fabric*, like a piece of *knitting* with stitches and knots.

The form is elliptic and characteristic.

At the level of the juxtaposition of the two children in contact, one on the left side, the other on the right (the first repulsive, the second attractive), the fluid was condensed, specialized, and individualized into rounded dots; this form seems to represent the balance and fusion of two fluidic forms, opposed in their direction and abruptly halted at the moment of the animic contraction of the two children, forming but a single soul for a certain period.

The bath that spread incompletely over the whole surface of the plate at once produced such a visible spot; with a camera, but without electricity or red light; the second photograph, taken without emotion, is the portrait of the two children on hobbyhorses.

Baraduc. *L'Ame humaine, ses mouvements, ses lumières et l'iconographie de l'invisibile fluidique.* Explanation of print XXXVIII (Fig. 36).

12 The "Auracular" Self-Portrait

Compared iconographies of the living body, the vital soul, and the spiritual soul.— I here provide a comparative table of four graphs: 1. My photograph taken by Nadar; 2. The obograph of my fluidic body, emanation of the sensitive soul, concomitant with the repulsion of the biometric needle of 2, as the plate was placed between the hand and the biometer; 3. An iconograph of my pscyhiconic ghost; 4. The graph of the psychecstatic soul and the spiritual soul with four rays.

Explanation XXVIII. 1. Photograph of my living body in daylight, by Nadar. 2. Spontaneous obic icon, representing the fluidic ghost of the aromal body reproducing the form of my head. This icon was made in red light, with the right hand facing the sensitive plate, which was itself placed before the biometric apparatus, in order to study both the expansive force of the Ob pushing the needle 2d.'s, and signing its own signature as it traverses the sensitive layer, the glass, and the camera, finally pushing the needle (without electric method, fingers facing the sensitive coating). 3. Psychicon of my head; involution of a thought relating to me in an odic mass, in the midst of which clearly appears my desired icon; thought of my myself (with electric method, fingers facing the plate). 4. Psychic soul, spiritual self. Spiritualized soul, a finely starred bead with four branches (with magnetization) in the center, the sphere of the divine ray, a thin circle of odic vestment around it, four rays communicating with the four breaths of the spirit.

Baraduc, *L'Ame humaine, ses mouvements, ses lumières et l'iconographie de l'invisibile fluidique,* explanation of print XXVIII (see fig. 40).

13 The Aura Hysterica (Augustine)

It is comprised of the following phenomena: 1. pain located at the level of the right ovary (ovarian hyperesthesia); 2. sensation of a lump rising in the epigastric region (epigastric knot); 3. cardiac palpitations and laryngeal constriction (third knot); 4. finally, cephalic disturbances (beatings in the temple and the frontal part of the right side of the parietal bone, ringing in the right ear).

The aura appears a few minutes before the attack; the patient always has the time to lie down. Sometimes, however, she imagines that the attack is going to stop, that the phenomena she is experiencing will amount to nothing, and she does not lie down; occasionally she is mistaken, and she falls down, though without seriously injuring herself. . . . Beyond the prodromes already noted, we must point out the following: her speech becomes brief; G. . . is impolite, irritable; her movements are abrupt; her eyes become wild and fixed; her pupils dilate, the attack breaks out without a cry.

Bourneville and Régnard, *Iconographie photographique de la Salpêtrière,* II: 129, 133.

14 Explanation of the Synoptic Table of the Great Hysterical Attack

Plate V [see fig. 46] represents a synoptic table of the great hysterical attack and the varieties that result from modifications to the elements that comprise it. It was composed with most of the illustrations in this book gathered together and arranged in an order that allows one to take in, at a single glance, the different periods of the complete and regular great hysterical attack and thereby deduce its principal varieties.

The first horizontal line gives the schematic reproduction of the great attack in its perfect development. All the periods and their different phases are represented in their classical form.

All the other figures arranged in vertical columns are as many varieties of the classic type, varieties that it would be easy to multiply. Each column thus includes the various forms of the phase represented by the figure on top, which belongs to the classic schema and represents the most ordinary manifestation.

Prodromes ——————————————————————A			
		Great Tonic Movements ———B	
First Period	Tonic Phase		
		Tonic Immobility——————C	
	Clonic Phase ——————————————D		
	Phase of Resolution——————————E		
Second Period	Phase of Contortions ——————————F		
Or Clownism			
		Rhythmic —G	
	Phase of Great Movements		
		Disordered –H	
Third Period	Happy *Attitude Passionnelle* ————————I		
Or *Attitudes*	Sad *Attitude Passionnelle*——————————J		
Passionnelles			
Fourth Period	Delirium, Zooscopy ——————————K		
Or Period of	Generalized Contractures ——————L		
Delirium			

Richer, *Etudes cliniques sur la grande hystérie ou hystéro-épilepsie,* 167 (see fig. 46).

15 The "Scintillating Scotoma"

I will not enter into the story of the ophthalmic migraine today, it being a subject that will occupy our attention exclusively some day. I will only remind you that, in a vulgar fit of the ophthalmic migraine, clearly characterized, there is a luminous figure manifested in the visual field, first circular, then half-circular, in the form of a zigzag, or drawn like a fortification, shaken in very rapidly vibrating movement, sometimes a white, phosphorescent image, sometimes tinted with more or less accentuated yellows, reds, and blues.

The scotoma often gives way to a temporary hemianopsic failure of the visual field, such that one can perceive no more than half of all objects.

The campimetrical exam, quite useful in such a case, points to a hemianopsic failure, in general homonymous and lateral, that normally does not extend all the way to the point of fixation.

This is followed by a pain in the temple on the side where the visual defect or specter is occurring, and the corresponding eye is the locus of a pain from tension that is sometimes reminiscent of the pain felt in acute glaucoma. Vomiting terminates the episode, and order is restored.

Charcot, "Leçons sur les maladies du système nerveux," *Oeuvres Complètes,* III: 74–75 (see fig. 55).

16 Cure or Experimentation?

While I was Charcot's intern or his clinical chief, how many times did I hear, in the midst of a discussion of my master's work: "At the Salpêtrière, you cultivate hysteria, you don't cure it." When this came back to Charcot, he would respond: "To learn how to cure, one must first have learned how to recognize; diagnosis is treatment's greatest advantage." He was reproached for not being a therapist—he, Charcot, who gave the true formula for the treatment of hysteria and epilepsy; who found the sole means of curing the vertiginous auraculars who, prior to Charcot, were abandoned to their unfortunate lot; he who, in matters of therapy, has never recoiled from any kind of experimentation, whose maxim on the matter was that "a good remedy is one that cures." On this subject, reread one of his most recent works, a kind of philosophical testament, *La Foi qui guérit* [The Faith that Cures].

Gilles de la Tourette, "Jean-Martin Charcot," *Nouvelle Iconographie de la Salpêtrière* (1893), 246.

17 Gesture and Expression: Cerebral Automatism

The examples we will first report were observed in the very early stages of our research on hypnotism. They consist in the influence of gesture on the expression of the physiognomy. While the subject is in a cataleptic state, the eyes remain open, and the face is not indifferent to the positions imprinted on the body, whatever they may be. When these positions are expressive, the face comes into harmony with them and contributes to the same expression. Thus a tragic position imprints a severe expression on the physiognomy, and the brow contracts. To the contrary, if one brings two open hands to the mouth, as in the act of blowing a kiss, a smile immediately appears on the lips.

In these two examples, regarding two feelings that are opposed and easy to characterize, the impact of gesture upon the physiognomy is quite striking, and is produced most distinctly.

But, however docile she may be, it is difficult to imprint perfectly expressive movements on a model, and the number of attitudes that can be fully communicated in relation to a given feeling seems to us to be relatively limited.

Thus we had the idea of proceeding in the reverse manner, and rather than acting on gesture to modify physiognomy, we have sought the influence of physiognomy on gesture.

The means of imprinting various expressions on the physiognomy were discovered by an able experimenter. We have taken recourse to localized faradization of the muscles of the face, according to the procedures adopted by Duchenne (de Boulogne) in his studies on the mechanism of physiognomy. . . . Even in our earliest experiments, we saw the position and the appropriate gesture follow upon the expression that the electric excitation imprinted on the physiognomy. As the movement of the features became more and more accentuated, one could see the whole body enter into action, spontaneously in a way, and complete the expression of the face with a gesture. When, because of an error or hesitation in the operating procedure, the expression of the physiognomy was not frankly accentuated, the gesture also remained indecisive.

Once produced, the movement imprinted on the facial features is not effaced, although the cause that produced it ceases with the removal of the electrodes. The physiognomy remains immobilized in catalepsy, as do the position and gesture that accompanied it. The subject thus finds himself transformed into a kind of expressive statue, an immobile model representing the most varied expressions with striking truth, and which artists can most certainly, turn to the best account.

The immobility of attitudes obtained in this way is highly favorable to photographic reproduction. With the assistance of Monsieur Londe, responsible for the photographic service of the Salpêtrière, we have obtained a series of photographs, the most interesting of which we have reproduced here, and which, we note, were taken during the earliest experiments attempted in this domain.

Charcot, "Leçons sur la métallothérapie et l'hypnotisme," *Oeuvres completes*, IX, 441–443.

18 A *Tableau Vivant* of Cataleptics

We know that in hysterics, any violent and unexpected noise will provoke catalepsy; however, various patients take on totally different positions which are, in general, consistent for each of them. We have not yet discovered the clinical value of the particular attitude of each subject, but perhaps it exists, and by gathering together a large number of prints of this kind, we will doubtless obtain interesting results.

Here is the reproduction of a photograph taken at the Salpêtrière [see fig. 89]. The hysterics were brought before the camera on the pretext of having their portrait taken. At this moment, a gong was struck and all of them were plunged into catalepsy, as is shown in the sketch made from the print, by Dr. Richer.

In this particular case, the exposure can be as long as desired, for in the state of catalepsy the patient presents an almost total immobility. However, although the position is conserved over a rather long period of time, there is a general fatigue of the muscles in their use and pictures taken after a certain interval would clearly show this fact.

Londe, *La photographie médicale,* 90.

19 Provoked Deliria: Augustine's Account

Delirium provoked by ether.—Although we have already repeatedly recounted the hallucinations and feelings experienced by hysterics under the influence of inhalations of ether, and in particular those of L. . . (v. II, p. 161), we thought it interesting to reproduce the account written by the patient herself, upon our request and after reiterated insistence, regarding the sensations brought about by the ether which make her demand it so frequently:

> Since March 3 (1877), after having absorbed a certain amount of ether, for three days I still had some evil thoughts from the hallucinations and the things I had seen and felt with pleasure. These thoughts were: I was still with my dearly beloved M. . . ; my mind was with him alone, wherever I went I seemed to see him constantly, and hear him calling me. When I was alone in moments, I'd try to reflect on what I could do to . . . be able to love him and possess him like I wanted to; then I would cover my face with my hands, and it was then, while feeling a great happiness, that I would ask him: "Do you love me?" It seemed to me that he'd answer "Yes"; then I was overcome with joy, believing that I could feel him kiss me and press me to his breast; sometimes I'd hear him ask me the same thing, and I'd always answer "Yes." (But unfortunately this was only a dream.) During these three days I experienced this happiness about ten times a day. When it was time for bed, it became even worse, for I could feel him lying with me, wrapping his arms around me, holding me to his heart and telling me to fall asleep—I wanted to, but before that I'd have preferred that he make me completely happy and thus prove that he loved me, but it seemed to me that he said "No"; so I'd be confused and angry at this response, and I felt a malaise that I don't want to withhold from you: suddenly, I'd be overcome with shivers and palpitations, a cold sweat would come over my face; I'd have raised myself up, but I couldn't move my arms or my head. This would last around 4 or 5 minutes. Then, at the end, I felt a delight that I don't dare explain to you. I'd experience this kind of malaise every time I felt him pressing against my breast; I could feel him kissing my breast, and I was asking him for something that he wouldn't do to me, then I'd feel the malaise again and I'd have a hard time falling asleep after

chasing away all those ideas. For those three days, every time I'd go to bed I felt the same thing. Since I've been sick I haven't felt this at all, except for the times that I've had the chance to see the charming person who always makes me want to kiss him, and yet, when I'm in front of him I get intimidated, and I restrain myself as much as I can so I don't show him I love him. I won't name the person, because I don't think you need me to, and plus I wouldn't dare.

P.S. I've told you everything you asked me and even more; I'd speak to you more openly if I dared; but I'm afraid it would be in front of everyone.

Thus, the effects of ether were prolonged for a rather extended period after inhalation. If the above account is exact—and we believe it to be, for it conforms to the account of most patients—ether almost constantly produces agreeable and voluptuous dreams, and puts the patient into the situation in which she finds herself for part of the happy phase of the delirious period of the attacks.

Effects resulting from inhalations of amyl nitrate.—At the end of November, 1877, that is, a period during which X. . . L. . . was rather easy to handle, she gave us the following details of the phenomena she experiences upon inhaling amyl nitrate:

After the amyl nitrate, I snuggled into my bed; I started falling asleep, when I saw M. . . coming towards me. He lay down beside me, took me into his arms, and was kissing me, tickling me, and touching me.

I kissed him back and covered him with caresses, hugging myself against him, and then I'd shiver, animated, happy. Then I'd wriggle about, behaving in a most unseemly manner . . . Still believing that M. . . was caressing me, touching my breasts, then making . . . And I was happy, I always did it with pleasure and zeal; this lasted for two hours; I fell asleep for a few hours, still joyful with the same person. I dreamed that I wasn't at the Salpêtrière anymore, I'd been living with him for a few days, I'd take walks by his side, in the Bois de Boulogne, and he'd always show me pretty things: still dreaming, I went to the theater where a revolution was being performed: there were Negroes with red eyes and blue teeth who were fighting each other with firearms. M. . . was hit in the head by a bullet, his blood flowed, I was crying, and, when I woke up I realized my mistake.

The rest of the day went pretty well, but I was even more excited than usual; this is why I'm going to give you an example. That same evening, an intern from the service came to speak with me. He took me by the hand and said "Good day"; then I felt as if I'd been electrified from head to foot; he noticed it, and asked me what had come over me; I didn't answer, but I wanted to and it took much firmness of character not to kiss him, because he represented M. . . to me.

The action of amyl nitrate is less agreeable than that of ether. We can see that mixed with voluptuous sensations were painful dreams, in which the patient saw red eyes, blue teeth, blood, etc.

Bourneville and Régnard, *Iconographie photographique de la Salpêtrière*, III, 187–190.

20 Theatrical Suggestion

We are trying to push the experiment even further; we've already seen that in this cataleptic state, it is sufficient to place the arms of the patient in the position of the beginning of an attack for the attack to immediately follow. Now we are trying simply to tell her that she is having an attack. There is a moment of stupor and hesitation, but after a few seconds, a veritable hystero-epileptic attack manifests itself, which we then stop through ovarian compression. This experiment repeated many times over has always yielded the same results. . . .

Hallucination can bear on the very substance of the subject of the experiment who, according to the fancy of the experimenter, believes himself to be made of glass, wax, rubber, etc. As with certain lunatics, a systematized delirium is seen to develop in relation to the nature of the suggestion. If the patient believes herself to be made of glass, she will not budge without taking infinite precautions out of a fear of breaking herself, etc.

The patient can also be transformed into a bird, a dog, etc., and she clearly tries to reproduce the aspect of these animals.—She speaks, however, and answers the questions put to her, without seeming to notice what might be contradictory in the fact of an animal using human language. Nonetheless, the patient claims to be fully able to see and feel her beak and feathers, or her muzzle and fur, etc. Experiments still more interesting, especially from a psychological point of view, consist in changing personalities. A subject under the influence of verbal suggestion might believe himself to be Monsieur X. or Y. He then loses the notion of anything that contributes to formation of his own personality, and with the help of his memories, creates the new personality imposed upon him.

Monsieur Charles Richet has cited some quite curious examples that he distinguishes with the name of objectifications of types, because the subject, rather than conceiving a type as anyone else might be able to do, realizes and objectifies this type. She no longer watches the images unfolding before him as a spectator, like someone hallucinating; she's like an actor who, in the grip of madness, imagines that the drama she's performing is

reality, not a fiction, and that she is transformed body and soul into the personality she is responsible for playing.

Here are a few examples of these objectifications.

Under the influence of verbal suggestion one of his subjects, Madame A. . . , underwent the following metamorphoses:

A peasant woman.—(She rubs her eyes and stretches.) "What time is it? Four in the morning!" (She walks as if she were dragging clogs). "Let's see, I must get up! Let's go to the stable. Gee up! Ginger! Let's go, turn around . . ." (She pretends to milk a cow.) "Leave me alone, Gros-Jean. See now, Gros-Jean, leave me alone, I say! When I've finished working. You know very well that I haven't finished working. Ah! Yes, yes! Later."

An actress.—Her face takes on a smiling aspect, instead of the severe and bored air she had previously exhibited. "You can see my skirt. Well! My director's the one who had it lengthened. Those directors are such a bore. For my part, I think the shorter the skirt, the better. There's always too much of it. Just a fig leaf. My God, that's plenty. You think so too, don't you, darling, that there's no need for anything more than a fig leaf. Have a look at that beanpole Lucie, she's got some legs, eh!

"So tell me, darling (she starts to laugh) you're quite shy with the ladies; you shouldn't be. Come see me sometime. You know, at three o'clock, I'm home every day. So come for a little visit, and bring me something. . . ."

A nun.—(She immediately sinks to her knees), and begins reciting her prayers and crossing herself as quickly as possible, then she rises.) "Let's go to the hospital. There's a casualty in this room. Well, my friend, aren't you feeling better this morning? See now! Let me undo your bandage. (She makes the gesture of unrolling a bandage.) I'm doing it very gently; doesn't it soothe you? See now, my poor friend, have as much courage before pain as you had before the enemy."

This example is sufficient to show the operation of this absolute transformation of the personality into this or that imaginary type. It is not a simple dream, but a lived dream, in the words of Monsieur Charles Richet.

Richer, *Etudes cliniques sur la grande hystérie ou hystéro-épilepsie*, 728–730.

21 Somnambular Writing

The first time we performed this test, he started writing out a song entitled "The Wine of Marsala." Once he had begun this activity, he was wholly concentrated on it, to an unimaginable extent. One could yell at his sides, speak into his ears, march one's fingers around his face and into the conjunctiva, arriving from the side. If the hand moving about him then entered the narrow circle to which his visual field seemed to be restricted,

he generally saw not a hand but a cockroach that he tried to catch. Then he began to write again. One could place a card between his hand and his eyes, and he'd continue to write without direction, without ink in his pen if necessary, with concern for the obstacle. One might say that everything was happening in his head, that in reality he was not leading his hand with his eyes, but that it was all a simple mental image of what he was accomplishing. Suppose that several pieces of paper were stacked in front of him. If the paper on which he was writing was rapidly removed from him, he'd take no notice and continue the downstroke of the letter he was in the midst of tracing on the following page and continue his task on this page the top half of which was blank. One could even take the whole packet of paper away from him. It mattered little to him, he continued to write on the wood of the table or on the waxed cloth covering it.

What's more, once the couplet he was writing was finished, he'd stop and prepare to reread everything he'd written. White paper was then placed before his eyes; he thus found himself in the presence of a page devoid of any characters. This didn't stop him; his song, we'd say, was not to be found on the paper but in his brain. He thus continued to see it on the white page and reread it, adding periods, commas, accents, and crossing his t's. If one then compared the first two pages with the third, one could see that a horizontal bar, an acute or grave accent exactly corresponded to an unaccentuated letter or an uncrossed t on one or the other of the sheets. This test is the most characteristic that can be imagined.

Charcot, *Clinique des maladies du système nerveux*, 126–127 (drafted by Guinon).

22 How Far Does Hypnotic Suggestion Go?

I tell Wit. . . while she's sleeping: "When you wake up you will put this hat on your head and walk around the table." I blow on her eyes; now she is awake; you see that she is punctually accomplishing the act I commanded. Note that I could have told her to perform the act in an hour, or tomorrow, or in a week, and things would have occurred precisely at the indicated moment.

It is the events in this second category that have particularly struck observers. They have wondered: But if one can order a hypnotized woman to commit an act at a fixed date, nothing would be easier than for an able criminal to put a hypnotizable person to sleep, and make her commit and act of forgery, theft, or assassination at a more or less distant date.

This is an apparently plausible hypothesis, all the more so because experimental suggestion has not been limited to insignificant acts like that

which I had Wit. . . perform, but certain kinds of laboratory crimes have been realized.

Is it possible to have a crime performed by suggestion?

At first sight, experiments lead one to answer this question in the affirmative. It is incontestable that, in the laboratory, hypnotized hysterics can be made to commit simulacra of robberies and murder. The experiments of this kind are so impressive that it is difficult to resist the tendency to imagine that in ordinary life things would occur as they do in the hospital. This tendency can be found in the report given in 1883 at the Medico-Psychological Society by Monsieur Charles Féré, now a physician at Bicêtre.

The hypnotized indeed appear to be pure automatons. And it can be readily conceded that, influenced by appearances, the hypnotized have been said to belong to the hypnotizer "like the traveler's stick belongs to the traveler." Or again, as Monsieur Liébault has said, the hypnotized "move toward their goal like a falling stone."

Nonetheless, by closely considering the facts, it is easy to see that this is not quite the case.

I will show you that subject of suggestion is not, as some like to say, an absolutely passive automaton.

The young woman I'm introducing to you is, as you can tell, quite easily hypnotizable. I have her leave the room. She'll return later on, to perform the suggestions that I'm going to give her. But while she isn't here, I want to tell you what I hope to demonstrate with her. You'll see that this young woman will perform irrelevant suggestions with no trouble whatsoever, but when I order her to perform acts that are repugnant to her for various reasons, the more repugnant to her they are, the more she will resist carrying them out.

I bring her back and put her to sleep again.

1st experiment: I order her to scratch her nose when she wakes up; I wake her; you see that she immediately performs the ordered act.

2nd experiment: I order her to thumb her nose at the audience. Note that this second suggestion is accomplished with a certain hesitation. All things considered, it's not a very serious act and simply shows a lack of respect for the people present.

3rd experiment: I won't reproduce this one in front of you, for reasons you'll understand. But I've done it several times in the relative isolation of the office. I ordered the patient (for note that we are concerned with someone ill) to kiss one of the people present. Upon awakening, the instincts of modesty in this young, chaste girl were appalled; she ultimately

obeyed me (halfway, for I stopped the act as it was being performed), but only after having put up great resistance to the suggested temptation.

4th experiment: I show her this glass and tell her: "there's arsenic in it. When you awake you will present the glass to Monsieur X., who is very mean and says bad things about you." I blow on her eyes. Now she's awake. She takes the glass, but with difficulty. Note that the experiment has not succeeded. In a half hour, a quarter of an hour it may succeed. I'm not sure, but I admit the possibility.

What I want you to remember about these four experiments is that the young woman does not passively obey the suggestions. She resists some of them and resists them all the more forcefully when they go against her instincts and tendencies. Obedience is thus not as absolute and constant as has been said. The automatism is positive, but relative. This fact allows you to have a sense of at least some difficulties one is exposed to in claiming to use an honest person to commit a criminal act by suggestion.

Ballet, "La suggestion hypnotique au point de vue médico-légal," *Gazette hebdomadaire de médecine et de chirurgie* (October 1891), 6, 11–13.

Notes

1 The Outbreak

1. Friedrich Nietzsche, "Beyond Good and Evil" (1886), in *Basic Writings of Nietzsche* (New York: Modern Library, 1968), 295.

2. Ibid., 299.

3. Or at least under the aegis of a portrait of Pinel. See Sigmund Freud, "Charcot" (1893), III: 18.

4. See Michel Foucault, *Histoire de la folie à l'âge classique* (1961) (Paris: Plon, 1972), 483–497; Marcel Gauchet and Gladys Swain, *La pratique de l'esprit humain. L'institution asilaire et la révolution démocratique* (Paris: Gallimard, 1980), 68–100.

5. See G. W. F. Hegel, *Encyclopedia of Philosophy*, trans. Gustav Mueller (New York: Philosophical Library, 1959); Foucault, *Histoire de la folie*, 501.

6. Philippe Pinel, *Traité médico-philosophique sur l'aliénation mentale ou la manie*, 2nd ed. (Paris: Richard, 1809), 437.

7. Hegel, *The Phenomenology of Spirit*, trans. A. V. Miller (Oxford: Oxford University Press, 1977), 403, 405, 383.

8. See Freud, "The Unconscious" (1915), XIV: 198.

9. Pinel, cited by Gauchet and Swain, *La pratique de l'esprit humain*, 131.

10. See Immanuel Kant, *Anthropology from a Pragmatic Point of View* (1798), trans. Victor Lyle Dowdell (Carbondale: Southern Illinois University Press, 1978), 64–66.

11. Jean-Martin Charcot, *Oeuvres complètes*, lectures collected and published by Bourneville, Babinski, Bernard, Féré, Guinon, Marie, Gilles de la Tourette, Brissaud, Sevestre., 9 vols. (Paris: Progrès médical/Lecrosnier & Babé, 1886–1893), I: 321.

12. Claude Bernard, *Introduction à l'étude de la médecine expérimentale* (Paris: Ballière, 1865), 173.

13. See Martin Heidegger, "The Age of the World Picture" (1938), in *The Question Concerning Technology and Other Essays,* trans. William Lovitt (New York: Harper and Row, 1977), 134.

14. Freud, "New Introductory Lectures on Psycho-Analysis" (1933), XXII: 58–59.

15. See Georges Canguilhem, "Qu'est-ce que la psychologie," in *Etudes d'histoire et de philosophie des sciences* (Paris: Vrin, 1968), 365.

16. Charles Baudelaire, *Oeuvres complètes,* 2 vols. (Paris: Gallimard, 1975–1976), I: 587.

17. See Nietzsche, "Beyond Good and Evil," 349.

18. See Georges Guillain and Pierre Mathieu, *La Salpêtrière* (Paris: Masson, 1925), 48.

2 Clinical Knowledge

1. See Guillain and Mathieu, *La Salpêtrière* (Paris: Masson, 1925), 41.

2. Délibération de l'Hôpital général, 1679, cited by Foucault, *Histoire de la folie,* 97.

3. See Jean Losserand, "Epilepsie et hystérie. Contribution à l'histoire des maladies," *Revue française de psychanalyse* 42, no. 3 (1978): 429.

4. See Jacqueline Sonolet, *Trois siècles d'histoire hospitalière. La Salpêtrière* (Exposition, 1958), passim.

5. See A. Husson, *Rapport sur le service des aliénés du département de la Seine pour l'année 1862* (Paris: Dupont, 1863), passim. See also Husson, *Etude sur les hôpitaux considérés sous le rapport de leur construction, de la distribution de leurs bâtiments, de l'ameublement, de l'hygiène et du Service des salles de malades* (Paris: Dupont, 1862), passim.

6. Ibid., lvi–lvii.

7. Ibid., 11.

8. Jules Clarétie, "Charcot, le consolateur," *Les annales politiques et littéraires* 21, no. 1056 (1903): 79–80.

9. Ibid., 79.

10. See Alexandre-Achille Souques, *Charcot intime* (Paris: Masson, 1925), 3–4; Daudet, *Les oeuvres dans les hommes* (Paris: Nouvelle Librairie Nationale, 1922), 205; Gilles de la Tourette, "Jean-Martin Charcot," in *NIS* (1893), 245.

11. Dante, "Inferno," in *The Divine Comedy,* trans. Allen Mandelbaum (New York: Alfred A. Knopf, 1995), 72 (canto 4:1–11).

12. See Emile Baudelaire, "Don Juan aux Enfers," I:20.

13. Marie, cited by Guillain, *J.-M. Charcot (1825–1893). Sa vie. Son oeuvre* (Paris: Masson, 1955), 134–135. My emphasis.

14. See Emile Benveniste, *Problèmes de linguistique générale,* 2 vols. (Paris: Gallimard, 1966–1974), II: 248–249.

15. Charcot, *OC* I:2.

16. Ibid.

17. See Léon Daudet, *Les morticoles* (Paris: Charpentier & Fasquelle, 1894), passim; Daudet, *Les oeuvres dans les hommes,* 197–243.

18. Gilles de la Tourette, "Jean-Martin Charcot," in *NIS,* 249.

19. See "Centenaire de Charcot," *Revue Neurologique,* no. 6 (1925): 732–1192.

20. Guillain, *J.-M. Charcot (1825–1893). Sa vie. Son oeuvre,* 143.

21. Freud, "Charcot," VIII: 13; Jacques Nassif, "Freud et la science," *Cahiers pour l'analyse,* no. 9 (1968): 155; François Laplassotte, "Sexualité et névrose avant Freud: une mise au point," *Psychanalyse à l'université* 3, no. 10 (1978): 220–225.

22. See Charcot, *Leçons du mardi à la Salpêtrière. Policlinique 1888–9,* Course notes by Blin, Charcot, and Colin, 2 vols. (Paris: Progrès médical/Lecrosnier & Babé, 1888–1889), 37.

23. See Joseph Babinski, *Oeuvre scientifique: recueil des principaux travaux* (Paris: Masson, 1934), 457–527.

24. Pierre Janet, "J.-M. Charcot. Son oeuvre psychologique," *Revue philosophique,* June (1895): 573.

25. Bernard, *La médecine expérimentale,* 24.

26. Ibid., 382–396.

27. Ibid., 322–332.

28. Ibid., 63–71.

29. Ibid., 304–313.

30. Ibid., 170–171.

31. Canguilhem, *The Normal and the Pathological,* trans. Carolyn Fawcett (New York: Zone Books, 1989), 212; Charcot, *La médecine empirique et la médecine scientifique* (Paris: Delahaye, 1867), 4–5.

32. Ibid., 21. See also Charcot, *OC* III: 9. (citing Bernard).

33. Charcot, *Leçons du mardi à la Salpêtrière. Policlinique,* Course notes by Blin, Charcot, and Colin (Paris: Progrès médical/Delahaye & Lecrosnier, 1887–1888), 115.

34. Charcot, *La médecine empirique et la médecine scientifique,* 17. My emphasis.

35. See Freud, "On Narcissism: An Introduction" (1914), XIV: 94–95.

36. See Charcot and Albert Pitres, *Les centres moteurs corticaux chez l'homme* (Paris: Rueff, 1895), 17.

37. See Henry Meige, "Une révolution anatomique," in *NIS* (1907), 97.

38. Foucault, *The Birth of the Clinic: An Archeology of Medical Perception,* trans. A. M. Sheridan Smith (New York: Pantheon Books/Random House, 1973), 55.

39. Charcot, *OC* III: 22.

40. Charcot, *Clinique des maladies du système nerveux,* ed. G. Guinon, 2 vols. (Paris: Progrès médical/Babé, 1892–1893), I:ii.

41. Souques and Meige, cited by Guillain, *J.-M. Charcot,* 51.

42. Foucault, *Clinic,* 107–108.

43. Ibid., 90.

44. Charcot, *OC* I: 277.

45. Janet, "J.-M. Charcot." 576.

46. See Briquet, *Traité clinique et thérapeutique de l'hystérie* (Paris: Ballière, 1859), 5. See also Charcot, preface to Paul Richer, *Etudes cliniques sur la grande hystérie ou hystéro-épilepsie,* 2nd ed. (Paris: Delahaye & Lecrosnier, 1881–1885).

47. See Foucault, *Clinic,* 95–97, 105.

48. Freud, "Fragment of an Analysis of a Case of Hysteria" (1905), VII: 16.

49. Charcot, *Leçons du mardi* (1887–1888), 231.

50. See Foucault, *Clinic,* 120–122.

51. See Souques, *Charcot intime* 24–30; Guillain, *J.-M. Charcot,* 10–11, 26–30.

52. Freud, "Charcot" (1893), III: 12; Nassif, *Freud—L'inconscient,* 58, 62.

53. See Edmund Burke, *A Philosophical Enquiry into the Origin of Our Ideas of the Sublime and the Beautiful,* ed. J. T. Boulton (London: Routledge and Paul, 1958), 31.

54. See Foucault, *Histoire de la folie,* 326–342.

55. See Lacan, *Ecrits* (Paris: Seuil, 1966). ("Le temps logique et l'assertion de certitude anticipée: un nouveau sophisme.")

3 Legends of Photography

1. Charcot, *Leçons du mardi* (1887–1888), 178.

2. See Damisch, "Agitphot. Pour le cinquantenaire de la 'Petite histoire de la Photographie' de Walter Benjamin," *Les cahiers de la photographie,* no. 3 (1981): 25.

3. Charcot, *OC* III: 5–6.

4. See *Cires anatomiques du XIXième siècle. Collection du Docteur Spitzner* (Exposition, Centre Culturel de la Communauté française de Belgique, Paris, 1980), 28, 33.

5. See Etienne-Jules Marey, *La méthode graphique dans les sciences expérimentales et principalement en physiologie et en médecine,* 2nd ed. (Paris: Masson, 1878), i.

6. Marey, *Le développement de la méthode graphique par la photographie* (Paris: Masson, 1885), 2.

7. H. W. Diamond, "On the Application of Photography to the Physiognomic and Mental Phenomena of Insanity (1856)," in *The Face of Madness* (New York: Brunnel/Mazel, 1976), 19.

8. See Roland Barthes, "The Photographic Message (1962)," in *The Responsibility of Forms,* trans. Richard Howard (Berkeley: University of California Press, 1985), 5.

9. Londe, *La photographie moderne. Traité pratique de la photographie et de ses applications à l'industrie et à la science* (Paris: Masson, 1896), 546, 650.

10. Émile Zola, cited by Susan Sontag, *On Photography* (New York: Farrar, Straus and Giroux, 1977), 87.

11. See Benjamin, "The Work of Art in the Age of Mechanical Reproduction," in *Illuminations,* trans. Harry Zohn (New York: Schocken Books, 1968), 226.

12. Canguilhem, *The Normal and the Pathological,* 40.

13. Londe, *La photographie dans les arts, les sciences et l'industrie* (Paris: Gauthier-Villars, 1888), 8.

14. Souques, *Charcot intime,* 32–34.

15. Alfred Hardy and A. Montméja, *Clinique photographique de l'Hôpital Saint-Louis* (Paris: Chamerot & Lauwereyns, 1868), unnumbered plate.

16. Georges Bataille, *Oeuvres complètes,* 9 vols. (Paris: Gallimard, 1970–1979), I: 229–230.

17. Désiré-Magloire Bourneville, "Notes et observations sur quelques maladies puerpérales. V. Deux cas de déchirure du périnée," *Revue photographique des Hôpitaux de Paris,* (1871): 137.

18. Charles Le Brun, "Conférence sur l'expression générale et particulière (1668–96)," *Nouvelle Revue de Psychanalyse,* no. 21 (1980): 95. My emphasis.

19. See Damisch, "L'alphabet des masques," *Nouvelle Revue de Psychanalyse,* no. 21 (1980): passim.

20. See Johann Lavater, *L'art de connaître les hommes par la physionomie* (1775–1778), ed. Moreau, 10 vols. (Paris: Depélafol, 1820), VII: 1–71, VIII: 209–282.

21. Jean Esquirol, cited by Jean Adhémar, "Un dessinateur passionné pour le visage humain: Georges-François-Marie Gabriel (1775–ca. 1836)" in *Omagiu lui George Oprescu* (Bucharest: 1961), 1–2.

22. See Franco Cagnetta and Jacqueline Sonolet, "Nascita della fotografia psichiatrica" (Exposition: Ca'Corner della Regina, Venice, 1981), 44–45, 65–66.

23. See plates in: Bénédict Auguste Morel, *Traité des dégénérescences physiques, intellectuelles et morales de l'espèce humaine, et des causes qui produisent ces variétés maladives* (Paris: Ballière, 1857); Henri Dagonet, *Nouveau traité élémentaire et pratique des maladies mentales* (Paris: Ballière, 1876); Auguste Voisin, *Leçons cliniques sur les maladies mentales professées à la Salpêtrière* (Paris: Ballière, 1876); Voisin, *Leçons cli-*

niques sur les maladies mentales et sur les maladies nerveuses (Paris: Ballière, 1883); Joseph Grasset, *Traité pratique des maladies du système nerveux,* 3rd ed. (Paris: Coulet, Montpellier & Delahaye & Lecrosnier, 1886); J.-G.-F. Baillarger, *Recherches sur les maladies mentales,* 2 vols. (Paris: Masson, 1890); Valentin Magnan, *Recherches sur les centres nerveux. Alcoolisme, folie des héréditaires dégénérés, paralysie générale, médecine légale,* 2 vols. (Paris: Masson, 1876–1893); Bourneville, *Album de photographie d'idiots de Bicêtre* (Paris: Bibliothèque Charcot, n.d.).

24. Augusto Tebaldi, *Fisionomia ed espressione studiate nelle loro deviasioni con una appendice sulla espressione del delirio nell'arte* (Verona: Drucker e Tedeschi, 1884), plates.

25. *IPS* (1875), passim.

26. See in particular Londe, *La photographie moderne. Pratique et applications* (Paris: Masson, 1888); Londe, *Traité pratique de la photographie,* passim.

27. See Londe, *Le service photographique de la Salpêtrière* (Paris: Doin, n.d.), passim.

28. See Londe, *Pratique et applications,* 212; Londe, *La photographie médicale. Application aux sciences médicales et physiologiques,* Pref. Charcot (Paris: Gauthier-Villars, 1893), 12–16.

29. See Londe, *La photographie médicale,* 131–135; Londe, *La photographie à l'éclair magnésique* (Paris: Gauthier-Villars, 1905), passim; Londe, *La photographie à la lumière artificielle* (Paris: Doin, 1914), passim.

30. See Londe, *La photographie médicale,* 105–115.

31. See Londe, *Traité pratique du développement. Etude raisonnée des divers révélateurs et de leur mode d'emploi* (Paris: Gauthier-Villars, 1889), passim; Londe, *La photographie médicale,* 53, 63.

32. Londe, *La photographie dans les arts,* 9.

33. Marey, *Le développement de la méthode graphique par la photographie,* 3.

34. See Londe, *La photographie dans les arts,* 6–7, 26–40; Londe, *La photographie médicale,* 176–212; Londe, *Traité pratique de la photographie,* 456–512.

35. See Londe, *La photographie médicale,* 6; Londe, *Aide-mémoire pratique de la photographie* (Paris: Ballière, 1893), passim.

36. Londe, *La photographie médicale,* 64.

37. Ibid., 77.

38. Londe, *L'évolution de la photographie* (Paris: Association française pour l'avancement des sciences, 1889), 15.

39. See Hegel, *Phenomenology,* 441–442. [The German *"vorstellen"* is translated into French as *"représentation,"* while the English translation renders it as "picture thinking." I have chosen to retain the French term, given its importance in Didi-Huberman's argument.—Trans.]

40. See Auguste Comte, "Considérations générales sur l'étude positive des fonctions intellectuelles et morales ou cérébrales" (1837), in *Philosophie première* (Paris: Hermann, 1975), 846–882.

41. See Bourneville, *Idiots de Bicêtre,* passim; Bourneville, "Mémoire sur la condition de la bouche chez les idiots, suivi d'une étude sur la médecine légale des aliénés, à propos du Traité de Médecine légale de M. Casper," *Journal des connaissances médicales et pharmaceutiques,* nos. 13, 15, 22, 26 (1862) and 3, 19, 20, 22 (1863): 7–13.

42. See Duchenne de Boulogne, *Mécanisme de la physionomie humaine ou analyse électrophysiologique de l'expression des passions* (Paris: Renouard, 1862), passim.

43. See Charles Darwin, *The Expression of the Emotions in Man and Animals* (1871), ed. Francis Darwin (London: W. Pickering, 1989), passim.

44. See Francis Galton, *Inquiries into Human Faculty and Its Development* (London: Macmillan, 1883), passim.

45. Londe, *Traité pratique de la photographie,* 77 (citing Galton).

46. Londe, *La photographie dans les arts,* 24; see also Londe, *La photographie médicale,* 5.

47. See Londe, *Pratique et applications,* 165–171; Londe, *Traité pratique de la photographie,* 636–648; Gilardi, *Storia sociale della fotografia* (Milan: Feltrinelli, 1976); Cagnetta and Sonolet, "Fotografia psichiatrica," 45–48.

48. See Ernest Lacan, *Esquisses photographiques, à propos de l'Exposition universelle et de la guerre d'Orient* (Paris: Grassart, 1856), 39–40.

49. See Cagnetta and Sonolet, "Fotografia psichiatrica," 47.

50. See Alphonse Bertillon, *La photographie judiciaire* (Paris: Gauthier-Villars, 1890), 81–111.

51. Ibid., 81.

52. Ibid., 3.

53. Ibid., 6–25, 60–74.

54. Bertillon, *Identification anthropométrique—Instructions signalétiques* (Paris: Gauthier-Villars, 1890–1893), 129.

55. Ibid., 133.

56. See Bertillon, *La photographie judiciare,* 26–45, 104–106.

57. Londe, *Traité pratique de la photographie,* 655.

58. Baudelaire, *OC* II: 617.

59. Ibid., 617–618.

60. See Barthes, "Photographic Message," 12.

61. See Walter Benjamin, "Little History of Photography" (1931), in *Walter Benjamin: Selected Writings,* vol. 2, trans. Edmund Jephcott and Kingsly Shorter (Cambridge: Harvard University Press, 1999), 74; Damisch, "Agitphot," 24.

62. See Barthes, *Camera Lucida,* 30, 76–77, 85–88.

63. Lacan, *Esquisses photographiques,* 125.

64. See Heidegger, "World Picture," 153.

65. See Paul Valéry, "Centenaire de la Photographie (1939)," in *Vues* (Paris: La Table ronde, 1948), passim.

66. See Jean-Luc Nancy, *Ego sum* (Paris: Flammarion, 1979), 61–94.

67. See Freud, "The Interpretation of Dreams" (1900), V: 536.

68. See Gustav Janouch, *Conversations with Kafka,* trans. Goronwy Rees (New York: New Directions, 1971), 144.

69. See Philippe Lacoue-Labarthe, *Portrait de l'artiste, en général* (Paris: Bourgois, 1979), 61.

70. See Barthes, *Camera Lucida,* 18.

71. Jean-Louis Schefer, *Le Déluge, la Peste, Paolo Uccello* (Paris: Galilée, 1976), 12.

72. See Baudelaire, *OC* II: 456 ("De l'idéal et du modèle").

73. Stéphane Mallarmé, *Oeuvres complètes* (Paris: Gallimard, 1945), 310 ("Mimique").

74. See Barthes, *Roland Barthes by Roland Barthes,* trans. Richard Howard (Berkeley: University of California Press, 1977), 36; Lacoue-Labarthe, *Portrait de l'artiste,* 24; Barthes, *Camera Lucida,* 102.

75. See Benjamin, "Little History of Photography," 510; Barthes, *Camera Lucida,* 25–27, 43–60, 90–91.

4 A Thousand Forms, in None

1. See Lautréamont, *Oeuvres complètes* (Paris: Gallimard, 1970), 136–137.

2. Freud, "Hysteria" (1888), I: 41.

3. Briquet, *Traité clinique et thérapeutique,* v.

4. Cited by Veith, *Hysteria: the History of a Disease* (Chicago: University of Chicago Press, 1965), 10.

5. François Rabelais, "Book Three," in *The Complete Works of François Rabelais,* trans. Donald M. Frame (Berkeley: University of California Press, 1991), 356.

6. Janet, *Etat mental des hystériques. Les stigmates mentaux* (Paris: Rueff, 1893), 300.

7. Hector Landouzy, *Traité complet de l'hystérie* (Paris: Ballière, 1846), 14. See also Frédéric Dubois, *Histoire philosophique de l'hypocondrie et de l'hystérie* (Paris: Baillière, 1837) 13–14.

8. Zola, *Son Excellence E. Rougon,* in *Rougon-Macquart,* ed. A Laroux, H. Mitterand (Paris: Gallimard, 1961), II: 114.

9. Paré, cited by Pierre Morel and Claude Quetel, *Les fous et leurs médecines de la Renaissance au XIXième siècle* (Paris: Hachette, 1979), 42.

10. Ibid., 43.

11. See Briquet, *Traité clinique et thérapeutique,* 605–717.

12. Ibid., 706.

13. Frédéric Dubois, *Histoire philosophique de l'hypocondrie et de l'hystérie* (Paris: Ballière, 1837), 455.

14. Briquet, *Traité clinique et thérapeutique,* 632.

15. See Bossier de Sauvages, cited by Veith, *Hysteria,* 166–168.

16. Gilles de la Tourette, *Leçons de clinique thérapeutique sur les maladies du système nerveux* (Paris: Plon-Nourrit, 1898), 154–155.

17. Charcot, *OC* III: 15.

18. Charcot and Pitres, *Les centres moteurs corticaux,* 27.

19. See Foucault, *Histoire de la folie,* 243–250; Jean Starobinski, *A History of Medicine,* trans. Bernard C. Swift (New York: Hawthorne Books, 1964), passim.

20. Broussais, *De l'irritation et de la folie, ouvrage dans lequel les rapports du physique et du moral sont établis sur les bases de la médecine physiologique,* 2 vols. (Paris: Ballière, 1828), I:3.

21. Ibid., II: 348.

22. See Briquet, *Traité clinique et thérapeutique,* 164–165.

23. Ibid., 51.

24. Gilles de la Tourette, *Traité clinique et thérapeutique de l'hystérie, d'après l'enseignement de la Salpêtrière,* 3 vols. (Paris: Plon, 1891–1895), I: 576, also 37–127; Guinon, *Les agents provocateurs de l'hystérie* (Paris: Progrès Médical and Delahaye & Lecrosnier, 1889), passim; Pitres, *Leçons cliniques sur l'hystérie et l'hypnotisme,* 2 vols. (Paris: Doin, 1891), I: 13–46.

25. Landouzy, *Traité complet,* 230, also 211–213; see also Louyer-Villermay, *Traité des maladies nerveuses en vapeurs et particulièrement de l'hystérie et de l'hypocondrie,* 2 vols. (Paris: Méquignon, 1816), passim.

26. Briquet, *Traité clinique et thérapeutique,* 3.

27. Ibid., 600–601.

28. See Félix Voisin, *Des causes morales et physiques des maladies mentales et de quelques autres affections nerveuses, telles que l'hystérie, la nymphomanie et le satyriasis* (Paris: Ballière, 1826), 348–359.

29. Ibid., xiii.

30. Briquet, *Traité clinique et thérapeutique,* 600.

31. Ibid., vii.

32. Pitres, *Leçons cliniques,* I: 2.

33. Ibid., I: 11.

34. *IPS* III, 3.

35. See Briquet, *Traité clinique et thérapeutique,* 490–604; Richer, "Observation de contracture hystérique guérie subitement après une durée de deux années," in *NIS* (1889), 208 and passim.

36. Charcot, *Leçons du mardi* (1888–1889), 522.

37. Freud, "Preface and Footnotes to the Translation of Charcot's Tuesday Lectures" (1892–1894), I: 139; see also Freud, "Case of Hysteria" (1901–1905), 115, and "An Autobiographical Study" (1925), XX: 13.

38. Freud, "A Note on the Unconscious in Psycho-analysis" (1912), XII: 262. My emphasis.

39. Charcot, *OC* IX: 277, III: 15.

40. See Landouzy, *Traité complet,* 236–238.

41. See Charcot, *Leçons du mardi* (1887–1888), 121–122. See also Freud, "Charcot's *Tuesday Lectures,*" I: 141.

42. Charcot, *Clinique des maladies* I: 177. My emphasis.

43. Charcot, *Leçons du mardi* (1887–1888), 178–179.

44. Charcot, *Leçons du mardi* (1888–1889), 151.

45. Charcot, *Leçons du mardi* (1887–1888), 252.

46. Charcot, *Clinique des maladies* I: 362. See also Charcot, *Leçons du mardi* (1887–1888), 113.

47. Charcot, preface to Alexandre Athanassio, *Les troubles trophiques dans l'hystérie,* (Paris: Progrès Médical/Lecrosnier & Babé, 1890), 3. My emphasis.

48. See Paul Sollier, *Genèse et nature de l'hystérie. Recherches cliniques et expérimentales de psycho-physiologie,* 2 vols. (Paris: Alcan, 1897), passim; Haberberg, "De Charcot à Babinski. Etude du rôle de l'hystérie dans la naissance de la neurologie moderne" (Medical thesis, Faculté de Créteil, 1979), passim.

49. See Freud, *Letters of Sigmund Freud,* ed. Ernst L. Freud, trans. Tania and James Stern (New York: Basic Books, 1960), 171–173, 179, 82–84, 202–203, 210.

50. Ibid., 200.

51. Freud, "Report on My Studies in Paris and Berlin" (1886), I: 5.

52. *IPS* II: 22–27 and pl. III.

53. Freud, *Letters,* 185.

54. Ibid., 193.

55. Ibid.

56. See Ernest Jones, *The Life and Work of Sigmund Freud,* 2 vols. (New York: Basic Books, 1953), I: 66.

57. Ibid., 201.

58. See Freud, "Preface to the Translation of Charcot's Lectures on the Diseases of the Nervous System" (1886), I: 21; Freud, "Charcot's *Tuesday Lectures*" (1892–1894), I: passim.

59. See Freud, "Sketches for the 'Preliminary Communication' of 1893," I: 151.

60. See Freud, "Charcot," III: passim.

61. See Nassif, "Freud et la science," *Cahiers pour l'analyse,* no. 9 (1968): 161; Nassif, *Freud—L'inconscient,* 78; J. A. Miller, "Some Aspects of Charcot's Influence on Freud," *Journal of the American Psychoanalytic Association,* no. 2 (1969): passim; Léon Chertok and Raymond de Saussure, *Naissance du psychanalyste. De Mesmer à Freud* (Paris: Payot, 1973), 114–129; Jean-Baptiste Pontalis, "Entre Freud et Charcot: d'une scène à l'autre," in *Entre le rêve et la douleur* (Paris: Gallimard, 1973), 15–17.

62. Charcot, *OC* III: 253.

63. Maurice Debove, "Eloge de J.-M. Charcot," *Bulletin médical,* no. 103 (1900): 1390.

64. See Charcot, *OC* I: 3 (Bourneville's note).

65. See Gilles de la Tourette, "L'attitude et la marche dans l'hémiplégie hystérique," in *NIS* (1888), pls. I, II.

66. *DESM* (4th series), XV: 331. See also Briquet, *Traité clinique et thérapeutique,* vii.

67. See Foucault, *The History of Sexuality, Volume I: An Introduction,* trans. Robert Hurley (New York: Pantheon Books, 1978), 4, 104, 105, 52–54; Gérard Wajeman, "Psyché de la femme: note sur l'hystérique au XIXième siècle," *Romantisme,* no. 13–14 (1976): passim.

68. Denis Diderot, "Sur les femmes (1772)," in *Oeuvres complètes* (Paris: Gallimard, 1951), 956.

5 Auras

1. Mallarmé, *OC,* 115 ("Photographies").

2. See *IPS* II: 123–186 and pls. XIV–XXX; *IPS* III: 187–199 and pls. XIII–XVIII; Richer, *Etudes cliniques,* passim.

3. Sartre, *L'imaginaire. Psychologie phénoménologique de l'imagination* (Paris: Gallimard, 1940), 104.

4. *IPS* II: 127–128.

5. Ibid., 125.

6. Ibid., 124, 133, and passim.

7. Heidegger, "World Picture," 154.

8. Schefer, *L'homme ordinaire du cinéma* (Paris: Cahiers du cinéma/Gallimard, 1980), 85.

9. Nadar, *Quand j'étais photographe* (Paris: Flammarion, 1900), 7, 8, and passim.

10. Barthes, *Camera Lucida,* 14.

11. Cited by Sontag, *On Photography,* 158. See also Krauss, "Tracing Nadar," *October,* no. 5 (1978): passim.

12. See *IPS* II: 124.

13. Benjamin, "Little History of Photography," 518.

14. Ibid.

15. Benjamin, "Mechanical Reproduction," 225–226.

16. Benjamin, "Little History of Photography," 510.

17. Ibid.

18. Benjamin, "Little History of Photography," 512.

19. See Adrien Guébhard, "L'auréole photographique," *Moniteur de la Photographie,* no. 29 (1890): passim.

20. Guébhard, "Pourquoi les lointains viennent trop en photographie," *Photomidi,* no. 1 (1898): 3.

Notes

21. Benjamin, "Little History of Photography," 508.

22. See Baraduc, *Double prolapsus ovarien chez une hystérique. Compression ovarienne intravaginale produisant le transfert* (Paris: Parent-Davy, 1882), passim.

23. See Baraduc, *La force vitale. Notre corps vital fluidique, sa formule biométrique* (Paris: Carré, 1893), 197.

24. Ibid., 169.

25. See Briquet, *Traité clinique et thérapeutique*, 600–601; Baraduc, *Double prolapsus ovarien*, passim.

26. See Baraduc, *Méthode de radiographie humaine. La force courbe cosmique. Photographie des vibrations de l'éther. Loi des Auras* (Paris: Ollendorff, 1897), 3, 6, 12–14, and passim.

27. Ibid., 33, 49.

28. See Baraduc, *La force vitale*, 220.

29. See Baraduc, *L'âme humaine, ses mouvements, ses lumières et l'iconographie de l'invisible fluidique* (Paris: Carré, 1896), 4–5, 51–52, and passim.

30. Ibid., 109.

31. See Baraduc, *Méthode de radiographie humaine*, passim.

32. Ibid., 49–50.

33. Baraduc, *L'âme humaine*, explanation of plate XXXVIII; see also Baraduc, *Méthode de radiographie humaine*, 14 and fig. 6.

34. Baraduc, *L'âme humaine*, explanation of plate XXXV; see also Baraduc, *Méthode de radiographie humaine*, 21 and fig. 9.

35. Baraduc, *Méthode de radiographie humaine*, 21, 27, and figs. 11, 12.

36. Baraduc, *L'âme humaine*, 121.

37. Ibid., explanation of plate XIV.

38. See Benveniste, *Problèmes de linguistique générale*, I: 134–135.

39. Baraduc, *L'âme humaine*, plates XLIX, LII.

40. Ibid., 258–299.

41. Ibid., 111.

42. See Eugène Azam, *Hypnotisme et double conscience* (Paris: Alcon, 1893), 348–349; Guébhard, "Sur les prétendus enregistrements photographiques de fluide vital," *La vie scientifique,* nos. 106, 108, 110 (1887): passim; Guébhard, "Petit manuel de photographie spirite sans 'fluide,'" in *La photographie pour tous* (1897–1898), passim.

43. *IPS* II: 167 (for the year 1877).

44. Ibid., 125.

45. See Charcot, *Clinique des maladies,* II: 389; Briquet, *Traité clinique et thérapeutique,* 197–203.

46. See Artaud, *Collected Works,* trans. Victor Corti (London: John Calder, 1978), I: 55 (*OC,* I*:58).

47. See *IPS* II: 134, 135.

48. Ibid., 133.

49. Ibid., 129, 143. See also *IPS* III: 190, 191.

50. See *IPS* II: 143.

51. Richer, *Etudes cliniques,* 29; see also 22–23.

52. Ibid., 22.

53. Charcot, *OC* I: 325; see also Charcot, *OC* III: 381.

54. See Freud, "Project for a Scientific Psychology" (1895), I: 351–357.

55. Freud, "Repression" (1915), XIV: 156; see also Breuer and Freud, *Studies on Hysteria* (1893–1895), II: 135.

56. See Freud, "Inhibitions, Symptoms, and Anxiety" (1926), XX: 111.

57. See Breuer and Freud, *Studies on Hysteria,* II: 29.

58. *IPS* I: 6 and pls. I–III.

59. See Lacoue-Labarthe, "Apocryphal Nietzsche," trans. Timothy D. Bent, in *The Subject of Philosophy, Theory, and History of Literature,* v. 83 (Minneapolis: University of Minnesota Press, 1993), 55–56. See also Lacoue-Labarthe, *Portrait de l'artiste,* 24.

60. Heidegger, *Being and Time,* trans. John Macquarrie and Edward Robinson (New York: Harper and Row, 1962), 52.

61. Charcot, *OC* III: 390.

62. Charcot, "De l'expectation en médecine" (Thesis for the *agrégation* exam, Paris: Baillière, 1857), 43. My emphasis.

63. Ibid., 45.

64. Ibid., 43.

65. See Baudelaire, *OC* I: 163 ("Les promesses d'un visage").

66. *IPS* II: 167. My emphasis.

67. Paul Brouardel, *Le secret médical* (Paris: Ballière, 1887), 240.

68. Ibid., 241, 242.

69. Schelling, cited by Henri Maldiney, *Aîtres de la langue et demeures de la pensée* (Lausanne: L'âge d'homme, 1975), 38.

70. Louis Marin, *Détruire la peinture* (Paris: Galilée, 1977), 70.

71. See Louis-Basile Carré de Montgeron, *La vérité des miracles opérés à l'interces-sion de M. de Pâris et autres appelans, démontrée contre M. l'Archevêque de Sens.*, 3 vols. (n.p., 1737), passim.

72. Gotthold Lessing, "Laocoön," in *Laocoön, Nathan the Wise, Minna von Barn-helm,* trans. W. A. Steel (London: J. M. Dent & Sons, 1930), 54.

73. See Hegel, *Phenomenology,* 58–66.

74. *IPS* I: 22 and pl. VIII.

75. Londe, *Pratique et applications,* 78.

76. Londe, *L'évolution de la photographie,* 14.

77. Benjamin, "Little History of Photography," 515.

78. See Barthes, *Camera Lucida,* 78–79.

79. Benjamin, "Little History of Photography," 514.

80. Benjamin, cited by Lacoue-Labarthe, *Portrait de l'artiste,* 55. My emphasis.

81. See Joyce, *Finnegan's Wake* (New York: Viking Press, 1947), 16, 17.

82. Barthes, *Camera Lucida,* 90.

83. See Deleuze, *Difference and Repetition,* trans. Paul Patton (London: Athalone Press, 1994), 115–116, 119, 24–25.

84. See Freud, "Thoughts for the Times on War and Death" (1915), XIV: 300.

85. See *IPS* II: 129.

86. Ibid., 161.

87. See Rimbaud, *Oeuvres complètes* (Paris: Gallimard, 1972), 12 ("Ophélie").

88. See Kant, *Anthropology,* 155 ("On the Faculty of Desire").

89. Charcot, *OC* IV: 322–323.

90. Charcot, *Leçons du mardi* (1888–1889), 69.

91. Artaud, *OC* XIV**: 245.

92. *IPS* II: 143.

6 Attacks and Exposures

1. See Charcot, *OC* I: 367–385, 435–448; Richer, *Etudes cliniques,* 1–168; Gilles de la Tourette, *Traité clinique et thérapeutique,* II: 1–76.

2. See Richer, *Etudes cliniques,* 1–338.

3. See Charcot, *OC* I: 435–448 (the description was written by Richer).

4. See Charcot, *OC* I: 367–385.

5. See Freud, "Paris and Berlin," I: 11; Freud, "Hysteria" (1888), I: 41–42.

6. Cited and reproduced by Charcot, *Leçons du mardi* (1888–1889), 425–430.

7. See Rummo, *Iconografia fotografica del Grande Isterismo—Istero-Epilessia, omaggio al Prof. J.-M. Charcot* (Naples: Clinica Medica Propedeutica di Pisa, 1890), passim.

8. *IPS* II: 200–201.

9. Charcot, *OC* I: 396. See also Bourneville, *Recherches cliniques et thérapeutiques sur l'épilepsie et l'hystérie,* report on observations made at the Salpêtrière between 1872 and 1875 (Paris: Progrès Médical/Delahaye, 1876), 100–101.

10. Richer, *Etudes cliniques,* 90.

11. See Paulus-Julius Moebius, *Allgemeine Diagnostik der Nervenkrankheiten* (Leipzig: Vogel, 1886), 110 (fig. 33); Moebius, *De la débilité mentale physiologique chez la femme* (1901), trans. Roche (Paris: Solin, 1980), passim.

12. *IPS* II: 184.

13. Ibid., 132–133, 137, and passim.

14. Ibid., 130–131, 169–173, and passim. See also Richer, *Etudes cliniques,* 75–76, 186.

15. Hegel, *Phenomenology,* 437–438.

16. Charcot, *OC* IX: 456. My emphasis. See also Charcot, *OC* I: 347–366.

17. Charcot, *OC* IX: 447. See also Richer, "Diathèse de contracture," in *NIS* (1891), passim.

18. Briquet, *Traité clinique et thérapeutique,* 477–478.

19. See Pitres, *Leçons cliniques* I: 377–481; Gilles de la Tourette, *Traité clinique et thérapeutique de l'hystérie,* I: 433–485, III: 1–157. See also Richer, *Paralysies et contractures hystériques* (Paris: Doin, 1892), 2–3 and passim.

20. See *IPS* II: 183.

21. Ibid., 134, 135, 137, 139, 144.

22. Richer, *Etudes cliniques,* 44.

23. See M. Noica, "Le mécanisme de la contracture chez les spasmodiques, hémiplégiques ou paraplégiques," in *Nouvelle Iconographie de la Salpêtrière* (1908), 36.

24. See Charcot, *OC* III: 99–100; Charcot, *Leçons du mardi* (1888–1889), 350.

25. See Richer, *Etudes cliniques,* pl. II, 39–68 (esp. 61–62).

26. Charcot, *OC* III: 41–42. See also Bourneville and Paul Voulet, *De la contracture hystérique permanente* (Paris: Delahaye, 1872), passim; Richer, "Observation de contracture hystérique," passim.

27. Kant, *Anthropology,* 165. My emphasis. [Translation modified.—Trans.]

28. Ibid.

29. Freud, "Some Points for a Comparative Study of Organic and Hysterical Motor Paralyses" (1888–1893), I: 168–169.

30. Ibid., 170.

31. Ibid., 171, 172.

32. *IPS* II: 142.

33. Charcot, *Leçons du mardi* (1887–1888), 294.

34. Charcot, *Leçons du mardi* (1888–1889), 163.

35. Charcot, *OC* I: 429 (written by Bourneville).

36. Ibid. See also Gilles de la Tourette, *Traité clinique et thérapeutique* I: 321–432.

37. See C. Schaffer, "De la morphologie des contractures réflexes intrahypnotiques et de l'action de la suggestion sur ces contractures," in *NIS* (1893), 305–321, and *NIS* (1894) 22–34 and passim.

38. *IPS* II: 129, 136.

39. Ibid.

40. See Lafon and Teulières, "Mydriase hystérique," in *Nouvelle Iconographie de la Salpêtriere* (1907), passim.

41. See Charles Féré, *De l'asymétrie chromatique de l'iris considérée comme stigmate névropathique (stigmate iridien)* (Paris: Delahaye & Lecrosnier, 1886), passim.

42. Londe, *Traité pratique de la photographie,* 290.

43. Gilles de la Tourette, "De la superposition des troubles de la sensibilité et des spasmes de la face et du cou chez les hystériques," in *Nouvelle Iconographie de la Salpêtrière* (1889), 111.

44. Ibid., 129.

45. Ibid., 186–187.

46. Charcot, *OC* III: 6.

47. See Charcot, *OC* I: 430.

48. See Freud, "The Psycho-Analytic View of Psychogenic Disturbance of Vision" (1910), XI: 212–213.

49. Ibid.

50. Ibid., 216.

51. Ibid., 212.

52. Charcot, *OC* III: 74–75.

53. Charcot, *Leçons du mardi* (1887–1888), 69.

54. See Charcot, *OC* III: 178–192.

55. Ibid., 182, 187, and passim.

56. Ibid., 188–192.

57. See Freud, "Case of Hysteria," VII: 64–111.

58. Ibid., 15.

59. Léon Hervey de Saint-Denys, *Les rêves et les moyens de les diriger. Observations pratiques* (Paris: Amyot, 1867), passim.

60. Ibid., 18–33.

61. See *IPS* II: 131.

62. *IPS* III: 189–190.

63. *IPS* II: 135.

64. *IPS* III: 199. My emphasis.

65. See Baudelaire, *OC* I: 159 ("Les metamorphoses du vampire").

66. See René Descartes, *Oeuvres et lettres* (Paris: Gallimard, 1953), 706.

67. See Pitres, *Leçons cliniques* II: 34–47.

68. See Freud, "The Neuro-Psychoses of Defense" (1894), III: 59.

69. *IPS* II: 162.

70. Rimbaud, *OC,* 100 ("Une saison en enfer"). My emphasis.

71. *IPS* II: 147.

72. Ibid., 129. See also Charcot, *OC* IX: 292; Richer, *Etudes cliniques,* 9.

73. See also Richer, *Etudes cliniques*, 11.

74. *IPS* II: 132.

75. Ibid., 164. See also Richer, *Etudes cliniques*, 10.

76. See *IPS* II: 147–151 and passim.

77. See Charcot, *OC* I: 432–433; Richer, *Etudes cliniques*, 10.

78. See Richer, *Etudes cliniques*, 89–116 and pl. IV.

79. *IPS* II: 220.

80. See Richer, *Etudes cliniques*, 211–222.

81. See Mallarmé, *Pour un Tombeau d'Anatole* (Paris: Seuil, 1961), 110.

82. *IPS* II: 162.

83. Ibid., 162–163, and also 135, 140, 145–146, 164. See also *IPS* III: 189–190; Richer, *Etudes cliniques*, 121–123, 134–135, 211–212, 226–229.

84. See Artaud, *OC* I★: 235 ("Extase").

85. Ibid.

86. See Lacan, *The Seminar of Jacques Lacan: On Feminine Sexuality (Book XX-Encore)*, trans. Bruce Fink (New York: W. W. Norton, 1998), 4–5, 13, 73.

87. See Descartes, *Oeuvres et lettres*, 751 (De la pâmoison).

88. Louis Aragon and André Breton, "Le cinquantenaire de l'hystérie," *La Révolution surréaliste*, no. 11 (1928): 20.

89. *IPS* I: 151.

90. *IPS* II: 203.

91. Ibid., 207.

92. Lacan, "L'étourdit," *Scilicet*, no. 4 (1973): 23.

93. *IPS* I: 72.

94. Ibid., 70–71.

95. Rimbaud, *OC,* 102–103 ("Une saison en enfer"—"Délires I"—"Vierge folle").

96. See Kant, *Anthropology,* §63.

97. Diderot, "Sur les femmes" (1772), 950.

98. See Lacan, *Encore,* 6–7.

99. Ibid., 45, 72–73.

100. See *IPS* II: 123, 153, and passim.

101. See Moustapha Safouan, *L'échec du principe de plaisir* (Paris: Seuil, 1979), 60–61, 64.

102. See Breuer and Freud, *Studies on Hysteria* II: 165; Freud, "Project for a Scientific Psychology," I: 317–319 ("The Experience of Satisfaction").

103. Artaud, *OC* XIV★★: 56.

104. Dostoevsky, *Demons,* trans. Pevear and Volokhonsky (New York: Knopf, 1994), 275.

105. Londe, *La photographie médicale,* 102.

106. See Freud, "Scientific psychology," I: 347–348.

107. See Gilles de la Tourette, *Traité clinique et thérapeutique* I: 486–555.

108. See Breuer and Freud, *Studies on Hysteria* II: 192–203, 209–210; Freud, "Scientific Psychology," I: 295–297.

109. See Freud, "Organic and Hysterical Paralyses," I: 171; Freud, "Scientific Psychology," I: 321–322.

110. Breuer and Freud, *Studies on Hysteria* II: 8.

111. Ibid., 11. [Translation slightly modified.—Trans.]

112. See Freud, "Project for a Scientific Psychology," I: 297–302; Breuer and Freud, *Studies on Hysteria* II: 161–162, 286.

113. Breuer and Freud, *Studies on Hysteria* II: 7; see also 215–222.

114. See Freud, "Scientific Psychology," I: 320–321.

115. Breuer and Freud, *Studies on Hysteria* II: 15.

116. See Charcot, *Leçons du mardi* (1888–1889), 131–139; Eduard Thyssen, *Contribution à l'étude de l'hystérie traumatique* (Paris: Davy, 1888), passim.

117. *IPS* III: 33.

118. *IPS* II: 189.

119. See Charcot, *Leçons du mardi* (1888–1889), 439 and fig. 95.

120. Charcot, *Leçons du mardi* (1887–1888), 251.

121. Ibid., 111.

122. See Charcot, *Leçons du mardi* (1888–1889), 527–535 (written by Dutil).

123. See Charcot, *OC* IV: 323.

124. See Breuer and Freud, *Studies on Hysteria* II: 4.

125. See Freud, "Charcot's Tuesday Lectures" I: 139–140; Freud, "Five Lectures on Psychoanalysis" (1909–1910), XI: 21.

126. Breuer and Freud, *Studies on Hysteria* II: 178.

127. Ibid., 150.

128. Ibid., 123–124. See also Freud, "The Aetiology of Hysteria" (1896) III: 211–212.

129. Breuer and Freud, *Studies on Hysteria* II: 174.

130. Ibid., 4.

131. See Schefer, *L'invention du corps chrétien. Saint-Augustin, le dictionnaire, la mémoire* (Paris: Galilée, 1975), 128–129.

132. See Descartes, *Oeuvres et lettres*, 715–716.

133. See Henri Bergson, *Oeuvres* (Paris: PUF, 1959), 276–277.

134. Charcot, *Clinique des maladies* II: 266.

135. See Charcot, *OC* III: 178, 518–519.

136. Freud, "Scientific Psychology," 352.

137. See Breuer and Freud, *Studies on Hysteria* II: 11; Freud, "Case of Hysteria," VII: 17–18; Freud, "Inhibitions," XX: 163.

138. Freud, "Inhibitions," XX: 98–99.

139. Schefer, *L'invention du corps chrétien*, 24.

140. See Artaud, *OC* XIV**: 48. My emphasis.

141. See Monique David-Ménard, "Pour une épistémologie de la métaphore biologique en psychanalyse: la conversion hystérique" (Thesis, Université de Paris VIII, 1978), 283–284 and passim.

142. See Freud, "The Neuro-Psychoses of Defence" (1894), III: 49–50; Freud, "Repression" (1915), XIV: 155–156.

143. Freud, "Case of Hysteria," VII: 84–85.

144. *IPS* II: 126–127.

145. See Wajeman, "Théorie de la simulation," *Ornicar?—Analytica* 22 (1980): passim.

146. See Freud, "Screen Memories" (1899), III: passim; Freud, "Psychopathology of Everyday Life" (1901), VI: 43–52.

147. Freud, "Screen Memories" (1899), III: 308.

148. See Freud, "The Psychopathology of Everyday Life" (1901), p.56.

149. See Breuer and Freud, *Studies on Hysteria* II: 296–298.

150. Ibid., 179.

151. Ibid., 175–176.

152. See Freud, "Case of Hysteria" (1905), VII: 30–31; Freud, "Hysterical Phantasies and their Relation to Bisexuality" (1908), IX: 163.

153. Freud, "Hysterical Phantasies," IX: 161. My emphasis. [Translation slightly modified.—Trans.]

154. Ibid., 162.

155. Freud, "Sketches for the Preliminary Communication of 1893" (1892), I: 152. See also Freud, "Hysterical Phantasies" (1908), IX: 160–161.

156. Freud, "Some General Remarks on Hysterical Attacks" (1909), IX: 229–230.

157. Ibid., 230–231.

158. Freud, "Scientific Psychology," I: 356.

159. *IPS* I: 78. My emphasis.

160. *IPS* II: 139, 161.

161. [You can't make an omelet without breaking eggs.—Trans.] Freud, "Case of Hysteria," VII: 49.

162. See Guiraud, *Dictionnaire historique, stylistique, rhétorique, etymologique de la littérature érotique* (Paris: Payot, 1978), 15–23 (the 1300 words for coitus).

163. See Freud, "Heredity and the Aetiology of the Neuroses" (1896), III: 50–52; Freud, "Further Remarks on the Neuro-Psychoses of Defence" (1896), III: 163–168; Freud, "Three Essays on the Theory of Sexuality" (1905), VII: 159, 239–241.

164. See Freud, *The Interpretation of Dreams* V: 346.

165. See Freud, "Hysterical Attacks," IX: 233–234.

166. Freud, "On the History of the Psycho-analytic Movement" (1914), XIV: 14.

167. *IPS* II: 151, 161. See also 150, 152–153.

168. *IPS* I: 70–71.

169. See Charcot, *OC* I: 388–390.

170. See *IPS* II: 133, 139, 147, and passim.

171. See Freud, "Hysterical Attacks," IX: 232–234.

172. Proust, *Sodome et Gomorreh,* in *A la recherche du temps perdu,* ed. P. Clarac, A. Ferre (Paris: Gallimard, 1961), II: 620.

173. See Freud, "Case of Hysteria," VII: 47.

174. See Richer, *Etudes cliniques,* 69–78, esp. 76.

175. Freud, "Hysterical Phantasies," IX: 166.

176. Ibid. My emphasis.

177. See Maldiney, *Aîtres de la langue,* 18–20; David-Ménard, "Pour une épistémologie de la métaphore biologique en psychanalyse," 33–36.

178. See Blanchot, *The Space of Literature,* trans. Ann Smock (Lincoln: University of Nebraska Press, 1982), 171–176 ("Orpheus's Gaze").

179. Mallarmé, *OC,* 310 ("Mimique").

180. Diderot, "Sur les femmes," 952. My emphasis.

181. Gilles de la Tourette, *Traité clinique et thérapeutique* I: 111.

182. See *IPS* III: 22 and passim.

183. See Freud, "Group Psychology and the Analysis of the Ego" (1921), XVIII:106–107.

184. Freud, "Hysterical Attacks," IX: 230.

185. *IPS* II: 135 and passim.

186. Baudelaire, *OC* II: 714 ("La femme"), II: 715 ("Eloge du maquillage").

187. Dostoevsky, *Demons,* 141–142.

188. *IPS* II: 168.

189. Ibid., 167–168.

190. See Heidegger, *Introduction to Metaphysics,* trans. Ralph Manheim (Oxford: Oxford University Press, 1959), 98.

191. *IPS* II: 214.

192. Ibid., 215.

193. Ibid., 206, pl. XXXIX.

194. *IPS* III: 7.

195. See Lacan, *The Seminar of Jacques Lacan. Book XI: The Four Fundamental Concepts of Psycho-Analysis,* trans. Alan Sheridan (New York: W. W. Norton, 1981), 214–215; Lacan, "Position de l'inconscient," in *Écrits,* 843–844.

196. See Lacan, *Four Fundamental Concepts,* 37–39.

197. See Freud, "Creative Writers and Day-Dreaming" (1908), IX: 153.

198. Lacan, *Séminaire sur l'identification* (1961–1962), 2 vols. (New York: International General, n.d.), 315–316. See also Lacan, "Intervention sur le transfert," in *Écrits,* 221–222.

199. Lacan, *Séminaire sur l'identification*, 362.

200. Ibid., 281. See also Lacan, *Ecrits,* 99, 165–166, 170–177, 524, and passim.

201. Baudelaire, *OC* II: 713 ("La femme").

202. Freud, "Observations on Transference-Love" (1915), XII: 160–170. My emphasis. [Translation slightly modified.—Trans.]

203. See Guillain, *J.-M. Charcot,* 134–135.

204. Barthes, *Roland Barthes,* 65.

205. Breuer and Freud, *Studies on Hysteria* II: 265. My emphasis.

206. See *IPS* I: 70–71.

207. Freud, "A Case of Hysteria," VII: 116.

208. Breuer and Freud, *Studies on Hysteria* II: 302.

209. See Freud, "Hysteria" VII: 117.

210. Freud, "Transference-Love" XII: 169.

211. Ibid., 165.

212. Ibid., 166–167.

213. Ibid., 166, 169.

214. [In English in the text.—Trans.]

215. See Daniel Sibony, *Le nom et le corps* (Paris: Seuil, 1974), 194.

216. See Freud, "Case of Hysteria," VII: 43.

217. See Baudelaire, *OC* I: 546 ("Choix de maximes consolantes sur l'amour").

218. Ibid., 41 ("Semper Eadem"), 99 ("L'amour du mensonge").

219. See Barthes, *Roland Barthes,* 193–194.

220. See Octave Mannoni, *Un commencement qui n'en finit pas. Transfert, interprétation, théorie* (Paris: Seuil, 1980), 13–55; Sibony, *Le nom et le corps,* 179.

221. See Freud, "A Case of Hysteria," VII: 43–44.

7 Repetitions, Rehearsals, Stagings

1. See Foucault, *Clinic*, 121–123.

2. See Briquet, *Traité clinique*, 693–696.

3. Ibid., V: 694.

4. See *IPS* I: 118–121, 153.

5. See Gilles de la Tourette, *Leçons de clinique*, 181; Henri Cesbron, *Histoire critique de l'hystérie* (Paris: Houzeau, 1909), 171–173; Jacqueline Carroy-Thirard, "Figures de femmes hystériques dans la psychiatrie française du XIXième siècle," *Psychanalyse à l'université* IV, no. 14 (1979): 315.

6. See Jean Clavreul, *L'ordre médical* (Paris: Seuil, 1978), 102.

7. See *IPS* I: pl. XXXIX.

8. See Régnard, *Les maladies épidémiques de l'esprit—Sorcellerie, magnétisme, morphinisme, délire des grandeurs* (Paris: Plon-Nourrit, 1887), passim.

9. Briquet, *Traité clinique*, 307.

10. Ibid., 267–306. See also Janet, *L'automatisme psychologique. Essai de psychologie expérimentale sur les formes inférieures de l'activité humaine.* (Paris: Alcan, 1889), 280–288; Pitres, *Leçons cliniques* I: 55–180.

11. See Briquet, *Traité clinique*, 204–266; Pitres, *Leçons cliniques* I: 181–206.

12. Féré, *La pathologie des émotions. Etudes physiologiques et cliniques* (Paris: Alcan, 1892), 499 (based on Rosenthal).

13. *IPS* III: 26.

14. Charcot, *OC* I: 315.

15. Ibid., 300–319. See also Charcot, *Leçons du mardi* (1887–1888), 138 and passim.

16. See *IPS* II: 123–124 and passim.

17. See Souques, "Contribution à l'étude des syndromes hystériques 'simulateurs' des maladies organiques de la moelle épiniere," in *NIS* (1891), 427–429, and pl. XLIII.

18. See Binet and Féré, *Recherches expérimentales sur la physiologie des mouvements chez les hystériques* (Paris: Masson, 1887), passim.

19. See Richer, *Etudes cliniques,* 63 and passim.

20. See Charcot, *Leçons du mardi* (1888–1889), 507; Bourneville, *Etudes cliniques et thermométriques sur les maladies du système nerveux* (Paris: Delahaye, 1872–1873), 241–328.

21. Richer, *Etudes cliniques,* 96–97, 139.

22. Charcot, "De l'expectation en médecine," 5.

23. Ibid., 4, 5.

24. Ibid., 11.

25. See Derrida, *The Archeology of the Frivolous,* trans. John. P. Leavey (Pittsburgh: Duquesne University Press, 1980), 9–40, 101 (esp. 33).

26. Charcot, *Leçons du mardi* (1887–1888), 174.

27. Ibid., 179.

28. See Joseph Delboeuf, "De l'influence de l'imitation et de l'éducation dans le somnambulisme provoqué," *Revue philosophique* XXII (1886): passim; Henri Ellenberger, *The Discovery of the Unconscious: The History and Evolution of Dynamic Psychiatry* (New York: Basic Books, 1970), 95–97, 761–764.

29. Gilles de la Tourette, "Jean-Martin Charcot," 246.

30. Richer, *Etudes cliniques,* 256.

31. See Artaud, *OC* I*: 85.

32. Charcot, *Leçons du mardi* (1888–1889), 65.

33. Ibid., 67.

34. Ibid., 64.

35. See *IPS* III: 118–139.

36. Charcot, *Leçons du mardi* (1888–1889), 63–64.

37. Ibid., 271–277. See also Gilles de la Tourette, *Traité clinique et thérapeutique* II: 202–263; Olga Conta, *Contribution à l'étude du sommeil hystérique* (Paris: Ollier-Henry, 1897), passim.

38. See *IPS* III: 88–100; Régnard, *Les maladies épidémiques de l'esprit,* 203; Charcot, *Clinique des maladies* II: 56–69, 168–176; Georges Guinon, "Documents pour

servir à l'histoire des somnambulismes," in *Progrès médical* (1891–1892), reprinted in Charcot, *Clinique des maladies,* 70–167, 177–265.

39. Régnard, *Les maladies épidémiques de l'esprit,* 203.

40. See Chertok and de Saussure, *Naissance du psychanalyste,* 71; Veith, *Hysteria,* 235.

41. Charcot, preface to Eugène Azam, *Hypnotisme et double conscience* (Paris: Alcon, 1893), 10.

42. Freud, "Paris and Berlin," I: 13.

43. See Azam, *Hypnotisme, double conscience et altérations de la personnalité,* 9–60. See also Azam, *Hypnotisme et double conscience,* passim.

44. See Richer, *Etudes cliniques,* 505–798.

45. See Gilles de la Tourette, *L'hypnotisme et les états analogues au point de vue médico-légal* (Paris: Plon-Nourrit, 1887), 215–244.

46. See Régnard, *Les maladies épidémiques de l'esprit,* 205; Richer, *Etudes cliniques,* 505.

47. See Pitres, *Leçons cliniques* II: 68–533 and passim.

48. See *IPS* III:147–228, pl. XIII–XL.

49. Charcot, *OC* IX: 310.

50. Charcot, *La médecine empirique,* 20.

51. Charcot, *OC* III: 337.

52. La Mettrie, cited by D. Leduc-Fayette, "La Mettrie et 'le labyrinthe de l'homme,'" *Revue philosophique,* no. 3 (1980): 349.

53. Charcot, *OC* IX: 468–469. See also 297–308 and passim.

54. Charcot, *OC* III:340. See also Charcot, *Leçons du mardi* (1887–1888), 376–377.

55. See Freud, "On Psychotherapy" (1905), VII: 260–261.

56. Charcot, *Leçons du mardi* (1887–1888), 373.

57. Ibid., 136.

58. Régnard, *Les maladies épidémiques de l'esprit,* 243. See also *IPS* III: 463.

59. See *IPS* III: 458–462.

60. Ibid., 469.

61. Breuer and Freud, *Studies on Hysteria* II: 270–271.

62. *IPS* III: 192. See also 19–20 and passim.

63. Ibid., 191. See also Charcot, *OC* IX: 314–335, 463.

64. See Charcot, *OC* IX: 278–288; C. Laufenauer, "Des contractures spontanées et provoquées de la langue chez les hystéro-épileptiques," in *NIS* (1889), passim; Guinon and S. Woltke, "De l'influence des excitations sensitives et sensorielles dans les phases cataleptique et somnambulique du grand hypnotisme," in *NIS* (1891); Guinon and Woltke, "De l'influence des excitations des organes des sens sur les hallucinations de la phase passionnelle de l'attaque hystérique," *Archives de Neurologie*, no. 63 (1891), in Charcot, *Clinique des maladies.*

65. See Schaffer, "De la morphologie des contractures réflexes intrahypnotiques," 305.

66. *IPS* III: 192.

67. Ibid., 193.

68. Charcot, *OC* IX: 257. See also Richer, *Etudes cliniques,* 253–323.

69. See Charcot, *OC* IX: 309–421.

70. See Bernard, *Leçons sur la physiologie et la pathologie du système nerveux,* 2 vols. (Paris: Baillière, 1858) II: 32–35, 40–41.

71. Ibid., I: 144, figs. 14–16.

72. Duchenne de Boulogne, *Mécanisme de la physionomie humaine* (Paris: Renouard, 1862), 15.

73. Ibid., 38, 15.

74. See Duchenne de Boulogne, *De l'électrisation localisée et de son application à la pathologie et à la thérapeutique,* 3rd ed. (Paris: Ballière, 1862), 316, 574, 711–728, and passim.

75. See Charcot, *OC* IX: 483–501.

76. Montméja, "Machine d'induction," *Revue Médico-photographique des Hôpitaux de Paris* (1874): 250, pl. XXXVI. See also Charles Legros and Ernest Onimus,

Traité d'électricité médicale. Recherches physiologiques et cliniques (1888), 2nd ed. (Paris: Alcan, 1872), passim; Onimus, "De l'action thérapeutique des courants continus," *Revue photographique des Hôpitaux de Paris* (1872): passim; Arthur Arthuis, *Traitement des maladies nerveuses, affections rhumatismales, maladies chroniques, par l'électricité statique,* 3rd ed. (Paris: Delahaye, 1880), passim; Arthuis, *Electricité statique. Manuel pratique de ses applications médicales,* 3rd ed. (Paris: Doin, 1887), passim.

77. See Duchenne de Boulogne, *Mécanisme de la physionomie humaine,* 15 and passim, and Charcot, *OC* IX: 410 and passim.

78. Ibid., v–vi (preface).

79. Ibid., 45–47.

80. Ibid., 133.

81. Charcot, *OC* IX: 362.

82. Artaud, *Watchfiends and Rack Screams,* trans. Clayton Eshleman (Boston: Exact Change, 1995), 258 (Artaud, *OC* XVI**: 62).

83. Richer, *Etudes cliniques,* 671.

84. Ibid. My emphasis.

85. See Charcot, *OC* IX: 355–377, pl. V–IX; *IPS* III, pl. XIII–XL.

86. See Alfred Binet and Féré, *Le magnétisme animal* (Paris: Alcan, 1887), 323–332.

87. See Charcot, *OC* IX: 434–447.

88. Charcot, *OC* IX: 443.

89. Ibid.

90. Londe, *La photographie médicale,* 91. My emphasis.

91. Ibid.

92. Ibid.

93. See Schaffer, "De la morphologie des contractures réflexes intrahypnotiques," passim.

94. *IPS* III: 194.

95. Jules Luys, *Leçons cliniques sur les principaux phénomènes de l'hypnotisme dans leurs rapports avec la pathologie mentale* (Paris: Carré, 1890), 285, pl. III.

96. See *IPS* III: 178, fig. 11, 194.

97. See Charcot, *OC* IX: 304–305.

98. Régnard, *Les maladies épidémiques de l'esprit*, 262.

99. See Londe, *La photographie médicale*, 90–91; Richer, *Etudes cliniques*, 525–529.

100. Londe, *La photographie médicale*, 90.

101. Charcot, *OC* IX: 294.

102. Laufenauer, "Des contractures spontanées et provoquées," 205, pls. XXXIII, XXXIV.

103. See Charcot, *OC* IX: 213–252, 265–271.

104. See *IPS* III: 132–133, 137, 141, 143; Charcot, *OC* IX: 234, 396, and passim.

105. See Charcot, *OC* IX: 220–221.

106. See Bourneville, "Recherches cliniques et thérapeutiques sur l'épilepsie, l'hystérie et l'idiotie" (1880–1906), III: 89–91, and figs. 1–13.

107. Charcot, *OC* IX: 245.

108. Ibid., 230–231. My emphasis.

109. See Charcot, *Leçons du mardi* (1887–1888), 117.

110. See Charcot, *OC* IX: 228–229.

111. See Richer, *Etudes cliniques*, 328–329.

112. See Bernard, *Leçons sur la physiologie et la pathologie du système nerveux* I: 75–97.

113. Charcot, *OC* I: 402. See also *IPS* II: 130.

114. *IPS* II: 158.

115. Ibid., 161.

116. *IPS* III: 188.

117. Ibid., 189.

118. Ibid.

119. *IPS* II: 160.

120. Ibid.

121. See IPS I: 10; *IPS* II: 46, 55, 78, 81; *IPS* III: 35, 67, 83.

122. See M. Eloire, "Vomissements chez une hystérique. Traitement par la fumée de tabac," *Revue médico-photographique des Hôpitaux de Paris* (1874): 102–105.

123. See Freud, "Case of Hysteria," VII: 91–93, 109–122.

124. See Luys, *Les émotions chez les sujets en état d'hypnotisme. Etudes de psychologie expérimentale faites à l'aide de substances médicamenteuses ou toxiques impressionnant à distance les réseaux nerveux périphériques* (Paris: Ballière, 1887), passim.

125. See Guinon and Woltke, "Excitations sensitives," 46–51.

126. Charcot, *Leçons du mardi* (1887–1888), 374.

127. Charcot, *OC* IX: 475.

128. Charcot, *Leçons du mardi* (1887–1888), 173. See also Carroy-Thirard, "Hypnose et expérimentation," *Bulletin de psychologie* XXXIV, no. 348 (1981): 41.

129. Guinon and Woltke, "De l'influence des excitations des organes des sens," 37, reprinted in Charcot, *Clinique des maladies,* 36–55. See also Gilles de la Tourette, *Traité clinique et thérapeutique* II: 264–376.

130. *IPS* III: 162–163.

131. Ibid., 180.

132. Ibid., 194, pl. XVIII.

133. Ibid., 192.

134. Régnard, *Les maladies épidémiques de l'esprit,* 247.

135. Søren Kierkegaard, *The Seducer's Diary,* trans. Howard V. Hong and Edna H. Hong (Princeton: Princeton University Press, 1997), 122.

136. Luys, *Leçons cliniques,* 287, pl. XI.

137. *IPS* III: 194.

138. Ibid., 195.

139. Charcot, *OC* IX: 293.

140. Duchenne de Boulogne, *Mécanisme de la physionomie humaine,* 194. See also 169–183, figs. 81–83.

141. William Shakespeare, "The Tragedy of Macbeth," in *The Riverside Shakespeare,* ed. G. Blakemore Evans (Boston: Houghton Mifflin, 1974), 1316 (act 1, scene 5).

142. Duchenne de Boulogne, *Mécanisme de la physionomie humaine,* 174.

143. See Pitres, *Leçons cliniques* II: 144–194, pls. II–VIII.

144. Richer, *Etudes cliniques,* 728.

145. Ibid.

146. Ibid., 729–730.

147. Artaud, *OC* IV: 125. See also Artaud, *Collected Works,* vol. IV, 100.

148. See Diderot, "Paradoxe sur le comédien" (1773), in *Oeuvres complètes* (Paris: Gallimard, 1951), 1022.

149. Ibid., 1008–1009.

150. See Charcot, *Leçons du mardi* (1887–1888), 137, 375.

151. Richer, *Etudes cliniques,* 663.

152. Charcot, *Leçons du mardi* (1887–1888), 136.

153. Ibid., 113, 114.

154. Shakespeare, *The Tragedy of Macbeth,* 1335 (act 5, scene 1).

155. Ibid.

156. See Charcot, *Clinique des maladies* II: 126–129.

157. Freud, "Remembering, Repeating, and Working Through" (1914), XII: 151.

158. See Breuer and Freud, *Studies on Hysteria* II: 11–17, 247–248, and passim.

159. Freud, "Group Psychology," XVIII: 114–115.

160. Ibid. See also 115–116; Freud, "An Autobiographical Study" (1925), XX: 27–28.

161. See Freud, "Group Psychology," XVIII: 142–143.

162. Ibid., 89. See also Freud, "An Autobiographical Study," XX: 16–18.

163. See Veith, *Hysteria,* 749–770; Chertok and Saussure, *Naissance du psychanalyste,* 61–84; Gérard Miller, "Crime et suggestion. Suivi de: Note sur Freud et l'hypnose," *Ornicar?* no. 4 (1975): passim.

164. See Azam, *Hypnotisme, double conscience et altérations de la personnalité,* 231–280.

165. See Gilles de la Tourette, *L'hypnotisme,* 279–528.

166. See Carroy-Thirard, "Hypnose et expériementation," 45, 49.

167. Babinski, *Oeuvre scientifique,* 513. See also Ballet, "La suggestion hypnotique au point de vue médico-légal," *Gazette hebdomadaire de Médecine et de Chirurgie* (1891 Oct.): 6–13, and passim.

168. Bergson, "Simulation inconsciente dans l'état d'hypnotisme," *Revue philosophique* XXII (1886): 531.

169. See François-Victor Foveau de Courmelles, *L'hypnotisme* (Paris: Hachette, 1890), 33 and passim; Hahn, "Charcot et son influence sur l'opinion publique," *Revue des questions scientifiques* 2nd series, VI (1894): passim.

170. See Delboeuf, "De l'influence de l'imitation et de l'éducation," 147.

171. See Guillain, *J.-M. Charcot,* 62.

172. See Bergson, "Simulation inconsciente," passim; Delboeuf, "De l'influence de l'imitation et de l'éducation," passim; Freud, "Charcot's *Tuesday Lectures,*" I: 140–141 and passim.

173. See Charcot, preface to Azam, *Hypnotisme et double conscience,* 10.

174. Gilles de la Tourette, "Jean-Martin Charcot," 246; Guillain, *J.-M. Charcot,* 165–176; Ellenberger, *The Discovery of the Unconscious,* 97–98.

175. Guillain, *J.-M. Charcot,* 165.

176. Ibid., 175.

177. Ibid., 174. See also Ellenberger, *The Discovery of the Unconscious,* 98.

178. Charcot, *Leçons du mardi* (1888–1889), 247–256.

179. See Gilles de la Tourette, *L'hypnotisme,* 298–320.

180. See Ellenberger, *The Discovery of the Unconscious,* 750–751 and passim.

181. *IPS* III: 150.

182. Charcot, *OC* IX: 479–480.

183. Binet and Féré, *Le magnétisme animal,* 283.

184. Charcot, *Leçons du mardi* (1887–1888), 113.

185. Mallarmé, *OC,* 269 ("Le phénomène future").

186. See Foveau de Courmelles, *L'hypnotisme,* 33 and passim.

187. See Ellenberger, *The Discovery of the Unconscious,* 96.

188. Babinski, preface to Charcot, *Leçons du mardi* (1887–1888), ii.

189. Ibid., iii.

190. Daudet, *Les oeuvres dans les hommes,* 201.

191. Guillain, *J.-M. Charcot,* 54 (see appendix 2). See also Debove, "Eloge de J.-M. Charcot," 1391.

192. See Daudet, *Les oeuvres dans les hommes,* 226.

193. See Carroy-Thirard, "Possession, extase, hystérie au XIXième siècle," *Psychanalyse à l'université* V, no. 14 (1980): 507.

194. See Lyubimov, cited by Ellenberger, *The Discovery of the Unconscious,* 95.

195. Charcot, *Clinique des maladies* II: 280.

196. Kierkegaard, *The Seducer's Diary,* 89.

197. Charcot, *OC* III: 245–246.

198. Charcot, *Leçons du mardi* (1887–1888), 385.

199. Freud, cited by Jones, *The Life and Work of Sigmund Freud* I: 208–209.

200. Ibid., 185.

201. Ibid., 209–210.

202. Leygues (1898), 683.

203. Claretie, "Charcot, le consolateur," 179.

204. Ibid., 180.

205. Rimbaud, *OC*, 101–102 ("Une saison en enfer").

206. Jacques Lacan, *Television* (1973), trans. Denis Hollier, Rosalind Krauss, and Annette Michelsen (New York: W. W. Norton, 1990), 7. My emphasis.

207. See Charcot, *La foi qui guérit* (1892) (Paris: Progrès médical/Alcan, 1897), 3.

208. See Charcot, *Leçons du mardi* (1887–1888), 139.

209. Charcot, *La foi qui guérit*, 4–5, 16.

210. Gilles de la Tourette, *Leçons de clinique*, 181.

211. Charcot, *La foi qui guérit*, 10.

212. Cited by Jones, *The Life and Work of Sigmund Freud* I: 186.

213. See Charcot, *Leçons du mardi* (1887–1888) and Charcot, *Leçons du mardi* (1888–1889), passim.

214. Charcot, *OC* III: 433.

215. Sibony, *Le groupe inconscient—Le lien et la peur* (Paris: Bourgois, 1980), 167. See also Pierre Legendre, *La passion d'être un autre. Etude pour la danse* (Paris: Seuil, 1978), 24 and passim.

216. Mallarmé, *OC*, 316 ("Crayonné au théâtre"); Lacan, "La méprise du sujet supposé savoir," *Scilicet*, no. 1 (1968): passim.

217. Mallarmé, *OC*, 314 ("Crayonné au théâtre").

218. Baudelaire, *OC* I: 682 ("Mon coeur mis à nu").

219. Heidegger, *Being and Time*, 211–219 ("Idle Talk," "Curiosity," "Ambiguity").

220. Mallarmé, *OC*, 384.

221. See Lacan, *The Seminar of Jacques Lacan. Book I: Freud's Papers on Technique (1953–1954)*, ed. Jacques-Alain Miller, trans. John Forrester (New York: W. W. Norton, 1988), 132.

222. Kant, *The Critique of Judgement* (1790), trans. James Creed Meredith (Oxford: Clarenden Press, 1952), 64 (§12).

223. *IPS* II: 138, 146.

224. Ibid., 123.

225. See Freud, "Three Essays on Sexuality" (1905), VII: 156.

226. See Fédida, *Le concept et la violence* (Paris: UGE, 1977), 39.

227. Freud, "Three Essays on Sexuality," VII: 165.

228. Freud, "Hysterical Phantasies," IX: 162.

229. See Fédida, *Le concept et la violence,* 41–42 (the perverse contract).

230. *IPS* II: 148.

231. See Clavreul, "Le couple pervers," in *Le désir et la perversion* (Paris: Seuil, 1967), 117; Lacan, *Television (1973),* 38–39.

232. See Lacan, *Seminar I: Freud's Papers on Technique,* 221.

233. Freud, "Three Essays," VII: 154. See also Lacan, *Séminaire sur l'identification* (Dec. 19, 1956).

234. Mallarmé, *OC,* 311 ("Crayonné au théâtre").

235. Ibid., 319. (Mallarmé in fact writes "actor," not "actress.")

236. Artaud, *Watchfiends,* 323 ("The theater of cruelty").

237. Artaud, "Affective Athleticism," in *Collected Works,* 102.

238. See Deleuze, *Difference and Repetition,* 67–69 (but the "disparate" [*dispars*] is instead called "sub-representative").

239. Mallarmé, *OC,* 315 ("Crayonné au théâtre").

240. Ibid., 310 ("Mimique").

241. Ibid., 304 ("Ballets").

242. See Artaud, "Affective Athleticism," 100.

243. Charcot, *OC* III: 476.

244. Ibid., 476–477.

245. Charcot, *Leçons du mardi* (1887–1888), 140.

246. *IPS* II: 165–166.

247. See Guillain, *J.-M. Charcot*, 174.

248. Charcot, *OC* IX: 281. See also *IPS* I: 14–28.

249. Gilles de la Tourette, Guinon, and E. Huet, "Contribution à l'étude des baillements hystériques," in *NIS* (1890), 111.

250. Freud, "Remembering," XII: 151.

251. Baudelaire, *OC* I: 321 ("Une mort héroïque").

252. *IPS* I: 79.

253. *IPS* II: 205.

254. See Lacan, *Encore*, 85; Lacan, *Le Séminaire de Jacques Lacan. Livre IV: La relation d'objet* (1956–1957), ed. Jacques-Alain Miller (Paris: Seuil, 1994), 136–144.

255. Freud, "Transference-Love," XII: 167.

256. *IPS* II: 160.

257. Ibid., 148, 150.

258. Ibid., 150.

259. Freud, "Transference-Love," XII: 162.

8 Show-Stopper

1. Artaud, "The Theater of the Seraphim," in *Selected Writings*, ed. Susan Sontag, trans. Helen Weaver (New York: Farrar, Straus and Giroux, 1976), 274.

2. *IPS* II: 162.

3. Richer, *Etudes cliniques*, 82.

4. Ibid., 19, 44.

5. Briquet, *Traité clinique et thérapeutique*, 317–318.

6. See *IPS* II: 139, 164.

7. Ibid., 138.

8. Ibid., 155.

9. See Richer, *Etudes cliniques,* 90–97.

10. Freud, "Inhibitions," XX: 112.

11. Charcot, *Leçons du mardi* (1887–1888), 176.

12. Charcot, *Leçons du mardi* (1888–1889), 276.

13. Freud, "New Introductory Lectures," XXII: 95 (translation modified.—G. D.-H.).

14. Lacan, *Écrits,* 848 ("Position de l'inconscient").

15. Ibid., 847.

16. Ibid., 774 ("Kant avec Sade").

17. See Freud, "The Unconscious," XIV: 182–183; Freud, "New Introductory Lectures," XXII: 82–83, 93–94.

18. Bataille, *OC* II: 403–404 ("Masque").

19. Artaud, *OC* IV: 130.

20. Ibid., 273.

21. See Blanchot, *The Space of Literature,* 51–54.

22. Lessing, "Laocoön," 14–15.

23. Bataille, "Mouth," in *Visions of Excess: Selected Writings, 1927–39* (Minneapolis: University of Minnesota Press, 1985), 59–60 (Bataille, *OC* I: 237–238)

24. Artaud, *OC* I*: 185 ("Horripilation").

25. Ibid., 58.

26. See Freud, "New Introductory Lectures," XXII: 81–84.

27. Heidegger, *Being and Time,* 172–178 ("The Fundamental Attunement of Angst as an Eminent Disclosedness of Dasein"); Lacan, *Four Fundamental Concepts,* 41 (anxiety: that which does not deceive).

28. Freud, "Some Points for a Comparative Study of Organic and Hysterical Motor Paralyses," I: 164.

29. See Maldiney, *Aîtres de la langue,* 41–50 (on the temporality of desire according to Shelling). See also Maldiney, "Pulsion et présence," *Psychanalyse à l'université,* no. 5 (1976): passim.

30. Heidegger, *Being and Time,* 228–235.

31. Blanchot, *The Space of Literature,* 171.

32. Lacan, *Séminaire sur l'identification,* 356. See also Lacan, "Ecrits," 824.

33. See Maldiney, *Aîtres de la langue,* 252–253.

34. Freud, "Hysterical Attacks," IX: 230.

35. Bataille, *OC* III: 105–106 ("L'impossible").

36. See Briquet, *Traité clinique et thérapeutique,* 215; Jocelyne Livi, "Vapeurs de femmes," *Ornicar?* no. 15 (1978): 77.

37. *IPS* III: 190.

38. Rimbaud, *OC,* 65.

39. *IPS* II: 141.

40. Ibid., 140.

41. Bataille, "The Practice of Joy Before Death," in *Visions of Excess,* 236.

42. Bataille, "Mme Edwarda," trans. Austryn Wainhouse, in *The Bataille Reader,* ed. Fred Botting and Scott Wilson (London: Blackwell, 1997), 232–233.

43. Artaud, *OC* XIV★: 48–49.

44. *IPS* II: 126–127.

45. Ibid., 132.

46. Ibid., 123.

47. See Landouzy, *Traité complet de l'hystérie,* 14.

48. *IPS* II: 125.

49. Ibid., 133, 137, 166–168. See also *IPS* III: 198–199.

50. See Landouzy, *Traité complet de l'hystérie*, 164–165, 195–196; Briquet, *Traité clinique et thérapeutique*, 149.

51. Charcot, *OC* I: 394.

52. Ibid., 301–302.

53. See Legendre, "La phalla-cieuse," in *Vel*. No. 2. (Paris: UGE, 1976), 14–15; Foucault, *Histoire de la folie*, 299–302 (le chaud et l'humide), 322–323 (l'urine, le sang. . .); Foucault, *The History of Sexuality*, 146–149.

54. Foucault, *Histoire de la folie*, 81.

55. See Briquet, *Traité clinique et thérapeutique*, 479–489.

56. Pomme, cited by Foucault, *Clinic*, v.

57. Landouzy, *Traité complet de l'hystérie*, 299, 342.

58. Charcot, *OC* I: 303.

59. See *IPS* II: 140, 141, 153; Richer, *Etudes cliniques*, 228.

60. *IPS* II: 131.

61. *IPS* I: 83.

62. Meige, "La maladie de la fille de Saint-Géosmes," 223.

63. Landouzy, *Traité complet de l'hystérie*, 130; Wilhelm Fliess, *Les relations entre le nez et les organes génitaux féminins, présentés selon leurs significations biologiques* (1886), trans. Ach and Guir (Paris: Seuil, 1977), passim, esp. 9–10.

64. Commented by Schefer, *L'espèce de chose mélancolie* (Paris: Flammarion, 1978), 133.

65. *IPS* II: 168.

66. Breuer and Freud, *Studies on Hysteria* II: 204.

67. See Lacan, *Ecrits*, 197–213 ("Le temps logique").

68. Charcot, *OC* I: 386 (the case of Augustine).

69. *IPS* II: 172.

70. See Richer, *Etudes cliniques*, 88.

71. *IPS* III: 11.

72. *IPS* II: 139. See also Richer, *Etudes cliniques,* 134.

73. *IPS* III: 197.

74. See Bourneville, *Manuel des infirmières,* 3 vols. (Paris: Progrès Médical, 1878), passim.

75. *IPS* II: 150.

76. Breuer and Freud, *Studies on Hysteria* II: 65.

77. See Ellenberger, *The Discovery of the Unconscious,* 769.

78. André Lorde, *Théâtre d'épouvante* (Paris: Charpentier et Fasquelle, 1909), 79–81 ("A lecture at the Salpêtrière").

79. Breuer and Freud, *Studies on Hysteria,* II: 280–281.

80. See *IPS* II: 187, 196.

81. See Charcot and Richer, *Les démoniaques dans l'art* (1887) (Paris: Macula, 1984), passim. I am simply introducing the next episode of this research.

82. Nietzsche, "Beyond Good and Evil," 279.

Bibliography

Adhémar, Jean. "Un dessinateur passionné pour le visage humain: Georges-François-Marie Gabriel (1775–ca. 1836)." In *Omagiu lui George Oprescu.* Bucharest, 1961.

Aragon, Louis and André Breton. "Le cinquantenaire de l'hystérie." *La Révolution surréaliste,* no. 11 (1928): 20–22.

Artaud, Antonin. *Collected Works.* Trans. Victor Corti. London: John Calder, 1978.

———. *Oeuvres complètes.* Paris: Gallimard, 1976–.

———. "The Theater of the Seraphim." In *Selected Writings,* ed. Susan Sontag, trans. Helen Weaver. New York: Farrar, Straus and Giroux, 1976.

———. *Watchfiends and Rack Screams.* Trans. Clayton Eshleman. Boston: Exact Change, 1995.

Arthuis, Arthur. *Electricité statique. Manuel pratique de ses applications médicales.* 3rd ed. Paris: Doin, 1887.

———. *Traitement des maladies nerveuses, affections rhumatismales, maladies chroniques, par l'électricité statique.* 3rd ed. Paris: Delahaye, 1880.

Athanassio, Alexandre. *Les troubles trophiques dans l'hystérie.* Preface by Charcot. Paris: Progrès Médical/Lecrosnier & Babé, 1890.

Azam, Eugène. *Hypnotisme, double conscience et altérations de la personnalité.* Preface by Charcot. Paris: Ballière, 1887.

———. *Hypnotisme et double conscience.* Preface by P. Bert, Charcot, Ribot. Paris: Alcon, 1893.

Babinski, Joseph. *Oeuvre scientifique.* Collection of his principal works. Paris: Masson, 1934.

Baillarger, Jules-Gabriel-François. *Recherches sur les maladies mentales*. 2 vols. Paris: Masson, 1890.

Ballet, Gilbert. "La suggestion hypnotique au point de vue médico-légal." *Gazette hebdomadaire de Médecine et de Chirurgie* (1891 Oct.).

Baraduc, Hippolyte. *Double prolapsus ovarien chez une hystérique. Compression ovarienne intravaginale produisant le transfert*. Paris: Parent-Davy, 1882.

————. *La force vitale. Notre corps vital fluidique, sa formule biométrique*. Paris: Carré, 1893.

————. *L'âme humaine, ses mouvements, ses lumières et l'iconographie de l'invisible fluidique*. Paris: Carré, 1896.

————. *Méthode de radiographie humaine. La force courbe cosmique. Photographie des vibrations de l'éther. Loi des Auras*. Paris: Ollendorff, 1897.

Barthes, Roland. *Camera Lucida: Reflections on Photography*. Trans. Richard Howard. New York: Hill and Wang, 1981.

————. *A Lover's Discourse: Fragments*. Trans. Richard Howard. New York: Hill and Wang, 1978.

————. "The Photographic Message" (1962). In *The Responsibility of Forms*, trans. Richard Howard. Berkeley: University of California Press, 1985.

————. *Roland Barthes by Roland Barthes*. Trans. Richard Howard. Berkeley: University of California Press, 1977.

Bataille, Georges. "Mme Edwarda." In *The Bataille Reader*, ed. Fred Botting and Scott Wilson, trans. Austryn Wainhouse. London: Blackwell, 1997.

————. *Visions of Excess: Selected Writings, 1927–39*. Minneapolis: University of Minnesota Press, 1985.

————. *Oeuvres complètes*. 9 vols. Paris: Gallimard, 1970–1979.

Baudelaire, Charles. *Oeuvres complètes*. 2 vols. Paris: Gallimard, 1975–1976.

Baumgaertner. *Kranken-physionomik*. Stuttgart: Rieger, 1842.

Benjamin, Walter. "Little History of Photography" (1931). In *Walter Benjamin: Selected Writings*, vol. 2, trans. Edmund Jephcott and Kingsley Shorter. Cambridge: Harvard Unversity Press, 1999.

————. "The Work of Art in the Age of Mechanical Reproduction." In *Illuminations*, trans. Harry Zohn. 217–252. New York: Schocken Books, 1968.

Benveniste, Emile. *Problèmes de linguistique générale*. 2 vols. Paris: Gallimard, 1966–1974.

Bercherie, Paul. *Les fondements de la clinique. Histoire et structure du savoir psychiatrique*. Preface by Lantéri-Laura. Paris: Navarin, 1980.

Bergson, Henri. *Oeuvres*. Paris: PUF, 1959.

———. "Simulation inconsciente dans l'état d'hypnotisme." *Revue philosophique* XXII (1886): 525–531.

Bernard, Claude. *Introduction à l'étude de la médecine expérimentale*. Paris: Ballière, 1865.

———. *Leçons sur la physiologie et la pathologie du système nerveux*. 2 vols. Paris: Baillière, 1858.

Bertillon, Alphonse. *Identification anthropométrique—Instructions signalétiques*. New edition. Paris: Gauthier-Villars, 1890–1893.

———. *La photographie judiciaire*. Paris: Gauthier-Villars, 1890.

Binet, Alfred and Charles Féré. *Le magnétisme animal*. Paris: Alcan, 1887.

———. *Recherches expérimentales sur la physiologie des mouvements chez les hystériques*. Paris: Masson, 1887.

Blanchot, Maurice. *The Space of Literature*. Trans. Ann Smock. Lincoln: University of Nebraska Press, 1982.

Bourneville, Désiré-Magloire. *Album de photographie d'idiots de Bicêtre*. Paris: Bibliothèque Charcot, n.d.

———. *Etudes cliniques et thermométriques sur les maladies du système nerveux*. Paris: Delahaye, 1872–1873.

———. *Manuel des infirmières*. 3 vols. Paris: Progrès Médical, 1878.

———. "Mémoire sur la condition de la bouche chez les idiots, suivi d'une étude sur la médecine légale des aliénés, à propos du Traité de Médecine légale de M. Casper." *Journal des connaissances médicales et pharmaceutiques*, nos. 13, 15, 22, 26 (1862) and 3, 19, 20, 22 (1863).

———. "Notes et observations sur quelques maladies puerpérales. V. Deux cas de déchirure du périnée." *Revue photographique des Hôpitaux de Paris* (1871): 135–140.

———. *Recherches cliniques et thérapeutiques sur l'épilepsie et l'hystérie*. Report on observations made at the Salpêtrière between 1872 and 1875. Paris: Progrès Médical/Delahaye, 1876.

————. "Recherches cliniques et thérapeutiques sur l'épilepsie, l'hystérie et l'idiotie." Report of the service of epileptics and retarded children of the Bicêtre hospital, 1880–1906.

Bourneville, Désiré-Magloire and Paul Voulet. *De la contracture hystérique permanente.* Paris: Delahaye, 1872.

Breuer, Josef and Sigmund Freud. *Studies on Hysteria* (1893–1895). Ed. and trans. James Strachey. Vol. 3, *The Standard Edition of the Complete Psychological Works of Sigmund Freud.* 22 vols. London: Hogarth Press and the Institute of Psychoanalysis, 1962.

Briquet, Pierre. *Traité clinique et thérapeutique de l'hystérie.* Paris: Ballière, 1859.

Brouardel, Paul. *Le secret médical.* Paris: Ballière, 1887.

Brouardel, Paul, M. Leygues, and F. Raymond. "Inauguration du monument élevé à la mémoire du Professeur Charcot." *La médecine moderne* IX, no. 86 (1898): 681–683.

Broussais, François-Joseph-Victor. *De l'irritation et de la folie, ouvrage dans lequel les rapports du physique et du moral sont établis sur les bases de la médecine physiologique.* 2 vols. Paris: Ballière, 1828.

Burke, Edmund. *A Philosophical Enquiry into the Origin of Our Ideas of the Sublime and the Beautiful.* Ed. J. T. Boulton. London: Routledge and Paul, 1958.

Cagnetta, Franco and Jacqueline Sonolet. "Nascita della fotografia psichiatrica." Exposition: Ca'Corner della Regina, Venice, 1981.

Canguilhem, Georges. *The Normal and the Pathological.* Trans. Carolyn Fawcett. New York: Zone Books, 1989.

————. "Qu'est-ce que la psychologie." In *Etudes d'histoire et de philosophie des sciences.* Paris: Vrin, 1958.

Carré de Montgeron, Louis-Basile. *La vérité des miracles opérés à l'intercession de M. de Pâris et autres appelans, démontrée contre M. l'Archevêque de Sens.* 3 vols.: n.p., 1737.

Carroy-Thirard, Jacqueline. "Figures de femmes hystériques dans la psychiatrie française du XIXième siècle." *Psychanalyse à l'université* IV, no. 14 (1979): 313–324.

————. "Hypnose et expérimentation." *Bulletin de psychologie* XXXIV, no. 348 (1981): 41–50.

————. "Possession, extase, hystérie au XIXième siècle." *Psychanalyse à l'université* V, no. 14 (1980): 499–515.

"Centenaire de Charcot." *Revue Neurologique,* no. 6 (1925): 731–1192.

Cesbron, Henri. *Histoire critique de l'hystérie.* Paris: Houzeau, 1909.

Charcot, Jean-Martin. *Clinique des maladies du système nerveux.* Ed. G. Guinon. 2 vols. Paris: Progrès médical/Babé, 1892–1893.

———. "De l'expectation en médecine." Thesis for agrégation exam, Paris: Baillière, 1857.

———. *La foi qui guérit (1892).* Paris: Progrès médical/Alcan, 1897.

———. *La médecine empirique et la médecine scientifique.* Paris: Delahaye, 1867.

———. *Leçons du mardi à la Salpêtrière. Policlinique.* Course notes by Blin, Charcot, and Colin. Paris: Progrès médical/Delahaye & Lecrosnier, 1887–1888.

———. *Leçons du mardi à la Salpêtrière. Policlinique.* Course notes by Blin, Charcot, and Colin. Paris: Progrès médical/Lecrosnier & Babé, 1888–1889.

———. *Oeuvres complètes.* Lectures collected and published by Bourneville, Babinski, Bernard, Féré, Guinon, Marie, Gilles de la Tourette, Brisssaud, Sevestre. 9 vols. Paris: Progrès médical/Lecrosnier & Babé, 1886–1893.

Charcot, Jean-Martin, and Albert Pitres. *Les centres moteurs corticaux chez l'homme.* Paris: Rueff, 1895.

Charcot, Jean-Martin, and Paul Richer. *Les démoniaques dans l'art.* Paris: Delahaye & Lecrosnier, 1887.

Chertok, Léon and Raymond de Saussure. *Naissance du psychanalyste. De Mesmer à Freud.* Paris: Payot, 1973.

Cires anatomiques du XIXième siècle. Collection du Docteur Spitzner: Exposition, Centre Culturel de la Communauté française de Belgique, Paris, 1980.

Clarétie, Jules. "Charcot, le consolateur." *Les annales politiques et littéraires* XXI, no. 1056 (1903): 79–80.

Clavreul, Jean. "Le couple pervers." In *Le désir et la perversion.* 91–117. Paris: Seuil, 1967.

———. *L'ordre médical.* Paris: Seuil, 1978.

———. "Sémiologie clinique et sémiotique." In *Psychanalyse et sémiotique* (Milan colloquium—1974), 231–245. Paris: UGE, 1975.

Comte, Auguste. "Considérations générales sur l'étude positive des fonctions in-tellectuelles et morales ou cérébrales (45ième leçon du Cours de Philosophie positive) (1837)." In *Philosophie première*. 842–882. Paris: Hermann, 1975.

Conta, Olga. *Contribution à l'étude du sommeil hystérique*. Paris: Ollier-Henry, 1897.

Dagonet, Henri. *Nouveau traité élémentaire et pratique des maladies mentales*. Paris: Ballière, 1876.

Damisch, Hubert. "Agitphot. Pour le cinquantenaire de la 'Petite histoire de la Photographie' de Walter Benjamin." *Les cahiers de la photographie*, no. 3 (1981): 24–26.

———. "L'alphabet des masques." *Nouvelle Revue de Psychanalyse*, no. 21 (1980): 123–131.

Dante. "Inferno." In *The Divine Comedy*, trans. Allen Mandelbaum. New York: Alfred A. Knopf, 1995.

Darwin, Charles. *The Expression of the Emotions in Man and Animals*. Ed. Francis Darwin. London: W. Pickering, 1989.

Daudet, Léon. *Les morticoles*. Paris: Charpentier & Fasquelle, 1894.

———. *Les oeuvres dans les hommes*. Paris: Nouvelle Librairie Nationale, 1922.

David-Ménard, Monique. "Pour une épistémologie de la métaphore biologique en psychanalyse: la conversion hystérique." Thesis, Université de Paris VIII, 1978.

Debove, Maurice. "Eloge de J.-M. Charcot." *Bulletin médical*, no. 103 (1900): 1389–1394.

Delboeuf, Joseph. "De l'influence de l'imitation et de l'éducation dans le som-nambulisme provoqué." *Revue philosophique* XXII (1886): 146–171.

Deleuze, Gilles. *Difference and Repetition*. Trans. Paul Patton. London: Athalone Press, 1994.

Derrida, Jacques. *The Archeology of the Frivolous*. Trans. John. P. Leavey. Pittsburgh: Duquesne University Press, 1980.

Descartes, René. *Oeuvres et lettres*. Paris: Gallimard, 1953.

Diamond, H. W. "On the Application of Photography to the Physiognomic and Mental Phenomena of Insanity" (1856). In *The Face of Madness: H. W. Diamond*, 19–24. New York: Brunnel/Mazel, 1976.

Diderot, Denis. "Paradoxe sur le comédien (1773)." In *Oeuvres completes,* 1003–1058. Paris: Gallimard, 1951.

———. "Sur les femmes" (1772). In *Oeuvres completes,* 949–958. Paris: Gallimard, 1951.

Dostoevsky, Fyodor. *Demons.* Trans. Richard Pevear and Larissa Volokhonsky. New York: Knopf, 1994.

Dubois, Frédéric. *Histoire philosophique de l'hypocondrie et de l'hystérie.* Paris: Baillière, 1837.

Duchenne de Boulogne, Guillaume-Benjamin. *De l'électrisation localisée et de son application à la pathologie et à la thérapeutique* (1862). 3rd ed. Paris: Ballière, 1862.

———. *Mécanisme de la physionomie humaine ou analyse électrophysiologique de l'expression des passions.* Paris: Renouard, 1862.

Ellenberger, Henri F. *The Discovery of the Unconscious: The History and Evolution of Dynamic Psychiatry.* New York: Basic Books, 1970.

Eloire, M. "Vomissements chez une hystérique. Traitement par la fumée de tabac." *Revue médico-photographique des Hôpitaux de Paris* (1874): 102–105.

Esquirol, Jean. *Les maladies mentales considérées sous les rapports médical, hygiénique et médico-légal.* 2 vols. Paris: Ballière, 1838.

Fédida, Pierre. *Le concept et la violence.* Paris: UGE, 1977.

Féré, Charles. *De l'asymétrie chromatique de l'iris considérée comme stigmate névropathique (stigmate iridien).* Paris: Delahaye & Lecrosnier, 1886.

———. *La pathologie des émotions. Etudes physiologiques et cliniques.* Paris: Alcan, 1892.

Fliess, Wilhelm. *Les relations entre le nez et les organes génitaux féminins, présentés selon leurs significations biologiques* (1886). Trans. Ach and Guir. Paris: Seuil, 1977.

Foucault, Michel. *The Birth of the Clinic: An Archeology of Medical Perception.* Trans. A. M. Sheridan Smith. New York: Pantheon Books/Random House, 1973.

———. *Histoire de la folie à l'âge classique* (1961). Paris: Plon, 1972.

———. *The History of Sexuality. Volume I: An Introduction.* Trans. Robert Hurley. New York: Pantheon Books, 1978.

———. *The Order of Things: An Archeology of the Human Sciences.* New York: Pantheon Books, 1971.

Foveau de Courmelles, François-Victor. *L'hypnotisme*. Paris: Hachette, 1890.

Freud, Sigmund. *Letters of Sigmund Freud*. Trans. Tania and James Stern. Ed. Ernst L. Freud. New York: Basic Books, 1960.

———. *The Standard Edition of the Complete Psychological Works of Sigmund Freud*. Ed. and trans. James Strachey. 22 vols. London: Hogarth Press and the Institute of Psychoanalysis, 1962.

In the *Standard Edition*:

———. "Preface to the Translation of Charcot's *Lectures on the Diseases of the Nervous System*" (1886). Vol. I. 21–22.

———. "Report on My Studies in Paris and Berlin" (1956 [1886]). Vol. I. 5–18.

———. "Hysteria" (1888). Vol. I. 41–62.

———. "Some Points for a Comparative Study of Organic and Hysterical Motor Paralyses" (1893 [1888–1893]). Vol. I. 160–174.

———. "Sketches for the 'Preliminary Communication' of 1893" (1940–41 [1892]). Vol. I. 147–156.

———. "Preface and Footnotes to Charcot's *Tuesday Lectures*" (1892–94). Vol. I. 133–146.

———. "Charcot" (1893). Vol. III. 11–24.

———. "The Neuro-Psychoses of Defence" (1894). Vol. III. 43–70.

———. "The Aetiology of Hysteria" (1896). Vol. III. 191–224.

———. "Further Remarks on the Neuro-Psychoses of Defence" (1896). Vol. III. 162–188.

———. "Heredity and the Aetiology of the Neuroses" (1896). Vol. III. 141–158.

———. "Project for a Scientific Psychology" (1950 [1895]). Vol. I. 295–343.

———. "Screen Memories" (1899). Vol. III. 303–322.

———. "The Interpretation of Dreams" (1900). Vols. IV and V.

———. "The Psychopathology of Everyday Life" (1901). Vol. VI.

———. "On Psychotherapy" (1905). Vol. VII. 255–268.

———. "Fragment of an Analysis of a Case of Hysteria" (1905). Vol. VII. 1–122.

———. "Three Essays on the Theory of Sexuality" (1905). Vol. VII. 123–243.

———. "Creative Writers and Daydreaming" (1908). Vol. IX. 141–156.

———. "Hysterical Phantasies and their Relation to Bisexuality" (1908). Vol. IX. 155–166.

———. "Some General Remarks on Hysterical Attacks" (1909). Vol. IX. 227–234.

———. "Five Lectures on Psychoanalysis" (1910). Vol. XI. 1–58.

———. "The Psycho-Analytic View of Psychogenic Disturbance of Vision" (1910). Vol. XI. 209–218.

———. "A Note on the Unconscious in Psycho-Analysis" (1912). Vol. XII. 255–266.

———. "On the History of the Psycho-Analytic Movement" (1914). Vol. XIV. 1–66.

———. "Remembering, Repeating, and Working-Through" (1914). Vol. XII. 145–156.

———. "On Narcissism: An Introduction" (1914). Vol. XIV. 67–104.

———. "Observations on Transference-Love" (1915). Vol. XII. 157–171.

———. "Thoughts for the Times on War and Death" (1915). Vol. XIV. 273–300.

———. "Repression" (1915). Vol. XIV. 141–159.

———. "The Unconscious" (1915). Vol. XIV. 159–204.

———. "Group Psychology and the Analysis of the Ego" (1921). Vol. XVIII. 65–144.

———. "An Autobiographical Study" (1925). Vol. XX. 1–74.

———. "Inhibitions, Symptoms, and Anxiety" (1926). Vol. XX. 75–176.

———. "New Introductory Lectures on Psycho-Analysis" (1933). Vol. XXII. 1–182.

Galton, Francis. *Inquiries into Human Faculty and Its Development*. London: Macmillan, 1883.

Gauchet, Marcel and Gladys Swain. *La pratique de l'esprit humain. L'institution asilaire et la révolution démocratique.* Paris: Gallimard, 1980.

Gilardi, Ando. *Storia sociale della fotografia.* Milan: Feltrinelli, 1976.

Gilles de la Tourette, Georges. "De la superposition des troubles de la sensibilité et des spasmes de la face et du cou chez les hystériques." In *Nouvelle Iconographie de la Salpêtrière,* 170–187, 1889.

———. "Jean-Martin Charcot." In *Nouvelle Iconographie de la Salpêtrière,* 241–250, 1893.

———. "L'attitude et la marche dans l'hémiplégie hystérique." In *Nouvelle Iconographie de la Salpêtrière,* 1–12, 1888.

———. *Leçons de clinique thérapeutique sur les maladies du système nerveux.* Paris: Plon-Nourrit, 1898.

———. *L'hypnotisme et les états analogues au point de vue médico-légal.* Paris: Plon-Nourrit, 1887.

———. *Traité clinique et thérapeutique de l'hystérie, d'après l'enseignement de la Salpêtrière.* 3 vols. Preface by Charcot. Paris: Plon, 1891–1895.

Gilles de la Tourette, Georges, Georges Guinon, and E. Huet. "Contribution à l'étude des baillements hystériques." In *Nouvelle Iconographie de la Salpêtrière,* 97–119, 1890.

Grasset, Joseph. *Traité pratique des maladies du système nerveux.* 3rd ed. Paris: Coulet, Montpellier & Delahaye & Lecrosnier, 1886.

Guébhard, Adrien. "L'auréole photographique." *Moniteur de la Photographie,* no. 29 (1890): 115–119.

———. "Petit manuel de photographie spirite sans 'fluide.'" In *La photographie pour tous,* 1897–1898.

———. "Pourquoi les lointains viennent trop en photographie." *Photo-midi,* no. 1 (1898): 3–7.

———. "Sur les prétendus enregistrements photographiques de fluide vital." *La vie scientifique,* no. 106, 108, 110 (1887).

Guillain, Georges. *J.-M. Charcot (1825–1893). Sa vie. Son oeuvre.* Paris: Masson, 1955.

Guillain, Georges and Pierre Mathieu. *La Salpêtrière.* Paris: Masson, 1925.

Guinon, Georges. "Documents pour servir à l'histoire des somnambulismes." In *Progrès médical*, 1891–1892.

———. *Les agents provocateurs de l'hystérie.* Paris: Progrès Médical and Delahaye & Lecrosnier, 1889.

Guinon, Georges and S. Woltke. "De l'influence des excitations sensitives et sensorielles dans les phases cataleptique et somnambulique du grand hypnotisme." In *Nouvelle Iconographie de la Salpêtrière,* 77–88, 1891.

———. "De l'influence des excitations des organes des sens sur les hallucinations de la phase passionnelle de l'attaque hystérique." *Archives de Neurologie,* no. 63 (1891).

Guiraud, Pierre. *Dictionnaire historique, stylistique, rhétorique, etymologique de la littérature érotique.* Paris: Payot, 1978.

Haberberg, Georges. "De Charcot à Babinski. Etude du rôle de l'hystérie dans la naissance de la neurologie moderne." Medical thesis, University of Créteil, 1979.

Hahn, G. "Charcot et son influence sur l'opinion publique." *Revue des questions scientifiques* 2ième série, VI (1894): 230–261, 353–379.

Hardy, Alfred and A. Montméja. *Clinique photographique de l'Hôpital Saint-Louis.* Paris: Chamerot & Lauwereyns, 1868.

Hegel, G. W. F. *The Phenomenology of Spirit.* Trans. A. V. Miller. Oxford: Oxford University Press, 1977.

———. The Encyclopedia of Philosophy. Trans. Gustav Emil Mueller. New York: Philosophical Library, 1959.

Heidegger, Martin. "The Age of the World Picture" (1938). In *The Question Concerning Technology and Other Essays,* trans. William Lovitt. New York: Harper and Row, 1977.

———. *Being and Time.* Trans. John Macquarrie and Edward Robinson. New York: Harper and Row, 1962.

———. *Introduction to Metaphysics.* Trans. Ralph Manheim. Oxford: Oxford University Press, 1959.

Hénocque, A. "Photographie—Application aux sciences médicales." In *DESM,* 414–418, 1887.

Hervey de Saint-Denys, Léon. *Les rêves et les moyens de les diriger. Observations pratiques.* Paris: Amyot, 1867.

Hirt, L. *Das Hospiz "La Salpêtrière" in Paris und die Charcot'sche Klinik für Nervenkrankheiten*. Breslau: Grass-Barth, 1883.

Husson, A. *Etude sur les hôpitaux considérés sous le rapport de leur construction, de la distribution de leurs bâtiments, de l'ameublement, de l'hygiène et du Service des salles de malades*. Paris: Dupont, 1862.

—————. *Rapport sur le service des aliénés du département de la Seine pour l'année 1862*. Paris: Dupont, 1863.

Janet, Pierre. *Etat mental des hystériques. Les stigmates mentaux*. Paris: Rueff, 1893.

—————. "J.-M. Charcot. Son oeuvre psychologique." *Revue philosophique* (June 1895): 569–604.

—————. *L'automatisme psychologique. Essai de psychologie expérimentale sur les formes inférieures de l'activité humaine*. Paris: Alcan, 1889.

Janouch, Gustav. *Conversations with Kafka*. Trans. Goronwy Rees. New York: New Directions, 1971.

Jones, Ernest. *The Life and Work of Sigmund Freud*. 2 vols. New York: Basic Books, 1953.

Joyce, James. *Finnegans Wake*. New York: Viking Press, 1947.

Kant, Immanuel. *Anthropology from a Pragmatic Point of View* (1798). Trans. Victor Lyle Dowdell. Carbondale: Southern Illinois University Press, 1978.

—————. *The Critique of Judgement* (1790). Trans. James Creed Meredith. Oxford: Clarenden Press, 1952.

Kierkegaard, Søren. *The Seducer's Diary*. Trans. Howard V. Hong and Edna H. Hong. Princeton: Princeton University Press, 1997.

Krauss, Rosalind. "Tracing Nadar." *October*, no. 5 (1978): 29–47.

Lacan, Ernest. *Esquisses photographiques, à propos de l'Exposition universelle et de la guerre d'Orient*. Paris: Grassart, 1856.

Lacan, Jacques. *Ecrits*. Paris: Seuil, 1966.

—————. "L'étourdit." *Scilicet*, no. 4 (1973): 5–52.

—————. "La méprise du sujet supposé savoir." *Scilicet*, no. 1 (1968): 31–41.

—————. *Le Séminaire de Jacques Lacan. Livre IV: La relation d'objet* (1956–1957). Ed. Jacques-Alain Miller. Paris: Seuil, 1994.

———. *Séminaire sur l'identification* (1961–1962). 2 vols. New York: International General, n.d.

———. *The Seminar of Jacques Lacan. Book I: Freud's Papers on Technique* (1953–1954). Trans. John Forrester. Ed. Jacques-Alain Miller. New York: W. W. Norton, 1988.

———. *The Seminar of Jacques Lacan. Book XI: The Four Fundamental Concepts of Psycho-Analysis.* Trans. Alan Sheridan. New York: W. W. Norton, 1981.

———. *The Seminar of Jacques Lacan: On Feminine Sexuality (Book XX-Encore).* Trans. Bruce Fink. New York: W. W. Norton, 1998.

———. *Television* (1973). Trans. Denis Hollier, Rosalind Krauss, and Annette Michelsen. New York: W. W. Norton, 1990.

Lacoue-Labarthe, Philippe. "Apocryphal Nietzsche." In *The Subject of Philosophy,* ed. Thomas Trezise, trans. Timothy D. Bent. Minneapolis: University of Minnesota Press, 1993.

———. *Portrait de l'artiste, en général.* Paris: Bourgois, 1979.

Lafon, C. and Maurice Teulières. "Mydriase hystérique." In *Nouvelle Iconographie de la Salpêtriere,* 243–251, 1907.

Landouzy, Hector. *Traité complet de l'hystérie.* Paris: Ballière, 1846.

Laplassotte, François. "Sexualité et névrose avant Freud: une mise au point." *Psychanalyse à l'université* III, no. 10 (1978): 203–226.

Laufenauer, C. "Des contractures spontanées et provoquées de la langue chez les hystéro-épileptiques." In *Nouvelle Iconographie de la Salpêtrière,* 203–207, 1889.

Lautréamont. *Oeuvres complètes.* Paris: Gallimard, 1970.

Lavater, Johann. *L'art de connaître les hommes par la physionomie* (1775–1778). Ed. Moreau. 10 vols. Paris: Depélafol, 1820.

Le Brun, Charles. "Conférence sur l'expression générale et particulière (1668–96)." *Nouvelle Revue de Psychanalyse,* no. 21 (1980): 93–121.

Lechuga, Paul. "Introduction à une anatomie de la pensée médicale, à propos de l'hystérie au XIXième siècle." Medical thesis, Montpellier, 1978.

Leduc-Fayette, D. "La Mettrie et 'le labyrinthe de l'homme.'" *Revue philosophique,* no. 3 (1980): 343–364.

Legendre, Pierre. *La passion d'être un autre. Etude pour la danse.* Paris: Seuil, 1978.

———. "La phalla-cieuse." In *Vel.* No. 2. Paris: UGE, 1976.

Legros, Charles and Ernest Onimus. *Traité d'électricité médicale. Recherches physiologiques et cliniques* (1888), 2nd ed. Paris: Alcan, 1872.

Léonard, Jacques. *La France médicale. Médecins et malades au XIXième siècle.* Paris: Gallimard/Juilliard, 1978.

Lessing, Gotthold. "Laocoön." In *Laocoön, Nathan the Wise, Minna von Barnhelm,* trans. W. A. Steel. London: J. M. Dent & Sons, 1930.

Livi, Jocelyne. "Vapeurs de femmes." *Ornicar?* no. 15 (1978): 73–80.

Londe, Albert. *Aide-mémoire pratique de la photographie.* Paris: Ballière, 1893.

———. *La photographie à la lumière artificielle.* Paris: Doin, 1914.

———. *La photographie à l'éclair magnésique.* Paris: Gauthier-Villars, 1905.

———. *La photographie dans les arts, les sciences et l'industrie.* Paris: Gauthier-Villars, 1888.

———. *La photographie instantanée. Théorie et pratique.* Paris: Gauthier-Villars, 1886.

———. *La photographie médicale. Application aux sciences médicales et physiologiques.* Pref. by Charcot. Paris: Gauthier-Villars, 1893.

———. *La photographie moderne. Pratique et applications.* Paris: Masson, 1888.

———. *La photographie moderne. Traité pratique de la photographie et de ses applications à l'industrie et à la science.* Paris: Masson, 1896.

———. *Le service photographique de la Salpêtrière.* Paris: Doin, n.d.

———. *L'évolution de la photographie.* Paris: Association Française pour l'avancement des sciences, 1889.

———. *Traité pratique du développement. Etude raisonnée des divers révélateurs et de leur mode d'emploi.* Paris: Gauthier-Villars, 1889.

Lorde, André. *Théâtre d'épouvante.* Paris: Charpentier et Fasquelle, 1909.

Losserand, Jean. "Epilepsie et hystérie. Contribution à l'histoire des maladies." *Revue française de psychanalyse* XLII, no. 3 (1978): 411–438.

Louyer-Villermay, Jean-Baptiste. *Traité des maladies nerveuses en vapeurs et particulièrement de l'hystérie et de l'hypocondrie.* 2 vols. Paris: Méquignon, 1816.

Luys, Jules. *Iconographie photographique des centres nerveux.* Paris: Ballière, 1873.

————. *Leçons cliniques sur les principaux phénomènes de l'hypnotisme dans leurs rapports avec la pathologie mentale.* Paris: Carré, 1890.

————. *Les émotions chez les sujets en état d'hypnotisme. Etudes de psychologie expérimentale faites à l'aide de substances médicamenteuses ou toxiques impressionnant à distances les réseaux nerveux périphériques.* Paris: Ballière, 1887.

————. *Traité clinique et pratique des maladies mentales.* Paris: Delahaye & Lecrosnier, 1881.

Magnan, Valentin. *Recherches sur les centres nerveux. Alcoolisme, folie des héréditaires dégénérés, paralysie générale, médecine légale.* 2 vols. Paris: Masson, 1876–1893.

Maldiney, Henri. *Aîtres de la langue et demeures de la pensée.* Lausanne: L'âge d'homme, 1975.

————. "Pulsion et présence." *Psychanalyse à l'université,* no. 5 (1976): 49–77.

Mallarmé, Stéphane. *Oeuvres complètes.* Paris: Gallimard, 1945.

————. *Pour un Tombeau d'Anatole.* Ed. Jean-Pierre Richard. Paris: Seuil, 1961.

Mannoni, Octave. *Un commencement qui n'en finit pas. Transfert, interprétation, théorie.* Paris: Seuil, 1980.

Marey, Etienne-Jules. *La méthode graphique dans les sciences expérimentales et principalement en physiologie et en médecine.* 2nd ed. Paris: Masson, 1878.

————. *Le développement de la méthode graphique par la photographie.* Paris: Masson, 1885.

Marin, Louis. *Détruire la peinture.* Paris: Galilée, 1977.

Meige, Henry. "La maladie de la fille de Saint-Géosmes, d'après Jean-François-Clément Morand (1754)." In *Nouvelle Iconographie de la Salpêtrière,* 223–256, 1896.

————. "Une révolution anatomique." In *Nouvelle Iconographie de la Salpêtrière,* 97–115, 174–183, 1907.

Miller, Gérard. "Crime et suggestion. Suivi de: Note sur Freud et l'hypnose." *Ornicar?* no. 4 (1975): 27–51.

Miller, J. A. "Some Aspects of Charcot's Influence on Freud." *Journal of the American Psychoanalytic Association,* no. 2 (1969): 608–223.

Moebius, Paulus-Julius. *Allgemeine Diagnostik der Nervenkrankheiten.* Leipzig: Vogel, 1886.

———. *De la débilité mentale physiologique chez la femme* (1901). Trans. Roche. Paris: Solin, 1980.

Montméja, A. "Machine d'induction." *Revue Médico-photographique des Hôpitaux de Paris* (1874): 250.

Montméja, A. and J. Rengade. "Préface." *Revue photographique des Hôpitaux de Paris* I (1869): unpaginated.

Morel, Bénédict Auguste. *Etudes cliniques. Traité théorique et pratique des maladies mentales.* 2 vols. Paris: Grimblot & Raybois, Nancy/Masson, 1852.

———. *Traité des dégénérescences physiques, intellectuelles et morales de l'espèce humaine, et des causes qui produisent ces variétés maladives.* Paris: Ballière, 1857.

Morel, Pierre, and Claude Quetel. *Les fous et leurs médecines de la Renaissance au XIXième siècle.* Paris: Hachette, 1979.

Nadar. *Quand j'étais photographe.* Preface by Daudet. Paris: Flammarion, 1900.

Nancy, Jean-Luc. *Ego sum.* Paris: Flammarion, 1979.

Nassif, Jacques. *Freud—L'inconscient. Sur les commencements de la psychanalyse.* Paris: Galilée, 1977.

———. "Freud et la science." *Cahiers pour l'analyse,* no. 9 (1968): 147–167.

Nietzsche, Friedrich. "Beyond Good and Evil" (1886). In *Basic Writings of Nietzsche.* New York: Modern Library, 1968.

Noica, M. "Le mécanisme de la contracture chez les spasmodiques, hémiplégiques ou paraplégiques." In *Nouvelle Iconographie de la Salêtrière,* 25–36, 1908.

Onimus, Ernest. "De l'action thérapeutique des courants continus." *Revue photographique des Hôpitaux de Paris* (1872): 286–292 and 332–341.

Pinel, Philippe. *Traité médico-philosophique sur l'aliénation mentale ou la manie.* 2nd ed. Paris: Richard, 1809.

Pitres, Albert. *Leçons cliniques sur l'hystérie et l'hypnotisme.* 2 vols. Paris: Doin, 1891.

Pontalis, Jean-Baptiste. "Entre Freud et Charcot: d'une scène à l'autre." In *Entre le rêve et la douleur*, 11–17. Paris: Gallimard, 1973.

Proust, Marcel. *Sodome et Gomorrhe*. In *A la recherche du temps perdu*. Ed. P. Clarac, A. Ferre. Vol. 2. Paris: Gallimard, 1961.

Rabelais, François. "Book Three." In *The Complete Works of François Rabelais*, Trans. Donald M. Frame. Berkeley: University of California Press, 1991.

Régnard, Paul. *Les maladies épidémiques de l'esprit—Sorcellerie, magnétisme, morphinisme, délire des grandeurs*. Paris: Plon-Nourrit, 1887.

Régnard, Paul and Paul Richer. "Etudes sur l'attaque hystéro-épileptique faites à l'aide de la méthode graphique." *Revue mensuelle de médecine et de chirugie* (1878): 641–661.

Richer, Paul. "Diathèse de contracture." In *Nouvelle Iconographie de la Salpêtrière*. 344–353, 1891.

———. *Etudes cliniques sur la grande hystérie ou hystéro-épilepsie*. 2nd ed. Paris: Delahaye & Lecrosnier, 1881–1885.

———. "Observation de contracture hystérique guérie subitement après une durée de deux années." In *Nouvelle Iconographie de la Salpêtrière*, 208–213, 1889.

———. *Paralysies et contractures hystériques*. Paris: Doin, 1892.

Rimbaud, Arthur. *Oeuvres complètes*. Paris: Gallimard, 1972.

Rummo, G. *Iconografia fotografica del Grande Isterismo—Istero-Epilessia, omaggio al Prof. J.-M. Charcot*. Naples: Clinica Medica Propedeutica di Pisa, 1890.

Safouan, Moustapha. *L'échec du principe de plaisir*. Paris: Seuil, 1979.

Sartre, Jean-Paul. *L'imaginaire. Psychologie phénoménologique de l'imagination*. Paris: Gallimard, 1940.

Schaffer, C. "De la morphologie des contractures réflexes intrahypnotiques et de l'action de la suggestion sur ces contractures." In *Nouvelle Iconographie de la Salpêtrière,* 1893: 305–321, and 1894: 22–34.

Schefer, Jean-Louis. *L'espèce de chose mélancolie*. Paris: Flammarion, 1978.

———. *L'homme ordinaire du cinéma*. Paris: Cahiers du cinéma/Gallimard, 1980.

———. *Le Déluge, la Peste, Paolo Uccello*. Paris: Galilée, 1976.

———. *L'invention du corps chrétien. Saint-Augustin, le dictionnaire, la mémoire.* Paris: Galilée, 1975.

Shakespeare, William. *The Tragedy of Macbeth.* In *The Riverside Shakespeare,* ed. G. Blakemore Evans, 1306–1342. Boston: Houghton Mifflin, 1974.

Sibony, Daniel. *Le groupe inconscient—Le lien et la peur.* Paris: Bourgois, 1980.

———. *Le nom et le corps.* Paris: Seuil, 1974.

Sollier, Paul. *Genèse et nature de l'hystérie. Recherches cliniques et expérimentales de psycho-physiologie.* 2 vols. Paris: Alcan, 1897.

Sonolet, Jacqueline. *Trois siècles d'histoire hospitalière. La Salpêtrière.* Exposition, 1958.

Sontag, Susan. *On Photography.* New York: Farrar, Straus and Giroux, 1977.

Souques, Alexandre-Achille. *Charcot intime.* Paris: Masson, 1925.

———. "Contribution à l'étude des syndromes hystériques 'simulateurs' des maladies organiques de la moelle épinière." In *Nouvelle Iconographie de la Salpêtrière,* 1–52, 130–150, 300–326, 366–406, 409–55, 1891.

Starobinski, Jean. "Le passé de la passion. Textes médicaux et commentaires." *Nouvelle revue de psychanalyse,* no. 21 (1980): 51–76.

Tebaldi, Augusto. *Fisionomia ed espressione studiate nelle loro deviasioni con una appendice sulla espressione del delirio nell'arte.* Verona: Drucker e Tedeschi, 1884.

Thyssen, Eduard Hendrik Marie. *Contribution à l'étude de l'hystérie traumatique.* Paris: Davy, 1888.

Valéry, Paul. "Centenaire de la Photographie" (1939). In *Vues.* Paris: La Table ronde, 1948.

Veith, Ilza. *Hysteria: The History of a Disease.* Chicago: University of Chicago Press, 1965.

Villechenoux, Camille. "Le cadre de la folie hystérique de 1870 à 1918, contribution à l'histoire de la psychiatrie, aspects de l'évolution des idées sur la frontière entre la névrose et la psychose." Medical Thesis, Paris, 1968.

Voisin, Auguste. *Leçons cliniques sur les maladies mentales et sur les maladies nerveuses.* Paris: Ballière, 1883.

————. *Leçons cliniques sur les maladies mentales professées à la Salpêtrière.* Paris: Ballière, 1876.

Voisin, Félix. *Des causes morales et physiques des maladies mentales et de quelques autres affections nerveuses, telles que l'hystérie, la nymphomanie et le satyriasis.* Paris: Ballière, 1826.

Wajeman, Gérard. "La convulsion de Saint-Médard." *Ornicar?* no. 15 (1978): 13–30.

————. "Psyché de la femme: note sur l'hystérique au XIXième siècle." *Romantisme,* no. 13–14 (1976): 57–66.

————. "Théorie de la simulation." *Ornicar?—Analytica* 22 (1980): 17–33.

Zola, Emile. *Son Excellence E. Rougon.* In *Rougon-Maquart,* ed. A. Laroux and H. Mitterand. Paris: Gallimard, 1961.

Index

Printed in the United States
by Baker & Taylor Publisher Services